THE CRAFT OF
PHOTOGRAPHY

THE CRAFT OF
PHOTOGRAPHY
DAVID VESTAL

1817

HARPER & ROW, PUBLISHERS

New York, Evanston, San Francisco, London

Much of the material in this book first appeared in *Camera 35*.

THE CRAFT OF PHOTOGRAPHY. Copyright © 1972, 1973, 1974, 1975 by David Vestal. All rights reserved. Printed in the United States of America. No part of this book may be used or reproduced in any manner whatsoever without written permission except in the case of critical articles and reviews. For information address Harper & Row, Publishers, Inc., 10 East 53rd Street, New York, N.Y. 10022. Published simultaneously in Canada by Fitzhenry & Whiteside Limited, Toronto.

Designed by Alfred Manso

Library of Congress Cataloging in Publication Data
Vestal, David.
 The craft of photography.
 1. Photography. I. Title.
TR146.V49 1974 770 74-1865
ISBN 0-06-014497-1

Contents

Acknowledgments

A great many people and institutions have helped make this book possible, whether they know it or not. It would be impossible to list all of them, but certainly I owe thanks:

To my teacher, the late Sid Grossman, for helping me find my own way to photograph.

To Jim Hughes of *Camera 35* magazine, for his initiative in getting me started on the book, and to Marie Rodell for helping it go further.

To Barbara Lobron, Bob Nadler, Peggy Sealfon and Wes Disney of *Camera 35*, for ideas and for help in doing the job.

To Ralph Steiner, my ex-boss and ex-student, for encouragement and useful criticism.

To Charles Pratt, for "Dr. Pratt's" print-developer formula and much more.

To Bill Broecker, for cheerful help in many forms.

To Miles Barth at the Art Institute of Chicago, for teaching me how to mat prints painlessly.

To Henry Wilhelm of the East Street Gallery, Dr. Walter Clark, George Eaton of Kodak, and many others, for information on photographic permanence.

To Mike Sullivan of Kodak, to Norman Lipton acting for Ilford, and to many others in the photographic and related industries, for providing information and samples when I needed them.

To Tom Barrow, for letting me use the Xerox machine at the Art Museum of the University of New Mexico to the point of its exhaustion.

To Eastman Kodak, for making the superb film Tri-X, and to Polaroid, for making Type 52 4x5 "film," both of which made illustrating the book easier than seems reasonable.

To the John Simon Guggenheim Memorial Foundation, for its fellowships and support.

To the International Museum of Photography at George Eastman House, the Gernsheim Collection at the University of Texas, the Photographic Section of the Smithsonian Institution, the Picture Collection of the New York Public Library and other sources of historical pictures.

To Ann Harris and John Steele Gordon, for intelligent editing.

To my wife, the distinguished photographer Ann Treer, for putting up with it all.

DAVID VESTAL

Introduction and Capsule History

This is an advanced course in "straight" black-and-white photography for beginners and others. (It does not deal with such techniques as solarization and multiple printing.)

If you read attentively and do the experiments carefully, you can learn all you need to know to make straight photographs of any quality you want.

Photography is not difficult. You don't have to know much theory to make good negatives and prints. Technically, it's enough to understand a few working principles that control picture quality, and to know the necessary procedures. I'll tell you the procedures and you can experiment with the principles for yourself to see what really happens when you do what.

No one quite knows what photography is. *Webster's New Collegiate Dictionary* says it's "the art or process of producing images on sensitized surfaces by the action of light."

By that definition, eyesight is a form of photography, and suntan could be another. Camera-and-film photography, the kind we're concerned with here, is newer.

Cameras came before the chemistry. First there was the *camera obscura* ("dark room"): a lens at one end of a box threw an image on a screen at the other end. For centuries it was strictly to look at, but the idea of "trapping" the picture came up early. Aristotle described the principle of the camera obscura more than 2000 years ago. Ibn Al-Haitham, an Arab mathematician, is said to have used one to watch an eclipse before A.D. 1038. The

later re-invention of the camera obscura in Europe has been shakily credited to several men. Giovanni Battista della Porta, the usual candidate, described but did not invent it in 1558. By 1685 a Würzburg monk, Johann Zahn, had designed portable box and reflex cameras that could have taken photographs if he'd had some "sensitized surfaces." Many painters used the camera obscura. Vermeer must have: some of his paintings include out-of-focus areas that the unaided eye just doesn't see that way.

Johann Heinrich Schulze, a physicist, observed in 1727 that certain silver salts darkened in sunlight, and that light, not heat, caused the change. He couldn't stop his silver salts from turning black, or we might have had photography a century earlier. The idea was in the

Design for camera obscura by Johann Zahn, about 1685. (Division of Photographic History, Smithsonian Institution)

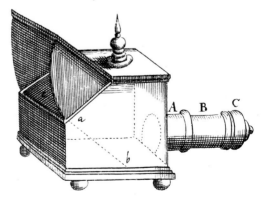

air: Tiphaine de la Roche's novel *Giphantie* predicted "sun pictures" in detail in 1760.

Thomas Wedgwood was making sun prints by 1802. He placed objects on sensitized paper and leather and put them out in the sunlight, which blackened the surface where it struck directly, while shaded areas temporarily stayed light. His process was too slow to permit using a camera, and he couldn't keep the image from turning completely black.

In 1819 Sir John Herschel found that "hyposulphite of soda" dissolved silver halides (light-sensitive salts). Twenty years later he introduced "hypo" as a "fixer" to make photographs permanent, and Daguerre and others stopped using table salt to stabilize their pictures. Sodium thiosulfate—its modern name—is still used and still called "hypo."

The earliest known existing photograph was made by Joseph Nicéphore Niépce in 1826. That same year Louis Jacques Mandé Daguerre wrote to Niépce to say he was working on the same problem. Hoping to invent a practical method for photography, they became partners in 1829. Niépce died in 1833 before they had made much progress.

Meanwhile an Englishman, William Henry Fox Talbot, got the bug. By 1835 he had made at least one tiny paper negative with a camera. By 1837 Daguerre had made some good photographs on silver, but wasn't ready to announce his process, no longer much related to Niépce's pioneering work.

The lid blew off in 1839. *Paris, January 7:* Daguerre's direct-positive process on silver was announced by François Jean Dominique Arago. *London, January 31:* Talbot read a paper on "Photogenic Drawing" (paper negatives and prints) to the Royal Society. *Paris, June 24:* Hippolyte Bayard exhibited thirty

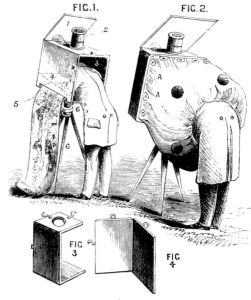

Nineteenth-century variations on the camera obscura.

Tracing the image in a small camera obscura.

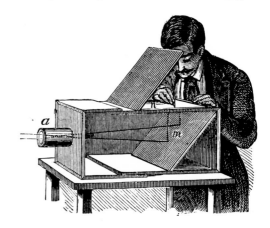

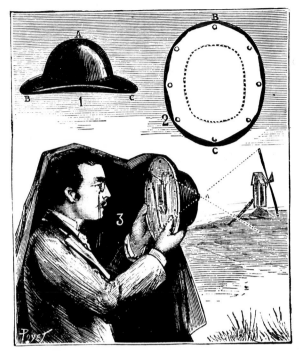

Fig. 1.—THE DERBY HAT AS A CAMERA OBSCURA.

The photographic gadget is not new.

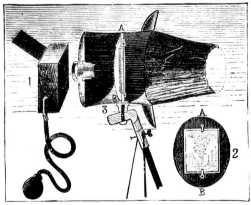

Fig. 2.—BEAVER HAT CONVERTED INTO A
PHOTOGRAPHIC CAMERA.

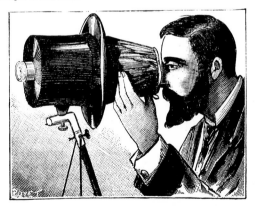

Fig. 3.—MODE OF USING THE APPARATUS.

Introduction and Capsule History **xi**

direct-positive photographs on paper made by a process of his own. (The unfortunate Bayard lacked Talbot's money and prestige and Daguerre's genius for publicity. His excellent work was ignored.) *Paris, August 19*: Arago explained the daguerreotype process to a joint meeting of the Académies des Sciences and des Beaux Arts. The next day Daguerre's manual—the first photographic how-to book—went on sale, along with cameras, plates and chemicals. Photography had arrived.

EARLY TECHNIQUES

Daguerreotype and calotype. Two techniques prevailed until the 1850s: the daguerreotype, with light tones formed by a white deposit on a mirror-like silver surface; and the calotype or talbotype—paper prints from paper negatives. The calotype allowed repeated prints of the pictures, but had a coarse paper-grain texture. In the daguerreotype the plate exposed in the camera was the one-and-

Made by Niépce in 1826, this may be the oldest surviving photograph. (Gernsheim Collection, Humanities Research Center, the University of Texas at Austin)

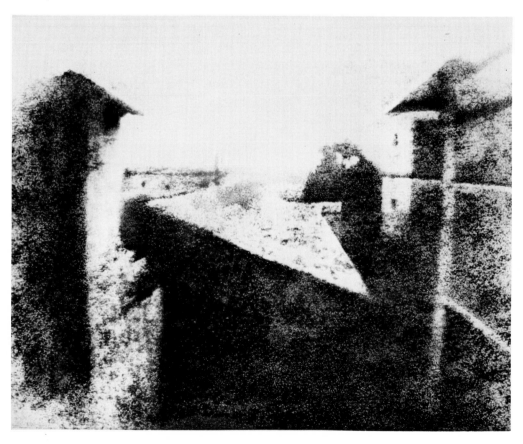

only picture, but the difficulty of making copies was offset by its exquisite rendition of tones and textures.

The Wet-Collodion process. After 1851 both processes were made obsolete by Frederick Scott Archer's wet-collodion process for photography on glass. Now repeated prints with delicate tones and sharp texture rendition were possible—the first to look like photographs as we know them.

A variant, the ambrotype, was a thin collodion negative mounted on a black backing. The image, lighter than the background, was seen as a positive, like a darkish daguerreotype. Being cheaper, the ambrotype put the daguerreotype out of business. A version of the ambrotype, the tintype, disappeared in the United States after 1950 because it couldn't compete with the new Polaroid Land process.

Wet-collodion or "wet-plate" photography was work. For each negative the photographer had to coat his plate with collodion, which gave off ether fumes; sensitize it in a silver-nitrate bath; expose it in the camera and develop the plate before the coating could dry. Wet-plate photographers took only pictures they were sure they wanted, so their "good picture" averages were high. Collodion was tougher than today's film. When William Henry Jackson photographed Yellowstone in 1868, he washed some negatives in nearly boiling geyser water and was pleased how fast the hot plates dried. Don't try this now!

Wet-plate photographs were taken in haste, but the plates were very slow—not very sensitive to light. Cameras had no shutters, were used on tripods or stands, and were focused on a groundglass which was replaced by the sensitized plate to take the picture. Exposures took at least several seconds and hand-held cameras were unheard of. Negative sizes ranged from "sixth-plate" (2¾x3¼ inches) to 20x24 inches and larger. Prints were contact prints, the size of the negative. Enlarged prints made directly from small negatives were rare: the paper was too slow. It was easier to make larger negatives and contact-print them. This was done either by using a big camera in the first place, as most people did, or by copying a small original negative onto a larger plate—a complicated process.

Dry Plates. Dr. Richard Leach Maddox couldn't stand breathing ether while coating wet plates, so in 1871 he thought of a way to make "dry plates" with gelatin instead of collodion. They had another advantage: they could be used any time. By 1880 factory-coated dry plates were being sold, making amateur photography possible on a large scale. The first dry plates were slow, but soon they became much faster than wet plates. "Instantaneous" hand-held photography—the snapshot and the "action shot"—were born, and new cameras were devised to serve them. In the 1880s many "detective cameras," disguised as parcels, and repeaters with dry-plate magazines were sold. A bank clerk named George Eastman, who had moonlighted as a dry-plate manufacturer, left the bank to concentrate on his new business.

Roll Film and the Snapshot. The next revolution was roll film, invented at about the same time by the Rev. Hannibal Goodwin and by Henry M. Reichenbach, a chemist for Eastman. Reichenbach applied for a roll-film patent in 1889 and promptly got it. Goodwin had applied in 1887, but his patent was only granted in 1898. He then sold it to Anthony and Scovill (later Ansco, now GAF), and died in 1901. After a prolonged infringement suit, the courts upheld Goodwin's patent in 1914. Eastman paid Ansco five million dollars,

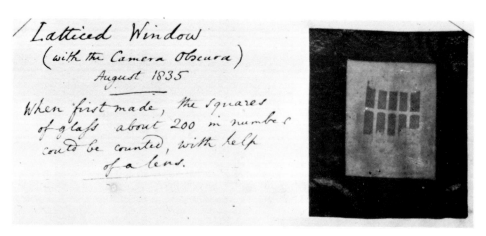

Early paper negative by William Henry Fox Talbot, showing a latticed window in his home, Lacock Abbey. August, 1835. (The Science Museum, London).

retroactively legalizing 25 years of Kodak roll film. Reichenbach's film had gone into production in 1889, replacing sensitized rolls of paper in the No. 1 Kodak camera that Eastman had introduced in 1888. ("You press the button—we do the rest" and the name Kodak were inspired word inventions by George Eastman that may have changed photography as much as film did.)

New Kinds of Cameras. The detective camera gave way to the Kodak and other roll-film box cameras. Johann Zahn's 1685 reflex was reborn with a shutter in the form of the Graflex and other hand-held single-lens reflex cameras around 1900. In the early 1900s folding roll-film cameras were the amateur's standby and sheet-film press cameras and reflexes were used by picture-taking reporters.

A New Way to Print. High-speed printing papers had now become available, so direct enlargements from small negatives became almost as common as contact prints.

New Kinds of Film. The original "color-blind" film (sensitive only to blue and ultra-violet light) was augmented by orthochromatic film, sensitive to all colors but red, and later by panchromatic film, sensitive to light of all visible colors. Most black-and-white film today is panchromatic.

The 35mm Revolution. In 1924 the 35mm Leica went into production: photography hasn't been the same since. But few photographers were ready for 35mm and the changes came slowly. When I first studied photography in 1947, my teacher, Sid Grossman, still considered the 35mm camera a toy, and used the 2¼-inch-square-format twin-lens reflex then regarded as the "professional" camera. Two years later he got a 35mm Contax and his photography loosened up considerably. This happened to so many photographers that today 35mm is the leading professional and advanced-amateur format.

The Eye-level Reflex Camera. The first 35mm eye-level single-lens reflexes appeared about 1949. Photographers are conformists:

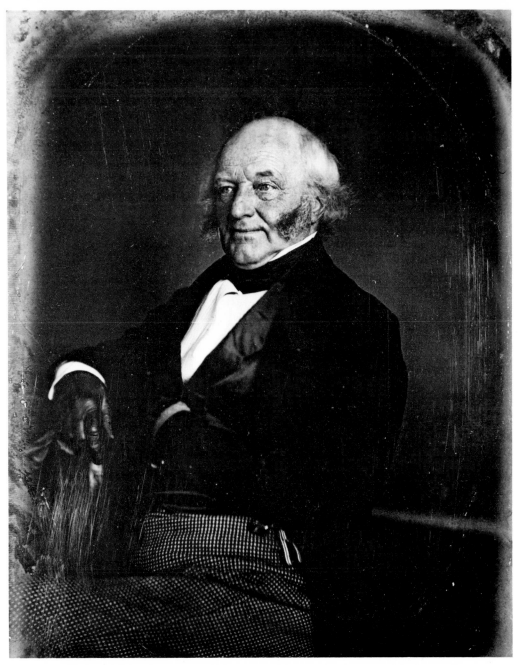

Daguerreotype of Martin Van Buren (1782–1862) by an unidentified maker, about 1845–1850. (Courtesy Chicago Historical Society)

Ambrotypes were really negatives on glass: when backed with black, the silver was seen as a light tone, so the picture was seen as a positive. (Photograph from the International Museum of Photography at George Eastman House)

the new cameras were not "in," so they were ignored for two or three years. Then, suddenly, the SLR was in fashion. They now dominate the 35mm field. I know of only one top-grade make of rangefinder camera with interchangeable lenses that is still being produced in the 1970s: the Leica.

The Ups and Downs of Craftsmanship. As cameras and techniques evolve, photographers change, too—not always for the better. Early photographers prepared their own plates and paper as well as taking the pictures, so they could coordinate their materials with their needs. After all that work, too, they were careful what and how they photographed. They tended to make stiff but very well executed pictures. They knew their craft.

Photography and Handmade Pictures. Photography was invented by painters and chemists who wanted to make magic paintings. Many early photographers were trained as painters, which helped in some ways, but tended to keep them from understanding that a photograph is not a machine-made drawing but something else entirely. It offers possibilities that are closed to artists who must

put the pigment onto their pictures by hand. Photographs often show us important things we didn't know we saw when we took them.

Directness vs. "Art," or How to Stay Modern. The photographs from the past that still reach us with the fresh power of today's experience were mostly made without any artistic aspirations. As clearly and exactly as possible, they recorded sights that interested the photographers. Today we find much art in some of these pictures, but only artiness in most of the more ambitious productions by painting-trained "artist-photographers." Sadly, many photographers still think of their medium as second-class painting. Too many "culture-conscious" photographers work hard to keep their pictures from looking photographic, or carefully avoid one of photography's main strengths: the clear representation of recognizable objects and relationships.

Plate XIII, "Queen's College, Oxford," from the first photographic book, Talbot's *Pencil of Nature*, 1844. No way to reproduce photographs with a printing press existed: each plate in each copy of the book was an original photographic print. (Division of Photographic History, Smithsonian Institution)

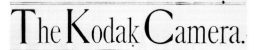

The Kodak Camera.

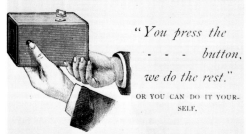

"You press the

- - - button,

we do the rest."

OR YOU CAN DO IT YOUR-
SELF.

The only camera that anybody can use without
instructions. As convenient to carry as an ordinary
field glass. World-wide success.

The Kodak is for sale by all Photo stock dealers.

Send for the Primer, free.

The Eastman Dry Plate and Film Co.,
ROCHESTER, N. Y.

Price, $25.00—Loaded for 100 Pictures.
Re-loading $2.00.

Advertisement for the first Kodak, December, 1889.

First-class photographs usually owe little or
nothing to other media. They are first-class
photographs, period.

Progress toward Mediocrity. As the tech-
nology advances, the craft recedes. Manu-
facturers and processing services take over
more and more of the work and the picture
decisions, while photographers get lazier and
less competent. While technology holds out
to us more possibilities than photographers
have ever known, we use them less and less
resourcefully. We have, on the whole, no
idea how much we could achieve, and it
doesn't occur to us to find out by trying. Too
often we are content with sloppy, mediocre

work. The one thing we've gained is spon-
taneity—useless without perception.

The Picture-Processing Industry. Of the
many well-equipped labs and skilled tech-
nicians in the processing business, very few
can afford the time to do their work as well
as they are able to do it. It's a profit-and-loss
financial problem. Fortunately for the labs,
few customers know the difference, and fewer
care.

The Easy Way. It remains easier to get
really good black-and-white photographs by
doing all the processing yourself than by en-
trusting any part of it to others, no matter
how skilled they are.

This book is for anyone who wants to learn

A Graflex that is still in use.

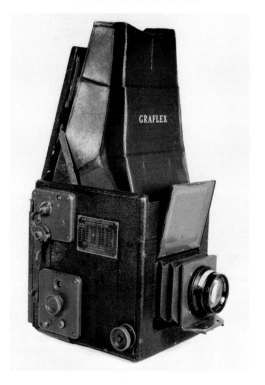

the craft of making first-class black-and-white photographs. Photography is an art as well, but art is not teachable. If you want art, you must bring your own.

Photo equipment of 1890.

PART ONE

HARDWARE
AND
SOFTWARE

1

Cameras and Lenses

A camera is a picture trap. A lens at one end of a dark box scoops up visions and throws them onto film at the other end. The camera's knobs, rings, levers and dials have two main functions: to adjust the light that makes each picture, and to move fresh film into place for the next picture.

LENSES

What Lenses Do to Light. The lens bends light to form on the film a picture of whatever is in front of the camera. You control exposure—how much image-forming light hits the film—and fit it to the film's "speed" or sensitivity in two ways: by varying the size of the lens opening and by varying the length of time light enters through it.

How Much Light? A wide-open lens lets light in more quickly than one that is "stopped down" to a small aperture, just as a faucet turned on hard lets water through faster than one that is almost turned off so it just trickles. You get the amount of light you want by increasing the time as the aperture gets smaller, or by shortening the time as the lens is opened wider.

Controlling Exposure. "Correct exposure" for any film is letting in the specific amount of light that best fits that film's sensitivity. A given film always needs about the same amount of light, regardless of how bright or dark the subject is. Thus when you photograph in the dark you must "give more exposure" to "get the same exposure": in other words, you must use a larger lens opening (f-stop) and/or a slower shutter speed to accumulate the same amount of light on the film that a smaller f-stop and/or a faster shutter speed would let in when you shoot in brighter light. By using both the variable f-stops and the shutter speeds, you can give a great range of exposures that can tailor almost any "subject brightness" to fit almost any film.

Focusing. Your eyes automatically adjust for distance, focusing sharply with no effort on your part on whatever you're looking at. The camera lens does not. It must be focused. To get a sharp, clearly defined picture of an object at a given distance, you must move the lens to a corresponding distance from the film. To focus on distant objects, the lens moves back closer to the film: for near objects, it moves forward away from the film.

Focusing Systems. Different cameras use different methods for judging focus. Some have a groundglass on which you see the picture become sharp as you move the lens into focus and unsharp as it goes out of focus. Some have mechanical rangefinders which merge two images of an object into one when it is in focus. Still others just have a distance scale marked off in feet or meters: you measure or guess the distance and set the lens accordingly. With practice, you can estimate distance with surprising accuracy. This is less surprising when you realize that the way two eyes work together is very much the same way that the two lenses of a rangefinder work together.

Focal Length

Long, "normal" and short. Lenses come in different focal lengths. "Long lenses" act like telescopes: they have a narrow angle of view and "see things large." "Short lenses" have the opposite effect, and show things small within a wide field of view. That's why they're called wide-angle lenses. Most lenses are "normal" ones—neither long nor short, but in between, with a conventional angle of view, neither very wide nor very narrow. (On 35mm cameras, lenses of 50mm focal length are usually considered normal.)

Near, far and infinity. As subjects are closer to the camera, the lens must move more to focus on them; as they are farther away, focusing movements diminish, up to a point where the lens is focused sharply on everything from a given "near distance"— say, across the street—to unlimited distance. On the focusing scale of a lens, this point is called "infinity": its symbol is the lazy eight: ∞.

Focal length defined. The focal length of any lens is the distance from what I call its optical center to the film when the lens is focused at infinity. (By "optical center" I mean the place, in lenses of conventional design, where the rays of light cross each other while passing through the iris diaphragm that controls the f-stops. In retrofocus and telephoto lenses, which are different, the optical center is the point where the rays *would* cross in a conventional lens that forms an image of the same size.)

The range of focal lengths. Focal lengths common in 35mm photography range from 20mm wide-angle lenses to 500mm tele-lenses. Shorter and longer lenses exist, but are exceptional.

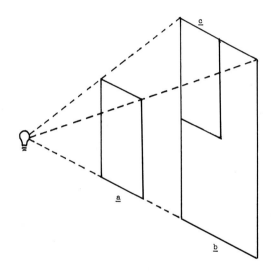

How the inverse square law works: when *a* is two feet from the lamp and *b* is four feet from the lamp, the same amount of light spreads over four times the area of *a* by the time it reaches *b* (note that *a* and *c* are the same size). The light on *a* is therefore four times as bright as the light on *b*.

Distance Changes Brightness: The Inverse-square Law. You'd think that two round holes, each one inch across, would let in the same amount of light. They do. Yet in lenses of different focal length they give different exposures. The "inverse-square law" tells why: "The intensity of light received at a point varies inversely as the square of the distance from its source." Thus a lamp two feet from a wall lights it four times as brightly as the same lamp at four feet, and nine times as brightly as at six feet. ($4/2=2$, $2^2=4$; $6/2=3$, $3^2=9$.) The lamp keeps giving off the same amount of light, but the light spreads "thinner" with increasing distance. At twice the distance it covers four times the area; at three times the distance it covers nine times the area, and so on.

Lens Speed and f-stops. The lens acts as a light source for the film, so lens "speed" is calculated not by a simple measurement of the aperture, but by relating the diameter of the lens opening to the focal length of the lens.

f-numbers Are Fractions. Relative aperture, the measure of lens speed, is expressed in f-stops. The f-number is a fraction: an aperture with a diameter equal to 1/8 the focal length is "f/8"; one that is 1/2 the focal length is "f/2." At f/8 the aperture of an eight-inch lens is one inch across: so is f/2 on a two-inch focal-length lens.

The Diaphragm and the Range of f-stops. An *iris diaphragm* adjusts the f-stop to any point from the largest to the smallest practical aperture on most lenses. Standard f-stop markings range from a small, slow f/90 to an ultra-fast f/1, but these extremes are seldom found on actual lenses. Typical lenses have an eight-stop range. The f-stops most frequently met and their relative speeds are listed below:

f-stop	fraction of focal length	relative speed
f/45	1/45	1×
f/32	1/32	2×
f/22	1/22	4×
f/16	1/16	8×
f/11	1/11	16×
f/8	1/8	32×
f/5.6	1/6 +	64×
f/4	1/4	128×
f/2.8	1/3 +	256×
f/2	1/2	512×
f/1.4	3/4 +	1024×

The 2x Factor. Note that lens speed—the amount of light let in during a given time—doubles with each larger f-stop. The conventional f-stop ranges for normal-focal-length lenses for 35mm cameras are from f/22 to f/2.8 or f/2 and from f/16 to f/2 or f/1.4. Many lenses have maximum apertures that are not "full stops": f/1.7 is a little faster than f/1.8, which is a little faster than f/2, and so on.

Depth of Field. Exposure control is not the only function of f-stops. At large apertures, everything nearer and farther than the plane of focus becomes abruptly and drastically unsharp: but at very small apertures, things go out of focus very gradually and look much less unsharp. When a considerable

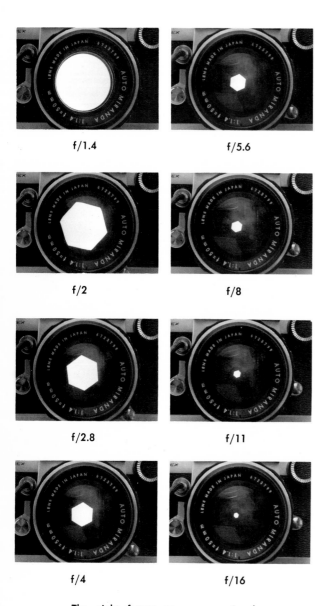

f/1.4	f/5.6
f/2	f/8
f/2.8	f/11
f/4	f/16

The eight f-stops on a conventional f/1.4 lens. As the lens is stopped down, each aperture lets in half as much light as the next larger one.

span of distance, from near the camera to far from it, looks sharp in a picture, it is said to have great *depth of field*. The smaller the lens opening, the greater the depth of field. Depth of field decreases as the lens is focused closer, and increases with distance at any f-stop.

Depth of Field and Focal Length. Focal length also affects depth of field. When the f-stop and the camera-to-subject distance stay the same, the longer the lens, the shallower the depth of field. At "normal shooting distances" (roughly, three feet to infinity), short lenses seem to have far more depth of field than long ones; but if image size instead of distance remains the same, the depth of field "cancels out." Objects shown the same size on the film will show equal depth of field at f/8 (or any given f-stop) in pictures taken with long lenses and in those made with short lenses, though the perspectives will differ because of the different viewing distances.

Changing the Aperture Changes the Depth of Field. The illustrations on p. 7 show why large apertures give less depth of field than small ones. In figure 1, the lens is wide open, so that light from any point on the subject is picked up by a wide area of lens, then bent to narrow down to a point again as it goes past the lens toward the film: because the lens opening is wide, it forms a fat cone. (A is the point on the subject, B is the lens, C is where the rays converge to a focus and D is the film.)

Out of Focus: Subject Too Close. In the top drawing, the subject is too close to be in focus. The cone of light hits the film before it can come to a point, so its round cross-section is recorded instead of a point. The elegant name of this cross-section is "circle of confusion."

In Focus. The middle drawing in figure 1

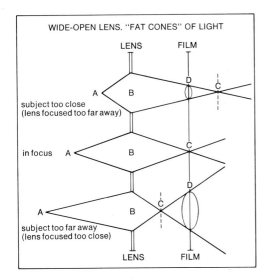

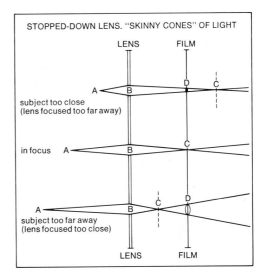

How lens aperture affects depth of field.

1. A wide-open lens transmits fat cones of light, producing large circles of confusion and shallow depth of field.

2. A stopped-down lens transmits skinny cones of light, producing smaller circles of confusion and greater depth of field. A = subject, B = lens opening, C = plane of focus, D = film plane.

shows the point of focus—the sharp end of this fat cone—just meeting the film, so the image of a point is recorded as a point.

Out of Focus: Subject Too Far Away. The bottom drawing in figure 1 shows the wide-open lens focused too close for a distant subject. The point of focus is in front of the film: the rays that form the fat cone cross and spread out again before they are sliced off by the film, to form another fat circle of confusion.

Circles and Points. When circles are small enough, we see them as points, so there is a range of distance—nearer and farther than the plane on which the lens is focused—where the circles of confusion look pointy to us instead of looking round. A slightly out-of-focus picture looks sharp within this range.

Small Apertures Make Thin Cones. Figure 2 shows the thin cones of light formed by small lens openings. For equal differences in focus, the film slices these skinny cones into smaller circles of confusion than the thicker cones formed by wide-open lenses.

As the Cones Get Thin, So Do the Circles. Depth of field increases when you stop down because the circles of confusion remain too small to look like circles over a greater range of "out-of-focusness."

Large Openings Lead to Big Circles. Depth of field shrinks as you open the lens wider because the circles of confusion expand more rapidly on both sides of the plane of focus. They not only expand, they overlap, and are then seen as "blur," not as distinct points.

Margin for Error. The f-stops let us increase

subject too far away
(lens focused too close)

in focus

subject too close
(lens focused too far away)

f/5.6
(wide
open)

f/45
(stopped
down)

How aperture affects depth of field. A lens of 6-inch focal length was focused on the middle target, 24 inches from the lens. The top target was 33 inches away, and the bottom target was 17 inches from the lens. (Exposures: f/5.6 at 1/100 second: f/45 at 1½ seconds.)

or decrease depth of field at will. Depth of field, when exploited, gives us a forgiving margin for focusing error, so we can get away with some inaccuracy.

Depth-of-field scales are engraved on the focusing mounts of most lenses. The one illustrated is on a Leica lens of 35mm focal length. The aperture is f/16, the lens is focused at ten feet, and the indicated depth of field at f/16 is from about 4½ feet to "beyond infinity."

What Standards Do You Follow? Actually, for a hypercritical photographer, the depth of field may be less. Manufacturers typically calibrate lenses for depth of field according to what looks sharp in comparatively small enlargements. If you make much larger prints, you may prefer a more critical standard. It is conventional among fussy photographers to consider the camera industry "two stops optimistic." For a supercritical reading of the depth of field with the lens set at f/16, read the f/8 marks on the scale: on the lens illustrated, they indicate acceptable sharpness from about 6 to 25 feet in front of the camera. To be very sure of critical sharpness within a known distance range, use an f-stop that is two stops smaller than the f-stop

The depth-of-field scale on a Leica lens of 35mm focal length: the lens is stopped down to f/16, and the indicated depth of field with the lens focused at about 10 feet ranges from about 4½ feet to "beyond infinity." The shutter-speed dial, also in sight, is set at 1/30 second.

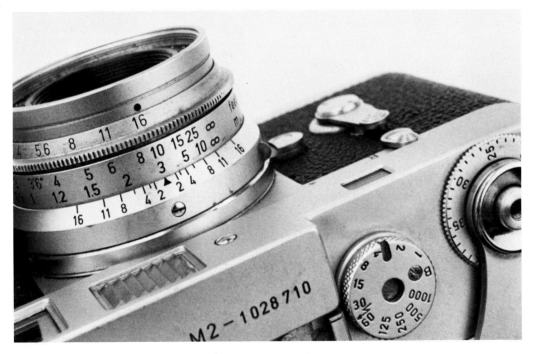

Shot with 500mm lens.

Shot with 50mm lens.

Shot with 21 mm lens.

Three shots taken from the same camera position with lenses of different focal lengths. The field of view is narrow with the 500mm lens, moderate with the 50mm, and wide with the 21mm, but the perspective remains the same in all three pictures.

you read on the depth-of-field scale. When shooting at f/16, read the indicated depth of field for f/8; at f/8, read f/4 on the scale, and so on.

Hyperfocal distance. It sounds forbidding, but do not be alarmed. It's really a lazy way to focus, using the depth-of-field scale. Stop down to the smallest aperture that the film/light/shutter-speed requirements of the situation permit, then focus by setting the infinity mark on the focusing scale at the mark for the f-stop you're using (or, if you're fussy, at the mark for "two stops wider open"). The

lens is now set at its hyperfocal distance, and the picture will be sharp from about half the distance the lens is focused on to infinity. As long as you are photographing things within that range, you don't need to change the focus at all: just aim the camera and shoot. By eliminating the focusing manipulation, this makes it easy to shoot with exact timing —just when things come together right— without having to worry about sharpness.

Hyperfocal distance varies with focal length, with f-stop and with the photographer's need for sharpness, but it's easy to use.

500mm shot.

50mm shot.

12 *Hardware and Software*

21mm shot.

When all three shots are printed so the bridge is the same size, it becomes obvious that the relative sizes of objects shot from the same viewpoint stay the same regardless of focal length. The difference is not in perspective, but in image size and definition within the negatives.

You don't have to memorize columns of numbers or make calculations: just set it on the depth-of-field scale as you shoot.

Perspective means "the way things look from a given viewpoint." The different ways that long, normal and short lenses show things in pictures are due largely to the different distances from which the pictures are shot. If you photograph from the same position with all three lenses, you will find the same view, with the same perspective, in each

picture. But a subject area that fills up the telephoto picture will be smaller within the normal-lens picture, and tiny in the wide-angle one.

Many ways to see things are made possible by different focal lengths, and they are all equally legitimate.

Distortion is a scare word. There is much unnecessary worry on the part of the timid, and pointless pride on the part of the brash, about distortion. There's a myth that conven-

tional pictures taken from eye level with normal lenses are undistorted. They are supposed to show things as the eye sees them (which they emphatically do not), and pictures made with other lenses or from other viewpoints are supposed to be "distorted." These suppositions do not stand up on examination.

Depending on whether you're a conformist or a rebel, you may consider distortion "bad" or "good." But it doesn't work that way. *All* photographs are distorted. *No* photograph shows things the way the eye sees them. This being so, I invite you to use whatever kind of distortion you prefer.

SHUTTERS

What Shutters Do to Light. We wouldn't be able to do much with lenses if we didn't have shutters to let light into the camera for variable, controlled lengths of time, thus giving us the other half of exposure control.

Types of Shutters. Shutters come in two main types: the leaf-type shutter, typically placed between the lens elements, and the focal-plane shutter, just in front of the film.

The leaf shutter is made of metal "leaves" (what else?) hinged to a ring. Powered by springs and timed by clockwork, they swing open, then close again. Typical leaf-shutter speeds range from 1 to 1/500 second and "T" and "B." T means "time": the shutter stays open until the button is pushed again. B is "bulb": the shutter stays open as long as you hold the button down, and closes itself when you let it go.

Focal-plane shutters consist of two curtains made of cloth, plastic or metal with a variable slit between them. For fast exposures, the slit is narrowed: for slow ones, it

widens. For very slow speeds, one curtain opens all the way across the picture area before the second one begins to follow it across to close the shutter. Focal-plane shutters typically have speeds from 1 to 1/1,000 second and bulb.

Leaf shutter vs. focal-plane shutter. The leaf shutter is quieter, smoother, and synchronizes with flash at all shutter speeds; but the focal-plane shutter offers higher speeds, greater efficiency at high speeds, and facilitates changing lenses: you don't have to buy a new focal-plane shutter for each new lens. But the focal-plane shutter must be used at relatively slow speeds with electronic flash. The curtains must be wide open when the flash goes off, or you get only a slit-wide slice of picture.

Shutter Speeds and the 2x Factor. Each shutter speed, like each f-stop, doubles or halves the exposure at the next setting. Standard speeds on modern shutters are:

1 second (marked "1")
1/2 second (marked "2")
1/4 second (marked "4")
1/8 second (marked "8")
1/15 second (marked "15")
1/30 second (marked "30")
1/60 second (marked "60")
1/125 second (marked "125")
1/250 second (marked "250)
1/500 second (marked "500")
1/1,000 second (marked "1000")

What Else Shutters Do. Like f-stops, shutter speeds have other effects on pictures beyond simple exposure control. A very slow shutter speed shows a path of motion more clearly than it shows the moving object; a

Fast shutter speed (1/250 second) "froze" the movement in this picture.

Slow shutter speed (one second) shows motion through space.

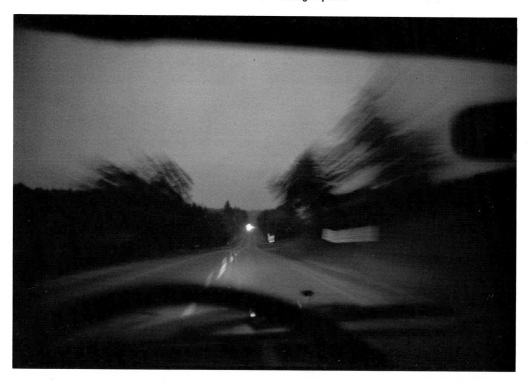

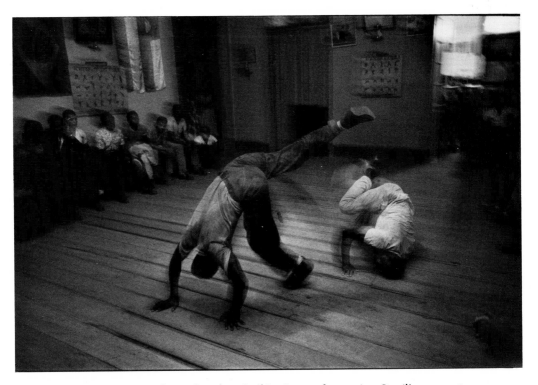

A mixed exposure—fast within slow. In this picture of capoeira, Brazil's answer to karate, the shutter speed was one second, and camera movement as well as the movement of the men makes everything unsharp. But a high-speed electronic flash unit, synchronized with the shutter, was also used, producing a sharp image within the unsharp one.

very fast one "freezes" motion and makes it look static, while showing the moving object sharply. Most shutter speeds are in between. Used sensitively, they can change the feeling and meaning of many pictures.

Picture Control by Aperture. To sum up control-by-aperture: the range of f-stops lets us choose "more," "intermediate" or "less" depth of field. When depth is most important, choose your f-stop first, then find a shutter speed to match it.

Picture Control by Shutter Speed. To sum up control-by-shutter-speed: the range of speeds lets us choose to "freeze" movement, to show it as an in-between or "soft-sharp" degree of "blur," or to let it flow through the picture. When time and motion are most important, pick your shutter speed first, then find the f-stop that will give you the best exposure.

Most pictures call for compromise—an acceptable shutter speed and an acceptable depth of field.

Introducing Exposure. The word *exposure*

has three main meanings that relate to the camera: the act of taking a picture; the f-stop-and-shutter-speed combination used; and the amount of light that hits the film.

"Correct" Exposure. There is much more to exposure than the special effects of f-stops and shutter speeds. What matters most is to expose the film to enough light, but not too much, to get a negative that is easy to print well.

Underexposure. If too little light hits the film, it is blank or very thin (transparent) when developed, and there is little or no picture.

Overexposure. If a great deal too much light hits the film, all the emulsion is exposed, the film is completely black when developed, and again there's no picture. With massive but less than total overexposure, there is a general loss of sharpness, contrast and clarity.

Versatility. A camera with enough different f-stops and shutter speeds to permit a great range of different exposure settings enables you to expose accurately under greatly varying light conditions.

CHOOSING CAMERAS AND LENSES

Function × Budget = Choice. If you concentrate on finding a camera you can both use and afford—one that has all the features you need but none that you don't need—the bewildering array of equipment on the market narrows abruptly to a few choices. Choose according to your budget and your experience. Most good new cameras are expensive—from about $75 to $1,000 or more. Prices depend largely on complexity or refinement of design, quality of materials and

workmanship, and volume of production. Good used cameras cost less, but should be checked by a good repairman before you complete the purchase: reputable dealers allow time for this.

Handle It Before You Decide. Whatever type of camera you choose, handle it before you buy it. All dials and scales should be easy to read and adjust, the viewfinder or rangefinder should give you a clear view of what you're shooting and allow rapid and positive focusing; and all control knobs, levers and what-have-you should be placed well for easy use. The camera should feel good in your hands. Its controls should be neither stiff nor floppily loose, but should work smoothly and easily.

FORMATS

The most popular amateur camera format today is probably "126," which Kodak calls *Instamatic*; but it is designed mainly for color snapshooting rather than for serious black-and-white photography. A few high-quality cameras are made for 126, but few black-and-white films are available in this format, and those are often hard to find.

35mm. More practical for serious black-and-white work is the standard 35mm format. 35mm still cameras come in two main types: the single-lens reflex (SLR) and the rangefinder camera (RF).

The 35mm SLR is more popular today. It is small and handy, and viewing and focusing are through the lens that takes the picture, via an optical system involving a mirror behind the lens which reflects the image up onto a groundglass screen on top of the camera. A five-sided pentaprism above the

groundglass juggles the image so you see it upright and unreversed through a window in the top of the camera back. When you shoot, the mirror swings up out of the way so the light can reach the film, and an automatic diaphragm stops the lens down to a preselected f-stop. (Not all lenses for SLRs stop down automatically, but most modern ones do.)

Leaf vs. Focal-plane Shutter for SLRs. Most 35mm SLRs have focal-plane shutters: leaf shutters in SLRs require very complicated mechanisms, since viewing must be done through the open shutter. A shield is kept in place meanwhile to protect the film from light. When you press the button on a leaf-shutter SLR, the following things must instantly take place: the shutter closes, the shield is withdrawn from the film, the diaphragm stops down to the chosen f-stop, the mirror swings up out of the light path—and then, and only then, the shutter can reopen for the exposure. Such mechanisms necessarily cost more and are more prone to mechanical ailments than the simpler arrangements in focal-plane-shutter SLRs.

A Logical Choice. For the beginner who wants a 35mm SLR, I suggest one with a focal-plane shutter and an interchangeable 50mm lens, with shutter speeds from 1 to 1/500 second. You don't need shutter speeds of 1000th of a second or faster, a lens faster

Three of my cameras, photographed with a fourth—a 4 × 5 view camera. Upper left, a Miranda single-lens reflex (acquired in 1970); lower left, a Leica M2 rangefinder camera (1966); and, right, a Rolleicord 2¼-inch square-format twin-lens reflex, bought in the 1950s. Good equipment lasts a long time.

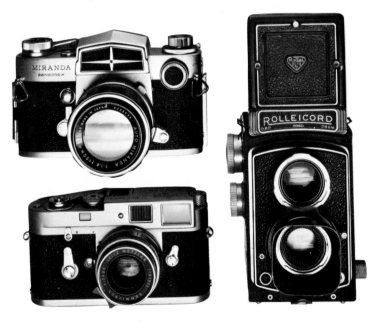

than f/2 or a built-in meter. Keep it simple and you will save money. It's better to get a simple high-quality camera than an elaborate but less well-made one.

SLR or Rangefinder? SLRs are generally good for 35mm, 50mm and longer lenses, but unless your eyesight is excellent, you may find it hard to focus with very short lenses on the SLR. The problem is that everything tends to *look* sharp, even when it is not really sharp enough for enlargement. (If your eyesight isn't up to it, a prescription lens added to the eyepiece can often help.)

The SLR Viewscreen. The "split-image" rangefinders built into some SLR viewscreens are hard to see in dim light, when you most need them. Microprism areas that "snap" in and out of focus are more useful, in my opinion; but I find that I cannot focus quite as accurately with them as with a plain groundglass. I prefer the plain groundglass for another reason, too: I like to see *only* the picture in the screen, without any "garbage" in the way. But plain groundglasses are rare in SLRs. I have mine installed by a good repairman. Some cameras—none of which I own—offer interchangeable viewscreens, a very desirable feature.

If you can't focus with a plain groundglass, but, like me, don't want your view cluttered with little rectangles, rings, doughnuts and other shapes of textured glass, an all-microprism screen may just possibly help you. If it doesn't, I suspect you'd be better off using a rangefinder camera instead of an SLR.

The 35mm rangefinder camera is similar to the SLR, except that viewing and focusing are through a separate optical system, not through the camera lens. With no need for swinging mirrors or automatic diaphragms,

RFs tend to be smaller and more rugged than SLRs of comparable quality. Focusing is quick, easy and positive with the coincidence-type rangefinder, regardless of focal length. Two images merge in the middle of the finder when the object you're looking at is in focus. That's why I like RFs for wide-angle work, in spite of parallax (the difference in viewpoint between the viewing window and the lens). RF cameras are less well adapted to long-lens photography than SLRs, but hold their own with 50mm and shorter lenses. Most top-quality RF cameras have recently been discontinued, but used ones are available. Besides the one surviving professional RF, the Leica, many lower-priced RFs are made, mostly with non-interchangeable lenses. Some are excellent.

Roll-film Cameras. Today's roll-film cameras are mostly SLRs or twin-lens reflexes (TLRs), though there are a few RFs as well. Most use 120 film to take twelve 2¼-inch-square pictures on a roll, though some use the same film to take larger or smaller rectangular negatives.

Roll-film Reflexes: One Lens or Two? Roll-film SLRs tend to be heavy, delicate and expensive; but several are of superb quality and offer interchangeable lenses. TLRs cost less and are usually more compact and more durable, though less versatile. As far as I know, only the Mamiya Company now makes roll-film TLRs with interchangeable lenses.

TLR and SLR Viewing and Focusing. The TLR's viewing lens is directly above the "taking" lens. A fixed mirror bounces the image onto a groundglass on top of the camera. You look down into it to frame and focus. The image is upright, but reversed right-for-left. The SLRs view the same way, but through the "taking" lens. Pentaprisms can

be added to convert some roll-film reflexes to eye-level, unreversed viewing like that of 35mm SLRs. A few roll-film SLRs are built like oversized 35mm ones.

A Good First Camera. For beginners, I'd suggest a moderate-price TLR. They are almost as small and handy as 35mm cameras, but their negatives have four times the area of a 35mm negative.

Large Cameras. Next come larger cameras that use sheet film. There are two main types: the press camera, usually with a rangefinder coupled to the lens and capable of use in the hand; and the view camera, always used on a tripod.

The Hand-held Press Camera. News photographers have mostly deserted the 4×5-inch press camera for 35mm, but it has the advantage of delivering a large, sharp negative with surprising ease. It's the largest camera you're likely to use without a tripod.

The View Camera: Tripod and Focusing-cloth Country. The view camera is deceptively simple. A photographer must know what he's doing to get much out of it. A bed or rail supports a movable front with the lens and shutter, and a movable back with a groundglass on a spring mount so a film holder can slip into its place. A bellows stretches between front and back. You focus by peering at the groundglass under a dark cloth and moving the lens, the camera back, or both. The image is upside down (as are all the images projected on film by photographic lenses).

View-camera Flexibility. The special quality of the view camera is that it is an optical acrobat. The front and back on the best ones can swing and tilt to almost any angle, rise, drop down, shift to the side: the combinations of these movements give you a nearly miraculous control of perspective, with which you can take outrageous liberties or force uncommon discipline, and a similar control of focus. The range of possible "corrections" and "distortions" is inexhaustible.

Texture and Detail. The view camera is used mainly to take highly detailed photographs of things that hold still, but it is capable of exquisite portraiture and other work with subjects that move.

Muscles. A view-camera photographer needs a strong back. Camera, tripod, film holders, extra lenses, carrying case and so on usually weigh thirty pounds or more; and the view camera has a tendency to be used outdoors in rugged country. You do a lot of carrying.

How Big Is It? View cameras come in various sizes, mostly large. A 4×5 view camera means one that makes 4×5-inch negatives, probably the most-used size. Smaller view cameras exist, but larger ones suit the approach better. 5×7 and 8×10 cameras are widely used, and a few heroes trudge around with 11×14 view cameras. Lenses are freely interchangeable, and there are many to choose from.

Which Camera Type Is for You? 35mm and roll-film cameras are probably the easiest to start with, but it's a matter of temperament. Look over all the types and get what most appeals to you.

My Arsenal: Cameras. Since I do various kinds of photography, I have various cameras. I find I use the 35mm RFs and SLRs a great deal, the 4×5 view camera occasionally and the roll-film TLR seldom. Others will reverse these frequencies.

Start with a Normal Lens. About lenses: if you choose a camera with interchangeable lenses, start with the normal lens. Then, if you find you have to keep moving back to

take more in, get a shorter lens; or if you have to keep moving closer, get a longer lens. Don't get them before you know you'll use them. Some photographers can do everything they want with one lens, usually the 50mm or the 35mm on 35mm cameras, or around 75mm on roll-film reflexes. If you do a lot of work in very dim light, an f/1.4 lens will help. If not, you don't need it.

My Arsenal: Lenses. My 35mm-camera lenses range from 21mm to 500mm, but most of my pictures are taken with three that fall between the extremes: the 28mm, the 35mm and the 50mm. The others are for occasional use as the need arises.

Zoom Lenses are beginning to be practical. They are expensive and bulky, but if you constantly need to change focal length, a well-chosen zoom lens could simplify life.

Don't Get Equipment-happy. I don't intend to add to my arsenal, but just to replace the equipment I wear out: I recommend a similar attitude to you. Unless you're rich, don't get lens-happy. Equipment sometimes makes pictures possible or impossible, but it seldom makes them better or worse in any important way. Pick the equipment that lets you do what you need to do, and stop there. Change equipment when you change needs.

THE PINHOLE CAMERA

You can photograph without a lens. A pinhole camera uses a tiny hole in a sheet of black paper or what-have-you (perfectionists use very thin sheet metal) instead of a complex structure of optical glass.

The No-lens Reflex. I once converted a single-lens reflex into a no-lens reflex by removing the lens and taping opaque black paper over the opening. A pinhole in the middle of the paper completed the camera.

Pinhole in a Box. If you don't have a camera with a removable lens, any small opaque box with a lid will do: you put a pinhole in the lid, and—in total darkness—tape a piece of film or photographic paper to the bottom of the box, that is, the side opposite the pinhole. Close the box, cover the pinhole and then you can turn on the light again.

Aiming. A pinhole camera is aimed by placing it so the pinhole side is toward whatever you want to photograph. There is no focusing.

Exposing. Exposures through a small hole take longer than through most lenses. I loaded my pinhole reflex with Tri-X and made some trial exposures. In winter sunlight, 1/2 second turned out to be plenty. Your film, pinhole and light are all likely to be different, so try a variety of exposures from about 1/15 second (if you're using a shutter) to eight seconds. Then develop the film or have it processed and you'll find out which exposure was best.

Not Sharp, but Not Out of Focus. Nothing in a pinhole picture is ever quite sharp, but you will notice that both near and distant objects have the same degree of slight unsharpness—much like that produced by a "soft-focus" lens.

A pinhole camera has no focus—or it has universal focus, if you like that better. To find out why, compare what a pinhole does to light to what a lens does.

What a Pinhole Does to Light. Unlike a lens, the pinhole does not bend light. The light from any point on the subject goes straight through the hole to strike a point on

the film that is directly opposite its source. (Incidentally, this is why the pictures inside cameras are always upside down.)

Diffraction. If the hole were infinitely small, would the picture be infinitely sharp? Sorry. A phenomenon called diffraction prevents that. Light bends slightly where it passes an edge—and a pinhole is largely edge, so a considerable proportion of the light gets bent in all directions as it passes through, making the picture slightly fuzzier than the size of the pinhole dictates by itself. (Besides making pinhole pictures unsharp, diffraction limits the sharpness of photographs made through lenses stopped down to apertures less than about one millimeter in diameter.)

Why Lenses Have to Be Focused. Because lenses have larger openings than pinholes, the only way they can make sharp pictures is to bend the light rays from all points on the subject so they strike corresponding points on the film. But, as we have seen, objects at different distances do not make sharp images at the same distances behind the lens, so focusing becomes necessary.

Why Pinholes Are Free from Focusing. So why does a pinhole have no focus and infinite depth of field? Because the rays of light that pass through it are not reshaped into cones that narrow as they approach the film. They pass straight through, spreading slightly

Portrait made with the pinhole camera.

as they go. That and diffraction are the reasons pinhole pictures cannot be either really sharp or out of focus.

THE BOX-CAMERA APPROACH

If your camera's complexity has been scaring you off, try using it like a box camera. Set it for average distance (10 feet) and average daylight (f/16 at 1/30 second), load it with fast film (ASA 400), then just point it and shoot.

Get Acquainted. If you don't yet know your camera, play with it before you put film in it. Find the shutter-speed dial, the f-stop adjustment that varies the lens opening, and the focusing scale that sets the lens for different distances. Also find the film-advance lever or knob, the rewind knob or crank (if it's a 35mm camera) and the shutter release—the "button."

Open the back of the camera, look through the lens and shoot at all the different f-stops and shutter speeds to see what happens. The machinery is complicated, but what it does is simple. The shutter lets in light for variable lengths of time and the diaphragm's f-stops vary the size of the hole the light comes through. Together they control how much light strikes the film when you take a picture. When you've seen what the lens and shutter do, you're ready to load the camera.

Get a fast film, like Kodak Tri-X or Ilford HP4. Fast films are best for the box-camera approach.

LOADING A 35MM CAMERA

Loading a 35mm Camera. Most 35mm cameras have a space at one end for the film

The box-camera settings for Tri-X or other ASA 400 film (black-and-white only) and sunlight. 1/30 second, f/16, focus at 10 feet.

cartridge, and a take-up spool at the other end. To load, fit the cartridge in place, pull out the tongue of film and insert it in the slit in the take-up spool. Fit the perforations in the film over the teeth of the sprocket near the take-up spool. With the camera back still open, "shoot" and wind film until the sprocket engages perforations on both edges of the film. Then close the back and shoot off "blank frames"—non-pictures—to get past the light-struck end of the film before you start taking pictures. In dim light, two "blanks" are enough; if you load in very bright light, shoot off five. Set the frame counter to zero (unless you have one that sets itself automatically).

Set and Shoot. Now set the focus at 10 feet, the f-stop at f/16 and the shutter at 1/30 second (marked "30"), and the camera is ready to shoot in bright daylight—sunlight or light overcast, outdoors.

Viewing and Choosing. Look through the viewfinder at anything you want to photo-

Loading a conventional 35mm camera.

1. Open the camera and remove used film.

2. Insert new cartridge and pull film tongue toward takeup spool.

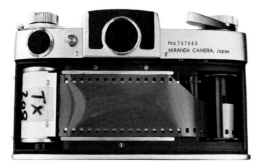

3. Push film tongue through slot in spool and wind camera half a turn: make sure sprocket teeth engage perforations in film.

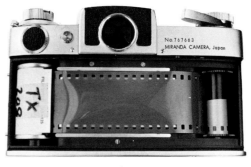

4. Wind film onto takeup spool until perforations on both sides of film engage sprocket teeth. Now close the camera and shoot off two to five "blank" frames to bypass all light-struck film before you start taking pictures.

graph, then move around until you like the way your picture fits in the finder's rectangle. When you're satisfied with that, hold the camera steady and press the button. Then advance the film, and you're ready for the next shot.

The Right Distance. Here's a cue to finding the right distance from your subject. Get close enough to fill up the picture with what's most important. Get far enough away to include everything you need in the picture. What's important? You decide. It's your picture; you're the photographer. No one else can say what is important to you.

AFTER SHOOTING

With 35mm, You Have to Rewind. Shoot a roll this point-and-shoot way. But when you reach the end of a 35mm roll, *do not* open the camera before you rewind the film back into its cartridge. Most cameras have either a button on the bottom of the camera that you press down while rewinding, or a lever or knob that you set to "A" for "advance" or "R" for "rewind." Use it and rewind the film until you stop feeling the resistance of the film and the rewind knob or crank turns freely. Then you can safely open the camera, remove the exposed film and reload.

If You Don't Develop Your Own Film Yet, have this first roll developed by any processing service to see what you get. If your seeing is good, your pictures should be good, even if they are slightly overexposed or out of focus.

What Makes a Picture "Good"? If a picture is lively or pertinent, and worth seeing, that is what matters. Only weak pictures need perfection. Strong ones can survive considerable faults.

2

Light Meters

WHY USE A METER?

The Trouble with Eyes. Our eyes adjust themselves with miraculous sensitivity to changing brightnesses of light. However, this process is not conscious, so the eye is a poor light-measuring instrument for photography. We don't even notice some drastic changes.

Exposure Sense. With observation and luck, you may acquire a good photographic sense of light—part knowledge and part feel. Not everyone can. It's usually more accurate to use a meter. Inaccurate exposure in shooting makes for difficult printing, so you can save much trouble by taking a little trouble where it counts.

TYPES OF LIGHT METERS

There are two main types of light meters, less accurately called exposure meters. *Reflected-light* meters measure the intensity of the light that the subject gives off: *incident-light* meters ignore the subject and measure the intensity of the light that falls on it.

Many meters can be used for both methods of reading, but some cannot be adapted. Spot meters and behind-the-lens (BTL) meters built into cameras are characteristically designed for reflected-light measurement only.

SELENIUM AND CdS CELLS

Two main types of light-sensing cells are used.

The selenium cell converts the energy of light directly into a weak electrical current that moves a needle across a dial. The brighter the light, the stronger the current and the higher the reading.

The cadmium-sulfide (CdS) cell produces no power. Instead, it decreases the electrical resistance in a battery-powered circuit as the intensity of the light that strikes the cell increases. As the resistance drops, the needle and the reading move up.

Selenium, Pro and Con. The selenium meter, introduced in the late 1920s, is far less sensitive to light than the best CdS meters; but it is also simpler and cheaper, and has no batteries to die at awkward times and places. Although the CdS cell is far smaller than the selenium cell, the selenium light meter is often more compact than a CdS meter of comparable quality.

CdS, Pro and Con. The cadmium-sulfide meter, introduced around 1960, has now become reliable. The best ones are sensitive enough to work accurately in light so dim that you need an illuminated dial to see the reading.

Which Cell Is for You? Both types of cells are practical for general use. If you work mostly in light bright enough for a hand-held camera, the selenium meter may be preferable. If you do much shooting in the dark, you'll do better with an ultra-sensitive CdS meter.

Behind-the-lens Meters. The BTL meters in some cameras read the light that comes through the lens. They are often accurate, but they give less information than a good separate meter. I tend to ignore the meter in the camera in favor of my old Weston IV reflected-light meter, which I find quicker and easier to use. It is a selenium meter, but has a greater useful range of sensitivity than any BTL meter I have tried.

Viewfinders Are for Pictures. I may be prejudiced, but I prefer to look through the viewfinder with nothing but the picture in mind, having already pre-set the exposure. Shooting, for me, is simpler and quicker this way. I find viewfinder-based metering awkward and irritating; it delays me and distracts me from the picture.

The light-receiving side of the meter. Behind the large glass insect-eye is a selenium cell—CdS cells use much smaller receptors. This meter is set for dim light. In bright light, the perforated baffle is closed over the cell, so only the light that comes through the holes affects the reading. An incident-light attachment can be fastened over the cell, too: I never seem to use the one I have.

Automatic-Exposure Cameras that sense the light and set their own exposures bypass this objection, and are desirable as long as you work in the kind of light for which the system was designed—light from behind the camera. Unfortunately, I am addicted to "backlight" that comes from behind the subject.

My Own Choice. I prefer to be an "automatic-exposure photographer," who senses the light and sets his own exposure: this works well in any kind of light the eye and the mind can cope with.

REFLECTED-LIGHT METERING

Holding the Meter. First learn how and where to hold the meter—near the part of the subject that you are reading, with the meter cell pointed straight at it. Get close enough so surrounding areas of different

A reflected-light meter.

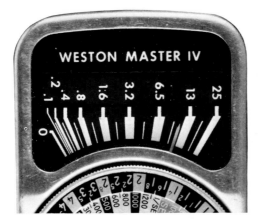

The dim-light and bright-light scales of the meter: when the baffle is closed over the cell, the bright scale flips into place.

Meter calculator dial. The film speed is set at ASA 400, and the pointer on the circular slide rule has been placed between 6.5 and 13 foot-candles, the reading on the meter's dim-light scale. All the combinations of f-stops and shutter speeds represent the same amount of exposure—the indicated exposure. From f/2 at 1/1000 second to f/32 at 1/4 second (and, by extension, f/45 at 1/2 second and f/64 at one second), they would all produce negatives of the same density.

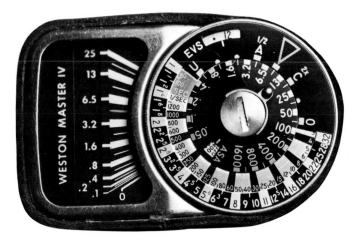

Weston meter calculator dial set for a reading of a dark tone in the subject—the darkest tone in which we want "detailed black" in the print.

We want dark tones to be thin in the negative—slightly under-exposed—so we set the 1/2 mark, instead of the regular pointer, at the value indicated by the meter needle. In this case, the needle points between 3.2 and 6.5; when we set the 1/2 mark there, we can use one of the revised exposures now indicated on the shutter-speed/aperture scales: for instance, 1/60 second at f/7. (f/7 is 1/3 stop more open than f/8.)

This one-stop decrease from normal indicated exposure for the dark tone is conservative. It is based on the scant tolerance for under-exposure that seems typical of ASA-rated black-and-white films.

Each mark from "U" (for "under") to "O" (for "over") on the calculator dial stands for a one-stop change in exposure from the next mark on either side. The Weston meter thus permits direct calculation of exposures ranging from 4 stops under (1/16 indicated exposure) to 3 stops over (8× indicated).

brightness do not invade the reading and make it inaccurate (most meters have about the same acceptance angle as a normal camera lens). Avoid accidentally reading out-of-context things like the meter's shadow, bright surface reflections, over-large areas of bright sky or misplaced straps and fingers.

Set the Film Speed. Don't forget to set the right film speed on the meter's calculator dial, where it says "ASA." Otherwise you may set the right exposure for a film you aren't using.

(All this also applies to BTL meters in cameras, but they will have the ASA setting elsewhere, since they have no calculator dials. To set exposure, you use the camera's f-stop and shutter controls to line up the meter needle in the viewscreen.)

Read the meter. Note where the needle points. Then set the marker on the calculator

dial to the same number or position. That places a series of f-stop numbers opposite a series of shutter-speed numbers on the dial. Each of these combinations of f-stop and shutter speed stands for the same amount of exposure—the *indicated exposure*.

Interpret the reading and set the camera for the appropriate exposure.

Choose Your Aperture and Shutter Speed According to Your Picture's Needs. If controlled depth of field is important (see above, page 5), set the f-stop where you want it first, then set the matching shutter speed that will give the desired exposure at that f-stop. If it's more important to control the exposure time, set the shutter first, then the f-stop.

INTERPRETING REFLECTANCE READINGS

The Camera-position Reading. It is common practice to hold the meter at the camera position, but aimed slightly downward to eliminate most of the sky from the reading. This is better than pure guesswork, but is seldom critically accurate. Since we use meters to get accurate exposure, I do not recommend the camera-position reading for most pictures.

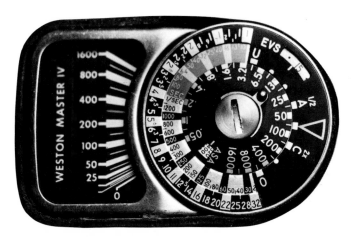

Calculator dial set for a bright-tone reading, with the meter aimed at a subject tone we want to print as "detailed white" or pale gray. In this case, the meter needle points between 200 and 400.

We want light tones to be dense in the negative—somewhat overexposed—so we place the "4×" dot (between 2× and 0 on the calculator) between 200 and 400, instead of the regular pointer. We can then give any of the exposures now indicated: for instance, 1/250 second at f/11. The highlight will be dense, but not too dense, in the negative; and will print light, but not too light, in the final photograph.

This 4× increase for highlight exposures is conservative, and is based on the large tolerance for overexposure that seems typical of ASA-rated black-and-white films.

The Mid-point Reading. Another common practice is to take one reading on the brightest area in the picture and another on the darkest part, then give an exposure that falls halfway between the indicated exposures for the two extremes. Any sense of security you get from this ritual is misleading: the approach is based on a misunderstanding of how film behaves. It seems more specific than the camera-position reading, but is not necessarily more accurate. I do not recommend the median-exposure approach, either.

Accurate Interpretation. I do recommend using the specific information you get from local readings on areas of the subject, interpreted in terms of the way film *does* behave.

Dark or Contrasty (very-light-to-very-dark) Subjects. If the subject is either all dark or very contrasty, use the meter to read the darkest area of the subject in which you want full detail in the print. Ignore the rest of the subject: read only this dark tone. Do *not* give the indicated exposure for it.

If you are unfamiliar with the film, use the manufacturer's ASA rating and give *one half the indicated exposure for the dark tone*.

If you have tested the film and know your own corrected exposure index for it, give *one fourth the indicated exposure for the dark tone*. (For test procedures to get a corrected exposure index, see page 61.)

The Dark Reading: Why We Expose Less Than the Meter Says To. The reason for giving less exposure than a dark reading indicates is simple: the meter reads all tones alike. For any of them—light, dark or in between—the indicated exposure will always give the same "middle-gray" density in a normally developed negative. But you want to print dark areas in dark tones, so you don't need that much density; therefore you expose

less. You give the *minimum practical exposure for the dark tones,* which is also *normal* exposure for all lighter tones in the picture.

Reading a Mid-tone Subject. If your subject is all in middle tones, read the "middlest" one and give the indicated exposure. A middle-gray exposure is right for a middle-gray picture.

The Bright-subject Reading: Why We Expose More Than the Meter Says To. If the subject is predominantly bright—sunlit snow against the sky—read the *lightest area* in the picture in which you want full detail in the print. Then give *four to six times the indicated exposure for that bright tone.* The reason is that you don't want to print the snow as middle gray: it must be bright. You need more than middle-gray density in the negative to get white tones of convincing brilliance in the print.

SUBSTITUTE-TARGET READINGS

The Poor Man's Spot Meter. When you can't get close enough to your subject to read its tones directly with a reflected-light meter, hold up a substitute target—your hand or sleeve, a gray or white card, or anything handy that has about the right tone—and turn it in the light, looking past it at the subject area you want to read. When the subject and target match in tone, take a normal meter reading on the target and interpret it according to the picture's needs. This is the poor man's spot meter, enabling you to read the brightness of the mountain across the plain or the pebble on the ground without adding to your equipment.

SPOT METERS

Spot meters are essentially ordinary re-

flected-light meters except for their very narrow acceptance angles. Use and interpret the spot meter as you would any conventional meter.

BTL METERS

Reading a BTL meter is easy. To interpret one, think in terms of camera exposure settings. After a dark-tone reading, stop down the lens or speed up the shutter to get the minimum practical exposure. After a middle-gray reading, give the indicated exposure; and after a highlight reading, open the lens two stops or slow the shutter to four times as long an exposure, and your exposures based on local readings will be accurate. (If the meter is not accurate but is consistent, you can compensate by changing the film-speed setting. To correct for thin, underexposed negatives, shift to a lower exposure-index number; to correct for dense, overexposed negatives, shift to a higher index number.)

INCIDENT-LIGHT METERING

Incident-light meters measure the light that

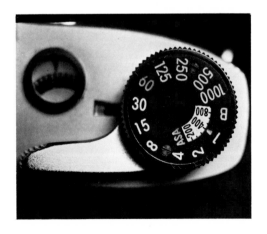

falls on the subject instead of the light that the subject gives off. An incident meter is held as close to the subject as possible, but its light receptor is aimed toward the camera, not toward the subject. It receives light from the same direction and in the same intensity as the subject does, and translates it into an average "middle-gray" exposure setting.

Pro and Con. The main advantage of the incident meter is that it cannot be fooled by subject tones. Its main disadvantage is that it cannot read them. It gives no specific information about subject brightnesses, but only a standard "educated guess," adequate for most photography under average conditions. The incident meter can't cope very well with non-average conditions.

Balancing Studio Lighting. It is at its best in the studio, especially as a tool to establish lighting balances. To get a 2:1 lighting ratio, for example, with one light twice as bright on the subject as the other, you measure the brightness of each lamp from the subject position, with the other lamp turned off. First read the stronger light; then turn it off, turn the other one on, and move it toward or away from the subject until the reading shows that it is half as bright as the first light. To get the correct exposure, turn on both lights and read their combined light from the subject position, pointing the meter toward the camera. Give the indicated exposure.

Film-speed setting on a BTL-metering camera. Here it is a small dial set into the shutter-speed knob, and is set at ASA 400. This one has ASA speeds only. Some cameras have both ASA and DIN numbers. Some have separate film-speed dials, which may be located almost anywhere on the camera.

Viewscreen of camera with BTL meter. The circle in the center indicates the field covered by the meter, the triangular mark at the lower right corner is the "zero" indicator, the needle is the light indicator, and the circle on the short needle is the follow-pointer, adjusted by setting lens opening, shutter speed, and ASA speed on the camera. Here the follow-pointer is separate from the meter needle, showing that the camera is not set correctly for the indicated exposure.

Here the follow-pointer has been moved, by adjusting the shutter speed or the lens opening or both, to coincide with the meter needle. The camera is now correctly set for the indicated exposure for the area seen within the metering circle in the middle of the viewscreen.

For Color Slides. The incident meter is also good for color-slide photography, in which it is most important not to overexpose. The incident reading, closely related to a highlight reading, is appropriate to these films.

EXPOSURE WITHOUT A METER

For photography's first 90 years there were no handy light meters.

Exposure Sense. Photographers relied on experience and a developed sense of light. Edward Weston, before the meter appeared, seems to have acquired good exposure sense with no conscious method at all. He would stop down his lens, open the shutter and wait for enough light to come in. He sometimes underexposed, but lost few pictures because of it.

After 20 years of meter reading, I find myself using the meter less and less. I have begun to know the light. I read the meter mostly to confirm my guesses, and it usually does.

The Data Sheet. For beginners with no such background, most manufacturers come to the rescue with the data sheet that is packed with each roll of film. These sheets prescribe "average exposures" for several conditions of daylight. Kodak, for instance, tells you about "Bright or Hazy Sun (Distinct Shadows); Cloudy Bright; Heavy Overcast; Open Shade."

Interpreting the Data Sheet. An observant beginner will note that there is a two-stop or four-times increase in exposure from sunlight to "cloudy bright," and a further one-stop or two-times increase for "heavy overcast" and "open shade," both of which require the same exposure. The "average subjects" for which the exposure times are given are light skin lighted from behind the camera, and

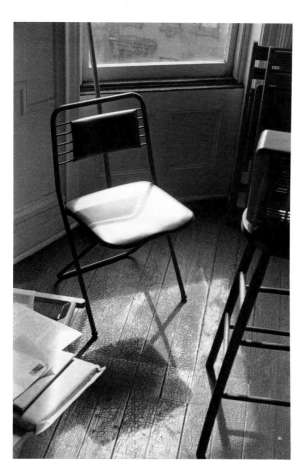

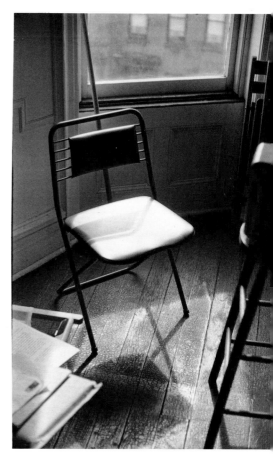

Correctly metered picture. Exposure was based on a reading of the darkest shadow behind the chair. Tri-X at ASA 400 was given half the indicated exposure for that shadow. Straight print on No. 2 paper.

Incorrectly metered picture (overexposed). Instead of exposing one stop less than the indicated exposure for the dark shadow, I exposed one stop more, thus giving four times the correct exposure. Straight print on No. 2 paper.

Hardware and Software

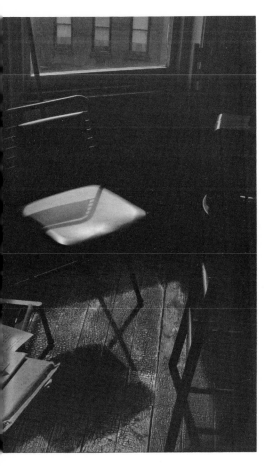

Incorrectly metered picture (underexposed). This shot was given the indicated exposure for the bright chair seat: the meter was accurate, but the exposure was way off. Straight print on No. 2 paper.

with light-toned backgrounds. If you are shooting darker subjects or if they are lighted from behind the subject or from one side, give twice as much exposure as the data sheet recommends for black-and-white film. If you get thin negatives, expose more; if they are too dense, expose less. After a few rolls, you should get consistently good exposure when you work in familiar lighting conditions.

For unknown lighting, expose more when in doubt and be careful not to overdevelop the film.

PRACTICAL START: USING A REFLECTED-LIGHT METER

In this exercise, we begin by doing things right. Then, because mistakes are useful to learn from, we will carefully do some things wrong.

You need a *reflected-light meter*, preferably calibrated in numbers (some meters have only marks without numbers—these make note-taking and interpretation more difficult); a camera with adjustable f-stops and shutter speeds; and some black-and-white film of known ASA rating.

For Most Subjects. The following technique is for use with subjects of average contrast or higher contrast, containing tones ranging from dark to bright or very bright. (It does not work well with subjects that lack dark tones: we'll get to those later.)

Read the Dark Tones. The truism says, "Expose for the shadows"—the subject's dark tones. It follows that the logical tones to read with the meter are the darkest ones in the subject in which you want full shadow detail and shadow contrast in the print. Brighter tones tell you nothing about the dark ones, so ignore light tones for now. If

Negative given indicated exposure for sunlit bricks at ASA 400, straight print on No. 2 paper. Both the sunlit bricks and the surrounding "black" print as flat grays.

The same negative—indicated exposure on the sunlit bricks—printed on No. 6 paper for higher contrast. The bricks now look normal, and the black surround is black.

Negative given indicated exposure for bricks in shade, straight print on No. 2 paper. Much contrastier than the negative exposed for sunlit bricks. The bricks in the shade are more contrasty even on No. 2 paper than the shaded bricks in the No. 6 print of the thinner negative, though other grays are softer; and the blacks are black.

you expose the dark ones right, the light tones take care of themselves.

This metering method is designed to give you the minimum practical exposure for the dark tones of the subject.

PROCEDURE (CORRECT PART):

1. Set the film-speed indicator on the meter to your film's ASA rating.

2. From as close as possible, aim the meter cell directly at *the darkest area of your subject in which you want full detail in the print.*

Only light from this dark area should affect the meter. Don't read surface glare on the subject or the shadow of the meter, and don't partly cover the meter cell with stray fingers, or you will get false readings.

3. Watch the meter needle. If it hardly moves, either the light is too dim to read or you need to change over to the meter's dim-light mode (by lifting a perforated baffle off a selenium cell, or using a switch with a CdS cell). If the needle swings all the way across the dial and wants to keep on going, switch to the bright-light mode.

When the needle moves decisively to a stopping point partway across the dial, that is your reading.

4. Set the pointer on the meter's calculator dial to the number or position the needle indicates (or, on BTL meters in cameras, superimpose the match-pointer on the needle).

5. Choose one of the f-stop/shutter-speed pairs shown on the calculator dial. This is your *indicated exposure.* (Or, with BTL-metered cameras, in matching the needle you have set the indicated exposure on the camera. Note the f-stop and shutter speed.)

6. Then use the chosen shutter speed, but close the lens down one stop; or use the chosen f-stop, but set the shutter to a speed twice as fast. This gives you *one half the indicated exposure for that dark tone you have been measuring.* It will therefore be slightly underexposed, and "thin" in the negative, as a dark tone logically should be. (If the indicated exposure is f/8 at 1/60 second, then half the indicated exposure would be f/11 at 1/60 or f/8 at 1/125.)

7. Take the picture and process according to the manufacturer's recommendation.

Examples. The pictures of the sunlit chair include one correctly metered one and two incorrect ones, all on Kodak Tri-X Pan.

The "correct" one was based on a meter reading of the darkest shadow on the floor behind the chair. The print is "straight" on No. 2 (normal-contrast) paper.

One "incorrect" picture looks almost exactly like the correct one: it was given four times the correct exposure, and the negative was twice as dense, so it printed on the same paper with just twice as much print exposure (17½ seconds at f/16 under the enlarger instead of 17½ seconds at f/22). *The lesson is that massive overexposure does little harm if you don't overdevelop the film.*

The other "incorrect" chair picture was given exactly the exposure indicated by an accurate, but misused, BTL meter. The bright chair-seat almost filled the meter cell, and all dark areas were ignored. Extreme underexposure resulted: the print has no dark detail, and its tones are sickly and flat.

PROCEDURE (WITH MISTAKES):

1. Find a subject with large areas of very different brightness.

2. Take a meter reading of each area in turn, and give each one the indicated exposure. Disregard all the other tones in the picture area.

3. Develop as recommended and print the results (or, if you aren't printing yet, have prints made on No. 2 paper).

4. Examine the prints and learn what you can.

The series of pictures showing a window, a sunlit and shadow brick wall and a patch of sky outside, and a white wall and window frame indoors, was made in this way. The film was Tri-X, rated at ASA 400. The exposure data follow:

Sunlit bricks: f/9, 1/250 second.
Shaded bricks: f/2.5, 1/250 second.
White paint, indoors: f/2, 1/30 second.

Again, we see that even the slight underexposure I got by taking the ASA 400 rating of Tri-X at face value degrades the tones in all exposures where the reading was based on bright tones instead of darker ones.

Item: *Given the indicated exposure at ASA 400, the sunlit bricks print as flat gray on No. 2 paper.* This negative is so thin that the surrounding "black" also prints as flat gray. (Other prints were made on more contrasty papers—No. 3, No. 4 and, "hardest" of all, No. 6. Only the extreme-contrast No. 6 paper produced a good black.) Reason: ASA 400 is not a *median* exposure index for Tri-X; it is a *minimum* exposure index. With recommended development, it tends to produce underexposure in dark tones.

Item: *The shaded bricks, exposed at ASA 400, print as flattish—but better—grays: all the brighter tones print in livelier contrast.*

Negative given indicated exposure for white indoor wall, straight print exposed for that wall on No. 2 paper. All outdoor tones are "washed out" in this print.

The same negative, exposed for the white indoor wall; but this time the straight print on No. 2 paper was exposed to render the sunlit bricks more or less normally. In spite of their extreme overexposure, the bricks print agreeably; and the surrounding indoor wall has become a rich, velvety black.

Item: *When the densest negative of all is printed in the gray that stands for "white paint in deep shade," the sunlit and shaded bricks are almost entirely burned-out white in the print. But when the same negative is printed for the brick tones, the "white" wall becomes a rich, velvety black.* Lesson: in spite of some commonly believed bad advice, you cannot get rich blacks in photographs by underexposing black-and-white film. *You need full exposure if you want rich dark tones.* Thin highlights mean thin, gutless shadows, unless you make high-contrast prints. (Then you get flat black shadows with no detail or modulation.)

To sum up: *reflected-light meters think everything is middle gray. They are mistaken.* It's up to you to interpret what they say.

3

Film and the Negative

History. Film is comparatively recent. Early photographers used plates and paper in their cameras. Flexible, transparent film came when photography was nearly fifty years old. Early sheet film was sliced from celluloid blocks, then sensitized. Later the technique of flowing liquid cellulose nitrate onto glass tables made larger sheets—and roll film—possible.

Modern Film-base Materials. This approach is still used, but the explosively inflammable cellulose nitrate has given way to slow-burning cellulose acetate "safety film," flowed onto slowly turning polished steel drums. A few films are made from polyester plastics for dimensional stability: polyester shrinks and expands less than acetate.

Film is a complex product made from animal, vegetable and mineral ingredients—basically, cattle bones and hides for gelatin, silver and potassium bromide to sensitize it, and cotton and wood pulp to make the cellulose-acetate base that supports the sensitive emulsion. After refinement, these raw materials are complexly cooked and combined into huge rolls of film which are then cut to size and packaged in total darkness. The photo industry employs many blind people for this skilled work.

Photographic film and paper are like wine. It matters whether the cattle whose hides and bones are used "grew on the north side of the slope." Like wine, film and printing paper first improve with age (the manufacturer keeps them on the shelf until they are "ripe" before shipping them out for use), then deteriorate. Most makers stamp expiration dates—"develop before March 19—"—on their packages. If storage conditions are cool and not too damp, these dates—usually about two years after purchase—are conservative. Most films and papers stay good a year or two longer than that, except under tropical conditions. Humidity ruins emulsions faster than heat alone.

Considering the extreme variability of the raw materials and the sensitivity of the products, the consistent quality of modern photographic materials is a remarkable achievement.

EXPOSURE AND THE LATENT IMAGE

What Light Does to Film. Exposure to light turns part of the film or paper darker than other parts that received less light. The

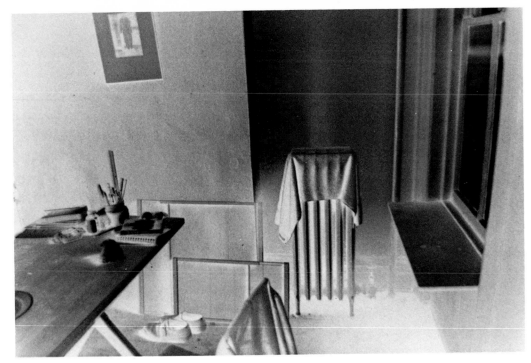

A 35mm negative, shown larger than its actual size (one inch by one-and-a-half). Its density and contrast are about normal.

more light strikes the emulsion, the darker the resulting tone. But it doesn't immediately become visible. The "latent image," like invisible ink, must be developed chemically to be seen.

There are exceptions. Photography began with silver salts blackening in the sun, and most early experiments relied on direct darkening of the image by the action of light. (One survivor of this class of photography is the "printing-out paper" still used by some old-time photographers for proof prints to show their customers. These proof prints darken a little whenever lights strikes them, so if permanent prints are wanted, they must be ordered.)

It was soon learned, though, that chemical treatment could "bring out" or develop pictures after much less exposure to light. This is the main approach today.

What Is a Latent Image? No one knows quite what happens in film to form a latent image and to preserve it until the film is developed, but the theories are getting more and more ingenious. One day we may learn what latent images are. Meanwhile we make and use them by the billion.

DEVELOPMENT

Development is the process of making the latent image visible and usable.

Development and Tone Control. Because

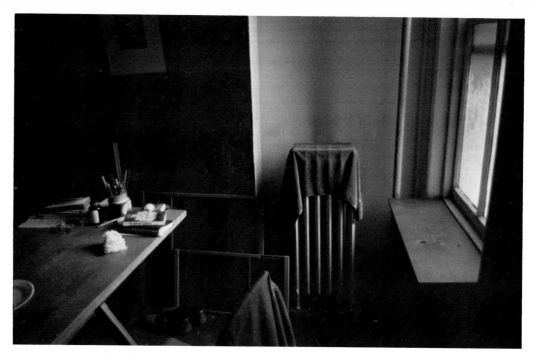

A positive print: this is a "straight" (unmanipulated) normal-contrast enlargement.

it is cumulative, building progressively from "nothing" to "a little" to "more," development gives us a simple and accurate way to control the tonal quality of the photograph.

What Development Does. Chemically, development converts exposed silver halides into metallic silver, leaving unexposed emulsion unchanged.

Fixing the Film. After development, the image is "fixed" and made permanent by using "hypo" to remove the unused silver salts.

Why Film Must Be Washed. Hypo itself is a chemical enemy of the silver in the photograph, so it must be thoroughly washed out of film and prints to prevent fading.

NEGATIVE, POSITIVE AND PRINT

The Negative. Light darkens silver salts, so the bright parts of what you photograph appear dark on the film. That's why negatives are called negatives. Any image in which dark stands for light and light for dark is a negative.

The Positive. Any image where light looks light and dark looks dark is a positive. Either can be on film, paper or other materials.

A *print* can be loosely defined as a photographic image that is made to be seen directly. Usually it is based on a negative that is not made to be seen.

The conventional print is a positive made by passing light through a film negative onto sensitized paper. It is a negative of a negative: the tones are re-reversed into positive form. You could make a negative print from a film or paper positive, however, and it would still be a print.

We are concerned here with conventional photography, so when I say "print" I mean a paper positive from a film negative.

DENSITY

Density is *how much silver* is on the developed film or paper. In transparent images, density is both relative opacity and relative darkness. Thin, transparent areas have low density: opaque, black ones are dense. In paper prints, density is relative darkness. Pale areas have low density, grays are intermediate and dark grays and blacks are dense.

The Density Pattern Is the Picture. A photograph is made up of light and dark areas— varying concentrations of specks of black silver metal—in the negative and the print. It is a self-portrait of the pattern of light that the lens projected onto the film, and of the shadow pattern that the negative held back from the paper during the print exposure. In both negative and print, density is greatest where the brightest light struck the emulsion, and density is lowest where the light was weakest.

EXPOSURE DETERMINES DENSITY

This is a basic principle. Where light has not affected the emulsion, there is no image density and no picture. How much light strikes any point on the film or paper determines how much silver can be developed there. Density can be *modified* by development, but no amount of development can turn unexposed silver salts into picture tones.

CONTRAST

This word has three main photographic meanings. *Subject contrast, negative contrast* and *print contrast* interact, but they are not the same.

Subject contrast is the range of different amounts of light given off by the parts of a photographic subject—the things that are photographed together. The brightness of any part of the subject is measured with a light meter. (Technically, measurable brightness is called luminance.)

Units of Measurement. In the United States, most meters are calibrated in standard measurement units called *foot candles* or candles-per-square-foot (c/ft^2); in Europe, "meter candles" are sometimes used.

Arithmetical vs. Log Scales. Some meters read directly and arithmetically in foot candles; others use logarithmic scales based on foot-candle or meter-candle measurements. I like foot-candle measurements because I am not much good at math, and understand arithmetical proportions better than the same proportions expressed on a log scale; but which scale is used makes no difference in most metering.

Meter Readings Show Subject Contrast. To give you some idea: black asphalt in the shade may give off 6.5 c/ft^2 and snow in sunlight may give off up to 2,400 c/ft^2, or 366 times as much light. Together, they are "contrasty."

High Subject Contrast. Consider a sunlit window in an otherwise unlighted coal cellar: a bright reading of 1,600 c/ft² with a darkest-dark reading of 1.6 c/ft² represents an extreme brightness range or a "long scale" of 1,000 to one. That is a *very* high-contrast subject.

Low Subject Contrast. When the brightest area reads 100 c/ft² and the darkest reads 50, the 1-to-2 ratio is the very short scale or brightness range of a low-contrast subject.

Coping with Subject Contrast. There is no photographic way to change subject contrast, but sometimes bright areas can be shaded and lamps or reflectors can be used to brighten dark areas. Studio photographers control subject contrast by controlling the light. Photographers who work outdoors or by "available" light usually control contrast photographically in the negative and the print, while leaving the light on the subject as it is.

Negative contrast is the range of densities in the negative, from the least-exposed, thinnest areas to the most-exposed, most-nearly-opaque, densest areas. But this general idea of negative contrast is an oversimplification.

Overall Contrast vs. Local Contrast. A high-contrast negative often has abnormally *low* contrast within its thinnest areas and its densest areas. It has high *overall* contrast, but low *local* contrast. In the thin, greatly underexposed parts, contrast is low because there can be little difference between "no image density" and "almost none." In the dense, greatly overexposed areas, contrast is low because there is little difference between "all the silver in the emulsion" and "almost all." Yet this negative with both very thin and very dense areas is a high-contrast one. It will print with lively contrast in the middle

grays, but its lighter and darker tones will print as "chalk" and "soot"—flat tones that lack internal contrast.

A *"normal-contrast"* negative is one that translates the subject's brightness range into a density range that fits the paper's tonal range. Such a negative "prints itself" on normal-contrast paper, rendering all tones of the subject in full, clear, lively detail without requiring any manipulation in the print exposure.

Low Contrast. A "flat" negative has contrast too low to fit normal-contrast paper, and prints as muddy gray on muddy gray.

High Contrast. An over-contrasty negative—much more common—has too long a density range for normal-contrast paper to register. Either the light or the dark tones "go off the scale" in printing. That is, if you expose the print for the best rendering of shadow detail, the dark and middle tones will look good, but the light tones will appear only as patches of blank white paper. If you expose the print for good highlight detail, the darker grays and the blacks run together in opaque, featureless pools of murk. A print with intermediate exposure will have both poor blacks and poor whites.

Print contrast is different—neither a matter of brightness range, like subject contrast, nor of density range, like negative contrast.

Tonal Range. Brightness range and density range are the same thing in a print. Together they form its *tonal* range, which is fixed within narrow limits. From saturated black to pure paper white, the tonal range of paper cannot go beyond a ratio of about 50-to-1. The white of a low-contrast print is the same as that of a high-contrast print; the same goes for their respective blacks.

What Print Contrast Is. Print contrast is

These negatives show differences in *density*, due to different *exposures* (top to bottom); and differences in *contrast*, due to different amounts of film development (left to right).

DENSITY: top-row negatives got only 1/4 of the recommended exposure, so they have low density and are *"thin": underexposed.* Middle-row negatives received twice the recommended exposure for Kodak Tri-X. Their density is about normal: detail can be seen in all tones. They are not thin, not dense; not underexposed, not overexposed. Bottom-row negatives were given 16 times the recommended exposure, so they are *dense: overexposed.*

CONTRAST: left-column negatives received only 1/2 the recommended development, so they are "soft" or "flat." They are *underdeveloped.* Center-column negatives were developed as recommended, so their contrast is about normal: neither "soft" nor "hard." They are *normally developed.* Right-column negatives received twice the recommended development, making them relatively contrasty or "hard." They are *overdeveloped.*

The middle negative in the center column is the "normal" negative—the easiest one to print well on "normal-contrast" paper.

Prints from these negatives show that density and contrast are not so simple. These negatives gain density with more exposure, but they also gain contrast with more exposure. Besides gaining contrast with more development, they also get much coarser in grain. They show clearly that you can print overexposed negatives better than you can print underexposed ones. The print exposures used (given in seconds at f/22 from left to right) are a fair measure of the relative densities of these negatives. Top row (EI 1600 negatives): 3″, 3½″, 5″. Second row (EI 200): 5″, 8″, 12½″. Bottom row (EI 25): 15″, 35″, 50″.

These are my 1972 test results with Tri-X film: other films, other photographers, and tests at other dates and under different conditions will naturally tend to give different results. For your photography, trust your own tests, not mine.

not the length of the scale, but the relative *abruptness* of tonal change from area to area across the print. The more gradual the changes, the lower the contrast: the more abrupt and extreme the changes, the higher the print contrast.

Low-contrast paper. A "soft" printing paper "compresses" the tones, recording a greater range of negative densities within its fixed tonal range than a contrastier paper can.

Normal-contrast paper, like low-contrast paper, compresses the negative densities to fit them into a somewhat more restricted range of print tones, but the compression is moderate. (Negatives have a naturally greater density range than prints.)

High-contrast paper. A "hard" paper "expands" a short range of negative densities to fill its own black-to-white range. It can record only a short "scale."

Print Contrast Complements Negative Contrast. A normal print is made from a normal-contrast negative on normal-contrast paper. It follows that a normal-looking print can be made from a moderately high-contrast negative by using a low-contrast paper; and a normal-looking print can be made from a low-contrast negative by using a high-contrast printing paper.

Papers come in many degrees of contrast to accommodate many different kinds of negatives and a great range of printing styles.

DEVELOPMENT DETERMINES NEGATIVE CONTRAST

This is a basic principle. Applied intelligently, it gives you control over the contrast of your negatives.

To understand development, you must realize that exposure and development do not work independently: they are the first and second parts of the same process: *forming the image.*

The density in the thinnest parts of the negative (the darkest parts of the subject) is controlled mainly by *exposure.* The density in the densest parts of the negative (the brightest parts of the subject) is controlled mainly by film *development.*

This is why an ancient photographic adage still applies: *Expose for the shadows, develop for the highlights.*

It means: *Expose enough* to get full shadow detail; *avoid overdevelopment* so that highlight detail in the negative will not become too dense to print.

Negative contrast results from two main factors: subject contrast, which you can seldom change; and the amount the film is developed, which you can change freely.

The higher the subject contrast, the higher the contrast of the negative will be, at a given development.

The longer the film development, the higher the negative contrast will be for a given subject: the shorter the development, the lower the contrast of the negative.

Film Development Complements Subject Contrast

Average-contrast subjects. You make normal-contrast negatives of average-contrast subjects by exposing normally and developing the film normally.

High-contrast subjects. You can make normal-contrast negatives of high-contrast subjects by giving the right exposure for the darkest subject tone and developing the film less than the normal time.

Low-contrast subjects. You can make normal-contrast negatives of low-contrast

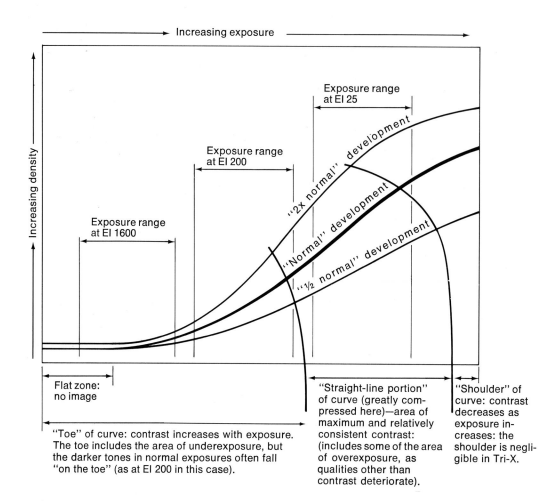

Increasing exposure

Increasing density

Exposure range at EI 25

Exposure range at EI 200

Exposure range at EI 1600

"2x normal" development

"Normal" development

"½ normal" development

Flat zone: no image

"Toe" of curve: contrast increases with exposure. The toe includes the area of underexposure, but the darker tones in normal exposures often fall "on the toe" (as at EI 200 in this case).

"Straight-line portion" of curve (greatly compressed here)—area of maximum and relatively consistent contrast: (includes some of the area of overexposure, as qualities other than contrast deteriorate).

"Shoulder" of curve: contrast decreases as exposure increases: the shoulder is negligible in Tri-X.

This graph shows why the negatives on page 46 gain contrast with increased exposure. It is a rough—estimated, not measured—chart of the "characteristic curve" of Tri-X, which, like all conventional negative films, has less contrast in underexposed and greatly overexposed areas than in areas that receive an intermediate amount of exposure. Think of the curve as a cross-section of the density of the negative. The steeper the slope of the curve, the higher the contrast: the flatter the slope, the lower the contrast.

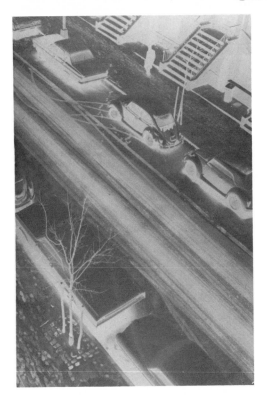 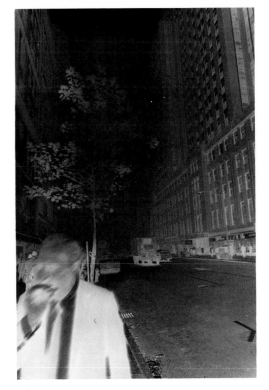

A soft or low-contrast negative (low-contrast or "short-scale" subject, normal exposure, film developed normally).

A hard or contrasty negative (high-contrast or "long-scale" subject, normal exposure, film overdeveloped).

subjects by exposing normally and developing the film longer than the normal time.

What is normal development? In practical terms, it is the degree of development that allows all the tones recorded in the negative to print well—with distinct and lively tones —on normal-contrast paper without manipulation. I tune my negatives to No. 2 paper, which I think of as normal in contrast. Some photographers match their negatives to the slightly contrastier No. 3 for normal-contrast prints: this is largely a matter of taste. Normal development is not always the same development that the film manufacturer recom-

mends. You have to experiment to find your own normal development.

The 25-percent Rule. Kodak has suggested that a 25-percent increase or decrease in film-development time should produce a contrast change in negatives roughly equivalent to a one-grade change in paper contrast. If negatives developed eight minutes at 68°F. are too contrasty for No. 2 (normal-contrast) paper but print well on soft No. 1 paper, six minutes' development at 68°F. should then give negatives of the same subject that print well on No. 2. It seldom works out quite so neatly. You find out by experimenting—

FILM AND THE NEGATIVE 49

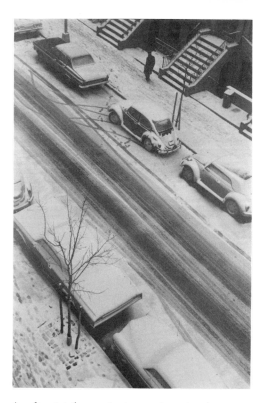

A soft print (low-contrast negative printed on normal-contrast No. 2 paper).

A normal-contrast print (low-contrast negative "normalized" by printing on high-contrast No. 6 paper).

shooting, developing and printing, adjusting your film development until the quality of the prints tells you it's right.

LATITUDE

It is preferable, but not absolutely necessary, to be accurate in both exposure and development. In both areas, latitude is your leeway to make mistakes that cause no serious loss of photographic quality. Latitude is *what you can get away with*.

Exposure latitude is necessarily built into

film. Pictures consist of different tones that result directly from different amounts of exposure, all of which must be handled well by the film emulsion. They must all be rendered clearly as printable densities with more or less proportional changes in tone corresponding to a very wide range of exposures.

Film Speed and Grain Size. Film sensitivity depends largely on the size of the silver-halide grains in the emulsion. The bigger the grains, the more sensitive they are to light.

Film Speed and Exposure Latitude. Grain size is more nearly uniform in slow, fine-

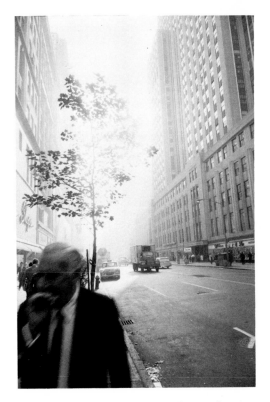

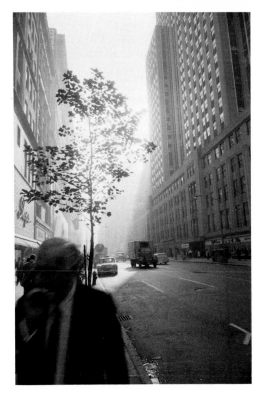

A contrasty print (high-contrast or long-scale negative printed on normal-contrast No. 2 paper, which cannot register all the tones in the negative. In this print, the whites have gone "off the scale" of the paper).

A normal-contrast print (high-contrast negative "normalized" by printing on low-contrast No. 1 paper. The white tones are recorded on this paper, which has a sufficiently "long scale" to match that of the negative).

grain films than in coarser-grained, fast films, so the slow films have less exposure latitude. In fast films, the largest grains are up to one hundred times as large and fast as the slowest, finest grains. When the large, fast grains have had all the exposure they can use, the smaller, slower ones are just beginning to respond to the light. In effect, a fast film is a mixture of many films of different speeds, from very slow to very fast. With fast films, it follows that overexposure does not become a serious problem until a considerable proportion of the slower grains receive full exposure.

With conventional negative films, overexposure harms picture quality less than underexposure.

What Is Normal Exposure? What is called "normal" exposure is close to the *minimum* exposure that can render all the tones of the subject printable.

Underexposure. When you expose less, the darkest tones may not appear in the negative at all, and the moderately dark tones lose

contrast and register as weak gray-on-gray tones when printed to show maximum detail.

Overexposed negatives become denser, but unless the film is also overdeveloped, they do not change much in any other way until overexposure is carried to extremes. The main disadvantage of moderate overexposure in negatives is that the print exposures take a few seconds longer—and that is sometimes an advantage. *When in doubt, give more exposure.*

Development latitude, for conventional negatives, is also broad but one-sided.

Underdevelopment. Unless they are underexposed, negatives can stand considerable underdevelopment with no visible loss in print quality, though more contrasty paper will be needed. But negatives can seldom stand much overdevelopment if you want to make excellent, clear-toned prints easily.

Overdevelopment quickly builds up the density of much-exposed areas to the point where they can't be printed easily, if at all; but it does not significantly build up underexposed areas. Overdevelopment can be useful when you want more contrast, but it does not help much when you want more film speed.

The high-contrast negatives that normally result from overdevelopment require low-contrast paper for normal-contrast printing—but really good "soft" papers are rare. Low-contrast negatives need contrasty papers for normal-contrast printing, and many good high-contrast papers are available.

Development and Grain. Overdeveloped negatives have coarser grain than normally developed or underdeveloped ones, even when the latter are greatly overexposed.

The "Latitude" of Grain. Coarse grain is not necessarily good or bad: it helps some pictures and hurts others. But if you want coarse grain, it can be superimposed on fine-grain pictures by printing through a texture screen much more effectively than unwanted grain can be eliminated from coarse-grained pictures.

How to Exploit Latitude. Work accurately when you can; but with moderate overexposure and underdevelopment, your negatives will still be easy to print well. The same degree of *under*exposure and *over*development will make good printing difficult or impossible.

Thus latitude in negatives lies mainly in the direction of overexposure and underdevelopment. *When in doubt, expose more and develop less.*

FILM SPEED

Films come in various speeds; that is, some are faster—more sensitive to light—than others, and require less exposure to produce negatives of similar density. Film speeds are rated by manufacturers according to industry standards which are slowly becoming uniform internationally.

Fast Film, Medium-speed Film, Slow Film. The three main speed categories of present-day black-and-white film are *fast* (about ASA 400), *medium speed* (about ASA 125) and *slow* (about ASA 32 to ASA 50). A few ultra-fast films with ratings of 3,200 or higher and ultra-slow ones rated at 10 or lower are also available: they serve specialized purposes well, but are less useful for general photography.

Rating Systems. The principal rating systems now used in western Europe and the United States are ASA (American Standards

Association), BSI (British Standards Institute) and the German system known as DIN (Deutsche Industrie Normal). All three are based on the same test methods and criteria, and are interchangeable. ASA and BSI use exactly the same arithmetical series of speed numbers, while DIN uses a logarithmic number series to represent the same film speeds.

Arithmetical and Log Ratings. ASA and BSI are arithmetical: thus an ASA 400 film is four times as fast as an ASA 100 film. For the same subject in the same light, you expose "two stops less" (give 1/4 the exposure) with ASA 400 film than with ASA 100 film to get a similar negative. With DIN, the film speed doubles with each increase of 3 in the speed number: DIN 24 film is twice as fast as DIN 21 film, which is twice as fast as DIN 18 film, and so on.

Standard Test Methods. The test methods on which these ratings are based are laboratory-and-math procedures which give results that do not exactly match those of actual picture-taking, so ASA ratings do not always lead to the best possible picture quality in practice. This is unavoidable: picture quality is largely a matter of taste—which fortunately cannot be standardized. It is quite right to exclude taste from the laboratory, and it is quite right to depart from the lab's recommendations to suit your own taste.

Personal Testing. Many photographers therefore test each new kind of black-and-white film they use to find the exposure-and-development combination that produces the kind of picture quality they like best. Instead of being tailored to an international standard, the film is then adapted to the photographer's own needs.

Unavoidable Variables. These include many variable factors that can't possibly be considered in the manufacturer's test lab. Among them, for example, are:

the things we photograph

the light we like

our taste in print tones

our need for, or indifference to, high film speed or fine grain

the age, design and quality of our cameras and lenses

our choice of meters and light-measuring methods

the optical behavior of our enlargers

our choice of printing papers

the climate where we work—and many more factors

Do Things Your Way. You are different from all other photographers, so you may need to expose and develop differently. If so, experiment to find the film speeds and developments that work best for you. Once you find your own best speed rating for a film, you can set it on your meter or camera in place of the ASA number and work simply.

The EI Nitpick. A film has only one ASA (or BSI, or DIN) number. It is not accurate to say of an ASA 400 film that you expose it "at ASA 1600" or "at ASA 200." Either of these exposure indexes might work well, with appropriate development, but neither one is the film's ASA rating. For altered ratings, replace the ASA prefix with "EI" for Exposure Index and you will be right.

Equivalent Film-speed Ratings. The table that follows may help if you find yourself using DIN-rated film or a DIN-calibrated meter instead of ASA or BSI film or meter values. EI is included with ASA and BSI,

since the same numbers stand for the same film speeds.

ASA BSI EI	DIN	ASA BSI EI	DIN
3	6	160	23
4	7	200	24
5	8	250	25
6	9	320	26
8	10	400	27
10	11	500	28
12	12	640	29
16	13	800	30
20	14	1000	31
25	15	1250	32
32	16	1600	33
40	17	2000	34
50	18	2500	35
64	19	3200	36
80	20	4000	37
100	21	5000	38
125	22	6400	39

Correct Exposure. No matter what kind of film-speed numbers you use, correct exposure is achieved by matching your f-stop-and-shutter-speed combination to the brightness of the light on your subject and to the actual speed of the film you are using—the speed that produces the kind of quality that helps your pictures most.

GRAIN

Film emulsion consists mainly of microscopic crystals of light-sensitive silver halides —mostly silver bromide—in a gelatin layer. As we've seen, the larger the crystals, the more sensitive they are to light; the smaller the crystals, the slower or less sensitive they are.

Development converts the exposed crystals to similar-sized grains of metallic silver, much too small to see even in much-enlarged prints.

Each visible "grain" is actually a clump of many silver particles that have moved together during processing. The larger the crystals, the bigger the clumps; so fast films look grainy, and finer-grained films are slower.

NEGATIVE CONTRAST

To summarize what we have already covered: fast films have lower contrast than slower films that have received the same amount of development; but all conventional black-and-white films—fast, medium-speed and slow—can easily be developed to any desired degree of contrast by controlling the development time at any given workable temperature. Fast films require a longer development, and slow films require a shorter one, to reach a given degree of contrast. The longer the development, the higher the contrast; the shorter the development, the lower the contrast.

SHARPNESS

No one knows exactly what sharpness is, except that it's the impression of great clarity of detail in a picture—especially clarity of edges. Impressions can be felt, but not measured.

Two aspects of sharpness *can* be measured: acutance and resolution.

Acutance is measured edge-definition. The test method is to place an opaque knife edge flat against the film for the sharpest possible shadow. After exposure to light and development, the film is examined with a micro-densitometer to find out how far past the edge traces of tone have "leaked," and to see how abrupt or gradual the cut-off is. High acutance—the most abrupt cut-off—tends to go together with the appearance of sharpness, but does not necessarily make visible the finest possible detail.

Resolution refers to the distinctness of separate details. It is tested by photographing

Target photo on 35mm Panatomic-X shows the high resolving power of this slow, fine-grain film. 56 lines per millimeter are clear in this 19× enlargement.

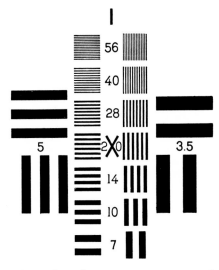

One form of resolution target. To use it, photograph it at a distance equal to 26 times the focal length of your lens. Then examine the negative under high magnification. How fine a pattern can you see clearly? (The numbers represent approximately the number of lines per millimeter in such a negative. A resolution of 20 lines per mm. is considered good.)

a standard target with black bars separated by white spaces of the same width. There are several sets of bars and spaces of diminishing sizes. When some of the smaller bars and spaces in the test negative merge into a gray mass, the limit of resolution has been reached. Observers do not always agree about just when the bars should be considered to have merged, and there are other uncertainties, but this method is used to test resolving power both in lenses and emulsions. The test results long ago established that the image with the highest resolution does not always have the highest acutance and does not always look sharp.

Acutance, Resolution and Contrast. Both acutance and resolution are inextricably linked to contrast. Black against white, black against gray and gray against white are all easier to see—and thus "sharper"—than gray against gray.

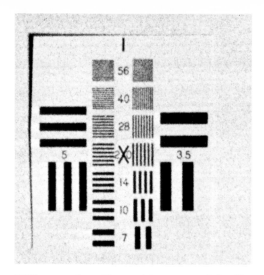

Tri-X target photo. The resolving power of this film is lower than that of Panatomic-X. 40 lines per millimeter are clear, 56 lines can only be seen fuzzily.

So When Is It Sharp? The final judgment about a picture's sharpness is personal and subjective. When it *looks* sharp enough, it *is* sharp enough, regardless of measurements. This has more to do with seeing and understanding than with focusing.

For example, 8 × 10-inch contact prints from 8 × 10 negatives by Edward Weston and Ansel Adams give such a strong sense of sharp exactness that they have become classic examples of photographic sharpness. Yet an analytical look at some of these prints shows soft edges and mushy textures of which any good 35mm photographer might be ashamed. Nevertheless, the pictures feel miraculously sharp because the *seeing* of these photographers is clear and unconfused, overcoming all the technical deficiencies. Part of this clarity is in contrast: Weston and Adams hardly ever let matching tones meet edge-to-edge in their pictures. The separation

may be subtle, but it is almost always extremely clear.

The sharpness that counts most is more in the eye and mind than in the negative.

COLOR SENSITIVITY AND FILTERS

Panchromatic Film. Most modern black-and-white films are panchromatic—sensitive to light of all colors—in about the same proportions as the eye, and reproduce the light-and-dark values of colored objects more or less as the eye sees them. If you like to photograph things about the way they look, you don't need any filters. (I don't own any and have never wanted any.)

Color Contrast Doesn't Guarantee Tonal Contrast. Things that the eye sees as different because of color may look the same in a black-and-white print. The red apple and the green leaves both produce the same photographic gray. To avoid tonal confusion, the photographer must learn to see in light-and-dark as well as in color.

Use a Viewing Filter. If you find this difficult, it may help you to look at the subject through a tea-colored Wratten No. 90 viewing filter. It plays down color so you see the subject in about the same light-and-dark values that panchromatic film will record without a filter.

Color-blind Film and Plates. Early emulsions were "color blind"—sensitive only to blue light and ultra-violet. Yellows, reds and greens looked dark gray or black, while blue skies were blank white. You can get a similar effect on pan film by exposing it through a strong blue filter.

Ortho Film. Later most film was ortho-chromatic—sensitive to all colors except red.

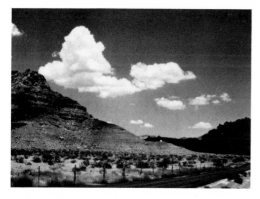

A Kodachrome transparency copied on panchromatic Polaroid Type 52 film without a filter (equivalent to a normal, unfiltered black-and-white shot on pan film).

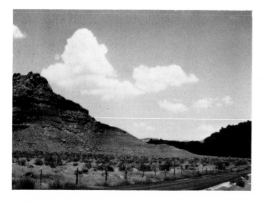

A blue filter, used to copy the same transparency on the same Polaroid pan film, produced this effect (pale sky, dark earth—the "color-blind" effect found in nineteenth-century photos).

A red filter did this (dark sky, light earth, bright clouds. The red filter is the classical white-cloud-in-black-sky melodrama filter).

Reds and yellows registered as black and dark gray (yellow light is a mixture of red and green light), but other colors looked natural. You can get an ortho effect on pan film by exposing it through a green filter.

Pan Film and Filters. Pan film is sensitive to light of all colors, so a filter of any color will "darken" its complementary color in the picture and "brighten" its own color. To find out what any filter will do, look at the subject through it and you will see its effect.

How Color Works. "White" light is really a balanced mixture of red, green and blue light. A red filter looks red because it absorbs the blue and the green, so only red rays come through. A red object looks red because it absorbs blue and green and reflects only red light.

Filters and Light. A yellow filter absorbs blue light, so red light and green light, balanced to look "yellow," pass through. A green filter absorbs red and blue, so green comes through. A blue filter absorbs red and green—and therefore yellow—so only blue light comes through.

Filters and Film. Translating this into the effect of filters on pan film: yellow filters darken blues, and brighten yellow most and red and green slightly: red filters darken blues and greens, and brighten reds: green filters darken reds and blues, and brighten greens: blue filters darken reds, greens and yellows, and brighten blues.

Limitations of Filters. A filter hardly ever screens out all light from an object of its complementary color. Few if any filters are pure in color or totally absorptive; and few if any of the colors in nature are pure. Most are mixtures balanced so that one color or another dominates. When the complementaries are screened out, light of the remaining

colors still passes through filter and lens to add exposure to the picture.

Filter Factors and Exposure. Filters subtract part of the light, so exposure must be increased proportionately to get normally dense negatives. The amount of exposure increase a filter requires is its filter factor. A factor of 2, for example, requires that the exposure be doubled; a factor of 5 requires five times normal exposure to get a normal negative.

When using filters, always compute the exposure from the factor. Do not try the short cut of reading the meter through the filter. This is likely to give a false reading, since the color sensitivity of the light meter may not match that of the film.

The Filter Trap. People who have learned a few conventional filter effects often seem to rely on filters as substitutes for perceptive seeing. The normal result is a slick-looking disaster. More pictures are ruined by the self-conscious over-use of filters than by their absence; so unless you have good reason to change the light-and-dark values in the picture—clarity or stronger expression—I suggest you forget filters and take the picture without them. If you must use a filter, choose the one that will help most.

Intelligent Filtering. One example of the intelligent use of filters is Ansel Adams' method for making sunlit grass gleam more in pictures. He uses a light red filter and adds enough exposure to render the green grass in its normal density in the negative. The white-light scintillation of sun on its surface is about one third red, so it adds proportionately more exposure to the film. The result is a more brilliant highlight in the print. There is no sense of trickery.

FILM FORMATS

Black-and-white films for normal photographs come in several main forms. (Drop-in-loading 126 film, very popular with color snapshooters, is harder to find in black-and-white, and is designed for automated factory processing, so I won't discuss it here.)

Roll film with paper backing comes in two main sizes: 127 film, for negatives 1⅝ inches wide; and the more widely used 120 film, for negatives 2¼ inches wide. The latter offers more emulsions and is the leading roll film used today. Some cameras that use 120 film also accept 220 rolls—longer film of the same width but with no paper backing. Perforated 70mm film is used in industry, and some cameras accept 70mm magazine backs as well as 120 and 220 roll backs.

35mm Film. The most popular format with advanced amateurs and many professionals today is 35mm film in cartridges of 20 or 36 exposures with a frame size of approximately 24 × 36mm (1 × 1½ inches). 35mm film also comes in long "bulk" rolls—50 or 100 feet—which are loaded into cartridges by the photographer. The loading is easy, and the savings are considerable. Bulk film costs less than half as much per roll as factory-loaded cartridges of the same film.

Sheet film offers the highest potential photographic quality and the greatest variety of emulsions, but the large negative size and the need to handle each film individually make it less convenient and more expensive than roll or 35mm film. The most popular sheet-film size is 4 × 5 inches. Many other sizes are available, from 2¼ × 3¼ inches to 16 × 20 inches and larger.

Very slow film, ultra-fine grain. This 19× enlargement from Kodak High Contrast Copy Film (EI 10), developed in H & W Control Developer, looks grainless and remarkably sharp.

Slow film, very fine grain. 19× detail from Kodak Panatomic-X (ASA 32) shows fine, even grain, very sharp rendition of subject.

BLACK-AND-WHITE EMULSIONS

Panchromatic film comes in five main types.

Ultra-fast films (such as Kodak Recording Film 2475) with exposure indexes of 1000 or higher are grainy and have relatively low resolution, but great exposure and development latitude.

High-speed films (such as Ilford HP4 and Kodak Tri-X), rated around ASA 400, offer fairly fine grain and moderately high resolution, with extreme latitude. (This is such a handy combination of working characteristics that I recommend these films for normal use.)

Medium-speed films, in the ASA 80 to ASA 160 range, have finer grain and higher resolution, but somewhat less latitude than the faster films. (Kodak Plus-X and Veri-chrome Pan, Ilford FP4, and GAF 125 are representative.)

Slow or fine-grain films, ASA 32 to 50 (Kodak Panatomic-X and Ilford Pan F) have very fine grain and extremely high resolution, but are more temperamental and have less latitude than faster films; and they are inconveniently slow for hand-held photography except in the brightest light.

Ultra-fine-grain films with exposure indexes in the 10 to 80 range (Kodak High Contrast Copy Film 5069 and H & W Control VTE Pan, for example) are really high-contrast microfilm materials adapted to almost-normal photography by special development. They have far finer grain and higher resolution than other films, but due to the thinness of their emulsions, the negatives can encompass only a very limited range of exposures. They can-

Fast film, fine grain, 19× detail from Kodak Tri-X (ASA 400) shows grain only slightly coarser than Panatomic-X, but less sharp rendition of subject (enlarged 8×, this picture looks sharp).

Ultra-fast film, coarse grain. 19× detail from Kodak Recording Film 2475 (EI 1600). Grain wipes out fine details, but print looks sharp because the grain is sharply defined.

not record subjects of extreme brightness range or high contrast. With these films, overexposure is as bad as underexposure. You must work within their narrow sensitivity range.

POLAROID: A DIFFERENT STORY

Polaroid "films" for instant pictures are really a direct-positive process that produces prints but no usable negatives. An exception is Type 55 P/N, which produces a good Polaroid print at one exposure index and an excellent negative for future printing at about twice the exposure for a good initial print. (Polaroid is working to get these exposures closer together.)

Polaroid direct-print materials such as Type 52 have limited latitude, and overexposure is worse than slight underexposure. An unex-

posed Polaroid print, when developed, is solid black: exposure, in effect, subtracts blackness to make the light parts of the picture. Too much exposure leaves too little image.

The tonal quality of a good Polaroid print is beautiful, but because the image is transferred chemically from one piece of paper to another (the technical process involves wandering molecules) a good Polaroid print is less sharp than a good contact print from a conventional negative. The difference is not enough to matter unless you want large copy prints. Polaroid "film" comes in packs and rolls to fit Polaroid cameras, and in 4 × 5 sheets that fit a Polaroid back for standard 4 × 5 cameras. Polaroid recently introduced a new PN format, Type 105, which produces 3¼ x 4¼-inch pictures, and a back which adapts it to the standard 4 × 5 camera.

Other manufacturers are working on com-

petitive diffusion transfer processes, so presumably Polaroid will not have this field of photography all to itself much longer.

PRACTICAL START: SHOOT A FILM-SPEED TEST

If you are new to photography or if you have not methodically explored the materials you use, try this test. You need a camera, two rolls of film and either a light meter (reflected-light type) or the manufacture's exposure instructions for the film (as packed with each roll). If you use sheet film, a 25-sheet box will do. Use a fresh high-speed or medium-speed black-and-white film: both rolls or all sheets should be the same film from the same manufacturer, and preferably from the same emulsion batch. (Most makers print a batch number on the box along with the expiration date.)

1. Find a high-contrast subject, such as one with dark-toned things in the shade and bright-toned ones in direct sunlight: for example, black pavement in shadow next to white-painted wood or bright concrete in the sun; or a black man wearing a white shirt, with his face in shadow and his sleeve in the sunlight.

2. Determine "normal" exposure according to the manufacturer's recommendations and the ASA rating.

If you have a reflected-light meter, set it at the film's ASA rating. Then read the darkest area of the subject in which you want detail in the print. Make a note of this reading. For your first test exposure, set the camera at one fourth of the exposure the meter indicates for this dark tone (by stopping down two f-stops or speeding up the shutter by two settings

from any of the indicated f-stop/shutter-speed combinations on the meter).

If you do not have a reflected-light meter, set the camera at the exposure the manufacturer recommends for "open shade" (the lighting condition of the important dark tone in your subject).

3. Make your first test shot at this exposure, whether it was metered or estimated. All other shots will be of the same subject from the same camera position.

4. Stop down the lens two f-stops or speed up the shutter to four times as fast and make the second test exposure. This negative will have one fourth of the recommended exposure.

5. Open the lens one stop and expose again. This negative will get half the recommended exposure.

6. Open the lens another stop and expose. This negative will get the recommended exposure.

7. Open another stop and expose. This negative will get twice the recommended exposure.

8. Open a stop and expose at four times the recommended exposure.

9. Open a stop (or slow the shutter by one speed) and expose at 8 times the recommended exposure.

10. Expose at *16x*.

11. Expose at *32x*.

12. Expose at *64x*.

13. Expose at *128x*.

Continue to increase the exposure by doubling it each time until the camera runs out of increased-exposure settings or you finish the roll.

 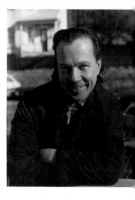

EI 3200 (1/8 recommended exposure).

EI 1600 (1/4 recommended exposure).

EI 800 (1/2 recommended exposure).

EI (ASA) 400 (recommend exposure).

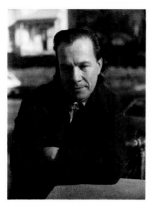 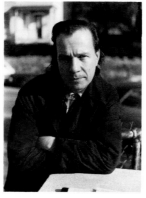 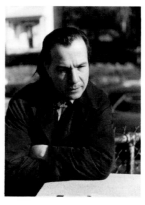

EI 200 (2× recommended exposure).

EI 100 (4× recommended exposure).

EI 50 (8× recommended exposure).

EI 25 (16× recommended exposure).

EI 12 (32× recommended exposure).

EI 6 (64× recommended exposure).

Prints from exposure-test negatives on 35mm Tri-X (rated at ASA 400). The negatives got from 1/8 to 64× recommended exposure, and were all developed as Kodak recommends. All the prints are on Kodak Ektalure E normal-contrast paper, processed as recommended. I prefer the EI 200 and EI 100 negatives (2× and 4× recommended exposure) to the recommended-exposure EI (ASA) 400 one: their dark tones look much better to me. Therefore I shoot my Tri-X at EI 200—the highest speed for this film that gives me the tones I like.) As you can see, overexposed negatives printed better than underexposed ones.

14. Shoot a second roll the same way.

15. Send one roll to a custom lab—or, in a pinch, to a drugstore—for "normal development" but not for printing. Save the other roll to develop yourself.

16. Look at the negatives and try to estimate what is the *least* exposure with good shadow detail and the *most* exposure with good highlight detail.

Write down these impressions in a notebook to compare with the results you will get later when you print these negatives. *You can't really judge a negative except by printing it,* but you can learn to see when it is badly underexposed or overexposed.

4

Starting a Darkroom

THE DARKROOM

Every serious black-and-white photographer needs a darkroom for film processing and printing.

The Illusion That You Don't Need a Darkroom. Some good photographers rely on others for all their processing, but they are mistaken if they think they are independent of the darkroom. They just have less control over what happens there.

The Easy Way. I believe it is easier to get the results you want by doing the work yourself than it is to teach others to develop and print your pictures your way. It is cheaper and more interesting to do your own work, and it keeps you in touch with what you are doing.

Photographers who are proud of never getting their hands wet make me think of the legendary eighteenth-century aristocrat who was asked how people of his class lived. "Oh," he said, "our servants do that for us." He was missing something.

The ideal darkroom is a comfortable, efficient permanent setup; but most of us start with improvised darkrooms. This is good. It's better to learn by improvising than to fall into the trap of those spoiled photographers who are taught their craft in over-elaborate darkrooms. Once on their own, they can't afford all the gadgets they have learned to depend on, and working without them seems very hard.

WHAT A DARKROOM NEEDS

Darkness. It must be dark enough so you can handle fast film without fogging it; not absolutely dark, but close to it. A rule of thumb is that if you can spend five minutes in the darkened room before you can see any light leaks at doors, windows or elsewhere, it's dark enough for most work—though it may look alarmingly bright after you've been there for half an hour. Get rid of all the light leaks if you can. Stuff a towel under the door or cover the leaks with cardboard before you bring out any high-speed film in the darkroom.

Ventilation. A darkroom needs fresh air. Ideally, a "light-trap" entrance will let both you and plenty of air move freely in and out of the darkroom without admitting light; but human-sized light traps take more space than can usually be spared for a home darkroom. A light-trapped exhaust fan or an air-conditioner will help. If, in emergencies, you must

work in a small closet, don't stay sealed in without fresh air any longer than you have to.

Wet and Dry Areas. You need two working areas: a "dry" area with a table for your materials and equipment, and a "wet" area with a table or, preferably, a sink for the actual processing. The wet-area work surface should be large enough for four print-processing trays—preferably larger. The entire wet area should be well separated from the dry area, if possible, so you can't splash or spill any liquids into the dry area, where they could destroy film, paper and negatives and damage your enlarger. If you can't keep the wet and dry areas that far apart—or even if you can—always take care to keep liquids away from the dry area.

Headroom. The darkroom must also be high enough so you can comfortably use your enlarger at its full height.

Safelights. The darkroom needs light. You process film in total darkness, but you need safelights for printing—colored lights that give you light to see by but do not affect the printing paper. I suggest the Kodak OC filter or the DuPont S-55X filter; both are designed to be safe for all conventional black-and-white printing papers, including variable-contrast papers. Keep the safelight at least as far away from your paper as the manufacturer recommends, and do not use brighter light bulbs than are recommended.

White Light. You will need white light, too. In the dry area, you need enough room light to inspect tiny proof prints and select negatives, as well as to set up and to clean the darkroom. In the wet area, you need a carefully adjusted print-inspection light, so you can judge the prints as you work. (It's a rare photographer who can judge prints by safelight. Don't try. All you can really expect to get from it is eyestrain.)

Water Supply. The darkroom needs water —ideally, hot and cold with a temperature-control mixing faucet that holds the flow at any desired temperature; but that's a luxury. It is enough to have hot and cold water and a simple mixing faucet or a Y-shaped hose that enables you to adjust the temperature by hand. You can work even without running water: just carry it in and out in buckets.

Temperature. The darkroom should be at a practical temperature. You can work in a cold 50°F. darkroom or a hot 100°F. one, but the photographic quality of your pictures is likely to suffer almost as much as you suffer. The ideal room temperature is between 70° and 80°F. Summer air-conditioning and winter heat help in most climates.

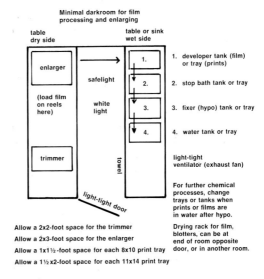

Floor plan for a minimal darkroom.

Keep It Clean. The darkroom should be clean: in particular, it should have a minimum of airborne dust. Few city darkrooms can be kept dust-free, so the law of survival is: *Don't disturb the dust.* Do NOT sweep the darkroom floor before you develop or print: that fills the air for hours with evil dust. Do wipe table surfaces gently with a clean, damp cloth to remove dust without flinging it into the air.

PRACTICAL START: SETTING UP A DARKROOM

First let us discuss the improvised home darkroom. Then, for the rich, the dedicated and the lucky, we can take up the "real" darkroom, designed and used for nothing else.

Improvising. Kitchens, bathrooms and basements, with built-in running water, are natural potential darkrooms; but any darkenable room that has electricity and is near water can be used. "Darkenable" is a relative term: some photographers develop and print only at night because they can't get rid of enough of the daylight. Pick your own compromise. Choose either the room you can most easily set up and take down, or the one that interferes least with your daily life.

An improvised home darkroom can and should be very simple. For now, let's think in terms of film processing, forgetting about printing except to leave enough room for it.

DARKENING THE ROOM

Doors that fit their frames darken efficiently, except that you will often have to cover the crack at the bottom. A rolled towel pushed against it will do. If the door fits loosely, some weatherstripping around the

edges of the frame will usually make it light-tight.

Windows are easy, too. If you can find opaque "blackout" window shades, their edges can run in light-trap grooves painted matte black inside. Then you can eliminate window light just by pulling the shade. Otherwise, a plywood cover cut to fit the window frame can be lifted into place, and any cracks around it sealed with tape or weatherstripping. Store the cover flat against the wall when you aren't using it. If you ventilate the room with a window air-conditioner, cut the cover to fit around it.

If the air conditioner leaks light, put a piece of dark cardboard between it and the room—just enough to cut off the light, not the air.

FINDING SPACE IN SMALL ROOMS

In the kitchen, the kitchen table, covered with plastic, can serve as a processing table. The enlarger can stand on a small table, on a fold-down shelf fastened to the wall with strong hinges and held up by removable legs or braces, or on a wheeled cart. In a pinch, it can even stand on top of the stove (beware of pilot lights).

In bathrooms, broad planks or a thick plywood top can be laid across the bathtub to make a processing table. If the tub is too low, some planks on edge, fastened to the top, can raise the top to a convenient height. A small table or cart can hold the enlarger: if there is a shelf under its top, the printing paper can be kept there.

In the bedroom, a flush door laid across a dressing table or on a pair of sawhorses can provide space for the trays. The enlarger can be kept in the closet, protected by a plastic

dust cover. Again, a small table or cart will do to hold it while you're using it.

In such improvised darkrooms, don't worry too much about separating the wet and dry areas. Do it if the room permits, but it's enough to be careful if the room does not allow separation.

In any makeshift darkroom, your main problems are: darkness; dry work space (room for an enlarger and your negatives and paper, or room to prepare film for development); wet work space (room for four 15 × 18-inch trays—the outside size of "11 × 14" trays); water supply (a sink or a place to put a couple of buckets); electricity (three outlets at least, for one white light, one safelight and the enlarger); and convenience in setting up and clearing away.

A "photo cart," with the enlarger on top and storage space for paper and accessories below, can be a big help. For the rest, you must plan your space. One approach is to cut sheets of cardboard to the sizes of your trays, tanks and all the other equipment and materials you must spread out for developing and for printing. Lay them out in the room in different ways until you get everything for developing and everything for printing, respectively, to fit into the space when arranged in a first-step-to-last-step sequence. Leave room for yourself to move among them.

Traffic Flow. If you work along a wall or around the room, left to right or right to left from start to finish, you have a good traffic flow that will ease your work.

THE PERMANENT DARKROOM

This deserves even more thought: permanent mistakes are a permanent drag.

The Sink. If you can get a stainless-steel or fiber-glass sink big enough for six of the largest trays you expect to use, it may make sense to design the darkroom to fit around the plumbing.

Chemical Storage. Developer, fixer and other bottled chemicals, as well as empty trays, belong on racks and shelves under the sink.

The Enlarging Table. Across the room, or at least well away from the sink, depending on space, is your dry table with the enlarger. For the greatest convenience, it should be about six feet long and three feet wide, though smaller tables can be used.

Paper and Proof-print Storage. The logical place for your printing papers and your current files of proof sheets and negatives is under or near this enlarging table.

Lighting. In each area, wet and dry, there should be at least one good safelight and one comfortably bright white light.

Clock. A clock with a clearly visible sweep second hand is good to have above the sink.

Utensils. There, too, on a shelf or on a rack, is a good place to keep graduates, tanks and reels between uses. The thermometer and an interval timer should be within easy view and reach.

Entrances. Ideally, the darkroom is entered through a light trap. If space does not permit, a light lock—two doors with a space between—is almost as good. You open and close first one door, then the other, so no light enters the room when you come and go. A variation on that theme is the revolving door with only one open quarter, which makes it impossible to open both sides of the light lock at the same time.

Ventilation and Temperature Control. A permanent darkroom must be well ventilated, and should have temperature control if the

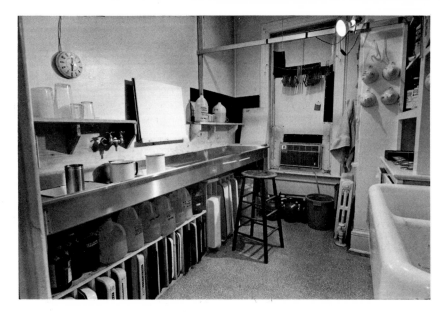

Wet room of two-room darkroom. Trays and processing chemicals are kept under the sink. Note the print-inspection board and its light, and the stainless steel tank and two graduates, set up for three-tank film development (described in the next chapter).

Dry room of two-room darkroom. Negatives, contact prints and printing paper are kept on shelves under the enlarging table. The drying rack for film and blotters is behind the enlarger at the right.

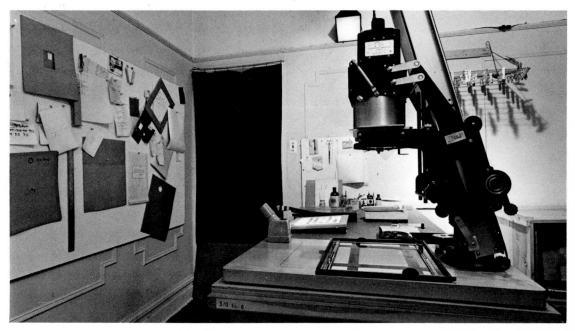

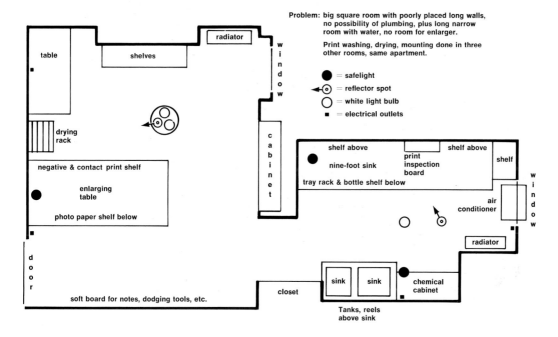

Problem: big square room with poorly placed long walls, no possibility of plumbing, plus long narrow room with water, no room for enlarger.

Print washing, drying, mounting done in three other rooms, same apartment.

● = safelight
◄⊙ = reflector spot
○ = white light bulb
■ = electrical outlets

table

shelves

radiator

w i n d o w

c a b i n e t

drying rack

negative & contact print shelf

enlarging table

photo paper shelf below

shelf above

nine-foot sink

print inspection board

shelf above

shelf

tray rack & bottle shelf below

w i n d o w

air conditioner

radiator

d o o r

soft board for notes, dodging tools, etc.

closet

sink

sink

chemical cabinet

Tanks, reels above sink

Floor plan of two-room darkroom.

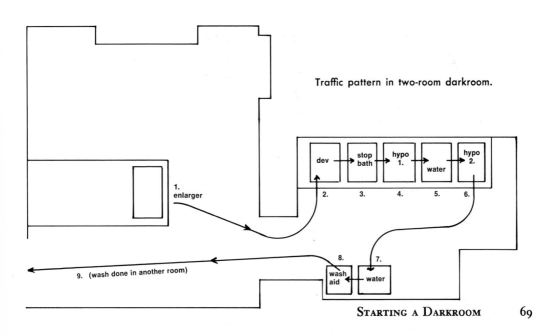

Traffic pattern in two-room darkroom.

dev	stop bath	hypo 1.	water	hypo 2.

1. enlarger

2. 3. 4. 5. 6.

8. wash aid

7. water

9. (wash done in another room)

climate requires it—air-conditioning or heat or both. It also needs hot and cold running water and at least one mixing faucet; must have ample electricity; and should be designed for both easy photographic work and easy cleaning. As important as any other factor, the darkroom should be a comfortable and pleasant place.

A Useful Book. Darkroom design and construction pose too many complex problems—some vital, some less so—to deal with in full detail here. A useful book that offers constructive information about many of them can be ordered from the Eastman Kodak Company, 343 State Street, Rochester, New York 14650. It is Kodak Publication K-13, *Photolab Design*; its 1974 price was $1.00. A well-designed, well-built darkroom is a plea-sure to use, but a botched one is a pain forever: before you make final arrangements, think well. When in doubt, experiment with alternative possibilities: what works well for one person may be an obstacle for another. Make sure your darkroom works for you.

DARKROOMLESS DARKROOMS

If no darkroom at all is available, it's possible, though not convenient, to do a great deal without one.

The Changing Bag. One small, inexpensive darkroom substitute that you can fold and stuff into a large pocket is a changing bag. Any camera store should have one or can order one for you. Most cost under ten dollars, and some cost under five.

Floor plan of a compact darkroom I once built into a New York loft: the sinks were marine plywood, painted and caulked. A film maker once wanted to use it as a location in a movie about beatniks, but found it too neat—not bohemian enough.

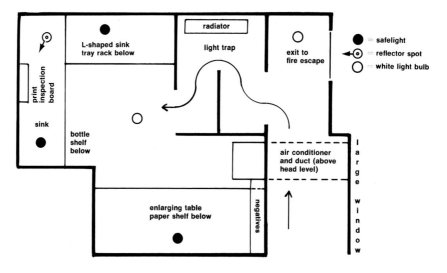

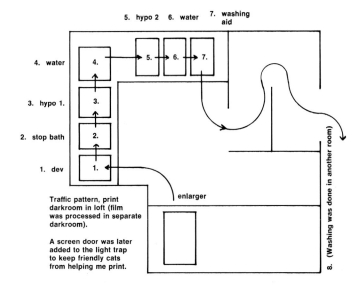

5. hypo 2 6. water 7. washing aid

4. water

3. hypo 1.

2. stop bath

1. dev

Traffic pattern, print darkroom in loft (film was processed in separate darkroom).

A screen door was later added to the light trap to keep friendly cats from helping me print.

enlarger

8. (Washing was done in another room)

Traffic pattern in the loft darkroom, which was slightly larger than nine feet by nine. A studio skylight filled the corner between the enlarging table and the sink; I sealed the cracks against light with the opaque paper that is used to back roll film.

A screen door was later added to the light trap to keep friendly cats from helping me print.

The traditional changing bag looks like a black cloth shirt for a headless person. It has sleeves and a "torso," but no neck opening. The waist is closed by a zipper. Mine has a second zipper under that one, which opens a light-tight rubberized bag inside the black cloth one. The sleeves are held tight around the arms by elastic. The bag can be used to load exposed film into tanks for development in room light; but try a dry run or two before you do it with "live" film.

Changing-Bag Film Development. To use the bag for loading a developing tank with 35mm film, unzip everything and put into the bag your tank, its lid, a tankload of reels, the tank's stem if it has one, and some exposed film—not more than one tankful. If the film is in Kodak factory-loaded cartridges, put in a beer-can opener, too.

Zip the bag closed with all zippers, then put your arms into the sleeves. Pull the

sleeves up. Feel for the tank, reels, stem and lid, and place them all where you can find them. Face all the spiral reels in the same direction to make loading easy. Now find the cartridges and the can opener.

Open the first cartridge, take out the film on its spool and put the empty cartridge shell and its cap well away from the reels and the tank.

Loading the Reels. Load the first reel by touch. Start by inserting the end of the film into the clip or the core at the center of the reel, then turn the reel so it draws the film onto the reel. Keep turning until it is all loaded. It helps to hold a finger and thumb touching the edges of the reel at top and bottom and holding the film so it is slightly curved in cross-section. As it goes onto the track, it straightens in cross-section and is held in place by the reel. (For detailed reel-loading instructions, see page 86.)

A mini-darkroom: my changing bag in use.

mizes the inaccuracy of timing caused by the pouring process.

D-76 1:1 Time-temperature Table. Kodak's recommended development times (1974) for Tri-X film in D-76 diluted 1:1 are approximately as follows:

65°F	10½ minutes		71°F	7½ minutes	
66	10	"	72	7	"
67	9½	"	73	6	"
*68	9	"	74	5½	"
69	8½	"	75	5	"
70	8	"			

* recommended temperature.

Developing, Stop Bath, Fixing. Take the temperature of your mixed 1:1 developer and set your timer accordingly (or you can use a clock or watch instead).

When you're ready to start developing, first start your timer (or check the minute and second on your clock or watch). *Immediately* pour the developer quickly into the tank through the center opening in the lid, which admits liquids but not light.

Develop in the normal way, with intermittent agitation. (For detailed developing instructions, see page 86.) At 30 seconds before the end of the development time, start pouring out the developer. (Throw it away: 1:1 developer is for one-time use only.) Immediately pour in the stop bath, agitate once and pour it out. Pour in the fixer and agitate intermittently.

After the recommended fixing time, funnel the fixer back into its bottle, then take the lid off the tank. Then proceed in the normal way with hypo neutralizer, washing and drying, which can be done in ordinary room light.

Other Uses for Changing Bags. Changing

Place the loaded reel on the stem, but don't put it in the tank until all the reels are loaded.

Repeat with the other rolls. When all loaded reels are on the stem, put them in the tank and close its light-tight lid.

Set Up Your Chemicals. Unzip the changing bag and take out the tank. Prepare your chemicals (developer, stop bath, fixer and hypo neutralizer), setting out the right amount of each at the right temperature (preferably 68°F).

Pour-in, Pour-out Film Processing. For tank development in a lighted room, the processing chemicals must be poured in and out of the developing tank without removing its light-tight lid. The small pouring opening in the center of the lid is used. I suggest using Kodak D-76 diluted 1:1 (one part stock developer mixed with one part water). This stretches the development time and mini-

bags are good to have along even when you don't need to develop film. For instance, if the film jams in the camera, you can cut your losses by unloading it in the changing bag.

The changing bag got its name because it was used to load and unload plate and sheet-film holders; it remains a regular life-saver for view-camera photographers.

How Resourceful Can You Get? Much can be done even without a changing bag. In the late 1930s, Edward Weston turned his Ford, Heimie, into a darkroom by covering the top of the car and its windows with blankets while he changed 8 × 10-inch sheet film, unloading exposed film from holders and putting fresh film in. This worked in the glare and heat of Death Valley, so it should work anywhere. For this routine, determination is as necessary as the blankets.

Resourceful photographers have used coats, blankets and other unlikely items as desperation darkrooms. Alfred Stieglitz claimed that over a long period he did all his developing and printing under a table, with a long tablecloth that reached the floor to keep the light out. I don't recommend that one.

Curtains can be used over doors and windows if rooms are too bright at night without them. Folding screens can serve the same purpose. (Total darkness is not absolutely necessary.)

Non-tray Trays. If you have no trays, but have some sheet plastic (soft, not stiff), you can improvise trays by draping the plastic over pieces of wood. They are easy to fill and use, but hard to empty without disaster: bail until they're almost empty, then lift the corners carefully so no liquid spills. This is probably the cheapest way to make giant trays for photomurals.

Extension Cords and Such. Electricity can be brought in by extension cord, or if three-prong appliances must be used with two-hole outlets, this can be done using cube taps with three holes and a grounding wire. Strips of outlets with 3-hole taps every few inches can also be plugged in anywhere. For two-prong appliances, you can get continuous two-groove strips that will take them at any point. With all electrical outlets and extensions, be careful to place them in dry locations and do not overload them. (If you have a 15-ampere line, it's intelligent to limit the total wattage of everything that uses its current to 1,000 watts or less, even if all the appliances will never be turned on at the same time.) Ground all equipment that is provided with a three-prong plug: it is there for a reason.

Space Expanders. If you must increase your table space, wet or dry, don't forget card tables and wheeled tables that can be folded or rolled away.

One-by-twelve-inch shelving, cheap lumber, can be nailed together quickly to make neat, sturdy shelves.

PART TWO

BASIC
PROCEDURES

5

Developing Film

WHAT YOU NEED

1. Exposed film to develop.

2. A dark room.

3. Beer-can opener (to open factory-loaded Kodak 35mm cartridges).

4. An invertible stainless-steel or plastic developing tank, preferably of the Nikor-Kindermann-Brooks type or the Paterson type. Brand names are secondary.

5. Developing reels to fit your film and tank (or developing "aprons" such as Kodak's).

6. D-76 developer, 1-gallon bottle (glass bottles are better than plastic ones for storing developers).

7. D-76R replenisher, four 1-quart bottles.

8. Acetic acid, 28 percent, 1-quart bottle.

9. Kodak Rapid Fixer (with hardener), 1-gallon bottle.

10. Photographic thermometer (a dial type such as the Weston thermometer is good).

11. Interval timer.

12. Funnel (preferably a two-piece one that will hold a coffee filter: if so, add a supply of 3-inch coffee filters without a hole in the middle).

13. Two 2-quart graduates (or open-topped plastic juice containers large enough to hold a tankful of film reels and enough liquid to cover them).

14. One 8-ounce graduate.

15. A clean viscose sponge to wipe water off film after washing: two sponges are better.

16. A plastic or glass refrigerator container to keep the sponges in.

17. A line or rack at least six feet above the floor, in a dust-free place in or near the darkroom, for film drying.

18. Hypo neutralizer such as Perma Wash or Kodak Hypo Clearing Agent, 1-gallon bottle of working solution.

19. Running water at 65° to 70° F., or several buckets of clean water at the same temperature.

20. The day before developing: hot water to mix developer and replenisher.

21. A clean plastic, enamel or stainless-steel bucket for mixing chemicals.

22. A plastic stirring rod for mixing chemicals.

23. A dry working space to load film onto reels, etc.: a table, a shelf or, in a pinch, a very clean floor.

24. A wet working area: a table or, better, a sink for preparing chemicals and for processing.

25. Plenty of clean towels, cloth or paper or both, placed where you can find them instantly in the dark.

26. Scissors.

27. Glassine sleeves for negatives.

28. When ready to develop, with all chemicals pre-mixed and at room temperature: at least one hour of uninterrupted time.

29. Courage.

30. Patience—the most valuable skill a photographer can learn.

If you have three 8 × 10-inch processing trays to put under your developing tank and the two graduates (one with stop bath, the other with fixer), they make the work cleaner and easier. But they are not essential.

There is no logical order to this list of items: you need all these things at the same time. Don't try to develop film before you have them all.

Why I Don't Develop by Inspection. The approach I am giving you is called *time-and-temperature* development. I recommend it in preference to development by inspection because it offers better control and is much easier to do well. Anyone can read a clock and a thermometer, but very few people can judge the quality of faint, half-developed negative images on milkily opaque film, looked at in a hurry under an extremely dim

green light. That skill exists, but it is rare. Most people who have it spent years in the dark acquiring it—and some of them admit that it's as much a matter of having the right hunches as of really seeing what's on the film.

Therefore we develop the easy and controllable way, by time and temperature.

Mix in Advance. If you can, mix your chemicals at least one day before you use them. Then they will be at room temperature and the work will be simpler. They will stay fresh enough to use for up to two months in tightly closed glass bottles, or up to one month in plastic bottles. Avoid aluminum bottle caps,

The basic tools of film development: a stainless-steel developing tank with four wire reels and their stem, an interval timer and a photographic thermometer. Film has been loaded onto one reel. (Steel tanks and reels cost more to buy than plastic ones, but last forever; for example, this one is 26 years old.)

which are not compatible with some photographic chemicals.

WHY I USE THREE TANKS

My three-tank development method requires putting the film into the developer, the stop bath and the fixer in darkness, and is sometimes considered difficult, especially since developing tanks are designed so that processing solutions can safely be poured in and out of them in room light.

Pour-in Development. Pouring the developer in and out of the tank, then pouring stop bath or water in and out, then fixer, is the method used by most amateur photographers. It is a good method if you have no trouble with air bubbles and if your development time is long enough so a 30-second discrepancy in development will not change the contrast seriously. With an 8-minute development, it should cause no problem. With a 3-minute or 5-minute development, you will definitely be better off using the three-tank method.

Pour-in Timing. To time pour-in development, start the timer when you start to pour developer into the tank. Then start pouring it out just when the clock rings. This will give you consistent timing.

Pour-in Disadvantages. The two disadvantages of pour-in development are its inaccurate timing, which can't be anything but vague; and the tendency of developer to foam when poured rapidly over reels, depositing air bubbles on the film. These must be shaken off by banging the tank against the sink or table, or they are bad trouble: where there's air, there is no developer.

Three-tank Advantages. I use three-tank development because the timing is accurate to within a second or two when you dunk the film right into the developer, and because the dunk method produces far fewer air-bubble problems. (In fact, I have never had this trouble, which I met for the first time only after I started teaching photography and saw the Swiss-cheese density patterns in negatives that students brought in. Invariably, they were pour-in practitioners. Changing to three-tank development solved their problem.)

PRACTICAL START: THREE-TANK FILM DEVELOPMENT, STEP BY STEP

Dry Runs. If you have never developed film before, carry out all of the following procedures with dry tanks and dummy films— practice rolls, without pictures. "Wasting" this film will save the rolls you care about, so it is not really wasted. Carry out the whole process in two types of dry runs before you actually develop any film: first do it all in full room light; then, when you're familiar with each step, do it all again in the dark.

1. In the dry work area, set out the *rolls of film* you want to develop (or dummy rolls), *scissors, beer-can opener* if you are using factory-loaded Kodak film, the *reels* (or Kodak developing aprons) and the *stem* that holds the reels.

Put film, scissors and can opener at the left, the reels in a row to their right, and the stem to the right of the reels. Face all reels the same way so the film can be loaded on all of them with the same movements.

2. In the wet area, set out the tanks and

Exposed film set out ready to load on reels for development. (I number my cartridges so I can easily keep track of my shooting.) As each reel is loaded, it is placed on the stem in the dark. When the stem is full, it's ready to put in the developer.

Setup for 3-tank development. Left to right, developer in steel tank (thermometer says 68°F), fresh stop bath in middle graduate, fixer in right-hand graduate. Remember to put the tank lid where you can find it instantly in total darkness: beside the tank.

Next, set the timer according to the temperature of the developer. Don't forget to take the thermometer out of the tank before you turn off the light and load the film onto the reels.

chemicals: at the left, the *developing tank* filled with undiluted Kodak *D-76 developer.* The tank stands in a small dry tray with the tank lid beside it where you can find it instantly in the dark. Before you continue, *take the developer's temperature.* If it is between 65° and 75° F., use it as is. If it's below 65° or above 75° F., warm or cool it to within that range, preferably to 68° F.

The *stop bath* is next, in a two-quart graduate (or a juice container) standing in a tray to the right of the developer and about a foot away from it. To make stop bath, add three fluid ounces of *28-percent acetic acid* to two quarts of water and stir it in well. The stop bath should be at the same temperature as the developer.

To the right of the stop bath, also in a graduate standing in a tray, is *rapid fixer* at the same temperature.

A quart bottle of Kodak D-76R *replenisher,* a gallon of the working solution of a *hypo neutralizer* such as Heico *Perma Wash* or *Kodak Hypo Clearing Agent,* a funnel and a small graduate should be handy.

3. Before going further, *add the correct amount of replenisher* to the D-76 in the bottle (NOT to the tank): ½ ounce replenisher per 36-exposure roll developed.

(*Do not add any replenisher to a fresh bottle of developer for the first batch of film you develop with it.* Wait until the second tankful before starting to replenish each new gallon of developer.)

4. *Take the temperature of the developer* again (it may have changed) and *compute your development time* from the following time-temperature table. It was derived from Kodak's Customer Service Pamphlet AF-3,

Kodak Black-and-White Films for General Picture-Taking, dated December, 1973, and represents approximately their recommended development for 35mm Tri-X in undiluted D-76. This may not be the optimum development for any film, even Tri-X, but if you gave enough exposure it will give you printable negatives. (Later you will learn to adjust film development so it fits your needs accurately and gives you the quality you like best.) 68° F. is the recommended temperature, but this whole range will give good development.

65°F.	8	minutes	71°F.	5½ minutes	
66	7½	"	72	5¼	"
67	7	"	73	5	"
68	6½	"	74	4¾	"
69	6	"	75	4½	"
70	5¾	"	76	4¼	"

5. *Set the interval timer* to the right development time for the working temperature.

6. Check that everything is in place so you can find it in total darkness. *Wash and dry your hands.*

7. *Turn off all lights* and check to be sure the darkness is total (but not for the first dry runs).

8. In the dark, *open a cartridge, take out the film, cut or tear off its "leader" or "tongue"* and *load it onto a reel* (see below, p. 86). (With roll film, unroll the film and backing paper, separating them as you go, and discard the paper. If using aprons instead of reels, roll the film into the apron according to the manufacturer's instructions.) *Place*

the reel on the stem. Repeat until all films are on reels.

If you are developing less than a full tank-load of film—one, two or three rolls in a four-reel tank, for example—be sure to fill the stem with empty reels so the film reels cannot flop loose in the tank. Otherwise disaster will follow, in the form of uneven development.

Do I have to tell you not to load more reels than you can get into the tank?

9. When all films are on reels and all reels on the stem, carry them over to the developer.

10. Quickly but without haste, *put the film into the developer, close the tank tightly* and

11. *Immediately start the timer,*

12. *Turn on the light* and

13. Immediately *lift up the tank, invert it* and *rotate it* for a quarter-turn on its axis at the same time. *Repeat continuously for a period of ten seconds* (about four inversions and returns to upright, with rotation always in the same direction): then

14. BANG *the tank down onto its tray* hard enough to dislodge any air bubbles from the film.

15. After one minute of development, *repeat exactly* the lift, invert, rotate, BANG sequence—10 seconds, then BANG. This mad-bartender effect is *agitation,* essential for even and consistent development.

16. Watch the timer and *agitate for 10 seconds once each minute* during the whole development time.

17. When the timer shows that exactly one minute of developing time is left, *reset it to exactly five minutes.* This will time the fixing of the film.

18. When the reset timer reads four minutes 15 seconds (*15 seconds to go* for development), *turn off the light, take the lid off the developing tank* (remove the small central lid first or air pressure may hold the tank lid on too tightly for easy removal), *lift out the films* and *drain them* for a count of *15 seconds after lights out;* then

19. Quickly *immerse the films in the stop bath,* being sure not to get any stop bath in the developing tank; BANG films against the bottom of the stop-bath graduate, then lift and drain for 15 or 20 seconds; then

20. Quickly *immerse the films in the rapid fixer.* BANG them against the bottom of the graduate, then move them gently up and down and rotate them slightly every few seconds. Agitate this way continuously for a count of 60 seconds. (The count goes "one-thousand-one, one-thousand-two" and so on: some people prefer "one chimpanzee, two chimpanzee"—I once worked for a photographer who counted to eight in Hungarian as fast as he could for each second. Take your pick.)

21. *Turn on the light.* Continue to agitate the film (BANG, lift, turn) every few seconds for the rest of the fixing time. Meanwhile,

22. *Rinse your hands well,* then pour the used developer back into the D-76 bottle. (If it overflows a little, don't worry: that's because of the replenisher. Fill the bottle as far as you can.)

23. Run fresh water into the developer tank at the same temperature as the processing solutions. This should be a fairly rapid flow of water, but it does not have to run violently. Meanwhile, rinse the funnel.

24. When the timer rings, *lift the films from the fixer, drain them* and

25. *Put them into the rinse water* that is now flowing into the developer tank. Meanwhile,

26. *Pour out the stop bath.* (Mix fresh each time.)

27. *Funnel the rapid fixer back into its bottle* and rinse the funnel thoroughly.

28. *Rinse the film in running water* for a timed two minutes.

29. Then *pour out the rinse water and pour the hypo neutralizer into the tank. Agitate the film continuously for a timed two minutes* in Perma Wash or Kodak Hypo Clearing Agent. Meanwhile,

30. Wash out the stop-bath and fixer graduates.

31. After two minutes with agitation in hypo neutralizer, pour it back into its bottle and

32. *Wash the film* in rapidly running water at or near the processing temperature. Avoid sudden temperature changes. The wash must last for *at least 20 minutes*, according to chemical tests I have run. The water should be completely emptied from the tank and renewed at least five times during the wash: the more often, the better. Disregard claims that tempt you to wash the film less. Meanwhile,

33. Prepare your sponge by wetting it in clean water and squeezing it out as much as you can.

34. At the end of the full washing time, *remove the first roll from its reel*, set the reel on a clean surface to dry and *hang the film by one end from a clip.*

35. *Sponge all surface water drops off both sides of the film.* Hold the sponge against the film lightly—with just enough

Sponging water drops off freshly washed film (some print blotters were drying on the same rack when I shot this). I use two sponges, one pressed tenderly against each side of the film, so both sides are wiped at once. It's done with ceremonial slowness so the sponges will have time to soak up all of every drop. For unperforated roll film and sheet film, a smooth-edged automobile windshield wiper blade is much better and quicker than a sponge: one flick down each side of the film and you're done.

pressure so it touches the film all over—and move it s l o w l y down the film from top to bottom, first on the emulsion side (dull), then on the base side (shiny). The rate is not faster than about one second per frame as

you go down the roll of negatives. Repeat if necessary until *all* water drops are completely removed. Then *fasten a clip* to the bottom end of the roll to keep it from curling up as it dries.

Wiper blades for sheet and roll film. If you use unperforated roll film or sheet film, a new, smooth-edged automobile windshield wiper, used as a squeegee, is better and quicker than a sponge. One quick stroke down each side of the film removes all surface water. The wiper blade is not much good for 35mm film, unfortunately, because it can't get at the water in the perforations well enough to do more than smear it across the film.

Wetting agents for drying. Many photographers use a rinse of water with a wetting agent, such as Kodak Photo Flo, added to it according to directions, as a final treatment before hanging their film up to dry. This makes sponging unnecessary, since it destroys surface tension and allows *all* water to flow off the film, leaving no drops behind. It's an excellent idea.

There is one hitch. Once in a great while, impure water, defective wetting agent, or a mixture that is not sufficiently dilute can deposit innumerable tiny opaque specks on the film. These cannot be washed off after the negatives dry. After one such experience, I swore off wetting agents and went back to the sponge. Two full days of spotting (painting out white spots with dye) on one print was more than I wanted to spend, ever again.

Avoid forced drying. Do not use heat or a fan to dry your film. Either can cause reticulation—a sort of cracked-mud texture superimposed on the pictures—and blowers threaten the film with airborne dust.

36. Clean up the darkroom: wash tanks, containers, tools and surfaces and put things away. DO NOT SWEEP.

37. Tiptoe out of the darkroom without raising dust.

38. Wait at least an hour before you go back.

39. Examine the film. Feel its lower end to make sure it's completely dry. If it isn't, go away and wait some more.

40. When the film is completely dry, bring out one glassine sleeve for each roll and *cut the film into sleeve-length strips* (six frames of 35mm film, four frames of 2¼-inch-square roll-film negatives).

41. Mark each strip of negatives and each glassine sleeve to identify the negatives for your filing system. (If you don't have one, start one now.) India ink put on with a crow-quill drawing pen is good. The numbers on the edges of the negatives print in white-on-black on the contact proof print and key it positively to the negatives.

I number all my negatives with India ink as soon as I cut them down after drying. They are entered in a log at the same time, so I know when and how each batch has been developed—this information is sometimes useful.

Part of a hand-numbered roll (the factory-printed frame numbers on this roll are very faint). I also put the roll number on each strip of six negatives so it's unlikely to be filed with the wrong roll. Each number is inked in between two of the perforations in the film.

All the negatives of each roll go into a numbered and dated glassine sleeve (emulsion side facing the seamless side of the sleeve). Some photographers use a sleeve for each strip of six negatives—five or six sleeves for each roll. I see no need for this.

Where to Mark. There is plenty of room for identifying marks between the perforations on 35mm film and on the clear edges of roll film. Mark each strip to avoid future confusion. Keep all marks away from the pictures themselves—edges only—and *let the ink dry thoroughly* before you put the strips into their sleeve.

One Way to Number. My own negative-identification code starts with the year and goes on with a roll number and a frame

(1) Place reel on a table in the loading position, with the outer end of the spiral facing right at the "12 o'clock" position (if left handed, reverse all instructions, and hold drawings up to a mirror).

(2) Open a reloadable 35mm film cartridge. To open reloadable Kodak, GAF, Ilford and Agfa-Gevaert cartridges, hold the cartridge with the long end of the spool against the table and push down on the sides until the top end pops off. If necessary, bang the cartridge on the table. Open Kodak factory-loaded cartridges by prying off their lids with a beer-can opener.

(3) Tear or cut the film tongue off, but leave the roll on its spool. Then pick up the film in your right hand, long end of spool down and with the film facing left on the far side of the spool. Pick up the reel in your left hand, keeping it in the same position as on the table.

(4) Feel for the open side of the reel's core. The reel is in the loading position; on the Nikor reel that means the core is between "4 o'clock" and "5 o'clock" when the outer end of the reel faces right at "12 o'clock." While holding the film spool by its ends, pull out the end of the film, toward the reel.

(5) Press on the edges of the film to curve it so it will fit easily between the top and bottom of the reel. Guide the film end straight in toward the core of the reel, and push it into place in the core (or the clip) all the way in until it stops.

Film end is pushed into the reel core: the reel has not been turned yet.

(6) Rotate the reel counterclockwise (away from its open outer end). After one-half turn of the reel, the film begins to track in the spiral. As you turn the reel, hold the film-hand thumb and index finger lightly against the top and bottom spirals, both to hold the film in the proper curve and to guide it into the reel. If the film is fed into the reel core off-center, the film will pull strongly to one side and "bind" on the first or second turn of the reel; if this happens, unwind back to the beginning and start over. If the film edges are badly bent, it is easier to unwind the whole roll, remove the spool, and begin loading the reel again from the other end of the roll.

(7) After three turns of the reel, the film fills three inner turns of the spiral. Keep turning the reel counterclockwise until all the film is on the reel. Tear or cut the film off the spool.

How to load 35mm film onto wire reels (loading roll film is similar, except that the backing paper must first be removed from each roll: it's taped to one end of the film).

86 *Basic Procedures*

number: thus for 1972 my third roll is numbered "7203" on each strip; and the ninth shot on that roll is "7203-9." Some people also have subject codes: I shoot too miscellaneously for that—any roll might have anything from one to 20 or more subjects, since I shoot more by impulse than by plan.

HOW TO LOAD DEVELOPING REELS

Many people feel intimidated by the prospect of loading film onto a wire developing reel for the first time. Reel loading is difficult to describe, but easy to do: so easy that I have sometimes been unable to load a reel wrong when trying to show students how *not* to do it.

Here are step-by-step instructions. Begin by practicing either in total darkness, or with your hands, the reel and the film under a cloth where you can't see them. Use an expendable dummy roll of film. (If you begin by loading reels in the light, watching the process, you will have to learn it all over again in the dark.)

1. Place the reel on the table with its outer end away from you, in the "12 o'clock" position, with the opening facing to the right. (See drawing.)

2. Open the cartridge and take out the spool of film. (See drawing.)

Open Kodak factory-loaded cartridges by prying off their lids with a beer-can opener.

Reloadable Kodak, GAF, Ilford and Agfa-Gevaert cartridges are opened by holding the cartridge with the long end of the spool against the table and pushing down on the

sides of the cartridge until the top end pops off. If necessary, bang the cartridge on the table.

3. Tear off or cut off the narrow end or tongue of the film, but leave the roll on its spool. (See drawing.)

4. Pick up the film in your right hand, long end of spool down, and with the end of the film facing left on the far side of the spool.

5. Pick up the reel in your left hand, keeping it in the same position as on the table.

6. With the index finger of your left or reel hand, feel for the open side of the reel's core. On the Nikor reel, it is between "4 o'clock" and "5 o'clock" when the outer end of the reel faces right at "12 o'clock." (See drawing.)

7. While holding the film spool by its ends between the second joint of your right thumb and the inner joint of your right little finger, pull out the end of the film, toward the reel, with the thumb and index finger of your left (reel) hand, holding the reel between the base of the left thumb and the last two fingers.

8. Press on the edges of the film with the film-hand thumb and index finger, to curve it so it will fit easily between the top and bottom of the reel. (See drawing.)

9. Guide the film end straight in toward the core of the reel with the thumb and index finger of the reel hand. Push it into place in the core, all the way in until it stops, with the thumb and index finger of the film hand.

10. Rotate the reel counterclockwise (away from its open outer end) to wind the film into the spiral from the core outward.

Turning the reel draws the film in. As you turn the reel, hold the film-hand thumb and index finger lightly against the top and bottom spirals, both to hold the film in the proper curve and to guide it into the reel. (See drawing.)

11. Keep turning the reel counterclockwise until all the film is on the reel.

12. Tear or cut the film off the spool. That's all there is to it.

If the film is fed into the reel core off-center, it will signal this by pulling strongly to one side and "binding" on the first or second turn of the reel. If this happens, unwind back to the beginning and start over.

If the film edges are badly bent, it is easier to unwind the whole roll, remove the spool and begin loading the reel again from the other end of the roll. Be calm. If you are patient and persistent, you will get even the most stubborn roll onto the reel correctly.

If you're left-handed, it may be easier to turn the reels over before starting to load them, and do everything the other way around from this procedure.

When you have the first reel loaded, place it on the tank stem, but don't put it into the tank until all reels are loaded and on the stem. If you're developing less than a tankful of film, remember to put empty reels on the stem so the film won't slide around during agitation.

TROUBLE-SHOOTING FILM DEVELOPMENT

Many things can go wrong in film processing, though none should if you use the above procedures accurately. Here are some common symptoms of development errors and hints for their prevention (there are few cures).

Round or oval thin spots, in negatives, that print as small rounded dark spots, are usually caused by air bubbles that cling to the film during development. When developer is poured over the film into the tank, many bubbles form: that is why I recommend dunking the film into the developer instead (another reason is that dunking makes accurate timing much easier). To shake off air bubbles is the reason we bang the tank so earnestly at each agitation. If you get such spots, switch—if you haven't—from pouring to dunking, or *bang harder.*

Large, Irregular Clear or Milky Patches on the Film. The film was loaded onto the reel badly, so the back of one layer pressed against the face of the next. This prevented either the developer (clear blob), the fixer (milky blob) or, most often, both (milky blob) from working on that part of the film. No cure. Prevent this by loading reels accurately—not difficult, but it takes practice and care.

Mottled Tones in Negatives. Either there wasn't enough agitation in development, or the developer was contaminated or exhausted. Agitate on schedule, accurately and consistently; keep stop bath and fixer from splashing even a drop into the developer; replenish accurately and consistently; and *never* use weary developer. Discard a gallon of D-76 when one quart of replenisher has been added to it. It is still vigorous then; but the time to throw any solution out is *before* it shows any sign of exhaustion.

Extra Density at Edges of Film, with Streaks at Perforations. Cause: uneven development due to *overagitation.* No cure. Prevention: Don't work so hard. Agitate less.

Air-bubble trouble made the spots: underdevelopment caused the flat negative and print. Adequate density in shadows shows the negative had enough exposure.

The flying monster amoeba is where one layer of film stuck to the next during development and fixing. There are aliens among us when we misload our reels.

Basic Procedures

A disaster collection: greasy fingerprints, uneven development due to poor agitation, and a classical air bell are not all. The kidney-shaped UFO at the upper right was caused by a hypo-wet finger that touched the film before it was developed.

Uneven development due to poor agitation (perforation streaks) and half-filled developer tank (dense top, thin bottom) was compounded by not washing the film. That texture isn't snow, it's dried hypo crystals on the film.

Streaks across the perforated edge as well as the picture result from loading the camera in bright light and not shooting off any "blank frames": the negative is slightly lightstruck. Air bubbles and under-development are also here in force.

KODAK SAFETY FILM

Black negative with black edges is lightstruck: the camera back wasn't closed properly after loading.

Black negative with clear edges is overexposed, might also be overdeveloped: it isn't lightstruck.

Underexposure and incomplete fixing, not enough washing. Note that hypo crystals and uncleared emulsion on the film show more clearly in the print than in the negative.

Extra Edge Density, No Perforation Streaks: uneven development due to poor agitation. Some tanks cannot be inverted without spilling, so all agitation is in a horizontal plane, by moving the tank from side to side, by revolving it or by turning the film around inside it: all tend toward this problem. Solution: Get a tank you *can* invert, and agitate that way; or develop in the dark with the tank lid off, and *lift* the reels in the tank each time you agitate, as well as rotating them.

Milky or Cloudy Deposit on the Film. This is just uncleared emulsion that the fixer has failed to remove: incomplete fixing. Either the fixing time was too short, or there was not enough agitation in the fixer, or the fixer was exhausted. Cure (sometimes): Refix in fresh fixer, with proper agitation, then put the film through the hypo-clearing and wash procedures again. Prevention: Use fresh fixer and agitate methodically for the correct length of time. Change fixer each time you discard a gallon of developer.

Negatives Too Contrasty. Cause, overdevelopment: possibly from inaccurate temperature reading or timing (developer too warm or timed too long), or from overagitation. Over-replenishment could build up the "contrastiness" of a developer. Check your thermometer, be careful how you time your development, don't overagitate and don't over-replenish.

Negatives Too Thin and Low in Contrast. Underexposure is the most common cause, but underdevelopment could also cause it, or a combination of both. Could be caused by inaccurate temperature reading or development timing (developer too cold or time too short), by exhausted or contaminated developer or by insufficient agitation. Partial

cures: Increase apparent contrast by printing on high-contrast paper; as last resorts, make a new negative (a complicated job involving a film positive made from the first negative, and a second negative made from this "interpositive"—see page 232), or intensify the original weak negative chemically. Prevention: Expose enough in the first place: develop enough, using fresh developer and accurate agitation.

Round spots with dense edges that print as whitish rings: water drops that dried on the film. Usually incurable. Prevention: Sponge all drops off the film before any of them can dry.

WHAT AGITATION IS AND DOES

Agitation is the process of moving fresh solution into position to work on every part of the emulsion with equal strength. If the film just sat there during development and the developer didn't move in relation to it, the more exposed parts of the emulsion would quickly use up the chemicals in contact with them, and development in those areas would almost stop; this would cause low contrast. Some of the chemical byproducts of development are heavy and tend to sink toward the bottom of the tank during the development. Since they also affect density, they would cause streaks across the negative if there were no agitation. The developer's action is both weak and uneven when it is not renewed by redistribution, and that causes mottled tones all over the film.

What Agitation Does. Agitation works primarily by replacing tired developer with fresh, and by mixing tired with fresh so the

action of the developer stays relatively uniform; but its *movement* also adds some energy to the chemical reactions. Extra turbulence of liquid swirling through perforations and around the wire reel and the edges of the film accelerates development locally and causes extra density and contrast at the edges.

"Correct" agitation is not perfect and does not produce absolutely even development, but it avoids the obvious extremes—the mottle-and-streak of underagitation and the edge-density-and-streaks of overagitation.

Be Consistent. Agitation accelerates development, so it is just as necessary to agitate accurately and consistently as it is to watch time and temperature when you develop film. Otherwise you lose contrast control.

The Personal Factor. Agitation, unless done by machine, is personal. How you use your muscles has as much to do with the way your agitation affects the film as any standard procedure. There are many ways to agitate—all good when they work and bad when they don't. Experiment. Be careful, but not too careful.

Each Developer Has Its Own Needs. I learned years ago that I got more even development with D-76 when I moved the tank in an abrupt, slam-it-around way than when I carefully made every movement smooth. But some developers seem to want smooth movement when I use them—Acufine, for one. I have no idea why.

One Man's Dilemma. The recent experience of a student may help. Steve is a good craftsman, and kept getting better for three years. He had no problems with agitation, never thought about it and did fine.

Then he read some articles about agitation, decided he had been doing it wrong and began to agitate with great care. This got him into trouble at once. Every refinement he tried added new and worse problems. It took three weeks of worrying before we hit on the solution. What was it? "Forget about being ultra-careful, and do what you did before. Relax!" It worked beautifully and immediately.

REPLENISHMENT

Conventional developers consist of balanced amounts of several chemicals with different functions: one or more developing agents (metol or Phenidone and hydroquinone), an accelerator (sodium carbonate or a weaker alkali), a preservative (sodium sulfite), a restrainer (potassium bromide) and a solvent (water). Often there are other chemicals to help out.

When an exposed emulsion is developed, the developing agent and the accelerator are used up more rapidly than the other ingredients.

What a Replenisher Is. A replenisher is simply a variation on the developer formula, in which the manufacturer (or the photographer) has "gone heavy" on the developing agent and the accelerator, to restore to the developer approximately what has been used up.

Why It Doesn't Work Forever. It would continue to restore the balance and work permanently, except that chemicals from the emulsions developed are also added to the developer—notably silver bromide, which (like its cousin, potassium bromide) is a restrainer which "holds back" the development of less-exposed parts of the images; and, of course, the developer will slowly oxidize,

even if it is not used. One sign of an exhausted developer is a loss of shadow detail in the negatives, with no loss in more-exposed tones.

Replenishment doesn't maintain a developer forever. It is a convenient stopgap that lets us develop up to 60 rolls of film in a gallon of developer without changing the development time and with no noticeable change in quality.

SHOULD YOU REPLENISH OR NOT?

Replenishment works well with most standard film developers, as long as you don't overdo it.

When and How Much. If you develop five or more rolls of film per week, replenishment is probably a good idea. It can save you work. If you add 1/2 fluid ounce of D-76R replenisher per roll developed to a gallon of D-76, you can get consistently excellent quality for at least 60 rolls before it's time to mix fresh developer. (Kodak recommends using 1 ounce of D-76R per 36-exposure roll, but my experience suggests that this is too much.)

One caution: Do not replenish after the first tankful of film to go through a fresh bottle of developer. For obscure chemical reasons, developers seem to gain energy, rather than losing it, after the first use: so replenishment at that stage boosts it too much.

Over- and Under-replenishment. If you add too much replenisher, your negatives will get contrastier and harder to print as you go. Too little replenishment would do less harm, though you might eventually have to print on contrastier paper.

Over-used Developer. If you use replenished developer for too much film, silver bromide will build up and your pictures will lose shadow detail. You can easily avoid this by not adding more than one quart of replenisher to a gallon of developer. When you finish the quart of replenisher, it's time to throw out the developer and start a fresh gallon.

When Not to Replenish. If you develop less than five rolls of film a week, you may do better to use your developer as an unreplenished "one-shot," using fresh developer and discarding it with each use. Then your development will have the greatest possible consistency. For one-shot use, it's best to keep the developer in small, tightly closed glass bottles—enough for one tankful of film in each bottle. Each bottle stays as fresh as possible this way, with minimum oxidation. (A pint liquor bottle with a plastic screw-on cap is just right for one four-reel tankful of D-76 if you use the developer diluted one-to-one—one pint stock developer, one pint water.)

Economy. Film development is dirt cheap whether you replenish or not. It is better economy to spend the extra nickel or dime it takes to develop in fresh solutions than it would be to develop poorly for nothing. The cost comes in time and paper when you try to print poorly processed negatives.

FILING AND STORING NEGATIVES

Photographers traditionally work for years without a file, keeping untidy heaps of negatives in drawers, on tables, and under the bed. Then they start to despair because they can't find a picture without an all-day search, and

when they find it, it is stained, scratched and generally beat up. At that point, with great difficulty, they begin to file what is left. That is, they begin to put negatives and proof prints where they will be able to find them easily. That's all filing is.

When and How to File Negatives. The time to start is now. Mark each strip of each roll with a number, and keep them all in chronological and numerical order, and you will be able to find any negative quickly. It will be clean and in good condition, so printing will be easy, too.

Negative Storage. A simple negative file can be made using the 100-sheet 8×10-inch paper boxes that accumulate in the normal course of printing. One such box holds at least 200 rolls of negatives (stored on edge, not flat) and keeps them clean and relatively safe.

I store my negatives this way, with a white divider (cut from a clean, chemically pure photographic blotter) every 25 rolls. A roll number written on each divider tells me just what rolls are between them. The rolls, in numbered glassine sleeves, press lightly but firmly against each other and stay relatively flat (avoid undue pressure).

Negatives are kept by themselves. The contact prints that show what is on each roll are filed in the same numerical order in a shelf of looseleaf books. I can flip through all the proofs, book after book, without handling or endangering any negatives. Each roll of nega-

tives stays put at all times except when it is being printed.

The Contact-print File. In the next chapter you will start making contact prints, and can establish that half of your picture file. It will be a visual history of your life as a photographer. Treat it with respect: it will remember better than you are likely to.

My negatives live in old 8 × 10 photo-paper boxes, with numbered dividers to hold the film flat and to make each roll easy to find.

6

Contact Printing

WHY MAKE CONTACT PRINTS?

They Show You Your Pictures. Contact prints, often called proof sheets, are your best key to your work and your best guide to printing. Without them you would find it much harder to decide which pictures count. Photographers who believe they can "read" negatives are almost all mistaken: more important, a contact print is much easier to see, even if you can read negatives.

They Record Your Progress. Your proof file is a complete record of your black-and-white shooting, a visual diary. It's a good place to search your past and present for what they show about you as a changing person, as well as about the changing world you have been recording.

They're a Reference Source. I sometimes find myself looking up history in my proof sheets. The books that hold them are a reference work I can go to for facts the way I go to the library for other facts. They are useful beyond their function as a where-to-find-what guide.

WHAT YOU NEED FOR CONTACT PRINTING

Not every item here is indispensable, but all of them are useful. If you develop your own film, you already have some of them. Assemble them all before you start contact printing.

1. Negatives, numbered for filing.

2. A darkroom with wet and dry work areas.

3. Running water, preferably hot and cold, with a mixing faucet.

4. One or more safelights, with Kodak OC or DuPont S-55X filters.

5. A clock with a sweep second hand.

6. An interval timer.

7. An 8 × 10-inch or 11 × 14-inch printing frame (a sheet of plate glass is a poor substitute).

8. A 150-watt light to expose contact prints (I use my enlarger lamp, with lens and condenser removed). If you use a contact-printing paper such as Kodak Azo, use a bare bulb. If you use enlarging paper, use the enlarger as a light source, with condenser and stopped-down lens in place.

9. A white light for print inspection, above the fixer tray (wet area).

Parts of my proof-print file: contact-print books, magnifier, and "feedback suppressor."

10. A print-inspection board over the fixer tray.

11. A box of 8 × 10 or 8½ × 11 glossy No. 2 paper, double weight. I suggest Kodak Azo F2, a slow paper made for contact printing.

(Any good No. 2 enlarging paper can be used; but enlarging papers are up to 100 times as fast as Azo. The right exposure for one is wrong for the other.)

12. At least four trays, preferably the 11 × 14 size.

13. Four (or five) 1-gallon bottles, one for developer, two for fixer, one or two for hypo neutralizer.

14. Graduates to measure out water and chemicals: a 2-quart one and an 8-ounce one: extra ones are handy.

15. A plastic stirring rod for mixing chemicals.

16. A plastic bucket for mixing chemicals.

17. A photographic thermometer.

18. A funnel.

19. Print tongs (if you are allergic to developer. I prefer to use my hands).

20. Print developer: a 1-gallon can of Kodak Dektol, GAF Vividol or other normal-contrast print developer. Ilford Bromophen, which uses phenidone instead of metol, is nonallergenic. As a developer, when diluted 1:3, it behaves much like Dektol.

21. Stop bath: one quart of 28-percent acetic acid (dilute for use).

22. Fixer (or "hypo"—same thing): two 1-gallon bottles of Kodak Fixer or other acid hardening fixer. (Avoid rapid fixers for prints.)

23. Hypo neutralizer or washing aid (the terminology is not yet settled): one quart of Heico Perma Wash concentrate (dilute to make working solution), or one 5-gallon package of Kodak Hypo Clearing Agent (mix powder to make one gallon of stock solution, then dilute stock to make one gallon of working solution—KHCA requires two 1-gallon bottles). (Other "de-hypo" products also work well, according to tests.)

24. Clean towels: more than one, and plenty of paper towels.

25. A large waterproof wastebasket.

26. Print-washing setup. Minimum, a tray and a faucet; better, a tray and a tray siphon; best, a good print washer—costly, but worth its price in prints and labor saved.

Most print washers are poorly designed. Paterson makes fair ones: I prefer a type made by the East Street Gallery (P.O. Box 68, Grinnell, Iowa 50112).

27. A viscose sponge or a photographic squeegee.

28. Plenty of clean photographic blotters (I use about 200). *Avoid non-photographic blotters*, which often contain print-destroying chemicals, including hypo.

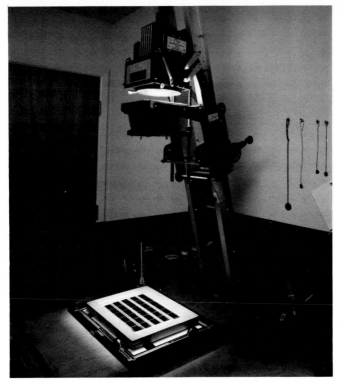

Exposing a contact print using the lamp in the enlarger (condenser and lens taken out to produce enough even light for slow contact-printing paper).

Blotter rolls are usable.

Blotter books are useless, in my opinion, unless taken apart (throw away the waxed paper and the spiral binding).

Drying racks made of stretched nylon or fiberglass window screen are a good and simple alternative.

Unless you photograph for a living, you don't need an electric dryer.

29. A line or rack for drying blotters. (I hang mine from a wire laundry rack, also used for film drying.)

30. Plenty of clips for the line or rack. Strong spring clothespins are good. (Plastic ones tend to fall apart.)

31. A simple filing system for contact proof prints, coordinated with your negative file so you can find any proof print and any negative quickly. I use looseleaf notebook binders to hold proof sheets in the order of their roll numbers.

SETTING UP THE DARKROOM FOR CONTACT PRINTING

Dry Area

Light for exposure. Most condenser enlargers have removable lenses and condensers, so you can use the bare enlarging bulb to expose contact prints, using any timer attached to the enlarger. If you have no enlarger, or can't remove the lens and condenser from the one you have, hang a 150-watt white light

bulb, with a switch, about three feet above the dry-area work table: this setup is for contact-printing paper only. If you use enlarging paper, use the enlarger as a light source, but with the condenser in place and with the lens stopped down (try f/11 for a start).

Room lighting. The dry-area work table should be well lighted, both by white light and, when it is turned off, by safelight.

Working order. From left to right on the table, place the file box in which you'll put the negatives after proofing; the pre-numbered negatives you want to contact-print; a box of printing paper; the enlarger timer or a clock with a sweep second hand (be sure you can read it by safelight); and, under the enlarger or the bulb, your printing frame. Put an empty printing-paper box near the frame. (There is no need to develop each proof print separately. Once you know the process, you can save them in the box after exposure and develop them together in batches.)

Wet Area

Safelight. The wet area needs a well-placed safelight. It must show the clock or interval timer clearly, and you must see the trays. You don't have to see all details of the prints by safelight as they develop, but the lighter the darkroom is, the better, short of fogging the paper.

Processing chemicals. Put four processing trays on the wet table or in the sink. Left to right: *developer* (Dektol or Vividol, diluted 1:2—one part developer, two parts water: Bromophen, diluted 1:3); *stop bath* (1½ fluid ounces of 28-percent acetic acid per quart of water); *fixer*; and a fourth tray filled with *water*. All are used at room temperature —preferably 65° F. to 80° F. (The thermometer is used for mixing chemicals according to

directions, and to check the temperature of the water during print washing. Otherwise, you don't need it in printing.)

Timer. Near the trays, within easy sight and reach, put the clock or interval timer. (A shelf over the sink is handy.)

Print-inspection setup. Above the hypo tray, place an inspection board and light. The board may as well be fastened there permanently. It should be chemically and visually neutral, and waterproof. The back of a clean tray or a flat sheet of plastic will do. Place it so it drains into the sink or the fixer tray.

Adjusting the Inspection Light. It should be directed obliquely from above or to one side to eliminate surface glare, should light the board evenly, and must not be too dim or too bright.

If the light is too strong, you will misjudge and print too dark: if it's too dim, you'll print too pale.

For a preliminary adjustment of the inspection light, find an unmounted print that looks good to you. Soak it in water for ten minutes; meanwhile spend the time in the darkroom by safelight so your eyes will be in the same condition as when you are printing. After the ten minutes, put the print up on the inspection board, turn on the inspection light and adjust it until you see the print at its best. It should look really good, showing all light and dark details clearly.

Why Wet the Print? Prints darken and tend to lose some contrast when they dry. When you examine a new, wet print, you want to see it as nearly as possible the way it will look when dry. Otherwise you are in for some unpleasant surprises. Keep your inspection light in good adjustment.

Water Supply. Water can be brought from across the darkroom, but it's better to have a

faucet near the trays. It should not splash into them. Short hoses on the faucets help.

Clean towels are necessary, and plenty of paper towels in addition are a help. Printing is wet work. Your hands will be soaked in alkaline developer and mildly acid fixer as well as water in the wet half of the work, but all these liquids must be kept strictly away from the dry area, the negatives and the undeveloped paper. Your hands must be clean and dry whenever you touch dry film or paper.

PRACTICAL START: CONTACT PRINTING, STEP BY STEP

1. Set up the dry area: negative file, negatives for proofing, printing paper, timer or clock for exposing, printing frame, enlarger or bulb ready for use, empty paper box. The enlarger head or the bulb should be about three feet above the printing frame. Be sure that the glass in the frame is clean and dry.

2. Set up the wet area. Solutions are as follows:

Developer: Mix 16 fluid ounces of stock-solution developer with one quart of water (1½ quarts for Bromophen).

Stop bath: Add 6 fluid ounces of 28-percent acetic acid to one gallon of water.

Fixer: One gallon of acid hardening fixer in tray.

Water: Fill the fourth tray with clean water at room temperature.

3. Make sure that the timer or clock, towels and paper towels, and the wastebasket are handy.

4. Make sure your hands are clean and dry.

5. Turn on safelights and switch off wet-area white lights.

6. In white light in the dry area, open the printing frame: press down the springs on the back, turn them and lift out the hinged back. Lay the open frame on the table, face down.

7. Put the first roll of negatives into the frame for proofing. Lay each strip of film emulsion-side-up (dull-side-up) on the glass. The strips should lie side by side without overlapping.

(My 8 × 10 printing frame holds five six-frame strips of 35mm negatives comfortably. I therefore load 30-exposure rolls of bulk film for my photography in preference to factory-loaded 36-exposure rolls. Six strips fit without crowding onto 8½ × 11-inch paper, for which you'd need an 11 × 14 printing frame.

Fringe benefit: bulk film in 100-foot rolls costs less than half as much as the same film in factory-loaded cartridges.)

8. Turn off all white light.

9. By safelight, open the box of contact-printing paper, take out one sheet and *reclose the box*. Put the sheet of paper face-down (shiny-side-down) on the negatives. Put the paper straight down into the frame without moving the negatives.

10. Hold the paper down at one end of the frame and fit half of the hinged back into the other end, fastening it down with the spring. Then let go of the paper and close the frame completely, so the hinged back is locked on by both springs.

11. Put the frame face-up on the table, directly under the light you will use to expose the contact prints.

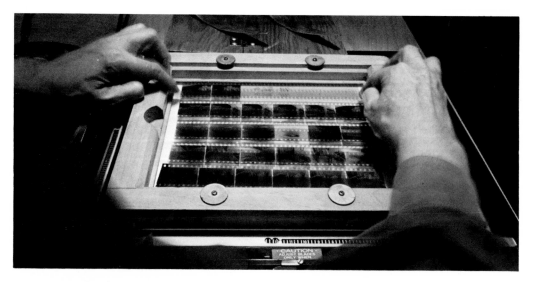

In white light, place the negatives on the glass inside the printing frame, emulsion side (dull, concave side) up.

12. Expose the contact print by switching the exposing light on for a timed interval, then off.

(For a trial exposure using Kodak Azo F2 paper and negatives of normal density, three feet from a 150-watt bulb, try 15 seconds.

If you are using enlarging paper, use the enlarger head at three feet above the frame, with condenser in place and lens stopped down to f/11. Try a 15-second trial exposure.)

13. By safelight, take the paper out of the printing frame, but leave the negatives there (this is a trial exposure: you may have to try again).

14. By safelight, develop the first contact print. The developing time is two minutes.

Putting the paper in the tray. There is a knack to getting the paper into the tray quickly so development will start evenly. Tilt the tray by lifting one edge so the developer is mostly at the other side of the tray. Slide the paper into the deep side, edge-first and face-up, and lay the tray flat as you do so. Then the developer rolls instantly across the paper like a small tidal wave.

Develop the print face-up. Do not put the paper into the developer face-down: trapped air under it could cause uneven development.

Rock the tray gently for constant agitation during the whole development time.

Keep it down. If corners of the print stick up out of the developer, poke them down.

Develop for the full time. Do not pull the print out of the developer before time, no matter how dark it looks. Give it the full time.

15. For an accurate two-minute development, the time to lift the print from the developer is after one minute and fifty seconds

of development. *Drain it for ten seconds* before putting it in the stop bath. Draining time counts as developing time.

16. Slide the print into the stop bath, rock the tray once or twice, then lift and drain as before. A few seconds in the stop bath are enough.

17. Set the interval timer for four minutes.

18. Slide the print into the fixer, start the timer and agitate by tray-rocking for two full minutes before turning on a white light. (If the light goes on earlier, you risk eventual stains in your print.)

19. After two minutes of fixing with constant agitation, lift and drain the print, rinse it briefly, and put it on the inspection board.

20. Rinse your hands well, dry them and turn on the inspection light. Examine the print quickly but attentively to see if it's too light, too dark, or well exposed. A good contact print should show all tones in the negatives clearly.

21. After a quick inspection, return the print to the fixer and agitate continuously.

22. At the end of four minutes' fixing, lift and drain the print and put it in the water tray.

23. Wash and dry your hands and turn off all wet-area white light.

24a. If the first print was exposed well—not too light in highlights or too dark in shadows—take the first negatives out of the

By safelight only, put a sheet of contact printing paper, emulsion side (shiny side) down, on the negatives in the frame.

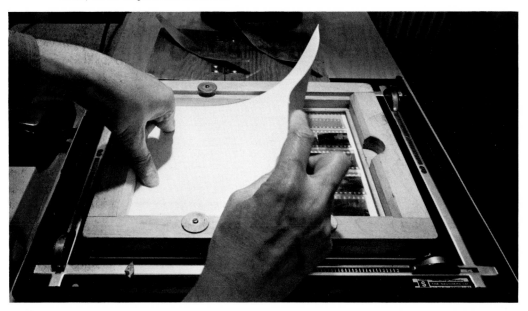

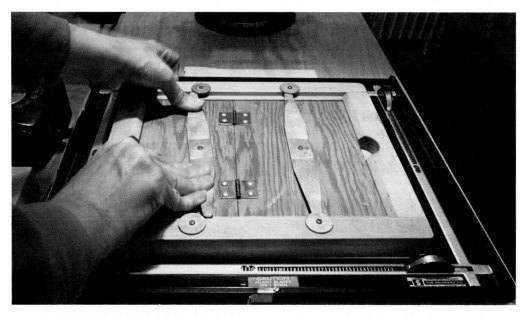

By safelight, place the hinged back of the frame on the paper and lock it shut. The springs press the paper and the negatives together against the glass so the contact print will be sharp.

Expose the contact print to white light. In this case, the enlarging lamp is the source: the white room light is left off so the exposure can be controlled accurately.

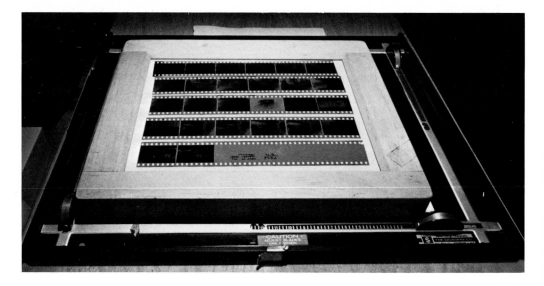

printing frame, put them in their sleeve and file them in your negative box.

24b. If the first print is too dark at 15 seconds' exposure, expose a new contact print of the same negatives for 7½ seconds, then develop and fix it like the first print.

24c. If the 15-second first print is too light, try a new print at 30 seconds' exposure and develop it.

24d. If the second try is still off, continue to correct exposure (more exposure to get a darker print, less for a lighter one) until you get a good contact print of the first roll of negatives.

25. After putting away the first roll of negatives, contact-print the remaining rolls. If the negatives are consistent, give each roll the same exposure you gave the first good contact print.

Time saver. Instead of developing each sheet separately, put each sheet of paper in the empty box after exposing it, to protect it from white light when you set up and expose the others.

When all sheets have been exposed and are in the box, you're ready to develop them.

26. The exposed sheets can now be developed in pairs (if this is all new to you), or in batches of five to 10 at a time after you have gained some experience.

Agitation by rotation. Agitation, when processing more than one print at a time, is not done by tray-rocking, but by *rotation.*

Putting the prints in. First put one sheet into the developer, then the next and the next, until all sheets are in. Be sure that each sheet is immersed completely before you add the next one. Do this reasonably quickly, but

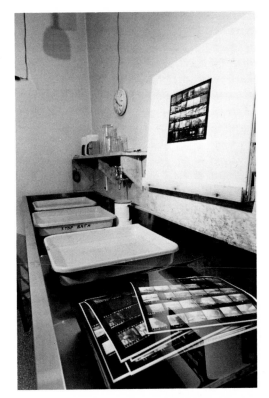

The wet setup for contact printing (and for enlarging): from top to bottom, developer, stop bath, first fixer and water-filled holding tray. A contact print is up on the inspection board.

without hurrying. Regular timing is more important than speed.

Pull and flip. As soon as the last sheet is in, pull the first (bottom) sheet out from under and put it face-down on top of the stack of prints. Immediately follow it with the next sheet from the bottom and continue until the whole pile is face-down.

Keep it going. At once pull them through again, one by one in the same order, to make a face-up pile: continue to flip through the

prints this way, carefully and regularly, until the end of the development time.

Use the same technique in the stop bath (one flip through is enough) and in the four-minute first fixer. The prints should come out of each processing solution in the same order as they went into it. Then processing time in each tray will be the same for all prints.

27. Each time you add freshly fixed prints to the water tray, change the water to prevent a buildup of hypo that could bleach the prints.

28. When all prints have been through the first fixer and are in the water tray, discard the used developer and stop bath and rinse their trays. Leave them to drain.

Pour the first fixer back into its bottle: mark this bottle "Hypo 1." (Felt-tip marker on masking tape is legible and easy to remove.) Rinse the fixer tray.

From here on, everything is done in white light. Turn off the safelights.

29. Mark the second bottle of fixer "Hypo 2," and pour it into the fixer tray.

30. Set the processing timer for four minutes.

31. Lift and drain the prints from the water tray, put them into the second fixer, start the timer and agitate continuously by rotation for four minutes' fixing.

32. Lift and drain the prints from the second fixer and put them in fresh water.

33. Pour the second fixer back into the "Hypo 2" bottle, and rinse the tray. Leave it draining.

34. Note how many 8 × 10 prints have gone through the second fixer, and write the number down. I keep this record on a strip of masking tape on the bottle. (After 100

8 × 10s, or the same area of paper in other print sizes, it will be time to change to a fresh second hypo. The former "Hypo 2" now becomes the first fixer for the next 100 8 × 10 prints, and the former "Hypo 1" is discarded.)

35. Give the prints a timed five-minute rinse in running water at 65° F. to 80° F. (80° is better), with constant agitation by rotation.

36. Washing-aid treatment: use Kodak Hypo Clearing Agent for three minutes or Heico Perma Wash for five minutes, with constant agitation by rotation. (Other washing aids can be used: just follow the directions on the package.)

Pour the used washing-aid solution back into its bottle for further use, and write down the number of prints treated.

KHCA useful life is given as 80 to 200 8 × 10 prints per gallon of working solution. Perma Wash capacity is given as 35 to 50 8 × 10 prints per gallon of working solution. For safety, always use the lower figure. Washing aids are cheaper than prints.

37. Wash the prints for a minimum of 40 minutes at 80° F. in rapidly flowing water. A longer wash is preferable. "Hard" water washes prints more rapidly than "soft" water.

Tray washing: Agitate prints by at least one complete rotation each five minutes. Change water completely at least once every five minutes.

Print washer: In a washer which keeps each print separate, maintain a sufficient flow to change water at least once every five minutes. Make sure prints are completely immersed, and maintain the 80° F. temperature.

The 80° temperature is given because it has proved to be the most efficient wash-

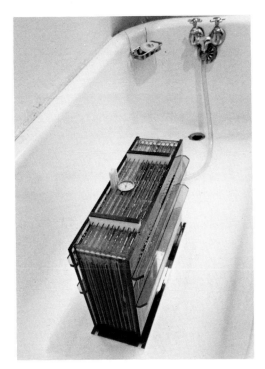

Thorough print washing is absolutely vital but absolutely dull: you might as well do it the easy way—use a well-designed print washer. The East Street Gallery Archival Print Washer is one of the most efficient ones now made. (Mine is an early model: current ones have water inlets at both ends for a better flow-and-aeration pattern.)

ing temperature: washing takes longer at lower temperatures, but is not shortened by higher temperatures. If you must wash at 70° F., wash for at least an hour. At 65° F., wash for two hours.

38. During the wash, clean the darkroom and put it in order for the next time.

39. Dry the prints. Lift them out of the washer into a clean tray, or pour the water out of the washing tray, and let them drain with the tray standing on end.

Blotter drying. Sponge off or squeegee off all surface, water drops from each print in turn, and put them between blotters in the following order:

First blotters. Put down one blotter on a clean, chemically inert surface; then one print, one blotter on top of it, one print, one blotter, and so on until all prints are between blotters.

Second blotters. Immediately turn the stack of first blotters and prints over, being careful not to spill prints out.

Change the prints at once to a second set of blotters. This time, put down three blotters, one print, three blotters, one print, three blotters, and so on until all prints are between blotters. Normally, they can be left in the second set of blotters for an hour or two.

The first blotters should be hung up to dry meanwhile.

Third blotters. Transfer the prints from the second stack of blotters to a third, again using three blotters under and over each print. The third blotters can be left under a weight (the blotter box you keep them in) until the prints are completely dry. No process produces flatter unmounted prints.

Do not leave prints in first blotters longer than a few minutes. (On moving to the Southwest, where the wash water is "hard" and alkaline, I find that the emulsion of a wet print is physically softer, so I must change blotters more often than I've suggested here, or some prints stick to the blotters.)

Drying rack. It's less work to use a fiberglass-screen rack for print drying, but the prints will be less flat. The procedure:

Sponge or squeegee each print as for blotting, then lay it face-down on the screen until dry.

Double-weight paper dried this way tends

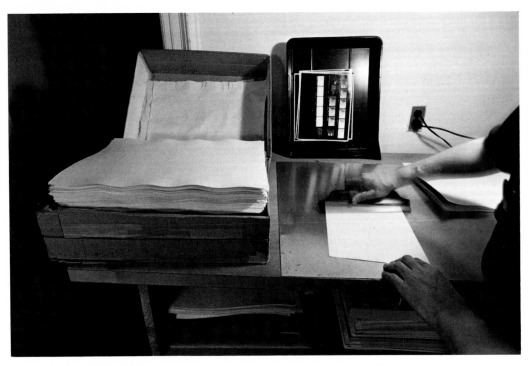

Freshly-washed contact prints being squeegeed and put into "first blotters."

to stand up on its corners: single-weight paper curls into tight little tubes. Therefore, use double-weight paper.

A good drying rack is available from the East Street Gallery, Box 68, Grinnell, Iowa 50112.

Heat drying. I do not care much for heat dryers. Most of them are chemically contaminated by careless photographers. If you need one, let *no* print that has not been carefully fixed in fresh fixer and thoroughly washed *ever* touch the dryer. In other words, don't let even good friends use it.

Although it works faster, a heat dryer re-quires no less work than blotters. For the most even drying, it must be used at low heat, so the prints must be fed through it repeatedly.

Many heat dryers damage prints physically as well as chemically.

Good ones, however, exist, in spite of everything.

40. When the contact prints are dry, punch them at the left edge to fit into a three-hole looseleaf binder, and put them in the book in the order of their roll numbers (inked on the negatives, these numbers ap-

pear on the contact sheets in white). This book begins your picture file.

TROUBLE-SHOOTING: FAULTS IN CONTACT PRINTS AND WHAT TO DO ABOUT THEM

Good contact-printing is easy, and you shouldn't have many problems. Here are some that do come up.

The Contact Print Is Unsharp. This is caused by poor contact between the negatives and the paper, which should touch firmly all over. Causes include overlapping film edges; a non-flat surface under plate glass used as a printing-frame substitute; and the behavior of some too-clever contact-printing devices with separators between strips of film that also prevent the film from being pressed flat against the paper. (Not all contact-printers with dividers have this fault.)

Solutions: Use a printing frame that holds the negatives in firm contact. I recommend the old-fashioned spring-back type as simple, cheap and efficient. Don't let film edges overlap: that is, don't try to put more than five strips of negatives into the eight-inch width of the paper. Six strips can be crammed into an 8 × 10 frame at the expense of clarity in the proof, but this is self-defeating. (If you use an 11 × 14 printing frame and 8½ × 11-inch paper, you can get six strips on each proof print without difficulty.)

Mottled, Uneven Print Tones. These usually result from underdeveloping the proof in the effort to compensate for overexposing it. Other causes include developing the print face-down, and using exhausted developer or fixer.

Solutions: Don't try to keep badly over-exposed prints from getting too dark by "pulling" them from the developer too soon. Expose correctly for the tone you want and develop fully. Develop prints face-up (except for the face-down intervals in agitation by rotation) and for the full two minutes. Use fresh developer, stop bath and fixer in clean trays.

The Print Is Too Light. The cause is underexposure in printing. Solution: expose longer. If the developed paper is white, with no visible image, check to be sure you're not trying to develop in stop bath or fixer; developing an unexposed sheet of paper; or trying to expose Azo with the enlarging lens and condenser in place. (The right exposure for a contact print on enlarging paper will make little or no impression on Azo, which needs much more exposure. For Azo, always use a bare bulb.)

The Print Is Too Dark. The cause is overexposure in printing. Solution: Expose less. If the print is solid black or nearly, check to be sure you're not exposing enlarging paper under a bare bulb: it needs the condenser and lens in place to provide even light of low-enough intensity. Another possibility is that you left the paper out and accidentally exposed it to white light outside the printing frame before you developed it. Solution: Don't. Be sure you close the paper box each time you take a sheet out.

Some pictures on the proof sheet are printed well, but others are too dark or too light. The cause is inconsistent exposure when shooting.

The short-term solution is to make a "compensated" proof print, by giving less ex-

posure for thin negatives and more for dense ones.

How to Make a "Compensated" Proof Print. Cardboard rectangles—many of them —are cut to sizes that will cover one to six of the negatives in a strip. Some of these are placed on the glass of the printing frame during the contact-print exposure, to cut off the light from selected negatives for part of the exposure.

Cover all very thin negatives after half the normal exposure. Cover all normal-density negatives after the normal exposure. Leave very dense negatives uncovered and give them two to four times the normal contact-print exposure. Pray, and develop the proof print. You can get an excellent contact print this way, but it is inconvenient.

Use the long-term solution whenever you can: *Expose and develop your negatives consistently.*

Do not throw away the first proof sheet, which shows which negatives are thin and which are dense. Keep it. This information is often useful when you are enlarging, so put the "straight" contact print in the book together with the "compensated" one.

FILING CONTACT PRINTS

This is almost too easy. In time, you will accumulate a number of looseleaf proof-print books. Just keep them on a bookshelf in chronological order.

If you use more than one camera, a strict order can't always be maintained, so use a non-strict one. Twelve rolls may go through camera A while you shoot one in camera B. My own answer is to number and file contact-print films roughly in the order of film development. When I develop several rolls together, I try to give the one with the earliest shots the first roll number and the latest one —if I know which it is—the last number. Such films are close enough together in time so the contact-print file stays reasonably close to consecutive.

On a trip or a project, you may accumulate many exposed rolls, over a period of months, that are most conveniently developed by the tankful after you take them out of the luggage.

Keep Track As You Shoot. There are several interrelated ways to keep these films in reasonable order for easy filing. One: Record dates and places on each roll of film as you shoot (scrawl the data on a large note pad and photograph it). Two: Before starting, number each cartridge. As you finish each day's shooting, write down which rolls you shot that day, by cartridge number. Then related films can be developed, numbered and proofed together without any doubt about their order. Three: For big projects or major trips, give all rolls the same project number and distinguish among them by additional roll numbers: "7265 R22."

Number Every Strip. I am a fanatic, so I number each negative of such a project individually, starting with frame 1 and ending, sometimes, up in the thousands. That's a lot of negative numbering; but each number stands for a specific negative and no other. (I have done this ever since an art director called up and ordered "No. 27" from a job that had 10 or 20 negatives numbered 27.) In my files, therefore, are 61110-5497 and 6622-4405—both pictures that I really like. I

"Feedback" in part of a contact sheet: the pictures compete so fiercely that it's hard to see any one of them clearly—you can't help seeing all the others at the same time.

can bring out any such negative in a minute or two.

When each negative in a multi-roll project has a unique frame number, its roll number is just a filing aid that does not have to be included in most records. Project number plus frame number are positive identification. If you use the frame numbers imprinted on the rolls, the roll number becomes essential identification within the project: 7265 R22-15 is frame 15, roll 22, project 65 of 1972. Caution: Manufacturers' frame numbers are not always legible when the film is developed. Don't count on them too much.

Write Information on the Film. Besides numbering rolls and frames, I generally date my negatives by year and month, and note places and names, as needed, on a blank frame or on the edge of the film (there's a lot of room between the perforations on 35mm film). I seldom need these notes, but sometimes I'm glad they are there.

Mark Each Proof Book. To identify a proof-print book at a glance, mark its spine with the first and last roll numbers it contains: "7101-7150" holds proof sheets of all pictures from the first roll through the fiftieth roll shot in 1971.

Mark Each Negative Box. Negative boxes are marked the same way. Both negative boxes and proof-print books are kept in numerical order on shelves in the dry area of the darkroom, where they are handy when needed.

HOW TO LOOK AT CONTACT PRINTS

Mainly, look at them attentively. If you use 35mm film, a good magnifier helps. A low-power glass that shows you a whole picture at once is more useful than a high-power one that shows you only much-magnified fragments.

Scan First. First, though, look at the proof sheet in good light without a magnifier. Scan the sheet to see if a strong single picture or sequence emerges from it.

Then Examine Each Frame. Bring on the magnifier. Begin by examining the shots that interest you most, but don't neglect the others. Sometimes a quiet, sneaky picture that is drowned out by the visual aggression of the others is worth more than they are.

The Feedback Problem. To find such pictures, and to see any picture on a contact print well, you must eliminate the visual feedback from other pictures on the sheet. Looking at a 30-picture proof sheet is like trying to hear what 30 people are saying when they all talk at once.

A *feedback-suppressor* is easy to make. Cut a neat, accurate, negative-sized window in a 3 × 5-inch file card, and hold it against the proof sheet so it "frames" one picture at a time. This makes a surprising difference in the clarity with which you see each one.

Leave Your Proofs Intact. Do not damage your contact prints by marking them with ink or poking holes in them. This may indicate what you have in mind at the moment, but it cuts down the information the proof sheet can give you. A poor cropping decision marked on the contact print may interfere with the process of trying to make a better decision later. If you must mark proof sheets, use a china-marking pencil, most of which can be wiped off.

What Proof Prints Are Good for. Contact

Singling out one picture from the same proof sheet by using a "feedback suppressor."

Once located on the proof sheet, a numbered negative is easy to find.

prints lead toward enlargements in more ways than one. When you see a picture on the proof sheet that gets you interested, of course you will want to consider printing it. But how? What should the print be like?

The proof sheet often leads the way. A well-made contact print establishes a demanding technical and esthetic standard. Each frame has beautiful photographic quality that is not easy to equal in an enlargement.

When you make an enlargement that is not only bigger but also better than the same picture in a good contact print, you can feel lucky. When you do it intentionally, under control, you can feel proud.

7

Enlarging (One)

ABOUT ENLARGERS

Once you are set up for contact printing, you have most of the equipment you need to make larger prints—except the enlarger.

What an Enlarger Is. An enlarger is a turned-around camera that takes large pictures on paper of small pictures on film.

Light from the subject (your negative) is focused onto a sensitive emulsion (the printing paper). The result is a paper negative of the film negative, with the tones re-reversed to form a positive print.

TYPES OF ENLARGERS

The two main types are condenser enlargers and diffusion enlargers. The difference is in the light they produce. Most modern enlargers are of the condenser type.

Diffusion Enlargers. A diffusion enlarger uses relatively non-directional light from a large, "soft" source. Tungsten light is bounced off a large reflector, or "cold light" is emitted by a luminous surface just above the negative. Either way, the light is diffused before it reaches the negative. About the only direction it has is that it passes through the negative from one side to the other. It is a glow, not a beam of light.

Print Contrast: Diffusion. Diffusion enlargements have lower contrast than condenser-enlarger prints, partly because diffuse light produces more fog (most of the light is focused to form the print image, but some stray light spreads over the whole print). But the main reason for the lower contrast of diffuse-light prints is that the light comes through all parts of the negative—thin, dense and in between—with the same degree of diffusion, so that the image-forming light that strikes the paper is held back in direct proportion to the negative's various densities.

Condenser Enlargers use smaller light sources, and their light is collimated: a double condenser lens directs it toward the negative in a beam of relatively parallel, unmixed light rays.

Print Contrast: Condenser. The higher contrast of condenser-enlarger prints is due mainly to the Callier effect. Light passes directly through thin areas of the negative without being scattered more than very slightly, and the lens projects it onto the paper as a focused image in full, concen-

trated intensity. But the thick silver deposits in denser areas of the negative scatter much of the light that passes through them, and it emerges weakened and somewhat diffused. Light from dense negative areas therefore strikes the paper with less-than-proportionate intensity as compared to light from thin areas, so print highlights receive relatively less exposure, and contrast becomes higher than in a diffusion-enlarger print of the same negative on the same enlarging paper.

Diffusion: Pro and Con. The diffusion enlarger has the advantage of even contrast distribution in mid-tones and highlights, and dirt and scratches on the negative are minimized in the print by fog. The main disadvantage is that fine detail, like dirt and scratches, is also played down by fog and made less visible.

Condenser: Pro and Con. The condenser enlarger has the advantage of higher image contrast, except in highlights, and lower fog level. The prints tend to look sharper and have relatively lively tones. Another advantage is flexibility: many condenser enlargers convert easily to diffused-light printing, either by the insertion of a diffusing glass above the condenser, or by changing to a cold-light enlarger head. The condenser enlarger's shortcomings are relatively low highlight contrast and a tendency to show up dirt and negative defects prominently in the prints.

Condenser Variants.

Single-condenser enlargers print slightly "softer" than double-condenser ones.

The variable-condenser enlarger has a movable condenser element that adapts it to different negative sizes and lens focal lengths.

The point-source enlarger is a condenser enlarger carried to extremes. It uses a very small, intense light source. Well-focused prints have maximum sharpness, contrast is high and all negative defects and dirt are dramatized mercilessly. Grain is shown at its grainiest. Few photographers will gain more than they lose by printing with a point-source enlarger; but it makes ultra-sharp prints possible. Every factor is critical here: there is no tolerance for small errors. Point-source printing is neither for beginners nor for most old hands.

The enlarger, the projected image on the easel, and the path of light formed by the lens.

ENLARGING LENSES

Characteristics. Enlarging lenses are much like camera lenses, except for two qualities. In their design, emphasis is placed on a flat focal field, and on maximum efficiency at the close distances of enlarging, instead of the greater distances of shooting with cameras.

Camera Lenses for Enlarging. Photographers used to believe that the best lens for enlarging a picture was the camera lens that took it. The idea—not so crazy—was that when the light from a negative went backward through the lens that took it, the image would be unraveled with the greatest possible accuracy.

The trouble is that camera lenses are designed less for flatness of field and good close-up performance than for other qualities, such as high speed, that are more important in picture-taking than in enlarging. To make the camera virtues possible, the enlarging virtues are generally compromised. Good camera lenses are reasonably good for enlarging, but good enlarging lenses are better.

WHAT TO LOOK FOR IN AN ENLARGER

Enlargers are simpler than cameras, but not much less expensive. A good enlarger is one that helps you print well, and that, with careful use, will last as long as you last. A poor one is one that doesn't last, or that gives you unnecessary difficulties and problems.

Be a Long-term Miser. It is cheaper in the long run to start with the best enlarger you can get than to buy a less good one, no matter what it costs, that will have to be replaced when you need a better one. Here are some factors to consider.

Practical design. All controls should be within easy reach, accurate and positive in handling, and made of durable materials. The whole enlarger should be rigid, not shaky. The lamphouse should not overheat, should use standard bulbs that are easy to replace, and should be accessible for cleaning. Avoid unnecessary complications. (An autofocus enlarger is an asset to a commercial lab, for instance, but I'd rather do my own focusing. Once out of adjustment, the autofocus machine is automatically *out* of focus.)

Right size. It should make prints of the sizes you want from negatives of the sizes you use, and still fit in your darkroom and leave you room to work. The upright column must be long enough and the baseboard big enough for your largest print size.

Versatility. Leave yourself some options. It's good to have an enlarger that allows for interchangeable heads, lenses and condensers, for different negative sizes, and for filters that can be placed above the negative for color printing or variable-contrast paper. But if you only want to make 7 × 10-inch prints from 35mm negatives on graded papers, you don't need all that versatility, so why pay for it?

Good maintenance and repair service. Try not to need it. Repairs and adjustments for enlargers are available in large cities, but hard to find elsewhere. (The makers of the Simmon Omega publish a pamphlet on how to line up your own enlarger.)

Some manufacturers are more accessible than others, and some are more responsible. Ask around. If you know a professional

printer who does good work, he is likely to know what manufacturer or service organization is best to deal with in your area, and what enlarger holds up well in his experience.

Look for a simple, sturdy enlarger you can understand, and take good care of it.

WHAT YOU NEED FOR SIMPLE ENLARGING

1. Everything you need for contact printing, except the printing frame, the contact-printing paper and the bare bulb.

2. Negatives to print (use a magnifier to choose them from your contact prints).

3. An enlarger with a negative carrier to fit your negatives.

4. An enlarging easel.

5. A fine, soft brush for dusting negatives.

6. A paper cutter (scissors will do in a pinch).

The following items are not absolutely necessary, but they help:

1. An enlarging focusing magnifier.
2. Masking tape.
3. A black felt-tip marker.
4. A pad of scratch paper.
5. A notebook and a soft lead pencil.

ABOUT ENLARGING EQUIPMENT

Negative Carriers. Most enlargers come with a choice of negative carriers, in different formats and in two main types: glass carriers and glassless ones.

A *glass carrier* holds the negative flat between two layers of optical glass, a necessity with autofocus enlargers, to keep the negative in the exact plane for which the focusing mechanism is adjusted. The glass carrier has two disadvantages—"Newton rings" and dust.

Newton's rings (their formal name) are irregular, rainbow-colored squiggly blobs that print all too clearly as a sort of visual static. They are an optical effect produced by glass touching glass-smooth film with uneven pressure. "Anti-Newton-ring" glass is fine ground glass which tends to diffuse the image slightly and add its own texture to the picture. It is a moot point whether the solution is preferable to the problem.

With a glass carrier, six surfaces—both sides of the film and of each sheet of glass—must be meticulously cleaned, or dust will print as white spots and curly hairlines. While you clean one surface, dust tends to settle on the other five, so the cleaning process is tedious and exacting, and tends to offset the convenience and speed of the autofocus enlarger. This is one reason I prefer manual focusing.

Glassless carriers. With a glassless carrier, only the two sides of the negative need cleaning, but the carrier does not hold it absolutely flat. It occasionally pops out of focus when the film warms up during the print exposure. This can usually be solved by prewarming the negative. Turn on the enlarging bulb for about a minute before focusing and again before the print exposure. When the negative is already in its "warm position," it will stay there for the whole exposure time.

Is the "Window" Big Enough for the Picture? Both glass and glassless carriers are often manufactured with openings considerably smaller than the negatives they are designed for. This cuts off the edges of every picture, whether you need to print those edges or not. I can't account for this except by believing that enlarger designers are crazy.

Centering a negative in a glassless negative carrier. A second windowed steel plate fits over the negative, forming a film sandwich. The round pins on the bottom plate align the top one accurately. (This carrier has been filed out to make the hole larger, not smaller, than the negative. This lets me print the whole picture—not just part of it.)

File It "Up" to Size. A glassless carrier can be carefully filed down so the opening is slightly larger than your largest negatives (the ones made with wide-angle lenses). Be careful not to leave burrs of metal to mangle your negatives. Don't file the opening to exactly the negative size: it's hard to place a negative that accurately, and the edge will cause optical interference anyway. Don't file too large an opening, or your negatives, with less support, may pop out of focus too often and too far. It is about right, with a 35mm carrier, to stop filing when you can see the inner sides of the perforations at both edges of the film. Leave the same amount of space at the ends of the frame.

With a glass carrier, filing is impractical. Get a somewhat larger carrier (2¼ × 2¼ inches instead of 35mm, for instance) and mask it down carefully with black paper.

An Easel to Hold Your Paper. *Easels* come in many forms, from simple single-size ones (not bad to start with) to very elaborate, expensive ones. If you want to center your prints on the paper, leaving a wide white border all around, a good four-bladed easel is a great convenience. Otherwise, one with two adjustable blades will let you print to any size within its limits, but not in the center of an untrimmed sheet of paper. The easel should be accurately rectangular in its masking, should hold the paper as flat as possible, and must be easy to handle. It should not slide around on the enlarger baseboard. If it does, put a thin sponge-rubber mat under it.

Dusting the Negatives. The *soft, fine brush* for dusting negatives is a personal preference: it works for me. Some people blow dust off the film with an ear syringe or a compressed-air can, others use a large "anti-static" brush. Some even smear Vaseline on the negative, then wipe it, and the dust, off. This makes me shudder, but it does the job for some photographers.

A four-bladed enlarging easel. This luxurious item lets me center my picture on the photo paper. In this shot, a sheet of "focusing paper" (blank photographic paper) is being placed in the easel. A standard print size is marked on the paper to help me adjust the easel easily.

Saunders easel, closed. By pushing the half-round bumps, the four masking blades can be moved to any position from the edges (11 × 14-inch print) to just short of the center of the easel (2 × 2-inch print). Within these limits, print borders can be set for any size, shape, and position on the paper. The masking mechanism can be lifted out to make 14 × 17-inch prints.

Dusting a negative with a soft sable brush. The enlarging lamp and lens are used as a spotlight.

Surface Texture. Glossy or semi-glossy paper is suggested because a lustrous surface renders dark tones well. No. 2 paper is recommended because it fits the contrast of many good negatives, and because it is untemperamental: changes in print exposure produce predictable results.

A Few Good Papers. Some papers are better than others. From my own experience, I can recommend Kodak Medalist F2 (glossy) and J2 (semi-glossy), DuPont Velour Black TW2 (glossy), Agfa-Gevaert Brovira 111, No. 2, and Portriga-Rapid 111, No. 2 (both glossy), and Spiratone GL2 DW (glossy). All have been consistently good for several years. They are not the only good No. 2 high-luster papers, just the ones I know best. All except the warm-toned Portriga-Rapid are more or less neutral in print color. A newer No. 2 paper of excellent quality is Ilford Ilfobrom IB2-1K (glossy).

Why do I use so many "normal" papers? Partly because paper contrast grades are not standardized, so some No. 2 papers are contrastier than others; but more because each photographic paper has a unique character of its own. This can't be measured; but once you know a few papers well, you can pick the one that will feel most right for a given picture.

Work with One Paper at First. For now, get one kind of No. 2 paper and leave the others alone. When you know your first paper well, then you can begin to evaluate others. Until then, switching from one paper to another is more likely to confuse you than to help you.

Preliminary "coarse focusing" without a magnifier. Here, the image on the easel is very unsharp —far out of focus.

Focusing Aids. If your near vision is good, you may not need a *focusing magnifier*. Otherwise it is a necessity. Two useful types are the high-magnification grain focuser and the parallax-effect focuser.

To use either, turn the enlarger on and the room lights off. You focus the projected image of the negative on a dummy sheet of printing paper in the easel, with the enlarging lens wide open. First bring the enlarger to the height that gives you the print size you want,

After you bring the image on the easel to the size you want, and coarse-focus by eye, it's time to fine-focus with a magnifier. This Bausch and Lomb one (parallax type) has been photographed by enlarger light, so it looks the way you'd see it in the darkroom. Place the oblong light-intake window directly below the enlarging lens.

then rough-focus it by eye judgment. Then you are ready to focus critically with the magnifier, placed on the dummy paper directly under the lens.

With the grain magnifier, simply focus until the grain is as sharp as you can get it.

With the parallax device, the technique is to move your eye slowly from side to side as you look into its eyepiece, focusing the enlarger until the image no longer moves relative to the reference marks or letters on the viewscreen of the magnifier. This type of focuser works on the rangefinder principle. Your eye can deceive you if you look mainly for sharpness: the sharpest-looking grain in the screen does not necessarily represent the best focus. If you disregard apparent sharp-

ness and concentrate on the relative movement in the image—the parallax effect—your focusing will be critically accurate.

The dummy paper stands in for the thickness of your printing paper. You remove it and replace it with printing paper for the exposure.

Some low-powered focusing magnifiers are practically useless because the coarse texture of their viewing groundglasses makes image grain almost invisible, even when it's sharp.

Other Items.

The *paper cutter* is to cut test strips without wasting photographic paper.

The *masking tape* is to keep your paper box from springing open after you close it. The paper's curl acts like a strong spring pushing against the lid. A few inches of tape at the opened end of the box will hold it closed and save your paper from being destroyed by fog. Replace the tape often: it gets tired before the paper does.

The *felt-tip marker* lets you mark the paper box boldly so you can identify it by safelight as "GL2" or "VB2" and avoid using the wrong box. You can also use it to make safelight-legible working notes.

The *scratch paper* is for those notes. I use it, for instance, to keep track of negative and print numbers so I can mark the back of each print correctly before exposing it and avoid later confusion.

The *notebook* is for a *print log*. Once you have made a good print, it's useful to know what paper and paper developer you used, the negative number, and the print exposure and development time. Then if you want to repeat the print, or to make a definitely different one, you can look up what you did under the appropriate print number in your

log. This eliminates much preliminary fumbling and helps you stay aware of what you have done and are doing.

The *pencil* is for writing print and negative numbers lightly on the back of each sheet of paper before exposing it, and for your log notes. Notations should be kept down to essentials, or they take more time and labor than they save.

PRACTICAL START: SIMPLE ENLARGING, STEP BY STEP

1. Set up the dry area, with the following items: *negatives* to print; *contact prints* of them; *paper cutter*; 8 × 10 No. 2 glossy or semi-glossy *enlarging paper*; *enlarger*, with *negative carrier*; enlarging *easel*, with white *focusing paper* in place; fine sable negative-dusting *brush* (I use a No. 0 or smaller watercolor brush); *focusing magnifier*; felt-tip *marker* and *scratch pad*; soft, sharp *lead pencil* and *notebook*.

2. Set up the wet area as you did for contact printing. *Developer, stop bath, first fixer* and *water* in trays are needed in that order for the first part of print processing. Use an *interval timer* or a clock to time development and fixing.

The second part of print processing requires a *second fixer,* a running-water *rinse* and a *washing aid* such as Perma Wash or Kodak Hypo Clearing Agent. You will need the same washing and print-drying setup as for contact prints.

Have clean towels, a wastebasket and your inspection light and board ready for use.

3. Turn safelights on and wet-area white lights off.

4. By white light, in the dry area, look through your contact prints and find the picture you want to print first. Choose one that you really like: it's a waste of time to print anything else unless you are being paid well for your labor. (Exception: Sometimes you must print a picture to find out if you like it enough to print.)

5. With the felt-tip marker, write the negative number of the selected picture on the scratch pad. Write it bold and large so you can read it by safelight.

6. Bring out the strip of negatives that includes the chosen one, and center that negative carefully in the negative carrier. Do not slide the film in the closed carrier, or you will scratch your negatives. Open the carrier and lift the film out to adjust it. Handle negatives only by their edges; every touch does some damage.

7. Turn off all white room light and turn on the enlarger lamp. Use the beam of light just below the wide-open lens as a spotlight to show up any dust specks on the film.

With the sable brush, gently flick each dust speck off one side of the film; then turn the carrier over and dust the other side. Recheck the first side for new dust.

When both sides are clean, place the negative carrier in its stage under the enlarger head.

Caution: Do not scrub hard with the brush at stubborn dust specks, or you are likely to scratch the film. Dust is easier to spot out on the print than scratches. Quit while you're ahead.

8. By safelight, not white room light, and with the enlarger lamp turned on and its lens wide open, raise or lower the enlarger head

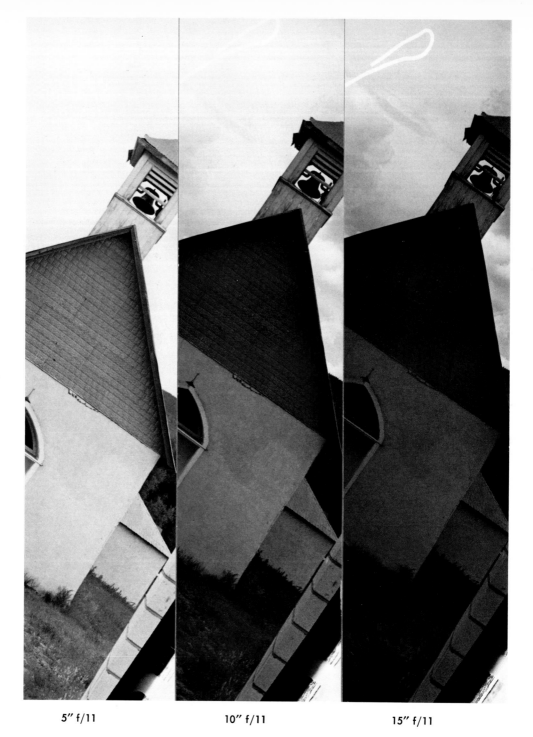

5" f/11 10" f/11 15" f/11

128 *Basic Procedures*

until the image it projects on the easel is about the size you intend to print (almost filling a 7 × 10 sheet of paper if you use 35mm film, or an 8 × 8 paper if you use 2¼-inch-square negatives).

Focus by eye judgment, then readjust image size and refocus until you have a sharp-looking image of the size you want. When you can see the grain, the picture is fairly well focused.

9. Check your focus with the focusing magnifier, and adjust until the focus is critically accurate.

10. Stop the enlarger lens down to f/11.

11. Adjust the blades of the easel to fit the projected image accurately. The print (for now) should include every bit of the negative, and nothing else. Let the margin meet the edge of the picture exactly. (We will take up cropping later.)

12. *By safelight only*, open the paper box, take out one sheet and cut it into ten 1 × 8-inch strips. Put these future test strips in the box on top of the paper, and close the box. (Once started, you will trim a test strip off each sheet you use for printing, so there is little waste.)

13. Examine the projected image on the easel and choose the position for your test strips.

Place these so each takes in all the important tones of the picture, or its lightest and darkest tones; or if one subject—a face, for example—is overwhelmingly important, the test strip should include that subject's main tones. Place a marker (the dust brush will do) next to the test-strip area as a guide. Turn off the enlarger.

14. By safelight only, take the first test strip from the box, then close the box.

With your soft pencil, write "#2, f/11, 15s" lightly on the back (the dull side) of the strip. When each of several strips is clearly marked with the paper grade and the exposure, you will not get them mixed up.

Place the strip on the easel in the chosen position, *emulsion-side-up* (shiny-side-up).

Expose it by turning the enlarger lamp on for exactly 15 seconds (the lens is already at f/11).

15. Develop the test strip for two minutes, with constant agitation. Drain it for the last 10 seconds of this time.

16. Put the strip in the stop bath, agitate briefly, then lift and drain.

17. Put the strip in the first fixer and agitate for 30 seconds.

18. Turn on the inspection light. Drain, then rinse the strip and put it up on the inspection board.

Practical test strips. Ilfobrom No. 2 glossy paper: 5 seconds at f/11 is too light; 10 seconds, slightly too dark; 15 seconds, much too dark—so the best exposure will be between 5 and 10 seconds. Each strip includes all important tones in the picture, from lightest to darkest; and they all show the same area, so they can be compared. Note the white "shadow" of a wire in the sky on the 10" and 15" strips. The wire is laid across the strip before the exposure: it shows when the "whites" begin to have some tone (not yet, for instance, in the 5" strip).

19. Examine and evaluate the strip. It is likely to be too light or too dark.

20. According to your evaluation, make two or three more test strips (which can be developed together to save time). Write the exposure on the back of each strip before you expose it.

- If the first strip (f/11, 15 seconds) *is just right*, make sure by making two more strips at f/11. Give one 10 seconds, so it will be lighter, and the other 20 seconds, so it will be darker. Seeing them may or may not change your mind.
- If the first strip looks slightly too pale, try two more f/11 strips. Give one 20 seconds, the other, 25.
- If the first strip looks slightly too dark, try two more f/11 strips, at 5 and at 10 seconds' exposure.
- If the first strip looks much too light, open the lens to f/8 and expose three new strips, for 10, 20 and 30 seconds.
- If the first strip looks much too dark, stop down to f/16 and expose three new strips for 5, 10 and 15 seconds.

21. Develop and evaluate the new test strips. Compare with the first one.

- If one seems exactly right, that is the exposure for your first print.
- If one strip is slightly too light and the next one is slightly too dark, expose the first print midway between them (7½ seconds for "between 5 and 10," for instance).
- If necessary, keep increasing or decreasing exposure, opening or stopping down

the lens, until you get satisfactory test strips.

The principle is: Make big changes in exposure first; then, when you have strips that are too dark and too light, you can zero in on the right exposure between them. Don't pussyfoot.

22. On the basis of your test strips, make your first print.

First, make a note in your logbook. Write down the date (5/24/74), the print number (1), the negative number (7415–6), the type of paper (GL2), the print size (7 × 10), the print exposure (15″ f/11), the print developer (Dektol 1:2), and the print development time (2′). Leave one column for remarks, to be added or left out later.

Check the enlarger f-stop to be sure it is set to the chosen aperture.

Turn off all white light, take a sheet of paper from the box, trim off a one-inch strip so the paper is 7 × 10, put the strip back in the box and close it.

Turn the paper face-down and write the negative number (7415–6) and the print number (p-1) *lightly* on the back in pencil. If you press hard, you ruin the print.

Open the easel, remove the focusing paper, put the printing paper carefully into place, shiny-side-up, and close the easel.

Expose the print by turning on the enlarger lamp for exactly the chosen time.

23. Develop the print, just as you developed your contact prints, for two minutes, draining the print for the last 10 seconds of this time. (Do *not* succumb to any temptation to "save" this print by pulling it out of the developer ahead of time, or leaving it in longer. It is really a 7 × 10-inch test strip. At this

How not to make test strips. The different exposures (5, 10, 15 and 20 seconds at f/11, bottom to top) are in areas so different in tone that they can't be compared. Each exposure zone gives you some information about its area, but tells nothing about any other area. A waste of time, effort and paper.

My best straight print got 8¾-seconds at f/11 on No. 2 Ilfobrom: a 10-second print was too dark, and a 7½-second one was too light, so I exposed in between. Two minutes development in Ilford's Bromophen—normal, same as test strips. (I think the sky at the left is anemic, so in a final print, I'd burn it in a bit—add some local exposure to that area. But I'd still leave the sky brighter at the left than at the right. Partly because it was brighter; partly because "monotony" is a word that means "all one tone.")

stage, you want *information*, not a masterpiece.)

Never try to judge print tones by safelight: that is a rare ability.

24. Put the print in the stop bath, agitate for a few seconds, then drain.

25. Set the timer for four minutes.

Put the print into the first fixer face up, start the timer and agitate constantly by rocking the tray. *Do not* turn on a white light until the prints have been in the fixer for two minutes.

26. After two minutes' fixing, turn on your white inspection light, drain the print for a few seconds, rinse it briefly and put it up on the inspection board.

27. Examine the print for not more than 30 seconds, then return it to the fixer and agitate constantly for the rest of the four minutes. Meanwhile, think.

Is this print satisfactory?

If so, you can now make more like it. (When you make only one good print of a picture, someone will step on it. This is a law of nature.)

If not, decide whether you want a lighter or a darker print.

28. After fixing, drain the print, put it in the water tray, throw out the accumulated test strips and change the water in the tray.

29. If necessary, make more trial prints until you get the quality you want, or until you learn that you cannot get it in a straight print on No. 2 paper.

Add any pertinent information to your print-log notes ("too contrasty for No. 2" or "too soft for No. 2" would suggest that No. 1 paper might be used for a contrasty negative, or No. 3 or No. 4 for a low-contrast one. It

follows, too, that future negatives might be given more development, to raise contrast; or less, to lower contrast).

Keeping methodical records from the start will help you understand what you have done. You can learn faster and avoid repeating mistakes.

30. Print the next negatives, using the same approach for each.

31. As you work, note how much working time you have left. It is seldom worthwhile to start printing when you have less than four hours to spend. Allow at least 1½ hours for the second half of print processing, from second fixing through putting prints in blotters or on racks to dry.

Know when to stop. If you let yourself be rushed during these processes, all your work may be wasted.

If you keep working after you become exhausted, your judgment and your printing will suffer, not to mention yourself.

32. All the remaining processes are exactly the same as in contact-printing. (For details, check the contact-printing instructions, pages 105–112.)

When all prints have been through the first fixer and are in the water tray, rearrange the wet area for the second stage of processing.

Throw out used developer and stop bath, and funnel the first fixer back into the "Hypo 1" bottle. Rinse the trays well.

Pour second fixer into the fixer tray, leave room under the faucet for the water tray, and pour the working solution of your washing aid into a third tray.

33. Give all prints together a timed four-minute second fixing, with constant agitation by rotation.

34. Give all prints together a timed five-

minute running-water rinse, preferably at 80° F., with constant agitation.

35. Treat all prints together in the working solution of your washing aid (Perma Wash, Kodak Hypo Clearing Agent or a similar product), giving the time specified for the solution used.

36. Wash the prints for at least 40 minutes at 80° F. (or one hour at 70° F. or two hours at 65° F.), with agitation of all prints and a complete change of water every five minutes.

Meanwhile, clean the darkroom and put everything away.

37. Dry the prints by the method of your choice.

8

Enlarging (Two)

WHICH PICTURES SHOULD YOU PRINT?

Print the ones you're sure are good, and the ones you think may be. In both classes, you'll get some surprises.

I must often print a picture in order to learn that it's no good. But sometimes other people like these no-good pictures. When others praise your failures, there is a temptation to think the pictures work, after all; but you are better off if you trust your own feeling. Your pictures represent your viewpoint, not theirs.

Many good photographers are poor judges of their own work—in my opinion. They would be mistaken to listen too carefully to me, as I would be wrong to trust their judgment more than mine.

It comes to this: the only judgment you have is your own. You're stuck with it, so you may as well trust it. Print what you feel like printing. We are all in the same boat.

HOW BIG, HOW SMALL?

No one knows why, but some pictures work better in large prints and others are stronger small. Some seem equally good or bad in any size.

It is a good idea to start small. A good 7 × 10 print is much easier to make than an equally good 9½ × 14. A small print seems to hold together more cohesively than a larger one. You have to work to pull a big print together visually: the larger the print, the harder this is.

When you like a picture, and the print has good tone and contrast, but something is wrong, try changing the print size. Make a print twice as big, and another half the size, and see what happens. You may find the right size for the picture. This sometimes solves everything. There are no rules: just try the alternatives and follow your feeling.

TONE AND CONTRAST

One vocal school of thought tells us that a "fine print" must have a full range of tones, from saturated black to paper white. Implied, though not stated, is the accompanying idea that the most contrasty print that can render all the tones is automatically the best print.

This belief is nonsense.

Such prints are often beautiful and convincing, but just as often they are neither.

White-on-white prints, gray-on-gray, black-on-black and other deviations are often just as "fine." Each picture dictates its own requirements. Sometimes harsh high-contrast printing or gray low-contrast printing is stronger than a crisp, delicious full-range print; sometimes not.

A tonally good print has the degree of contrast that best conveys the feeling of the picture, and tones that are alive, whether they are agreeable or ugly, and whether they conform to rules or violate them.

The best reason I can think of for starting with negatives calculated to print normally on No. 2 paper is that such middle-of-the-road negatives leave tone and contrast possibilities wide open when you print. They can be printed hard or soft, light or dark, in any combination, to fit the photograph's expressive needs.

CROPOSIS, A NERVOUS DISORDER

We have all heard of "creative cropping," but we seldom see any. More photographers shoot sensitively than crop sensitively. A negative is a weaker stimulus than a live subject in the real world, so we are seldom as deeply involved when we print as when we shoot.

Most cropping enthusiasts merely mutilate their pictures, happily slicing whole visions down to fragments.

The urge to crop is often a sign of indecision at the printing stage. The main use of cropping is to kill off pictures that surgery can't help. Sometimes they start as perfectly good photographs; then cropping is cruel.

We usually see more perceptively when we shoot than when we print. When we look at the world through the rectangular viewfinder, most of us automatically and unconsciously fit what we see into that shape, often with great skill. Why? Because the things we photograph are important to us, but the rectangle is just there: so we fit the rectangle to the subject, instead of doing things backward.

Unless you have had the misfortune to study "composition" (a four-letter word), you naturally concentrate on what matters and subordinate what doesn't matter. This is sensitivity, even if you don't notice at the time that you are being sensitive.

Most cropping is the photographer's attempt to outsmart his own vision instead of experiencing it fully. Clever disasters are the normal outcome.

But cropping is not a sin. When you have reason to crop, give yourself a chance to crop well.

How Not to Crop. Don't try to make cropping decisions by marking on the contact print. You can't see enough; and even good cropping of a $1 \times 1\frac{1}{2}$-inch picture is likely to be poor cropping for a 7×10 print. Size makes a difference.

Don't try to crop on the enlarging easel. The projected negative image is so different from the positive print that good cropping for it may be death for the print.

How to Crop Successfully. Experiment intelligently. Start by making a good-quality full-negative print that includes everything.

Give yourself time. Wash it and dry it, then put it on a table in good light and look at it. Does it really need cropping?

If the answer is yes, cover the edges you're

considering cropping with straight strips of cardboard. Move the strips on the four sides of the print to simulate various croppings.

When you see a satisfactory picture in one of the cropped versions, leave the strips in place on the print and carefully adjust the blades of your enlarging easel to match them. Don't change the height or focus of the enlarger.

Now make a cropped print at the same magnification as the first uncropped one. Put it on the inspection board and see if it works as you expected it to. (They don't always.)

If you like the new print, but want a larger one, raise the enlarger, reset the easel for the same cropping in the larger size, make new test strips and try again. See if you like this print or the smaller cropped one better. If you want more prints, use the format that you liked best.

WHAT IS GOOD PRINTING?

The first step toward good printing is to see something worth photographing. The next step is to shoot it perceptively; next, make a technically printable negative; and, finally, transfer the image to photographic paper. All these steps are parts of a single process: photography.

Approaches. Different people approach it differently. There is room for all possible approaches, and no one can legitimately tell anyone else what to do and what not to do—unless he's a client paying for a job.

The Path of No Resistance. My own approach is to try to understand photography's natural flow and its more obvious possibilities, and to steer the technical process that way, while letting the materials and the equipment do the work. It is a lazy man's approach: I see no virtue in difficulty.

In effect, I pour my photography from the top of a hill. It runs through interconnected pipes called processes, and prints spill out at the bottom.

I don't try to change the way things look, and I don't resist photography's ways of changing appearances, which I find beautiful.

Pressing on, Regardless. W. Eugene Smith is practically my opposite. I don't think he goes out of his way to make things hard (though he once taught a course, "Photography Made Difficult"); but he is not lazy. Gene wants results, and doesn't care about convenience.

His understanding of what he sees is different from what the camera records, so when he prints, he changes the picture, often drastically, to fit his vision and knowledge.

Since his negative has little to do with the final print, but is raw material from which the print must be laboriously smelted, Gene cares little about negative quality, except that the film must be exposed enough to contain all necessary information. His prints, as the world knows, are powerful and beautiful.

The Joy of Struggle. Ralph Gibson finds that he does best when the printing is not easy. He overexposes and overdevelops his negatives intentionally so they will fight back with spirit. For him, the stubbornness of the medium is a valued part of the process—and his prints combine subtlety and clarity with beauty.

Your way may be any of these, or something entirely different from any of them.

Why you need thorough fixing and washing. I made this print in 1947, according to the best information I had. I didn't know that 15 minutes in the fixer was too long, or that prints needed agitation in both the fixer and the wash. In 1947, I washed prints by putting the day's work into a tray and leaving it under a faucet for an hour; and finished the job by drying the prints on newspapers—loaded with hypo I didn't know was there. So now I have a colorful, faded, stained print. With all my mistakes, I'm surprised it still looks this good.

That is your business, no one else's. Feel free.

HIDDEN DANGERS: FIXING AND WASHING PRINTS

Many prints eventually deteriorate because most photographers do not fix and wash them well.

There is no need for this. Just use fresh fixer with good agitation, don't turn the white light on too soon, use a washing aid, wash the prints thoroughly and dry them carefully and cleanly.

Exhausted fixer, loaded with complex silver compounds from previous prints, "infects" new prints. The "poison" can't be washed out, so the silver compounds darken in time, staining the print; and the hypo they are mixed with bleaches it.

Not Enough Agitation. When the fixer is fresh, but agitation is not sufficient, areas of the print are fixed incompletely, leaving a mixture of silver salts and sulfur compounds in the print. What doesn't darken the print or bleach it may combine chemically into yellow-brown silver sulfide, the classical faded-print stain.

When the light goes on too soon, some of the print emulsion is still light-sensitive. The light starts chemical reactions that go on and on, and stains result.

Use a Washing Aid. With no washing aid, a long print wash can remove hypo and silver compounds fairly well; but half as much washing will be much more effective when a washing aid is used. A better wash that takes less time, water and work is all gain.

Poor washing leaves destructive hypo and silver compounds in the prints.

Hypo Contamination. Hypo-contaminated dryers, blotters, hands, other prints or anything else will efficiently reinfect well-processed prints, wet or dry.

How to Tell a "Clean" Print from a Contaminated One. The only way to be really sure is to test the print chemically (see p. 242). Some experienced photographers can often tell well-fixed, well-washed prints from "dirty" ones by touch (a clean print feels smooth, almost soapy) or sometimes by the smell of hypo. Nobody can *see* the difference until much later. That's why photographers assume that poor fixing and washing is "good enough" until chemistry catches up to them and their prints turn odd colors and fade.

Be lazy. Do things well just once, not wrong first and right later.

TROUBLE-SHOOTING: DEFECTS IN ENLARGEMENTS

Print Too Pale. Probable causes, underexposure in printing, use of exhausted developer, or bleaching by overfixing. Remedies: None. Make another print. Prevent by exposing the print enough (make test strips), by using fresh print developer (film developers are too weak for paper) and by timed fixing (I prefer a conventional acid hardening fixer to rapid fixers for prints).

Print Too Dark. Usual cause, overexposure in printing. Fogged paper is a possibility. (Test by developing and fixing an unexposed sheet of paper: if it stays white, it isn't fogged.) Remedy: Some dark prints can be bleached to normal tones with Farmer's re-

Print too pale: underexposed.

Print too dark: overexposed.

ducer (pp. 224 and 256). It is usually quicker, simpler and more satisfactory to make a new print. Prevention: Don't overexpose prints (make test strips). If you open the enlarging lens to check focus, remember to stop it down to the working aperture before you expose any prints.

Muddy, Gray Tones. Several causes can join together in any combination: paper too low in contrast grade for a soft negative (the same as "negative too soft for the paper"); "expired," out-of-date paper (most printing paper stays good for two years or longer); paper fogged by light leaks or an unsafe "safelight"; or paper with too dull a surface texture to yield good shadow contrast.

Mottled gray tones suggest an overexposed, underdeveloped print, and possibly exhausted print developer. Remedies: None. Prevent by using fresh, high-luster paper of the grade that "fits" the contrast of the negative, and fresh paper developer. Don't overexpose (make test strips) and don't underdevelop prints. Eliminate light leaks and check your safelight.

(*Safelight test.* By safelight only, put a fresh sheet of enlarging paper directly under the safelight, with an opaque object on the

Print too low in contrast: paper too soft.

Gray, fogged print. The paper box was not completely closed while the white light was on.

paper—a coin, a pair of scissors, anything that casts a definite shadow. Leave the paper under the safelight for 20 minutes, then develop and fix it. If the paper is blank, the safelight is OK. If the paper is gray, with a white image of the object, the safelight is fogging the paper. Check to be sure you are using the right safelight filter (the Kodak OC and the DuPont S55-X are safe for most enlarging papers, including variable-contrast ones). Check the wattage of your safelight bulb, and the safelight-to-paper distance. A weaker bulb, a longer distance or the right filter will solve the problem. (Any safelight that *tests* safe *is* safe, whether recommended by the paper manufacturer or not.)

Too High Contrast. The cause of harsh "soot-and-chalk" tones is either an overdeveloped negative or the use of a paper that is too "hard" for a normal or a contrasty negative. Prevent by not overdeveloping your film, and by fitting the paper grade to the negative (make test strips).

No detail in light tones in an otherwise

Mottled gray print resulted from overexposing the paper, then pulling it out of the developer too soon. (Don't try to judge print tones by safelight.)

Print contrast too high: No. 5 paper was used for a negative that fits on No. 2 paper.

normal-looking print. This means the print is too high in contrast and underexposed. Prevention, obvious.

Poor shadow detail in an otherwise normal-looking print. Ninety-nine times out of 100, the cause is an underexposed negative. No remedy; expose the next negatives more.

Dull-surfaced papers have normal mid-tone and highlight contrast, but dark tones, which may look lively while the print is wet, dry dull and flat. Such papers are best suited to light prints with little dark detail, though

some photographers have learned to make full-range negatives that print well on them.

Also, certain high-speed papers, notably No. 2 Kodabromide, have relatively low shadow contrast and are not designed for prints with prominent dark detail.

Prevent flat dark tones in prints by exposing negatives fully and developing them normally, and by using high-luster papers with relatively high shadow contrast (most of the papers I have listed are among these).

Print Is Unsharp. Either the negative is un-

Picture unsharp because the enlarger was out of focus. The dark tones spread, and no grain is visible.

Print is sharp in the middle, unsharp everywhere else: the negative "popped" during the print exposure because the heat of the enlarger bulb expanded it and changed its curvature.

sharp or the printing is unsharp, or both. If light tones "bulge" and spread past their natural boundaries, the negative is out of focus. If dark tones spread, the enlarger is out of focus. (Light spreads, shadows don't.) If part of the print shows sharp grain or detail, but definition in other parts is mushy, with bulgy black areas, either the negative has shifted in the enlarger during the print exposure (center sharp, all edges mushy) or the enlarging lens is out of line or does not have a fully flat focal field. (I had an otherwise excellent lens which focused all of the negative on the paper except one corner, which came to a focus two inches above the paper.)

Prevention: If the negative moves, prewarm it before focusing and again before exposing the print, by turning on the enlarger lamp for about a minute. The negative will then stay put in its warm position.

If the lens is out of line or lacks a flat field, expose prints at the smallest f-stop to minimize the unsharpness, and get the enlarger lined up or replace the lens.

This picture is unsharp because the camera was out of focus. Sharp grain shows that the enlarger was focused accurately.

If you have neglected to focus carefully, learn your lesson and reform.

Print has dark gray blobs or brown stains at one or more edges. Handprints caused by heat. Don't handle prints more than necessary during development.

White blobs or fingerprints on the print are caused by processing defects or dirt on the negative, or by hypo or stop bath splashed, smeared or fingerprinted on the paper before print development. Air bubbles trapped under a face-down print in the developer can also cause white or pale blobs. No remedy, except spotting in mild cases. Prevent by printing from clean negatives, by handling undeveloped paper only with clean, dry hands and by developing prints face-up with constant agitation. Don't splash chemicals. Use fresh, clean, dry towels for each printing session.

Stained Prints. Caused by exhausted or contaminated developer, stop bath, fixer, washing aid or wash water; by using no stop bath; by dirty hands or trays, or containers not chemically compatible with processing solutions (avoid aluminum trays, containers, bottle caps); by too-short or poorly-agitated fixing; poor washing; contaminated blotters, dryer, etc. No remedy. Prevent by using fresh, uncontaminated processing solutions, clean, chemically inert trays and containers, and clean, hypo-free blotters or other drying setup.

Warped, Wavy Prints. Uneven drying. With blotters, warping results from leaving water-soaked prints too long in the first or second blotters without changing to fresh blotters. In heat-dried prints, it results from uneven drying caused by an inefficient dryer with uneven heat, or from drying at too high

The dark stain is a developer thumbprint. The print was clutched tightly while in the stop bath, which never reached this spot; then the white light was turned on before the print was put in the fixer.

White fingerprints. The blobby ones are hypo spots. The sharp, FBI-type ones are grease fingerprints. Handle undeveloped paper with clean, dry hands or with clean, dry tongs.

a temperature. No remedy. Prevention, obvious.

Creased or Cracked Prints. Creases result from rough handling of wet prints; cracking, from too severe bending of dry ones. No remedy. Prevent by handling prints carefully and without haste at all stages of processing and afterward.

Small Black Non-image Marks on the Print. Usually caused by dust on the film during the camera exposure. Occasionally caused by impurities in the paper or its emulsion. Pre-

vent by keeping the inside of the camera clean. There are two dubious remedies. You can bleach the spot chemically (very tricky), or you can delicately etch or shave down the black silver of the spot until it matches the surrounding tones. This is done with the corner of a single-edge razor blade, or with a retouching tool, and it takes much practice. If you etch too far, the tone can be spotted back in, but if you dig through the emulsion into the paper, the print is ruined.

The problem with bleaching is to restrict it

The constellation is a juicy fingerprint on the negative. The white stripes are scratches on the negative. Sometimes, when the scratches are on the emulsion side of the film, they print as black lines. Straight scratches parallel to the length of the roll of film suggest that they were caused by dirt in the camera or the film cartridge: less straight, non-parallel scratches, as shown here, suggest careless handling of the film outside the camera: a dirty sponge could cause them.

to the spot and to avoid contaminating the print chemically. I prefer etching because it presents no chemical threat. The etched surface can be restored to approximately its normal luster by coating the spot lightly with gum arabic dissolved in water. The thicker the solution, the shinier the surface. Gum

arabic can be bought in powder or crystal form at drugstores. Crystals are easier to use.

Small White Spots, Squiggly Hairlines and Long White Scratch Lines on Prints. Caused by dust or damage on the negative. Prevent by keeping negatives clean, and by careful, minimal handling: touch negatives only by the edges. Dust them gently before printing. Remedy: Spot the print by adding dye to the white spots so they match the surrounding print tones.

HOW TO SPOT PRINTS

You need spotting colors; a fine sable watercolor brush, size 0 to 000, that comes to a very fine point; a clean white saucer for mixing; a cup of water; good near eyesight (magnifier or eyeglasses if necessary); good light; a firm support for the print; and time. Comfort helps. Do not use the same brush for spotting and for dusting negatives: you don't want dye on your negatives.

The dyes I use are called Spotone, made by Retouch Methods, Inc., and sold in photo stores. The dyes come in several colors, none of which quite matches any of the enlarging papers I use; but a close enough match to the tone of the print can be made by mixing some "cold" Spotone (No. 3 or No. 1) with some "warm" Spotone (No. 2 or No. 0). Exact color matching is not necessary unless you must fill in large areas of white: a close approximation of the warm-cold balance is generally enough.

I mix by eye judgment and by brush dip on a white saucer which serves as my palette for mixing both the right color and the right strength in lightness or darkness for the print area I'm spotting. (My usual mix is three dips of No. 3, called "neutral black" but blue

to my eye, and one dip of No. 2, a brown-black dye, stirred together in a small puddle with the brush.) These dyes dry somewhat darker and somewhat stronger in color than they look wet; so mix a bit on the "warm" side for cold-tone prints, and a bit "cool" for warm-tone prints.

Straight Spotone is hardly ever used on the print. Usually it is greatly diluted. Since the dye soaks into the surface of the print almost immediately and cannot be removed, and since it darkens as it dries, it is important to use Spotone lightly: don't put too much on, and don't miss your spot.

The easiest tones to spot are the middle grays; the most difficult are the blacks. Therefore, start spotting your prints in the middle range, then go lighter and finish with the darkest tones. This lets you get the feel of the process before you reach the hard parts.

When you've made your puddle of mixed but undiluted Spotone on the saucer, dip the brush in water and clean it well. Then take a brushful of water and dip it quickly into one edge of the puddle to lift a little dye out. Use this brushful and another dip of water to mix a new, dilute puddle.

Before you touch the print, repeat the process. Clean the brush and dip a little dye from the dilute puddle to make a new, more dilute, pale puddle.

Now you can start spotting. Remove most of the liquid from the brush by stroking it repeatedly against the saucer. The brush should be just slightly wetter than "damp"— not wet enough to leave a bead of liquid where it touches. Look at the tone your brush leaves on the saucer: it is the key to what print tone to spot first.

Find a gray tone in the print that is defi-

Spotting a print.

nitely somewhat darker than the brushmarks on the saucer. That is where you start.

Pick a white dot in that area, touch the tip of the brush to it and lift the brush. The dot should disappear. If it does, go on to the next spots you see in the same gray, touching each one accurately once. When a spot is too big for one touch, aim a second touch at the white that remains. If the spot remains a little lighter than the print tone around it, leave it alone for now. Either it will dry enough darker to match the tone, or one or two later touches with more dilute dye will build it up enough.

As you go, the brush will dry out somewhat. Then dip it in the water, brush off the

liquid, check the brushstroke tone on the saucer and spot in a lighter print area, where the print is just a little darker than the dye.

Spot the dark grays and the blacks last: the exact dilution is critical with these tones. Always spot somewhat lighter than the print tone: a slightly lighter spot goes unnoticed, while a darker one attracts attention. There is no need to match print tones exactly: it is enough to reduce the contrast between the dust spots and the print enough so the spots are not noticed.

Scratch lines are not hard to spot if you treat them as continuous rows of dots. Touch them with the brush, dot by dot, until the line is filled in. With practice, you can learn

Print spotting: enlarged details. A: before spotting (circles mark spots) B: brush touches spot. C: after spotting: the spots can be seen on examination, but are not obvious any more.

to draw the brush along the line in a slow, even stroke, but that is riskier and much more difficult, though quicker.

Large spots of white can be filled in by repeated dot-touches ("stippling"). This is where closely matched color becomes important.

That's all there is to spotting.

It is time-consuming but peaceful; and it shows you your photographs as you can never see them otherwise, because you look carefully at every square inch of the print to find the spots.

Spotting and Space. A fringe benefit is the lesson spotting teaches you about space in photographs. As you finish spotting a print, the three-dimensional space of the picture opens up, takes on depth and becomes clear. You look *into* the picture instead of at its surface.

This is what spotting is really for. The neatness that comes with banishing spots is secondary. The main function of spotting is to increase the picture's depth and clarity. Those little spots rivet the eye and the mind to the surface of the paper with extraordinary power, far out of proportion to their size and brightness. When they disappear, we can first begin to see past the paper and into the photograph.

FILING AND STORING PRINTS

Print filing is so personal that I can't tell you how you should do it. I can describe my own approach.

A Negative Number on Every Print. Some of my prints are from projects, but just as many are randomly shot and printed as pictures present themselves. They all have this in common: each print is identified by its negative number, penciled on the back at the time of printing.

Pictures from Projects. I file project prints by project: so I have several boxes labeled "Brazil 1961," with subheadings such as "Rio," "São Paulo," "Sertão da Bahia" and "portraits."

Filing Individual Pictures. Non-project prints are filed by subject, by place, by approximate date or by whatever characteristic most definitely sets them apart from other pictures. I have boxes for various states and dates ("Arizona 1966," "Maine 1968"), and others for places that defy dating because I've worked there too long. These are broken down by other factors ("New York streets," "NY subways and tunnels," "NY traffic," "NY interiors").

Separation by Size. These categories are all divided by print size, for convenience in storage—11 × 14 boxes on one shelf, 8 × 10 on another. Finally, they are divided between mounted and unmounted prints.

Storage is something else. Prints are fragile, and unmounted ones tend to curl up unless they are held flat. I protect them and keep them flat by storing them in acid-free paper envelopes, which are kept in boxes. When I have several matched prints from a negative, I put two or four of them, back-to-back and face-to-face, in an envelope. The curl of one print pushes against the curl of the next, so they flatten each other. The weight of other prints in the box completes the job.

The box and the envelopes protect prints from dirt, airborne sulfur compounds, light and physical damage. As far as possible, the print boxes are kept where temperatures are moderate and humidity is low.

Don't Mount Them All. By now, after

twenty-five years of photography, I have many prints. Because mounted prints take much more space than unmounted ones, and because mounting is costly and laborious, I no longer mount prints without an immediate reason. Prints are mounted for exhibits, or when they are sold, but not before the show or sale becomes definite.

Archival Processing and Storage. As used in photography, "archival" means that the print is processed well enough to last for 50 years or longer. Predictions that archival prints will last 3000 years or longer are tossed off glibly right now: there is a momentary mania for the word "archival" and for the idea of pictorial immortality.

Let's consider the facts. Archival processing is essentially just careful processing, which we owe ourselves anyway. There is no need to make a fuss about that. Archival storage is something else. Today's archivomaniacs go to odd extremes in some areas and neglect others. They condemn glassine envelopes (on vague grounds) and the boxes photographic paper comes in—both handy for print storage—and they mount their prints only on 100-percent-rag mounting board. (But since the advent of drip-dry fabrics, no one knows the chemical content of all-rag papers.) Some of them condemn dry-mounting tissue and urge us to use library paste instead—a sign of ignorance, since the tissue is chemically much safer.

Within limits, archival printing and storage make sense. Use good materials with care, and your pictures will last long enough so you don't have to keep reprinting them. For me, it will be enough if my prints last as long as I do.

My concession to archival storage is that I now keep my prints in acid-free paper envelopes and boxes (from the Hollinger Corporation, 3810 South Four Mile Run Drive, Arlington, Virginia 22206). However, I do not filter, dehumidify or refrigerate the air in the room. I can report that twenty years of earlier storage in glassine envelopes and photo-paper boxes in the sulfur-laden air of New York City does not seem to have harmed any prints—though poor fixing and washing, before I learned better, destroyed many.

Good fixing and washing seem to be what a print needs most if it is to last in "like-new" condition for a century or two. The 3,000-year print is most unlikely unless storage temperature, humidity and air purity stay under continuous control for all three millennia. How probable does that sound?

I think that much of the archival game is empty talk, just as most of the archival prints are mediocre photographs. The sooner those fade, the better.

Truly archival storage is possible and important for museums, libraries and historical collections—while *they* last—but it seems less urgent and less practical for individuals.

Ansel Adams writes that prints he made before he learned to fix and wash them well (about 1930) have largely deteriorated, but that prints made since then show no signs of fading or staining. His storage, like mine, is clean and careful, but not fanatically archival.

The moral seems to be: Enough is enough.

PART THREE

PHOTOGRAPHIC CONTROL

9

Basic Control—
Film Speed and Exposure

CONTROL THROUGH EXPERIMENT

Up to now, we have concentrated on the basic procedures of picture making. Now we can start learning to control the quality of our pictures by modifying these procedures.

Practice Counts More Than Theory. Some theory about this has been given. But theories are just word arrangements until they are tried out. Experiments show you what really happens, so you can see the strengths and weaknesses of theories—none of which are entirely right. So we use what works.

Why We Need Personal Tests. Few photographers grasp the immense range of possibilities open to us. We seldom fill the gaps in our information by making practical tests. It's easier to ask someone or read a book. But too often the answers—even in books—come from people who have asked or read still others. They are hearsay evidence. When you try things, you quickly learn that not all "authorities" test their beliefs.

Most Photographers Don't Bother to Learn from Experience. One result of this too-tired-to-try attitude is the prevailing technical mediocrity of today's photography, although technology now makes excellence easier to attain than ever before.

Don't Stop Halfway. A photographer who can see and shoot good pictures in the viewfinder, but is not sure of his exposure and lacks control over his developing and printing, is like an airplane pilot who can take off all right, but doesn't know how to navigate or land.

The Prints Tell About the Negatives. In spite of all those separate steps, black-and-white photography is one single process from beginning to end. We can learn much about the early stages by looking at the end result. Negatives are made to be printed. The way they print shows what, if anything, is wrong with them and what to do about it. (For example: If you have a print with empty black areas, hold it in front of a light bulb. If you see more detail in the blacks when the light comes through the print, you aren't get-

ting all you can from that negative. Then print it again. But if no more detail appears in front of a strong bulb, that area of the negative was underexposed. Expose your film more next time.)

Once you can determine exposure, shoot, develop and print your pictures, you have the skills you need to control their quality.

Control begins with coarse adjustments, followed, if necessary, by fine adjustments. This is a coarse-adjustment chapter. The refinements come later.

The method is careful trial and error. Change one variable factor at a time, and keep a record of what you do. Otherwise you won't know what change causes which effect.

EXPERIMENT 1

This experiment completes the film-speed test given on page 61, in which two rolls of the same kind of film were given identical exposure series in pictures of a high-contrast subject. All exposures were to be based on dark-tone meter readings or on the manufacturer's data sheet, and were to range, on each roll, from ¼ of the manufacturer's recommended exposure to greatly overexposed. One roll was to be developed "normally" by a custom lab, and the other was to be developed by you, carefully following the manufacturer's development instructions.

The first stage in evaluating this test was simply to look at the negatives and try to decide which were underexposed, which well exposed and which overexposed.

If you have not done this part of the experiment yet, do it now. If they are correctly developed the negatives will range from very thin to very dense. Those in which detail disappears in the thinnest parts of the negative are underexposed. Those that are dark all over are overexposed. In general, the well-exposed negatives will be slightly denser in their thinnest areas than the unexposed edges of the film around the edges of the picture area.

This experiment consists simply—if tediously—of printing every one of the negatives on both rolls so that you can see how different degrees of exposure actually affect the picture.

It is important to keep track of each exposure and to mark each roll so you can't get the lab-processed roll mixed up with the home-processed one.

The enlargements can teach you more than most books can about the following:

1. How to judge film exposure by the printing behavior of the negatives; as a by-product, you will begin to see what a good negative looks like.

2. The film's actual range of usable speeds (at the recommended development).

3. How overexposure, "correct" exposure and underexposure of the negatives affect the prints.

4. Whether or not "lab-normal" development produces the same results you get when you develop according to the manufacturer's recommendation. If not, what is the difference?

(Contrasty subjects are the ones that require the most accurate exposure and development. If all tones in a negative of such a subject print with clear detail and pleasing tones in a normally processed print on

Looking at prints from exposure-test negatives. Kodak Tri-X film was used. The home-developed negatives were developed in HC-110 according to manufacturer's recommendations and the lab-developed negatives in D-76 according to normal procedures. Except where noted, the paper used throughout was Spiratone GL2.

"normal-contrast" No. 2 paper, it's reasonable to consider it a normal negative.)

5. Whether your negatives need more or less than the recommended development.

HOW TO APPROACH THE EXPERIMENT

To learn all this, you must print carefully and look at the prints attentively and with an open mind.

Evaluate this test in terms of fact, more than in terms of taste. Taste is secondary here.

(In any case, a sense of photographic tone usually seems to be an acquired asset. Few people can see tone clearly at the start, and some—the tone-blind—never pick it up at all. But most photographers find their tone perception sharpening after a year or two of printing.

A useful short cut that can give you some

sense of what is possible before you can learn to do it yourself is to visit the photography collections of the Chicago Art Institute, the Museum of Modern Art in New York City, the International Museum of Photography at George Eastman House in Rochester and some other collections, and look carefully and for a long time at the prints of really strong photographers such as Edward Weston, Paul Strand, Ansel Adams, Alfred Stieglitz, Minor White and W. Eugene Smith. Among them, these men have used many modes of printing well.)

But nothing else improves tonal sense like careful, imaginative printing, in which you try out the alternatives each negative allows you. In this experiment, you introduce yourself to a few of the basic choices that are open to you. This is where to start working deliberately toward developing your own sense of tone. It will not be quite the same as anyone else's: taste is a complex and personal thing.

Back to facts. For now, we are playing scales, not music. We want to see whether or not we get clear, agreeable rendition of detail in all tones of a long-brightness-scale subject in a "straight," unmanipulated print from any of these negatives on normal-contrast paper.

If we don't get clear detail in both shadows and highlights in a carefully made No. 2-paper print, it is a sign that—for long-scale subjects, at least—the film needs a different exposure, a different development, or both.

The contrasty or long-scale subject is traditionally considered the toughest technical problem in black-and-white photography. Both the Stieglitz legend and the Steichen legend (don't get those two mixed up) tell how the photographer spent months or years photographing white objects against black velvet to learn how to hold detail in both.

Now that we have trustworthy light meters, the problem isn't that hard. Any intelligent beginner can solve the white-egg-on-black-velvet problem in a day or two of methodical testing. We are starting with a harder problem—brilliantly lighted white against black in the shade. This may take a beginner as long as a week. When you have solved it, all the other problems are easier, and you will understand approximately how to deal with most of them.

The recommended exposure and development for most films seem to be based on the notion that you are photographing pale faces against middle-gray backgrounds, in light that comes from behind you and falls on the front of the subject. If this is not the picture you usually take, you are likely to have to expose and develop differently from the manufacturer's idea of "normal."

WHAT YOU NEED FOR THE EXPERIMENT

1. Negatives made by exposing two rolls of the same film to a long-scale (contrasty) subject, with exposures, based on dark-area meter readings, that range from underexposure of ¼ the recommended exposure to overexposure of at least 128 times the recommended exposure. One roll is developed "normally" by a custom lab, and you develop the other, carefully following the manufacturer's development recommendations. Mark both rolls so you cannot get them confused.

2. Printing setup, including enlarger, trays, a box of 100 sheets of the glossy No. 2

8 × 10-inch enlarging paper of your choice, a standard print developer such as Kodak Dektol, GAF Vividol or DuPont 53-D, other processing solutions and a print-drying setup (as specified on pages 102–103).

3. At least two or three days of working time. This can be split into several sessions, but allow at least three hours per printing session. You can't get much done in less time. (Yes, this is a lot of work. It will teach you enough to save you a great deal more work.)

4. Pencils and notepaper. If you don't keep a complete record, including negative identification and print-exposure data on the back of each print, you will not be able to evaluate your results.

WHAT TO DO

It's tedious and simple (you need patience to be a good photographer).

Using the same paper and print developer, the same print-developing time, and making all prints the same size, print every negative on both rolls, making the best "straight" print you can for shadow rendition and the best print you can for highlight rendition. If the development is truly normal in practical terms, these will be the same print—that is, both shadows and highlights will look good on the same sheet of paper, and two prints will not be needed of any negative that prints this way. Do not be surprised or disappointed, though, if you have to print each negative of both rolls twice. Usually, this means a light print for the best dark tones and a darker print for the best light tones.

In printing, start with a negative (lab- or home-developed, it doesn't matter) that was given the recommended exposure. This will give you a print of at least fair quality, so you have some visual basis for judging the other prints. Then print the next thinner negative, and the thinnest one; and from there, go to the first negative that is denser than the recommended-exposure negative on each roll and print the overexposed ones in the order of increasing overexposure.

Print every overexposed negative, no matter how alarming it looks. Quite decent prints can often be made from negatives that look solid black to a casual observer. Experimenting is useless if you decide in advance what will happen and act on guesswork instead of observing results.

The reason we experiment is simply to find out what happens when we do this or that.

METHOD

The quickest and easiest way to do this experiment is to avoid all short cuts and perform each operation of each print thoroughly, carefully and to the best of your ability. Then you can do it once and be finished, instead of having to go through it all twice or three times.

Make test strips for each print: use a wide-enough spread of test exposures on the strips so that you can learn about both shadow and highlight values from them. That means starting with at least four strips for the first try—say 5, 10, 20 and 40 seconds if you are unfamiliar with the paper, or 5, 10, 15 and 20 seconds if you already know which f-stop on the enlarger will print a normal negative at, say, 10 or 15 seconds.

One way you *can* save working time in this experiment depends on your confidence in handling prints during processing. You can store each sheet of paper in a light-tight box after exposing it, then develop both the shadow and highlight prints of each negative together with the test strips for the next negative. This cuts your processing time to about 1/3 as long as it would take to develop each print and each set of test strips separately. If you time the development accurately and agitate constantly without letting any two pieces of paper stick together in the tray, you should get consistent results. It is easier than it sounds, and good practice in print handling. Try it with two or three negatives to see if you feel up to it.

Whenever you go from a denser negative to test strips for a thinner one, of course the strips will need less print exposure. When you go from thinner to denser, increase the test-strip exposures. You'll get a sense of about how much to change the exposures as you go, so you will probably need fewer test strips toward the end of your printing.

If your first set of test strips gives you only the shadow or the highlight print exposure but not both, do not make a print by guesswork. Make more test strips until you have your information. This will save you time, work and paper.

RENEW DEVELOPER

Print developer does not stay constant in its activity for many prints, and it is cheaper than either paper or your working time. Therefore, discard the developer after each 10 prints and replace it with fresh. Then your development will stay consistent. Do this when you print pictures as well as when you make tests.

TAKE NOTES

Before you expose each print, write on the back of the paper which negative is being printed, and the print exposure. To be useful, the information should include: whether the film was lab-normal or home-developed; the type of film; the exposure index at which the negative was shot, the printing paper used in the test, and the enlarging f-stop and exposure time in seconds. For example, here is the scribble on one of my test prints: "TX, EI 400, lab nor, GL2, 27½" f/22." Tri-X was exposed at EI 400—Kodak's recommended exposure—developed normally by a lab, printed on Spiratone glossy No. 2 paper at a print exposure of 27½ seconds with the enlarging lens set at f/22. The processing time and developer are not noted on each print, because they are conventional—Dektol diluted 1:2, with two minutes' development, throughout the test. If I had departed from such traditional processing in the test, that would have had to be noted, too.

On a separate note pad, write down these data for all test prints as you go. The time to make these notes is when you have looked at the test strips and made your print-exposure decisions. Date these overall notes. They may be handy later. (Films and paper are often changed in manufacture without any announcement. A recent date means that your test probably still applies. An old date means: Verify your data by a quick test before you base important shooting on old information.)

MORE ABOUT EXPOSURE INDEXES

If you took Latin in school or have a formal mind, it's all right to call them exposure *indices.*

If you have forgotten the basic information about film-speed ratings (ASA, BSI, DIN and EI), turn back to page 52 and refresh your memory. You want to be clear in your mind when you carry out this laborious test. If you aren't, the work will be wasted.

In theory, the same numbers mean the same film speed after all three prefixes: ASA 400 equals BSI 400 equals EI 400; and the same goes for all other numbers.

In practice, it isn't always quite so neat. For example, I have tested an ASA 500 film along with an ASA 400 film and found that, under my test conditions, the ASA 500 film was not faster but slower. At the same exposure to the same test target in the same light, with recommended development, it produced thinner negatives with less shadow detail.

ASA ratings, then, are manufacturers' test results that do not apply accurately to all ASA-rated films under all circumstances—and they seem to vary from one company to another. Take them as useful preliminary guides to experiment, not as eternal truths.

Language Problem. I'll be using a couple of idioms here—technical words in their secondary meanings—so I had better tell you what I mean by them.

Idiom 1: The EI numbers assigned to negatives in this test do not mean that the film has miraculously changed speed from one negative to the next. (If it had, the negatives would all be equally dense.)

In the context of this film-speed test, EI numbers assigned to negatives do not stand for film speeds, but are a way of saying how much exposure each negative was given. EI numbers, whether used as film-speed numbers or as "exposure-given" symbols, are constant: they refer to specific standard values that are measurable and repeatable.

An EI 1600 negative, in this context, is one that was given the exposure that would be normal for a film with a speed of EI 1600; an EI 3 negative on the same roll was given the exposure that would be normal for an EI 3 film.

If the best negative on a test roll of film rated at ASA 125 turns out to be one that was "exposed at EI 64," then EI 64 is the optimum speed for that film, shot and processed under those conditions. But if the "EI 125 negative" produces the best print, then the film's actual performance matches its ASA rating. The aim of the test is to find out what film speed works best with the film we are testing, no matter what its ASA rating may be.

Idiom 2: You will find me saying things like "one stop more exposure," "exposing two stops less" and so on.

This refers to the amount of exposure change you would get—everything else being equal—by opening the lens one f-stop wider, for example, or by closing it down two stops.

Each stop of change alters the exposure by a factor of two: so giving "one stop less" means giving half as much exposure, and "two stops more" means four times as much exposure, and "three stops more" equals eight times the exposure.

You can describe exposure changes in terms of so-many-stops increase or decrease regardless of whether you make the actual changes by adjusting the shutter or the lens opening or both, or by using a filter that cuts down the amount of light hitting the film, or turning lights on or off. This idiom is just a way to say how much you have changed the exposure, no matter how it's accomplished.

EVALUATING THE TEST PRINTS

After washing and drying the prints carefully, bring them all together in good light, arrange them in order of increasing exposure in a row for highlight prints and a row for shadow prints for each roll—that's four rows —and evaluate the results.

Give yourself plenty of time for this. It is important, and it is not simple.

Look at all the prints for one quality at a time. You cannot evaluate all factors at once.

Here are some of the questions to ask yourself as you look. (I am supplying answers derived from my own test prints, but do not assume that your tests should give the same results. *If you have exposed, developed and printed methodically and your results are different, trust your results, not mine.* This is a practical experiment, not a conformity contest.) If you have not been methodical, throw out your test negatives and prints and start over. This time do it right.

THE QUESTIONS

1. Is "lab normal" the same as home development following the manufacturer's recommendations?

(DV: In my case, no. The lab negatives were considerably denser and slightly more contrasty than my home-developed ones, and required about twice as much print exposure per negative. My inference: If you work with a lab, base your exposure on the lab test; if you process your own, follow the home-developed results in your photography.)

2. What is the minimum exposure—the highest exposure index—that gives a negative with full printable shadow detail?

(DV: For the film I tested—Tri-X, rated at ASA 400—with recommended development, the highest EI that gave full shadow detail was EI 200 on both rolls. The lab-developed roll was enough denser than the home-cooked roll to suggest that EI 250 or EI 320 might provide full shadow detail; but the EI 400 shadow-value print had somewhat less clear dark detail than the EI 200 one. I develop my own film, so I will trust my home-processed test results. For me then, EI 200 represents the thin-edge minimum exposure, with no safety factor, for practical work with Tri-X.)

3. Do different amounts of exposure produce negatives of consistently equal contrast?

(DV: Far from it. I can describe mine in terms of overall contrast, highlight contrast and shadow contrast, as it appears in the prints:

Overall contrast was high, for the long-scale subject photographed, from EI 1600 [¼ recommended exposure] to EI 3 [128x recommended exposure].

At EI 1.5 [256x recommended exposure] overall contrast was normal for the subject, in that all tones printed with full detail but were not too "soft" and gray to look good.

HOME DEVELOPED LAB DEVELOPED

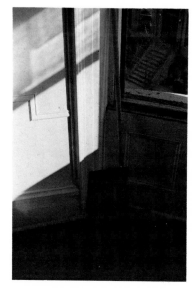 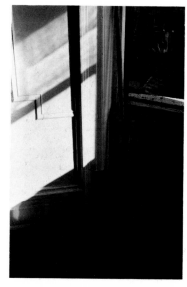 HIGHLIGHT
 PRINTS

EI 1600. 5 seconds at f/22. EI 1600. 12″ at f/22.

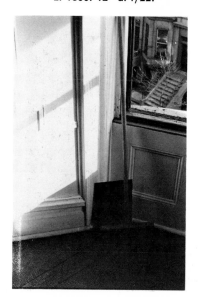

SHADOW
PRINTS

EI 1600. 5″ at f/22.

BASIC CONTROL—FILM SPEED AND EXPOSURE 161

HOME DEVELOPED LAB DEVELOPED

HIGHLIGHT
PRINTS

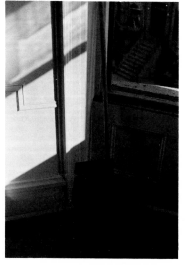

El 800. 8″ at f/22. El 800. 17½″ at f/22.

SHADOW
PRINTS

El 800. 5″ at f/22. El 800. 6″ at f/22.

HOME DEVELOPED LAB DEVELOPED

HIGHLIGHT
PRINTS

El 400 (recommended exposure).
12″ at f/22.

El 400 (recommended exposure).
27½″ at f/22.

SHADOW
PRINTS

El 400 (recommended exposure).
5″ at f/22.

El 400 (recommended exposure).
8½″ at f/22.

HOME DEVELOPED LAB DEVELOPED

HIGHLIGHT PRINTS

El 200. 17½" at f/22. El 200. 20" at f/16.

SHADOW PRINTS

El 200. 7½" at f/22. El 200. 6½" at f/16.

164 *Photographic Control*

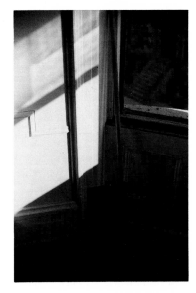

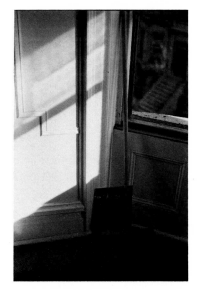

**HIGHLIGHT
PRINTS**

El 100. 26″ at f/22. El 100. 30″ at f/16.

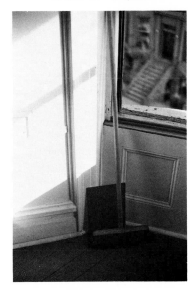

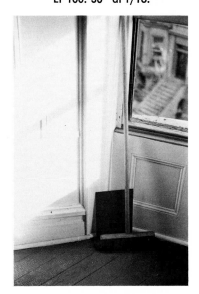

**SHADOW
PRINTS**

El 100. 11″ at f/22. El 100. 11½″ at f/16.

BASIC CONTROL—FILM SPEED AND EXPOSURE 165

**HIGHLIGHT
PRINTS**

El 50. 17″ at f/16. El 50. 18″ at f/11.

**SHADOW
PRINTS**

El 50. 7″ at f/16. El 50. 7½″ at f/11.

166 *Photographic Control*

HOME DEVELOPED LAB DEVELOPED

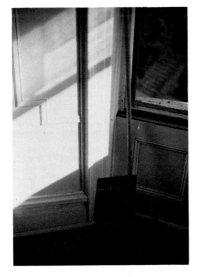

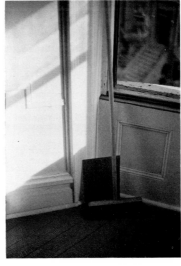

HIGHLIGHT
PRINTS

El 25. 25″ at f/16. El 25. 25″ at f/11.

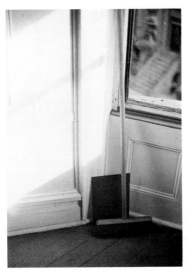

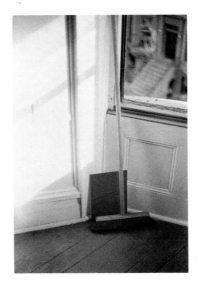

SHADOW
PRINTS

El 25. 10″ at f/16. El 25. 15″ at f/11.

	HOME DEVELOPED	LAB DEVELOPED

HIGHLIGHT PRINTS

El 12. 15″ at f/11.

El 12. 15″ at f/8.

SHADOW PRINTS

El 12. 7½″ at f/11.

El 12. 10″ at f/8.

HIGHLIGHT
PRINTS

El 6. 20″ at f/11. El 6. 18″ at f/8.

SHADOW
PRINTS

El 6. 11″ at f/11. El 6. 15″ at f/8.

|HOME DEVELOPED|LAB DEVELOPED|

**HIGHLIGHT
PRINTS**

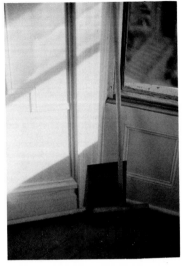 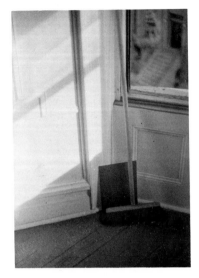

El 3. 12½" at f/8. El 3. 12½" at f/5.6.

**SHADOW
PRINTS**

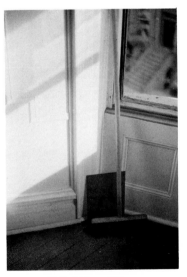 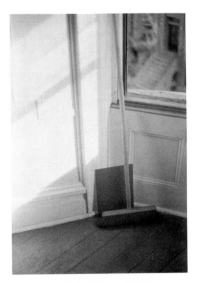

El 3. 10" at f/8. El 3. 10" at f/5.6.

HOME DEVELOPED LAB DEVELOPED

El 1.5
Combined shadow and highlight print,
13" at f/8.

El 1.5. Combined highlight and
shadow print, 15" at f/5.6.

HOME DEVELOPED

El 0.75. 17″ at f/8
(lighter than shadow print).

El 0.75. 20″ at f/8.

LAB DEVELOPED

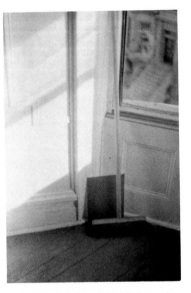

El 0.75. Combined highlight and
shadow print. 17½″ at f/5.6.

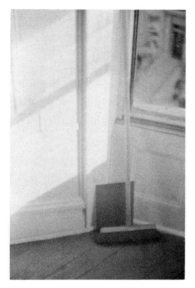

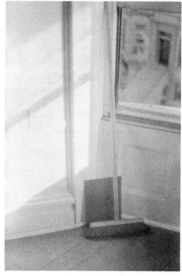

**HIGHLIGHT
PRINTS**

El 0.37. 17" at f/8
(much lighter than shadow print).

El. 037. (lighter than shadow print),
17½" at f/5.6.

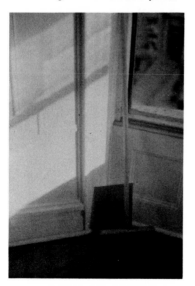

**SHADOW
PRINTS**

El 0.37. 27½" at f/8.

El 0.37. (darker than highlight print),
25" at f/5.6.

HOME DEVELOPED

EI 0.37. Print on No. 3 paper increases contrast. (darker than shadow print), GL3, 50" at f/5.6.

EI 0.37. Print on No. 3 paper restores picture to approximately normal contrast: GL3, 20" at f/5.6.

EI 0.37. Print on No. 3 paper increases contrast. (lighter than highlight print), GL3, 40" at f/5.6.

At EI 0.75 [512x recommended exposure] contrast was low and the prints were gray. At EI 0.37 [1024x recommended exposure] the contrast was still lower. No. 3 paper produced better-looking prints. At these speeds, the No. 2 paper test prints "turned around": the shadow prints needed *more* exposure than the highlight prints to produce the most convincing tones.

Highlight contrast was moderate from EI 1600 to perhaps EI 50, and diminished very gradually as exposure increased from there to EI 0.37. Differences were hard to detect from print to print.

Shadow contrast did not exist in either roll at EI 1600, since there was no shadow detail at all in the negatives. It was still very low at EI 400 and began to rise toward normal at EI 200. The lab roll was contrastier than the home-processed roll, both in dark tones and overall, at EI 200. Both rolls stayed fairly stable in shadow contrast between EI 200 and EI 6, and shadow contrast diminished markedly from EI 6 to EI 0.37.

Inference: Kodak's recommended development for Tri-X seems to be normal for a long-scale subject when the film is given 256 times the recommended exposure, at EI 1.5 instead of ASA 400.

However, the prints show that Tri-X loses definition and picks up enough grain to interfere with fine detail when exposed at EI 1.5 or lower ratings, though the pictures were not bad in other respects.

Presumably it makes more sense to adjust the film for long-scale subjects by developing it somewhat less rather than by increasing exposure this massively.

It is dramatically confirmed here that there is more margin for acceptable error on the overexposure side than toward underexposure. Underexposure by ¼ the recommended exposure produced unacceptable negatives with large areas completely missing, but overexposure by more than 1000 times the recommended amount produced negatives that rendered all tones acceptably and were not even hard to print, though some image deterioration was obvious.)

4. What is the optimum film speed for the test film, developed as recommended?

(DV: I get the impression that there is no one optimum speed, but an optimum *range* of speeds. The prints have essentially uniform qualities in negatives exposed at EI 200, EI 100 and EI 50, with exposures based on darkest-shadow readings, and adjusted for optimum exposure for all the lighter tones.

This is done, as mentioned when the first part of this test was given, by taking a meter reading of the darkest subject area in which detail is wanted in the print, and then giving ¼ the indicated exposure. The reason for doing this is that the darkest tones are the most vulnerable ones. They disappear when not exposed enough.

In the same way, the highlight reading can be interpreted by taking a reading on the brightest subject area in which detail is wanted and "overexposing" it by two stops— that is, giving 4 times the indicated exposure.

The reason is obvious if you consider it. You give dark areas less than the indicated exposure because you do not usually want to print dark shadows as middle grays. You want to print them dark, so a relatively thin part of the negative should represent them.

Similarly, you expose bright highlights in your subject more than a highlight meter reading indicates directly, because you don't usually want to print sunlit snow as middle gray. About four times the exposure a high-

light reading indicates will be enough to give that part of the negative enough density to print as a pale tone, but not so much density that detail and contrast within the tone are lost.

We can therefore figure out the minimum exposure for good dark tones and the maximum exposure for good light tones on Tri-X, developed as recommended, from these test prints.

The minimum dark-tone exposure for good shadow detail is two stops less than EI 200, which equals the indicated exposure for that shadow with the meter set at EI 800.

The maximum bright-tone exposure for Tri-X at its recommended development is two stops more than EI 50, which equals the indicated exposure for that highlight when the meter is set at EI 12.

In practice, it is a poor idea to keep resetting the film speed on the meter. It's too easy to forget to reset it again. Therefore, set it for a middle-gray value according to your own test results.

These values from my tests have already been given as a result of looking at prints— minimum exposure or highest practical rating, EI 200; maximum high-quality exposure or lowest practical rating for top quality on Tri-X at recommended development, EI 50.

For most pictures, I prefer EI 200, since it allows faster shutter speeds and smaller f-stops, for sharper pictures with greater depth of field, and lets me photograph in darker places. Therefore EI 200 is my usual rating for Tri-X. For me, at this speed, a "two-stop overexposure" still falls within the optimum-quality range of the film.

I repeat, do not assume that your results should match mine. I've had students who got drastic overexposure on Tri-X rated at EI 400 and had to switch to EI 800 to get negatives not much denser than my EI 200 ones. There are some wild variables in photography.

These notes on my results are to tell you what to look for, not what to find.)

5. What other differences do you notice in the test results?

(DV: Most things I can identify are mentioned above; but one more difference between the lab roll and the home-developed roll is that the lab roll is distinctly grainier. It does not have coarse grain, but the texture of the home-developed roll is much finer. This accompanies lower contrast in the prints, however, and probably much of the difference would disappear if the two rolls were printed in matching contrast.)

All right, enough for now: do your own test, make your own observations and choose the qualities you prefer.

10

Basic Control—
Film Development and
Negative Contrast

FILM DEVELOPMENT
CONTROLS CONTRAST

This is a basic principle of negative-and-print photography.

Picture contrast starts with subject contrast. The subject's range of luminances—measurable brightnesses—is transferred by the lens to the film as a range of relative exposures. When developed, these become a density range, more or less proportionate to the subject's luminance range. Fortunately, most negatives do not reproduce subject contrast accurately, or they would not be printable. The tonal range of photographic paper is far shorter than the luminance ranges of many things we photograph successfully.

The amount of development you give your film modifies the contrast of your negatives and brings it under control. The longer you develop the film, the higher the contrast will be; the shorter the development, the lower the contrast. The question is, how much development do most of your negatives need? It depends on a number of variables—what you photograph, what film you use, the contrast performance of your camera and your enlarger, your choice of "normal-contrast" printing paper, your taste in print tones, your choice of film developer, and so on.

Experiment 2, in this chapter, will show you how to control negative contrast by film development—that is, how to "tune" your negatives to match the printing characteristics of a normal-contrast enlarging paper.

When combined with the exposure information you get from Experiment 1, contrast control by film development makes it simple to get negatives that print well easily.

WHAT IS CONTRAST CONTROL?

Contrast control is a matter of relating the density and contrast in the thin parts of the negative (representing dark parts of the sub-

ject) to the density and contrast in the "thick" parts of the negative (bright-subject areas) so that all tones, from darkest shadow to brightest highlight, will print in lively, clear tones on a given enlarging paper at the same enlarging exposure. It is tailoring the density range of the negative to fit the tonal range of the paper. When the negative is tuned to a "normal-contrast" paper, it is a "normal-contrast" negative, regardless of the original subject contrast.

The thin areas of the negative must have enough density and contrast to print as rich, detail-filled dark tones. This is achieved mainly by giving the film *enough exposure.* When there is not enough exposure to record dark details on the film, no amount of development will supply them.

The dense areas of the negative must stay thin enough to print as rich, detail-filled light tones. This is achieved mainly by *avoiding overdevelopment* when you process your film.

From this combination of factors comes the ancient truism already mentioned, "Expose for the shadows, develop for the highlights." Although some authorities deny this today, it still works, as Experiment 2 will show you.

WHAT IS "NORMAL-CONTRAST" PAPER?

Normal-contrast paper is that grade of paper on which you can best print most of your pictures, if you shoot the same kinds of subjects that most of us shoot. It is an intermediate grade, neither very low nor very high in contrast. This lets you print pictures of contrasty subjects normally on low-contrast

paper and pictures of low-contrast subjects normally on high-contrast paper. Normal contrast is *intermediate* contrast, where printing paper is concerned.

Photographers differ on the question of which paper grade is normal: some tune their negatives to No. 3 paper, others to No. 2. Either can be right.

I like No. 2 because I find it the easiest paper to use. Its response to changes in print exposure is moderate, yet definite. It is sensitive to change, but not too sensitive: the tonal change stays proportional to the print-exposure change you make.

Many photographers develop their negatives less than I do, and do their normal-contrast printing on No. 3 paper. This leaves two "softer" grades, No. 2 and No. 1, to use with unusually contrasty negatives or for unusually soft prints. If you shoot much in high-contrast situations, this may be a good approach for you.

PAPER CONTRAST IS NOT STANDARDIZED

Like cheese or wine, photographic paper is a complex organic product that changes within its useful life. Paper grades have not been standardized. Within a given grade number, contrast behavior varies somewhat between different companies, different papers from the same company, different surfaces and thicknesses of the same kind of paper, and even between different batches of same-brand, same-weight, same-grade, same-surface paper. This is no disadvantage. When a negative falls between the grades of one paper, another paper will often be just right for it.

For consistency, though, it is good to find one paper that fits most of your pictures and stick to it. The largest volume of production permits the best quality control. Therefore the mass-produced papers made by the biggest manufacturers tend to be more consistent than most others. But choose by quality of performance, not by brand name.

EXPERIMENT 2

In experiment 1, you learned how film exposure controls negative density and has some side-effects on contrast. (The more exposure you give the film, the greater its density. With underexposure, shadow contrast becomes abnormally low compared to the contrast in the other tones of the negative. With *extreme* overexposure, contrast drops in all areas and definition suffers.)

Experiment 2 will show you what happens to the pictures when altered film development changes the contrast of the negatives.

The prints you will make in phase 2 of this experiment will show you what happens when you use "soft" and "hard" grades of paper to compensate for high-contrast and low-contrast negatives.

Phase 3 should bring you close to the optimum development for your personal negatives—the development that lets you print most negatives well, quickly and easily.

When the results of experiments 1 and 2 are combined, they give you all the information you need to test any conventional film-developer-paper combination to arrive at any kind of negative you want. This will help when the film or the paper you have come to know, love and depend on is suddenly discontinued or radically changed.

It is mostly a matter of using your eyes attentively and thinking clearly. Technique becomes self-evident. The problems usually dictate their own solutions.

WHAT YOU NEED FOR THE EXPERIMENT

1. Three subjects of different contrast—low, moderate and high—near enough to each other so you can quickly shoot all of them on each of four test rolls.

2. A reflected-light meter.

3. An adjustable camera.

4. Four short rolls of the film you are testing (you need at least nine exposures per roll).

5. Film-processing setup with D-76 developer (for GAF film, use Hyfinol).

6. Enlarging setup including a supply of "normal-contrast" glossy or semi-glossy paper and a developer such as Dektol or Vividol. For stage 2 of the test, you'll need some No. 1 and No. 4 paper, too.

I cannot know what papers are best for your photography. The following are certainly not the only good papers available, but I have used them enough to know that they work well for me.

No. 1 papers: Agfa Brovira 111, No. 1; Ilford Ilfobrom IBO-1K and IB1-1K.

No. 2 papers: Kodak Medalist J2; Agfa Brovira 111, No. 2; Agfa Portriga-Rapid 111, No. 2; Spiratone Enlarging Paper GL2; Ilford Ilfobrom IB2-1K.

No. 3 papers: Kodak Medalist J3; Agfa Brovira 111, No. 3; Agfa Portriga-Rapid 111,

No. 3; DuPont Velour Black TW3; Spira-
tone Enlarging Paper GL3; Ilford Ilfobrom
IB3-1K.

No. *4 papers:* DuPont Velour Black TW4; Il-
ford Ilfobrom IB4-1K.

No. *5 papers:* Agfa Brovira 111, No. 5; Ilford
Ilfobrom IB5-1K.

No. *6 paper:* Agfa Brovira 111, No. 6.

7. Note-taking materials—paper, pencil.
8. Several days of working time.
9. Plentiful patience.

EXPERIMENT 2, PHASE 1: PROCEDURES

Find Your Test Subjects. (I found mine in
a room.

The high-contrast shot, which had a "ten-
stop" luminance range, included a dimly lit
curtain inside and a sunlit white building
seen through the window.

The moderate-contrast shot, with a "three-
stop" range, used window light falling on a
white cabinet but missing a shaded recess.

The low-contrast shot, with a one-and-a-
half-stop range, shows a flatly lit lamp base
and a little carved head in a dim corner of
the room. Just by pivoting, I could shoot all
three situations in quick succession.)

Meter the Test Subjects. Take a brightest-
highlight reading and a darkest-important-
shadow reading of each subject. Write down
all six readings and the indicated exposure
for each at the optimum-film-speed rating
you identified by evaluating experiment 1.
(In my case, Tri-X at EI 200.)

Compute Your Test Exposures. On each
roll you will make three exposures of each
test subject: one at the optimum film speed
indicated by your experiment 1 results, one
at half that exposure and one at twice that
exposure. (Mine were Tri-X at EI 200, EI
400 and EI 100.)

For the high-contrast and moderate-
contrast shots, base your exposures on the
darkest-important-shadow reading. Give 1/4
the indicated exposure for that dark tone at
each of the three exposure indexes.

For the low-contrast subject, expose half-
way between the meter's indicated exposure
for the highlight and its indicated exposure
for the shadow at each of the three ex-
posure indexes.

Write down the camera setting—f-stop
and shutter speed—for each of the nine shots
on each roll. Put them in consecutive order
and use this note as a guide when you shoot
each roll.

Shoot Four Identically Exposed Test Rolls.
Shoot methodically, but quickly enough so
the light doesn't change significantly before
you finish.

Develop Three of the Test Rolls. Give one
the manufacturer's recommended develop-
ment. Give the second roll just half the rec-
ommended development, and give the third
roll twice the recommended development.
Save the fourth roll for later. You will de-
velop it according to what you learn when
you print the negatives on the first three rolls.

Mark each roll to identify the development
time of each strip and the exposure index for
each negative.

Enlarge Every Negative on the Three De-

veloped Rolls. Print them all the same size, on the same grade and surface of the same normal-contrast paper. Give all prints the same development—two minutes in a standard normal-contrast developer such as Dektol or Vividol, diluted 1:2 (one part stock developer, two parts water), or Ilford Bromophen, diluted 1:3. Use test strips to determine the exposure for each print. Expose the prints simply by turning the enlarger light on and then off after the right number of seconds, with no manipulation to change tones locally. These are to be "straight" prints: that way they show exactly how each negative fits, or fails to fit, the tonal scale of the paper. Each, within these limits, should be the best print you can make.

On the back of each print, write the following data before you expose the paper: film, exposure index used, amount of film development, paper used and the print exposure. This can be condensed: "TX, EI 200, 1/2 rec dev, J2, 15″ f/16."

Fix, wash and dry carefully.

Evaluate Your Prints. In good light, spread the prints out in order of subject contrast, film exposure and degree of development. Examine them all, and ask yourself, print by print:

Is the contrast too high? If the shadows are too dark to be clear, or the highlights too pale, in prints that show the other tones well, the negative is too contrasty for the paper. In terms of the subject and the printing paper, the negative is *overdeveloped*.

Is the contrast too low? If the tones are muddy and lifeless, with weak gray shadows and dull gray highlights, the negative is too low in contrast for the paper. It is *underdeveloped*.

Is the contrast "just right"? When the print has rich, clear, "juicy" shadow tones and brilliant but detailed highlights, the negative is tuned accurately to the normal-contrast paper. It is *normally developed*. Normal development, in practice, may or may not coincide with the development recommended by the manufacturer.

Is the negative underexposed? If the middle grays and highlights of the print have lively contrast, but the shadow tones are absent or are flat and lack contrast, the negative is probably underexposed. (When a more-exposed but identically developed negative of the same subject prints with richer, livelier shadows, but with the same mid-tone and highlight contrast, the underexposure of the thinner negative is established as a fact.)

Is the negative overexposed? If there is great density and a serious loss of contrast, and if the print exposure is tediously long, the negative may be overexposed, overdeveloped or both. When all the tones in a dense negative print with visible detail, but with "mushy," degraded definition and contrast, these are signs of vast overexposure. (If this happens at all in this test, you did something wrong. Start over and repeat the whole test.)

Which of the test negatives have the finest grain? Which have the coarsest grain? Both overexposure and overdevelopment increase grain. Your test prints will tell you which increases grain more than the other. Knowing this, you can suppress grain or cultivate it at will in the future.

Which negatives of each subject produced the best-looking prints? Both exposure and development cues from these pictures can be useful to you. The principle is: *When you find a combination that works well, use it.*

EXPERIMENT 2, PHASE 2: USING HIGH- AND LOW-CONTRAST PAPERS

In theory, it's preferable to make all your negatives so they will print well "straight" on normal-contrast paper. In real life this does not always happen. Fortunately for us, a kindly photo industry has produced enlarging papers that range from extremely high contrast to fairly low contrast, so we can rescue some of our misfortunes and compensate for some of our mistakes.

Many low-contrast negatives can be saved by printing them on high-contrast papers; not quite as many contrasty negatives can be saved by printing them on "soft," low-contrast papers.

The next step in this experiment is to pick out your best flat negatives and your best over-contrasty negatives from the test rolls and print them on the papers most likely to produce a normal-looking print in each case. You can then decide how successful or unsuccessful this approach is for you.

Print your best low-contrast negatives on No. 4 paper, in the same size and using the same procedures you used when printing on normal-contrast paper. Don't forget to write down the print exposure and the rest of the data.

Print your best high-contrast negative on No. 1 paper, technical notes and all. Wash and dry the new prints.

Evaluate Your Prints. Evaluate the No. 4 and No. 1 prints by themselves. Then compare them with each other. Then compare them to your best prints of the same subjects on normal-contrast paper.

EXPERIMENT 2, PHASE 3: DEVELOP THE FOURTH TEST ROLL AND PRINT IT

Using everything—information and feelings—that you've gathered from all your test prints, make an educated guess at the best development time to give the fourth roll of test exposures.

Develop the film accordingly.

Print the best-exposed negatives on the same normal-contrast paper.

If these are the best prints produced in this experiment, you're on the right track. If not, what did you do wrong? (Some people over-compensate, some undercompensate and some introduce changes when none are needed.)

Now apply all that you've learned from tests to your everyday photography for the next half-dozen rolls of film. Print the results and see how the technical decisions work out when the pictures are personal photographs instead of test samples. As you go, keep a critical eye on your prints and modify your negative-making procedures as needed.

Go by feel as much as by analytical knowledge. (It may stun you to realize that, in the end, all our analysis is done to satisfy our undefined and indefinable feelings, but that is the fact.)

MY OWN TEST RESULTS: OBSERVATIONS

My own tests held no big surprises, but some modest ones turned up. Having moved from New York to Chicago between chapters, I found that D-76 develops more vigor-

ously at a given time and temperature in Chicago than in New York City. Still another variable! (Why? I don't know. Guesses: More alkaline water in Chicago or more acid water in New York? The decadence of the East and the vitality of the Midwest?) Anyway, it turned out I needed some readjustment, so the test came in handy.

Test Prints: Low-contrast Shot, 1/2 Recommended Development

EI 400: The darkest tones of this weak, flat print are gray, not black, and are even flatter than the other tones. Cause, underexposure of Tri-X, made worse by underdevelopment. Very fine grain. Print exposure, 11 seconds at f/16 on Kodak Medalist J2.

EI 200: Substantially the same print except for darker, slightly contrastier dark tones. These are still flatter than the rest of the picture, however. Print exposure, 15 seconds at f/16 on Medalist J2.

EI 200 variant: The same negative printed on No. 4 paper. This is a dark print: a slight print-exposure error was exaggerated by the

Low-contrast subject, 1/2 recommended development: Tri-X, EI 400. Print on Kodak Medalist J2, 11" at f/16.

Low-contrast subject, 1/2 recommended development: TX, EI 200. Medalist J2, 15" at f/16.

Low-contrast subject, 1/2 recommended development: TX, EI 200. DuPont Velour Black TW4 (high-contrast paper), 10½" at f/11.

Low-contrast subject, 1/2 recommended development: TX, EI 100. Medalist J2, 25" at f/16.

hair-trigger response of the high-contrast paper. The contrast of the print looks normal, no longer flat, and the grain is fine, though more visible than in the J2 print. Corners of the print are dark due to slight vignetting by the camera lens (the center of the picture got slightly more exposure than the edges and corners): this hardly shows in softer prints. There is an irritating mottled texture due to uneven film development (this goes with very short development times). The mottle does not show in the J2 print. I

think as much was lost by going to No. 4 paper as was gained. Print exposure, 10½ seconds at f/11 on DuPont Velour Black TW4. (Medalist J4, unhappily, has been discontinued.)

EI 100: This print looks like the EI 400 and EI 200 prints on J2, but its dark tones are contrastier. They are now consistent with the rest of the print. The best-looking print of this series, but nothing to write home about. Print exposure, 20 seconds at f/11 on Medalist J2.

Low-contrast subject, recommended development: TX, EI 400. Medalist J2, 12½" at f/11.

Low-contrast subject, recommended development: TX, EI 200. Velour Black TW3 (moderately contrasty), 12" at f/16.

Low-contrast subject, recommended development: TX, EI 200. Medalist J2, 20" at f/11.

Low-contrast subject, recommended development: TX, EI 100. Medalist J2, 35" at f/11.

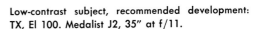

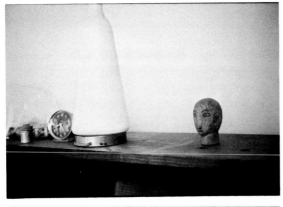

Low-contrast subject, 2× recommended development: TX, EI 400. Medalist J2, 12½" at f/5.6.

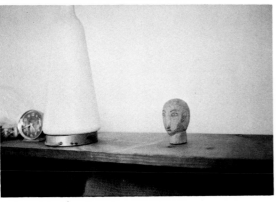

Low-contrast subject, 2× recommended development: TX, EI 200. Medalist J2, 20" at f/5.6.

Low-contrast subject, 2× recommended development: TX, EI 100. Medalist J2, 40" at f/5.6.

Test Prints: Low-contrast Shot, Recommended Development

EI 400: The low-contrast subject looks quite soft in this print that approaches, but does not quite reach, normal-looking contrast. The darkest tones are very flat due to under-exposure. Grain, moderately fine. Print exposure, 12½ seconds at f/11 on Medalist J2.

EI 200: Much like the EI 400 print, but the darkest tones are slightly less flat. Print exposure, 20 seconds at f/11 on Medalist J2.

EI 200 variant: The same negative on No. 3 paper. Temptation overcame me, and I printed this picture on Velour Black TW3 (not specified for the test) to see what would happen. It was moderately gratifying. Normal contrast, moderately fine grain, a fairly agreeable print. Slightly lighter than intended, the print has fairly lively dark tones. Print exposure, 12 seconds at f/16 on Velour Black TW3 (a faster paper than Medalist).

EI 100: Back to softish normal, but with

much better, contrastier dark tones. With this shot, EI 100 works much better than EI 200 and EI 400. Print exposure, 35 seconds at f/11 on Medalist J2.

Test Prints: Low-contrast Shot, 2X Recommended Development

EI 400: Doubling the development raises the contrast and helps the tones, but does not make them "perfect." It also produces quite coarse grain. The dark tones are not gray in this print, they are opaque black. The vignetting is conspicuous due to overdevelopment. Print exposure, 12½ seconds at f/5.6 on Medalist J2 (a hefty and inconvenient increase).

EI 200: For no reason I understand, the overall contrast of this print is distinctly lower than that of the corresponding EI 400 print just described, though the dark detail is contrastier and more visible. (I suppose Tri-X

has a roller-coaster-shaped characteristic curve, not a toe, a straight line and a shoulder as in the books.) The grain is still coarse. The vignetting shows less. Print exposure, 20 seconds at f/5.6 on Medalist J2.

EI 100: "Normal," somewhat lower overall contrast; lighter, contrastier, clearer dark detail. Coarse grain, subdued vignetting. Print exposure, 40 seconds at f/5.6 (this is getting ridiculous!) on Medalist J2.

Test Prints: Moderate-contrast Shot, 1/2 Recommended Development

EI 400: Very flat. Good, though soft, white tones, but the "blacks" are actually anemic grays, due to underexposure of the film. (They are way down on the "toe," where all tones are flat.) Very fine grain. Print exposure, 10 seconds at f/16 on J2 (a thin negative).

EI 200: Still flat. Same good whites,

Moderate-contrast subject, 1/2 recommended development: TX, EI 400. Medalist J2, 10" at f/16.

Moderate-contrast subject, 1/2 recommended development: TX, EI 200. Medalist J2, 15" at f/16.

slightly less weak gray "blacks." Print exposure, 15 seconds at f/16 on Medalist J2 (still thin).

EI 200 variant: Same negative on No. 4 paper. Quite a contrasty print. The blacks are now too black to show detail. Mottle due to uneven film development, not visible in the J2 print, is annoying here. Fine but definite grain. Probably No. 3 paper would do better. Print exposure, 8½ seconds at f/11 on Velour Black TW4.

EI 100: This looks almost exactly like the EI 200 print on J2, except for livelier, but still gray, "blacks." Very fine grain. Print exposure, 22 seconds at f/16 on J2.

EI 100 variant: Same negative on No. 4 paper: same story as the No. 4 print of the EI 200 negative, but more mottled. The blacks are somewhat lighter, contrastier and more visible, but this is still a heavy, depress-

ing print. Fine but definite grain. Print exposure, 11½ seconds at f/11 on Velour Black TW4.

Test Prints: Moderate-contrast Shot, Recommended Development

EI 400: Slightly flat print with very gray dark tones—underexposure again. The whites are livelier than in the less-developed version of this shot. Fine grain. Print exposure, 12 seconds at f/11 on Medalist J2 (fairly normal density).

EI 200: Like the EI 400 shot except for contrastier, darker "blacks" and more visible dark detail. Print exposure, 17½ seconds on Medalist J2.

EI 100: Virtually identical to the EI 200 shot (no gain from added exposure this time). Print exposure, 30 seconds at f/11 on Medalist J2 (a slightly dense negative).

(If I shot mostly this kind of contrast situa-

Moderate-contrast subject, 1/2 recommended development: TX, EI 200. Velour Black TW4, 8½" at f/11.

Moderate-contrast subject, 1/2 recommended development: TX, EI 100. Medalist J2, 22" at f/16.

Moderate-contrast subject, 1/2 recommended development: TX, EI 100. Velour Black TW4, 11½" at f/11.

Moderate-contrast subject, rec-
ommended development: TX,
EI 400. Medalist J2, 12″ at
f/11.

Moderate-contrast subject, rec-
ommended development: TX,
EI 200. Medalist J2, 17½″ at
f/11.

Moderate-contrast subject, rec-
ommended development: TX,
EI 100. Medalist J2, 30″ at
f/11.

tion, with a three-stop [1:8] luminance range, I'd use slightly *more* than the recommended development to get slightly higher contrast. But this is a relatively low-contrast situation in the context of my everyday photography. To bring it to exact "normalcy" would throw many of my more-contrasty shots off and make them hard to print. So I don't develop more than Kodak says to, except for test purposes.)

**Test Prints: Moderate-contrast Shot,
2X Recommended Development**

EI 400: A hard-boiled, contrasty, grainy print. If any dark detail existed, it was lost, swallowed by an inky pool of black. Print exposure, 32 seconds at f/8 on J2 (a dense negative).

EI 200: Much like the EI 400 print, but with livelier, more visible dark detail. Coarse-grained and crude. Print exposure, 45 seconds at f/8 on Medalist J2.

EI 200 variant: Same negative printed on No. 1 paper. This print is slightly more contrasty than the recommended development version of the same shot as printed on Medalist J2; but it is much softer than the print of this negative on J2. Tonally, it is one of the more pleasing prints in this set, with lively, normal-looking contrast. The grain is quite coarse. Print exposure, 22½ seconds at f/8 on Agfa-Gevaert Brovira 111, No. 1.

EI 100: Much like the J2/E1 200 print, but this one has much lighter and better-looking dark tones. (Remember, the 200-to-100 difference didn't show in the recommended-development set of the same shot. You never can tell.) Coarse grain, agreeable tones. Print exposure, 45 seconds at f/5.6 on Medalist J2 (dense!).

**Test Prints: High-contrast Shot,
1/2 Recommended Development**

EI 400: The print feels soft and gray, but

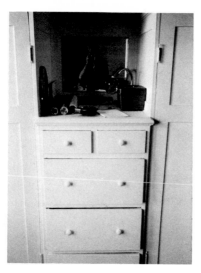

Moderate-contrast subject, 2×
recommended development: TX,
EI 400. Medalist J2, 32″ at f/8.

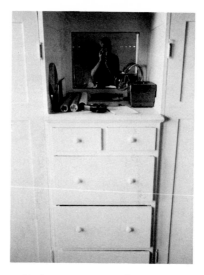

Moderate-contrast subject, 2×
recommended development: TX,
EI 200. Medalist J2, 45″ at f/8.

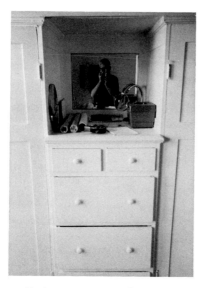

Moderate-contrast subject, 2×
recommended development: TX,
EI 200. Agfa-Gevaert Brovira
111, No. 1; 22½″ at f/8.

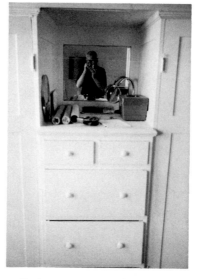

Moderate-contrast subject, 2×
recommended development: TX,
EI 100. Medalist J2, 45″ at f/5.6.

BASIC CONTROL—FILM DEVELOPMENT AND NEGATIVE CONTRAST 189

has full detail in the dark curtain indoors and some rendition of the sunlit white building outdoors (approximately 1000 times as bright as the curtain according to the meter —a ten-stop range). Traces of flare "leak" into edges of the window frame. Very fine grain. Print exposure, 17 seconds at f/11 on Medalist J2 (normal density).

EI 200: Similar. Slightly more flare, very slightly higher contrast in curtain. Print exposure, 27½ seconds at f/11 on Medalist J2 (slightly dense. Natural when you consider that the meter reading is based on the darkest tone—and here the bright tones are exceptionally bright. Exposure piles up, and a high fog level adds to it).

High-contrast subject, 1/2 recommended development: TX, EI 400. Medalist J2, 17" at f/11.

High-contrast subject, 1/2 recommended development: TX, EI 200. Medalist J2, 27½" at f/11.

High-contrast subject, 1/2 recommended development: TX, EI 100. Medalist J2, 16" at f/8.

Photographic Control

EI 100: Same but more flare. Print exposure, 16 seconds at f/8 on J2.

Test Prints: High-contrast Shot, Recommended Development

EI 400: Curtain and wall are somewhat contrastier than in half-recommended-development versions of this shot. The bright sunlit building is mostly washed-out blank-white here. Considerable flare, moderately fine grain. Print exposure, 27½ seconds at f/11 on Medalist J2.

EI 200: Contrastier curtain, more flare, building more washed out. Print exposure, 24 seconds at f/8 on J2 (definitely a dense negative).

EI 200 variant: Same negative on No. 1 paper. Wall and curtain are lighter than on the J2 print, and much more of the sunlit building is visible. Still some flare, but more detail can be seen through it. Moderately fine grain. This print has higher contrast than the J2 prints of negatives that got half the development. Print exposure, 40 seconds at f/11 on Brovira 111, No. 1.

EI 100: Like the J2/EI 200 print, but more flare, and the sunlit building is less visible. Print exposure, 15 seconds at f/5.6 on Medalist J2.

Test Prints: High-contrast Shot, 2X Recommended Development

EI 400: Brilliant contrast in wall and curtain, extreme flare, only faint traces of anything outside the window. Coarse grain. Print exposure, 25 seconds at f/5.6 on Medalist J2 (very dense negative).

EI 200: Same but more flare. Print exposure, 40 seconds at f/5.6 on J2.

EI 200 variant: Same negative on No. 1 paper. Slightly softer and more detailed in bright whites than the recommended-development/J2 prints. Grain very coarse, flare considerable, but this is an agreeable print. Print exposure, 60 seconds at f/5.6 (!) on Brovira 111, No. 1.

EI 100: Same as EI 200 on J2, but with maximum flare. Almost all outdoor tone is wiped out. Oddly, though this print shows

High-contrast subject, recommended development: TX, EI 400, Medalist J2, 27½" at f/11.

High-contrast subject, recommended development: TX, EI 200. Medalist J2, 24" at f/8.

High-contrast subject, recommended development: TX, El 200. Brovira 111, No. 1; 40″ at f/11.

High-contrast subject, recommended development: TX, El 100. Medalist J2, 15″ at f/5.6.

High-contrast subject, 2× recommended development: TX, El 400. Medalist J2, 25″ at f/5.6.

High-contrast subject, 2× recommended development: TX, El 200. Medalist J2, 40″ at f/5.6.

very little, it looks good. Print exposure, 72 seconds at f/5.6 (!!) on Medalist J2.

INFERENCES

My test prints produced quite a bit of use-ful information. Remember, though, that I am as odd a photographer as you are, and this test series has my set of variables built into it—as your test will contain your vari-ables. Some of them are likely to differ: once again, believe your results more than you be-

High-contrast subject, 2× recommended develop-
ment: TX, EI 200. Brovira 111, No. 1; 60" at
f/5.6.

High-contrast subject, 2× recommended develop-
ment: TX, EI 100. Medalist J2, 72" at f/5.6.

lieve mine. Mine are true for me, but not
necessarily for you. Now for the questions
and answers.

**How did the different subject-contrast situ-
ations relate to different film developments?**

The low-contrast shot looks most normal
when a moderately developed negative is
printed on a slightly contrasty (No. 3)
paper. Similar contrast is reached on No. 2
paper by doubling the film development, but
this also produces very coarse grain. (Grain
is not always "bad," so this piece of informa-
tion is part of my range of conscious choices.
When I want grain, I know how to get it; and
I know that low-contrast subjects are the log-
ical ones for the treatment.)

The moderate-contrast shot looks best with
moderate development—no surprise. An
overdeveloped negative of it, printed on No.
1 paper, has beautiful tones and coarse grain.
Clearly, *overdevelopment builds grain much
more actively than overexposure does.*

The high-contrast shot is at its best with

decreased film development. For this picture,
the recommended development is a consider-
able overdevelopment.

How Will I Develop Roll 4? To answer
that, I must consider my everyday photogra-
phy (my variables). What do I shoot? Every-
thing! In terms of contrast, my subjects range
from the flattest to the most contrasty. I have
a real weakness for shooting from dark coal
cellars directly into the sun surrounded by
bright white clouds—and I want to *see* all
the coal in the shade and all the bright
clouds. (No extremist, I don't insist on a
clear rendition of sunspots.)

Too many of my shots are in the eight-to-
twelve-stop ranges for the recommended de-
velopment to be short enough for me, yet
enough are in the three-to-six-stop ranges so
I don't want to chop off too much develop-
ment time. A compromise is called for—
what I'm after is a development that will let
me print most negatives "straight" on No. 2
paper with an occasional No. 3 print thrown

in; and that will also let me reach for the extremes—No. 1 paper and No. 6 paper—with best results and minimum fuss.

No development can possibly be right for all my shots; but the compromise that leaves me the most choices and the easiest work is to develop *a little* less than Kodak tells me to. About 10 percent below the recommended time is my current choice. (It used to be 30 percent less, but Kodak has veered in my direction where Tri-X is concerned.)

Whether that development is right for you, only your own photography will tell you. The best things I can say for the 10-percent chop are: It works fine for me, and it won't get anybody into really bad trouble that can't be taken care of in printing.

What About Exposure? This experiment continues to confirm what experiment 1 showed me. *In terms of the shadow contrast I require in my pictures, the recommended exposure for Tri-X (ASA 400) is underexposure;* therefore I rate Tri-X at EI 200 instead.

The shadow *detail* is all there and printable at EI 400 (same speed as ASA 400), but the shadow tones are sickly and I say, the hell with them. For richly printed spinach in the shade, expose at least as much as EI 200 dictates. No serious loss of quality sets in before a 20x overexposure, as long as the film is not overdeveloped. There is room: Kodak has made a superb, forgiving film here. I do not say they are wrong about the speed—they just haven't taken my taste for fat, rich shadows into account. In exposure, *all* the latitude is on the "over" side, at least for conventional black-and-white negatives. Experiment 2 repeats what experiment 1 already established: If you want deep black tones, expose plenty. (The myth that under-exposure will give you "good, rich blacks" is mistaken: underexposure gives you weak, sickly grays instead when the other tones are printed at their best.)

Using Paper Contrast to Compensate for High and Low Film Contrast.

Other things being equal, it works beautifully. In this test, alas, other things are not equal. They seldom are.

Therefore overdevelopment introduces more grain than you will usually want, though the tones print beautifully on No. 1 paper.

Therefore the mottled tones of a greatly underdeveloped negative are dramatized as much as the picture is by the use of high-contrast paper.

With *slight* over- and underdevelopment of the film, these effects are less marked, so contrast control by paper grade is generally practical if the negatives—unlike the over- and underdeveloped negatives in this test—are reasonably close to normal development. At a guess, I'd say within 30 percent over or under should work all right for subjects of average contrast or the contrast that is "favored" by the development (high contrast is favored by slight underdevelopment, and low subject contrast is favored or modified by slight overdevelopment).

In general, we do best when the negatives fit normal-contrast paper.

LATITUDE

Summing up the latitude lessons from both experiments:

You can get away with slight underdevelopment better than with overdevelopment, unless you are fond of coarse grain (if you are, why not?).

You can get away with great overexposure better than with the slightest amount of underexposure *as long as you don't overdevelop the film.*

Probably the strongest argument against overdevelopment is that it makes preposterously long print exposures necessary.

So make your mistakes on the overexposure side and on the underdevelopment side and your negatives will readily forgive you. Better still, expose and develop accurately, and they will actively help you.

RULE-OF-THUMB
CONTRAST CONTROL

Once you have done these experiments accurately and thoroughly, you should know enough not to have to repeat the whole business the next time the film or the paper is changed. There are short cuts in which you use your regular shooting as test negatives.

Kodak has said that a 25-percent change in film development produces about a one-paper-grade change in negative contrast. On this rough but useful starting point, we can build a method for closing in on the exact degree of development that works best for each of us as an individual, non-standard photographer.

What to Do About Flat Negatives. Develop more. For a start, 20 percent more. *Print and see.* If the prints are beautiful, hold it right there.

If the prints are still too soft, add a further 20 percent to your development, then print

again. If the increase was too much, go back to 10 percent more than your longest "too-flat" development, and fine-tune from there.

What to Do About Contrasty Negatives. Develop 20 percent less, for a start, and print the result. If the prints are "perfect," go no further.

If they are still too contrasty, decrease development by a further 20 percent. Print and see.

If the new prints are now too soft, go back to 10 percent less than your shortest "too-contrasty" development time, and you'll be very close.

CURING SYMPTOMS:
CHEMICAL INTENSIFICATION
AND REDUCTION

With some risk and usually some loss of photographic quality, you can chemically change the contrast and density of developed negatives by intensification or reduction. Contrast and density can be increased or decreased.

I mention this so you'll know about it if you need it, but I am not enthusiastic about these techniques. I recommend an easier solution: Make good negatives.

If you apply the information you gain from experimenting methodically and observantly—a matter of noticing what works and what doesn't—you should quickly gain enough control so you'll never need intensification or reduction. You will be intense enough, and not too dense.

11

Basic Control—
Using Paper Contrast
to Control Print Contrast

KINDS OF ENLARGING PAPER

Photographic papers come in a bewildering variety of surface textures, paper and emulsion colors, thicknesses, speeds and degrees of contrast.

To avoid confusion, and for good results, I suggest that you use double-weight glossy or semi-glossy enlarging papers for a start.

Surface Textures

The surfaces of printing papers range from rough and dull to smooth and shiny.

Glossy Papers. In general, glossy and semi-glossy papers are the easiest to use well, since they offer the greatest range of print tones and change appearance less than other papers when they dry.

Matte and semi-matte papers. Dull-surfaced papers look as good as glossy ones while the prints are still wet from processing; but when the prints dry, the surface reflects a veil of scattered light that gets between you and the picture. This degrades the dark tones, turning lively blacks into lifeless grays. By working consciously within the paper's limitations, it is possible to make excellent prints with a full range of tones on dull-surfaced papers; but the negative must have relatively high shadow contrast or it's difficult. For most photographers, these are not the best papers to use while learning to print.

Different manufacturers use different code letters or numbers for their paper surfaces. Here are a few that represent much-used papers in glossy and semi-glossy surfaces:

Agfa-Gevaert (double-weight glossy): 111
DuPont (double-weight glossy white): TW
(double-weight semi-glossy white): BTW
GAF (glossy): GL
Ilford (double-weight glossy): 1K
Kodak (glossy): F
(semi-glossy): J
Spiratone (glossy): GL

Paper Thickness. Most photo papers give you a choice of single weight (thin) and double weight (slightly thicker). Other thicknesses exist, but are uncommon.

Single-weight paper is comparatively hard

to handle while wet without damaging the prints, and it tends to curl into tubes after drying. On the credit side, it costs less than double-weight paper and it is easier to ferrotype (gloss-dry on a polished "tin" or drum).

Double-weight paper is easier to process and handle without damage, and curls less when dry, so I prefer it. I don't ferrotype my prints: they're shiny enough without that.

Paper Speeds. There are good and poor fast papers, and there are good and poor slow papers. The speed of the paper has little bearing on the quality of the print. Use the papers that suit your pictures best, whatever their speeds.

New ANSI (American National Standards Institute) standards for paper speed have been established, but most manufacturers have not yet adopted them. Making test strips is still one of the most useful ways to determine print exposures.

Paper Contrast. There are three categories of enlarging paper: contrast-graded paper, variable-contrast paper and monocontrast paper.

GRADED PAPER

Most printing papers are graded according to contrast. A given brand of paper will come in two to six different degrees of contrast, each identified by a code number on the package. The smaller the number, the lower the contrast; the larger the number, the higher the contrast.

In general, the grades may be described as follows:

No. 1: low-contrast paper—normal prints from contrasty negatives, flat prints from normal and soft negatives.

No. 2: normal-contrast paper—normal prints from normal negatives, soft prints from low-contrast negatives, contrasty prints from contrasty negatives.

No. 3: moderately high-contrast paper—normal prints from slightly soft negatives, slightly contrasty prints from normal negatives.

No. 4: high-contrast paper—normal prints from low-contrast negatives, contrasty prints from normal negatives.

No. 5: very high-contrast paper—normal prints from very soft negatives, very contrasty prints from normal negatives.

No. 6: extremely high-contrast paper—normal prints from extremely flat negatives, ultra-high-contrast prints from normal and contrasty negatives.

The grades are not standardized. The actual contrast of any grade number will vary from one manufacturer to another and from one paper to another. In addition, because photographic paper is a complex organic product, a given paper may change in its inherent printing characteristics over the years. I use one No. 2 paper that used to be unusually contrasty—call it a No. 2½—a few years ago. New boxes of this paper are now unusually soft, more like a No. 1½. That doesn't make it less excellent or useful: it just means I use it for contrastier negatives than I did before.

Besides such changes in manufacture, the paper in any package will gradually lose speed and contrast as it ages past its "expiration date" (stamped on the package by most manufacturers). Far from being a problem, this is a positive advantage: it gives us in-

between grades of paper to use with between-grades negatives. Manufacturers' expiration dates for printing paper are typically conservative. The paper is usually good for two or three more years, and may last twice that long.

We are lucky that papers vary both widely and subtly in contrast. Instead of having a few fixed choices, we have many possibilities. Once you know the papers on your shelf, the pictures will tell you, in effect, which papers they will work best with. A little silent voice says, "Print me on Medalist J3," or "I need Velour Black TW3"—very different papers in feeling, though they share a similar contrast range.

Each paper has what amounts to a personality, and bends the expression of the picture in its own direction. This may sound like nonsense, but in fact it is an important resource for the photographer who wants his "meanings" to be exact in the print. It's comparable to the different timbres of different musical instruments playing the same phrases in the same pitch range: a trumpet and a viola do entirely different things. That's how it is with papers.

A partial list of good double-weight glossy and semi-glossy papers follows. I have not printed on all grades of all of them, but have liked the grades I've used.

Graded Enlarging Papers:

Agfa-Gevaert: *Brovira 111*—1,2,3,4,5,6
Portriga-Rapid 111—2,3,4

Dupont: *Velour Black TW*—1,2,3,4

Ilford: *Ilfobrom 1K*—0,1,2,3,4,5 (printed as "IB3-1K," with the grade number in the middle).

Kodak: *Medalist F*—2,3
Medalist J—2,3

Spiratone: *Spiratone Enlarging Paper GL*—2,3

In general, the Agfa papers from No. 4 through No. 1 are lower in contrast than American-made graded papers with the same numbers. They were originally coded by contrast letters for a European market, and the Agfa Brovira numbers are consistent within the meanings of these:

No. 1 = BEW ("extra soft")
No. 2 = BW ("soft")
No. 3 = BS ("special")
No. 4 = BN ("normal")
No. 5 = BH ("hard")
No. 6 = BEH ("extra hard")

"Spezial" or No. 3 Brovira seems to me about equal to most American No. 2 papers in contrast.

The Ilford papers, from No. 2 through No. 5, seem contrastier than the same grades in American-made papers.

VARIABLE-CONTRAST PAPERS

The contrast of variable-contrast papers can be changed at will by using filters to change the color of the light that is used to expose the print (or, in a few enlargers, by changing the color of the light source).

How v/c Papers Work. About half of the paper's emulsion is sensitive to light of a certain color, and produces a relatively contrasty image. The other half is sensitive to light of a different color, producing a low-

contrast image. Neither half of the emulsion responds to the color of light that exposes the other half, but both respond about equally to "white" light as it is produced by standard incandescent enlarging bulbs (cold-light enlargers change the contrast of v/c papers unless correction filters are used to "whiten" their bluish light). The contrast filters used with v/c papers work by varying the proportions of both colors of light (and of white light) that reach the paper.

The way v/c emulsions are made is a manufacturer's problem, not ours; but there are two main approaches. One is to coat the paper with two thin emulsions that have the required characteristics and are matched to each other. The other approach is to make a single emulsion in which some grains are contrasty in their behavior and are sensitive to, say, blue light, while other grains are yellow-sensitive and tend to produce a low-contrast image. When the exposing light contains blue but no yellow, the print is contrasty; when it contains yellow but no blue, the image is soft. An equal mixture of yellow and blue, with this hypothetical emulsion, would produce a print of intermediate or "normal" contrast. A filter that transmits 75 percent yellow and 25 percent blue will have lower-than-normal contrast, but not as low as that produced by a filter that passes only yellow light.

In practice, a variable-contrast paper is like several papers of different grades that come in one box. It's as easy to use as any paper. The contrast is normal (equivalent to No. 2) without a filter, and you choose grades according to need by picking the filters. The higher the filter number, the higher the contrast.

The range of contrast attainable with a typical v/c paper is not as great as the range you can get from graded papers, but it is enough for most needs. In general, it is fair to say that the contrast range of v/c papers, though it is described as equal to the range from No. 1 through No. 4 graded papers, is more often equal in practice to grades from 1½ to 3 or 3½.

One great advantage of v/c paper is that you can get any degree of intermediate contrast—between the grades—by using two filters for successive exposures on the same sheet of paper.

These in-between "grades" are available either by using the two filters closest to the desired contrast (the PC-2 and PC-2½ filters, for example, when you want a "grade-2¼" print on Kodak Polycontrast), or by using the lowest- and highest-contrast filters —the PC-1 and PC-4—for a "split exposure." The whole print is exposed twice— once through the PC-1 and once through the PC-4. Either filter can be used first; the order doesn't seem to matter. The relative lengths of the soft and hard exposures control the contrast of the print. It works the same way with DuPont filters as with Kodak ones.

This split-filter technique is seldom needed. It is a refinement, not a primary technique. (For more about split-filter printing, see pages 251–254.)

V/c Filters. Present-day American v/c papers use either of two sets of filters: the five-filter set made by DuPont for Varigam and Varilour, and the seven-filter set made by Kodak for use with Polycontrast and other Kodak v/c papers. DuPont filters work well with Kodak papers, and Kodak filters work well with DuPont papers, so there is no need

to buy two sets of filters. GAF v/c papers use either the Kodak or the DuPont filters: as far as I know, there are no GAF v/c printing filters.

Overdoing It. Many photographers go overboard with v/c filters, like the man who once told me in great detail why he used all ten of the original Varigam filters (the five-filter set is more recent) in exposing each print.

Each filter, he said, had a vital expressive purpose, which he described at length. As far as I could tell, all the qualities he attributed to the filters were imaginary. I must admit that his prints were beautiful. He enjoyed it all, and he had the time, so why not? But such contortions are not necessary. Two filters will deliver all the variations that are possible with the paper: more often, one filter or none will do as well.

Some v/c Filters Fit Between the Lamp and the Negative. If you have an enlarger with a variable condenser that lets you open a little door and slip a filter in, or one with a filter drawer between the lamphouse and the negative carrier, I suggest that you get acetate filters of the same size as your condenser that can be used above the negative. This eliminates any risk of optical interference caused by surface irregularities in the filters.

Other Filters Go Under the Lens. If you can't place filters above the negative, you can buy smaller filters and a holder that fits below the enlarging lens. These are excellent for most printing, but may limit your ability to use more than one filter for a single print. (I have an old set of Polycontrast filters which do not lie exactly parallel in the holder under the lens, so the No. 1 and the No. 4 filters project their images onto the paper

slightly out of register, giving the objects in the pictures double edges when both filters are used. My acetate above-the-lens filters cause no problems at all, but could not be used on the enlarger for which I long ago got the below-the-lens filters.)

Exposure Compensation. The different filters transmit different amounts of light, so the exposure must be adjusted when you change filters. Having noticed that the ANSI speeds given by Kodak for Polycontrast with the different filters do not apply usefully to the Polycontrast paper I've used, I just make new test strips for each new filter as I print, rather than try to calculate corrections for calculations that have gone adrift. Test strips are not only quicker and easier, they are accurate. They save time, work and paper.

Here are some of the best-known variable-contrast papers:

DuPont:	*Varigam TW*
	Varilour TW
	Varilour BTW
GAF:	*Vee Cee GL*
Kodak:	*Polycontrast F*
	Polycontrast J
	Polycontrast Rapid F
	Polycontrast Rapid RC F

(Polycontrast Rapid RC, introduced in 1972, is resin-coated so that its paper base absorbs little or no liquid during processing. It requires a short fixing time—two minutes—and a short washing time—four minutes, according to the Kodak instruction sheet packed with the paper. It comes only in "MW"—medium weight, between single weight and double weight. The glossy surface is shinier than that of most Kodak F papers.)

MONOCONTRAST PAPERS

These have only one degree of inherent contrast for each paper: no grades, no filters. Typically, they are warm-toned professional portrait papers, designed for printing studio portrait negatives made with standard exposures under controlled studio lighting. But sometimes they work beautifully for other pictures.

These are silver-rich papers, highly responsive to variations in print development, and relatively vulnerable to fog and stains when handled and processed carelessly. Yet they are so rich and beautiful when handled with due respect that sometimes they are the only choice for a picture that needs rich or subtle tones.

Handle them with care, use fresh solutions in clean trays, and do not prolong the development too much or overfix them (they bleach readily in hypo), and they will serve you well.

Not many monocontrast papers are still made: warm-toned graded and v/c papers seem to be replacing them. Two gradeless papers I have recently used with pleasure are *Kodak Ektalure E*, with a brown emulsion on cream-white paper and a smooth, moderately lustrous eggshell texture; and *Luminos Chlorobromide Luxor E*, a rich, neutral-toned emulsion on warm white, with a slightly shinier, lumpier eggshell surface.

ABOUT RELATIVE PAPER CONTRAST

Because the contrast of most papers continually fluctuates somewhat, it is impractical to try to chart the exact relationships in con-trast between all the papers and v/c filters listed here. Such a chart would not stay accurate long.

Besides, most contrast differences between papers are not simple. How would you chart two papers, one of which has higher highlight contrast but lower shadow contrast than the other? You can't call them equal, but neither can you say in general terms that one is harder or softer than the other. Multiply this problem by the number of papers listed and you will understand why I do not attempt such a chart.

For practical purposes, print, notice what happens and suit the paper to the picture and the negative according to your own taste and experience.

A CLOSER LOOK AT CONTRAST: NEGATIVE CONTRAST REVIEWED

By now you know that different negatives have different degrees of contrast, caused by several factors: the range of brightnesses in the subject, the degree of film development and, to a lesser extent in most picture taking, how much the film is exposed. Underexposure flattens dark tones in the picture; great amounts of overexposure flatten all tones.

You have learned that negative contrast consists of the density range of the image on the film, through which you send light to expose the print.

You understand that the print is a paper negative of the film negative, representing thin film densities with dark print tones and "thick" black film densities with light print tones. A negative of a negative is a positive.

The Contrasty Negative. When the thinnest and densest parts of the negative have

extremely different densities, a great deal of light will pass through the thin areas while very little light manages to struggle through the densest areas. To get a normal-looking print from this high-contrast negative, you compensate by using a low-contrast paper.

The Flat Negative. When the thinnest and densest areas of the negative have almost equal density, not much more light passes through the thin areas than through the denser areas. This is a flat or low-contrast negative, which will produce a flat, gray-on-gray print unless a high-contrast paper is used to amplify the weak differences between the densities.

The normal negative is one whose density range fits "normal" paper (not high- or low-contrast paper) to produce a conventional print with a 50–50 compromise between *liveliness of tone* and *clarity of detail* in all its tones, from "the whites" (grays that say "white") to "the blacks" (grays that say "black" so you believe it).

PAPER CONTRAST REVIEWED

Back in chapter three, we touched on the nature of print contrast; but you may need reminding by now.

Print contrast, unlike negative contrast, is not primarily a matter of density range. A "soft" print and a "hard" one can have the same density range, either from paper white to saturated black or between any two grays.

Print contrast is the *abruptness* of tonal change across the surface of the print. Drastic changes are seen as high contrast; gradual changes are seen as low contrast.

This has some odd side-effects. For instance, when you print larger, you get a softer-looking print if you match the tones of a small print accurately, mostly because the change from tone to tone has been stretched across a longer distance on the paper. This is one reason why good small enlargements are easier to make than good big ones. When Modernage, a leading New York custom lab, made mural-sized prints from negatives that Ansel Adams prints for himself in the 8 × 10 format on No. 2 or No. 3 paper, the large prints had to be made on No. 5 paper to match the *feeling* of contrast in the smaller prints.

Shadow Speed, Highlight Speed and Contrast. The following may upset some tidy preconceptions, but it is a little too neat to be exactly true itself. I'm trying to make the principle clear, not describing the precise observed behavior of actual papers.

Paper contrast consists largely of the relationship between the paper's "shadow speed" and its "highlight speed": the amount of light it takes to print shadow tones with rich, lively dark detail as compared to the amount of light that will print highlight tones with rich, lively pale detail.

Normal Negative, Normal Paper. When a normal negative is printed on a normal-contrast paper, the negative's moderate density range matches the paper's moderate "scale" or sensitivity spread between its highlight and shadow speeds.

Contrasty Negative, Soft Paper. When a contrasty negative is printed on a low-contrast paper, the print looks normal because this paper's sensitivity spread is very wide. It responds less abruptly than a normal-contrast paper to differences in the intensity of the light that strikes the paper, so a 200-to-1 density difference in the negative may be

"compressed" to fit within the paper's 50-to-1 maximum tonal range. In this hypothetical case, it takes 200 times as much light to form a "detailed black" print tone as to form a "detailed white" tone. (The figures are imaginary: I have never actually measured the densities of a negative I liked well enough to print. Somehow that seems like measuring the girl to find out if you love her. The printing that matters is *subjective*: you go by feeling-plus-knowledge, not just by data.)

Soft Negative, Hard Paper. When a flat negative is printed on a contrasty paper, the print looks normal because this paper's sensitivity spread is very narrow (its "scale" is "short"). It responds with exaggerated eagerness to relatively small differences in the light that reaches the paper. A 5-to-1 range of negative densities may be expanded to produce tones that use the whole 50-to-1 black-to-white range of the paper. In this imaginary case, it takes only five times as much light to print "detailed black" as to print "detailed white."

"Hard" Papers. Print exposures on contrasty papers must be extremely accurate, or the tones will be much too light or dark. This is tricky work.

"Soft" Papers. With low-contrast papers, it takes a large change in print exposure to produce a small change in print tone. This can be tedious work.

Normal-Contrast Paper. Called normal largely because print-exposure changes produce proportional-seeming tonal changes, not amplified or suppressed ones. Normal papers are less temperamental than hard ones and less sluggish in their responses than soft ones. If your negatives are normal, printing on normal papers is easy.

Paper Speed and Contrast. The speed—the relative sensitivity—of a paper is no simple matter. It is not accurate to say that a No. 2 and a No. 3 paper have "the same speed": the contrast difference between them consists of speed differences.

If their *shadow speeds* are equal, the No. 3 will have a slower highlight speed. If their *highlight speeds* are equal, the No. 2 paper will have a slower shadow speed (its dark tones being less black when its light tones match those of the No. 3 paper). If their *middle-gray speeds* are equal, the No. 3 paper will have a slower highlight speed and a faster shadow speed (whiter light tones, blacker dark tones) than the No. 2.

Thus the relative speeds of papers vary with the picture you print. If the middle-gray speeds of a No. 1 and a No. 4 paper are equal, then a "normal" negative of a dark picture (black cat, coal cellar, midnight) will require less print exposure to reach detailed black on No. 4 paper than on No. 1; but if you print a "normal" negative of a pale picture (white cloud, sunlit snow), the No. 4 paper will need a longer print exposure to reach detailed white than the No. 1.

I repeat, these are hypothetical cases, using Platonically ideal papers: the soft ones consistently soft, the normal ones consistently moderate and the hard ones consistently hard across the whole black-to-white scale. Actual papers sometimes behave like this, but they can surprise you. One may have hard shadows and soft highlights, another will be the other way around, and a third will have normal middle grays but soft highlights and shadows. In the pictures, you don't analyze these differences, you feel them.

Moral: Make test strips. Don't believe that

anything you read applies exactly to anything you do. The most accurate technical data apply to specific conditions which you and I will never duplicate in our normal work, so for us the data given are approximate at best. Test strips are a way to see what happens, not what is supposed to happen. They have no illusions: that is their strength.

TESTING TO FIND THE RIGHT GRADE

Choosing the appropriate paper grade or v/c filter is part of the normal evaluation of test strips.

Use the same slice of the picture for all test strips. Be sure to write down the paper grade or v/c filter, as well as the print exposure, on the back of each test strip and print, or total confusion is likely.

To get full information, include these tones in each strip: the darkest and the lightest important tones in the picture, and the "key" tone, if any, of your subject (in a portrait, the face tones).

You will usually know at the start what grade you want for a picture. If so, use only that grade for the first test strips. They will soon confirm that you're right or show that you're wrong.

If the dark tones of a test strip look good but the light tones are washed out, or if the light tones look good but the dark tones are too dark, the paper contrast is too high. Try a softer paper grade or v/c filter for the next set of test strips.

If the light tones look good but the blacks show as weak grays, or if the blacks look good but the whites are too dark, the contrast is too low. Try a contrastier grade or filter.

If the face tones in a portrait or the grass tones in a picture of a meadow look gray and lifeless, try new strips on contrastier paper. If they look harsh and hard, with that "soot-and-chalk" quality, try lower-contrast test strips.

If in doubt, it sometimes helps to raise or lower the contrast by more than one grade. It is better to overcompensate than to pussyfoot. When you miss your target on both sides, you have it "surrounded" and know you can get close by aiming the next try in between. This is quicker, easier and may have less tendency to distort your judgment than the frustrating method of creeping up on your goal by tiny corrections that are too small to be decisive.

Another approach is to ask yourself which grade would be the closest too-soft one, and which grade would first be too contrasty. Expose test strips on both, and on the grade or grades between them. After all the strips are exposed, you can save time by developing them all together. Keep them moving in the tray and don't let them stick together, or uneven development may make them useless. Fix the strips, rinse them and look at them on your inspection board. Assemble the strips of each grade together, in the same order for each grade: light, middle, dark, and so on. One grade will probably look better than the rest. If so, find the best-looking exposure for that grade and use it to make a preliminary print.

If strips on two grades look equally good, make a preliminary print on each at its best-looking exposure as seen on the strips. These prints can also be developed and fixed together: agitate them by placing each on top

of the other in turn, throughout development, stop bath and fixing. Rinse them, put them on the board and compare them. They should show you enough to help you make a new print that is stronger than either of them.

You may have difficulty deciding at first. Beginning printers often have no awareness of photographic tone, so they can't tell what tones they like. I can think of only one solution: get some experience and grow some tone sense. Do a lot of printing and look attentively at prints by others.

When you have a number of prints done in different ways, some will look terrible to you and others will look good. That may not seem important, but it is. These little likes and dislikes are the beginning of personal taste in printing.

EXPERIMENT 3

This is a methodical way to try out contrast and light-or-dark alternatives in printing. The principle: When you don't know which way to go, try all directions.

There are nine main tonal alternatives in photographic printing, so a set of nine different prints can show you all of them for any negative.

The experiment is to make the nine prints, look at them and decide for yourself which direction works best for the picture.

What are the nine prints? Three of relatively normal contrast—one light, one "medium," one dark; three of lower contrast, also light, medium and dark; and three of higher contrast, light, medium and dark. If none of them seems to point in the right

direction, there may be no right direction: then you may have to start over with a different picture.

WHAT YOU NEED FOR THE EXPERIMENT

A normal-contrast negative of a picture that you like.

A low-contrast negative of a picture you like.

A contrasty negative of a picture you like.

A darkroom with an enlarging setup.

Normal-contrast glossy or semi-glossy enlarging paper (No. 2 or No. 3, or v/c paper with "normal" filter or no filter).

Low-contrast paper (No. 0 or No. 1 paper: I know of no v/c paper that is this low in contrast).

High-contrast paper (No. 4 or v/c paper with most contrasty filter: No. 5 or No. 6 paper for higher contrast).

Soft pencil to write data on test strips and prints.

WHAT YOU DO

Start with the normal-contrast negative and a normal-contrast paper or a v/c paper with normal filter (or none).

Make test strips to learn what exposure will give you a print that is not light or dark, but in between. Make the print.

With the help of test strips, make two more prints on this paper: the darkest one you can make in which the tones are clear and look good; and the lightest acceptable print.

Now change to the low-contrast paper, make test strips and then make a dark, a "medium," and a light print from the same negative.

Change to the contrasty paper and repeat the whole process.

You will now have nine different prints of the same picture. Their order will be clear if you arrange them in three rows of three: from left to right, by contrast—soft, normal and hard: from top to bottom, by density—light, medium and dark.

This arrangement, with eight prints in a hollow square around the "normal-normal" first print, is what Kodak calls a "ring around." My colleague Bill Pierce, a working professional whose excellent technique makes his pictures both fine in quality and easy to produce, often uses this nine-print method. He says, "I almost always get at least one print that's better than I know how to make." Not true, because he is modest, but he uses this approach to get superb prints quickly and easily.

Back to the experiment: repeat the process with the low-contrast negative, but use your head. You may not want to print this picture on anything softer than No. 2 paper. Then feel free to skip the No. 1 prints: add No. 5 or No. 6 prints if you like.

Repeat again with the contrasty negative. Again, use your head: but contrasty pictures sometimes look fine on contrasty paper, so don't outsmart yourself.

Wash all the prints thoroughly, dry them, then lay them out so you can look at them all—at least, nine at a time—in good light.

Don't be in a hurry to make up your mind. Many beginners have a naïve tendency to like contrastier prints best at first, because there is something impressive and authoritative about sharply separated black-on-white. It has "impact": if it's a good print, it has much more besides, but the non-photographer often doesn't notice the rest.

You are after a more serious, less hasty evaluation. Ignore impact, then, and ask yourself instead, *Which print is most true to the feeling of the picture?*

The strongest print is not always the nicest-looking one. Another photographer I know, Lisette Model, takes some pictures that need harsh prints with ugly tones to bring out their full strength. She once showed me some well-made custom-lab prints of her pictures, and said, "They are too beautiful—completely wrong." She was right.

For this critical and inquiring look at your prints, use enough light, take enough time and don't try to force a decision. The prints won't hurt you: just look at them, pay attention to what you see and let them work on you.

Put aside the ones you like less, until you get down to one per negative. At that point, do not be too sure you've reached a final decision. Look through your "rejects" again. Your best print may be among them.

It's easy to fool yourself. In my own work, the print I finally pick is not always one that looks like "a good print." It may or may not look beautiful, but it answers something deeper in me than my craftsman's sense of "print quality." I sometimes find I've put it aside among the early rejects before I recognize that it's Cinderella and bring it out again.

Put it another way. *Look for the print you like, not the print you think someone else*

will like. Other-people pleasers are often false alarms.

MY OWN TEST RESULTS

Looking at photographic prints is a far cry from looking at halftone reproductions. As I write this, the reproductions don't exist yet, so I'm talking about the prints. Don't be upset if you don't see on the pages all the tonal qualities I mention: make your own prints, and you'll really see what happens.

Normal-contrast Negative. This picture led me on to make twelve prints, not nine.

All three prints on No. 1 paper show every tone in the negative. I rather like the middle-range one, though it is a little muddy in tone. The light one is anemic, and the dark one looks too dark.

The No. 2 prints are livelier. The light print and the middle-range one now look too light to me (they didn't during printing). The dark No. 2 print is my choice from this set, because it feels right. I don't know why.

The No. 3 prints are still livelier, but none of them shows all the tones well. The two lighter ones look too light to me now, and the dark one looks too dark. I like the wet sidewalk in the middle-range one. With some dodging and burning-in, a good print could be made on No. 3.

The No. 6 prints were made to find out what would happen. The contrasty rendition of isolated areas of tone—some in one print, some in others—is beautiful, but the beauty isn't sustained in the rest of any print here. The wet pavement and the sinister, hairy branches in the dark print are worth seeing, but little else survives. No doubt this is a good way to print some other picture.

Low-contrast Negative. Developed normally, this negative nevertheless has very low contrast because it was underexposed. It's down on the "toe" of the characteristic curve, where the densest areas are so little denser than the thinnest areas that there can't be much contrast between them.

The No. 2 prints are almost ridiculously soft, so I didn't make any No. 1 prints. I have a sneaky liking for the pale and pearly tones of the lightest No. 2 print, though they are false to the picture. (She was singing Hungarian peasant songs in which you whistle, spit and sing, all in the same bar: the ethereal treatment is not appropriate.)

My favorite in this set is the mid-range No. 6 print, which struggles up to normal contrast in the highlights, though the "blacks" don't get past a tender middle gray (thanks to our friend, the toe; you can *use* this if you learn to expose the film accurately enough). The gray shadows are unnatural and unexpected, but I find I like them this time. The light No. 6 print looks all right, but I like it less. The dark print is too ponderous and dirty in tone. By bleaching the highlights to spectacular brightness and leaving the dark tones alone, a certain melodrama could be built up in this print—but that's not for me. However, that kind of printing-down-then-bleaching-back produces the Beethovenish beauty of W. Eugene Smith's moody, hot-highlight prints. (What's good for my pictures would probably be terrible for Gene's, and vice versa. It's a matter of temperament, and carries through everything a photographer does, from initial seeing to printing.)

High-contrast Negative. This one consists mostly of low-contrast and moderate-contrast areas, but their extreme range, from sun-

Normal-contrast negative, light soft print: Brovira No. 1 paper, 10" at f/11.

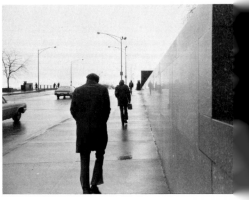

Normal-contrast negative, light normal-contrast print: Medalist J2, 15" at f/11.

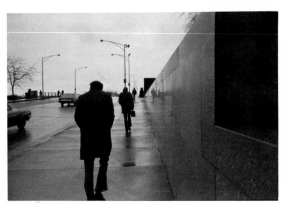

Normal-contrast negative, mid-range soft print: Brovira No. 1, 15" at f/11.

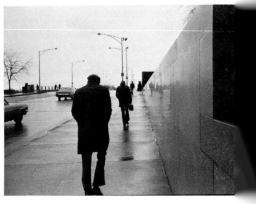

Normal-contrast negative, mid-range normal-contrast print: Medalist J2, 20" at f/11.

Normal-contrast negative, dark soft print: Brovira No. 1, 20" at f/11.

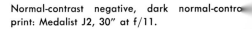

Normal-contrast negative, dark normal-contrast print: Medalist J2, 30" at f/11.

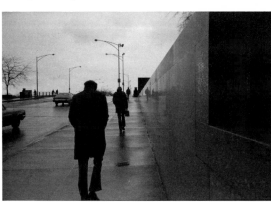

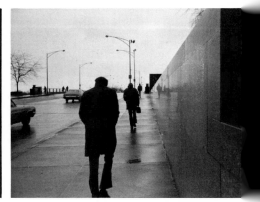

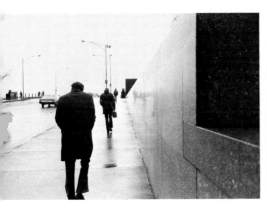

Normal-contrast negative, light moderately-contrasty print: Medalist J3, 12½" at f/11.

Normal-contrast negative, light high-contrast print: Brovira No. 6, 17½" at f/16.

Normal-contrast negative, mid-range moderately-contrasty print: Medalist J3, 20" at f/11.

Normal-contrast negative, mid-range high-contrast print: Brovira No. 6, 30" at f/16.

Normal-contrast negative, dark moderately-contrasty print: Medalist J3, 30" at f/11.

Normal-contrast negative, dark high-contrast print: Brovira No. 6, 45" at f/16.

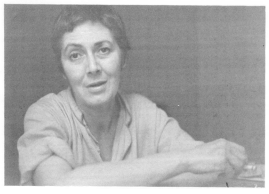

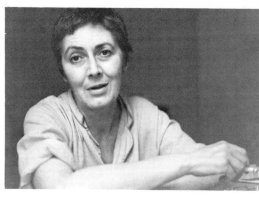

Low-contrast negative, light low-contrast print: Medalist J2, 7½" at f/16.

Low-contrast negative, light normal-contrast print: Brovira No. 6, 15" at f/22.

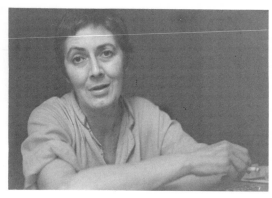

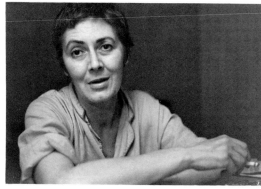

Low-contrast negative, mid-range low-contrast print: Medalist J2, 10" at f/16.

Low-contrast negative, mid-range normal-contrast print: Brovira No. 6, 17½" at f/22.

Low-contrast negative, dark low-contrast print: Medalist J2, 15" at f/16.

Low-contrast negative, dark normal-contrast print: Brovira No. 6, 25" at f/22.

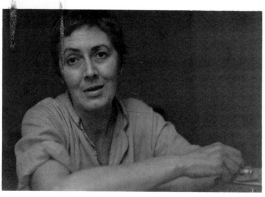

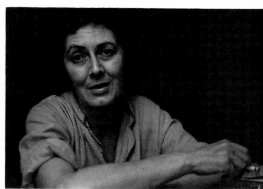

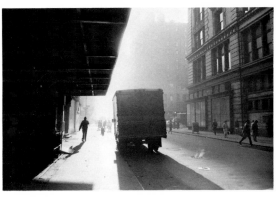

High-contrast negative, light normal-contrast print: Brovira No. 1, 20" at f/22.

High-contrast negative, light moderately-contrasty print: Medalist J2, 12½" at f/11.

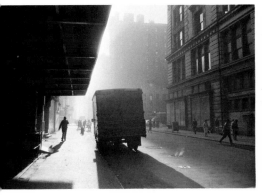

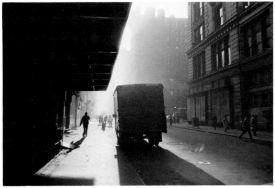

High-contrast negative, mid-range normal-contrast print: Brovira No. 1, 40" at f/22.

High-contrast negative, mid-range moderately-contrasty print: Medalist J2, 17½" at f/11.

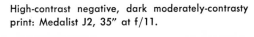

High-contrast negative, dark normal-contrast print: Brovira No. 1, 30" at f/16.

High-contrast negative, dark moderately-contrasty print: Medalist J2, 35" at f/11.

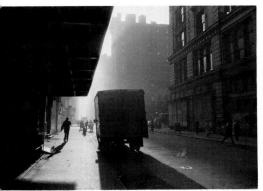

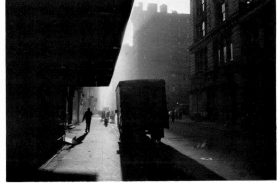

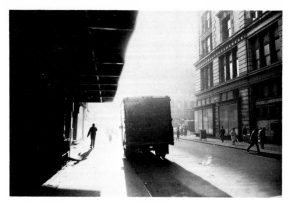

High-contrast negative, light extreme-contrast print: Brovira No. 6, 7½" at f/16.

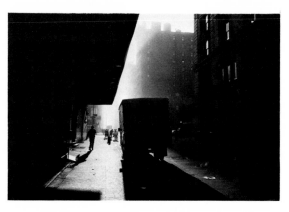

High-contrast negative, mid-range extreme-contrast print: Brovira No. 6, 20" at f/16.

High-contrast negative, dark extreme-contrast print: Brovira No. 6, 30" at f/16.

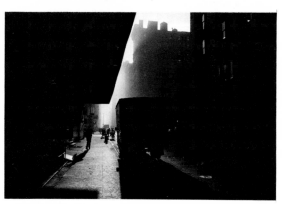

soaked haze to deep shade, adds up to contrast that requires No. 1 paper to render all its tones.

My choice is the darkest of the No. 1 prints, which strikes a balance between showing the light in the air and showing the surfaces the light falls on. Two other prints look fair to me: the mid-range No. 1 print and the mid-range No. 2 print—but the highlights in both are weak.

Because even No. 2 paper was too contrasty to show all the tones of this picture, I saw no point in pussyfooting toward higher contrast, and went straight to No. 6 paper for maximum zap. The only No. 6 print that interests me is the darkest one, which exploits the airborne light beautifully, though the black nothing around it is dull. The mid-range No. 6 print looked familiar: I realized that it is a familiar printing cliché. It puts black against white "impressively" and with "impact," but you can't see much in the picture. For my taste, this is non-printing. In this version, the picture has sunk to the level of an empty poster or "other-people pleaser."

12

Basic Control—
Burning-In and Dodging

WHAT ARE BURNING-IN
AND DODGING?

Burning-In ("burning" for short). A technique for darkening chosen parts of the print by exposing them more than the rest. Burning *adds* to the main print exposure.

After the main print exposure (or before it), a sheet of cardboard with a hole in it is held between the lens and the printing paper to add light to the area you want to darken, but not to the rest of the picture. Keep the card moving slightly as you burn, so the burned-in area will have a soft, inconspicuous edge. (You can use your hand instead of the card, but the results may be less consistent.)

To burn-in an edge of the picture, first expose the print normally, then use the card to keep light off the rest of the picture while you add more exposure at the edge. Move the card back and forth to get a gradual change of tone.

Dodging. The opposite of burning-in: you lighten chosen parts of your picture by casting the shadow of a dodging tool on them during the main print exposure. Dodging *subtracts* exposure locally.

Hold your dodger—a fold of masking tape or a piece of cardboard trimmed to a disk, on the end of a thin, stiff wire—between the enlarging lens and the printing paper, placed so its shadow falls only on the area you want to lighten. Keep it there for only a timed fraction of the exposure, unless you want a blank white spot; and keep the wire moving to prevent its shadow from printing as an unwanted light line.

To dodge the edge of a print and make it lighter, use the edge of a sheet of cardboard to hold the light back from the edge of the print during the main print exposure. Keep the card moving, as in burning-in an edge.

Confusion Department: Photo writers sometimes lump burning-in and dodging together and call them both "dodging." This is like saying "down" when you mean "up." Avoid this mistake. For clarity, always say which technique you mean. I repeat: Burning-in darkens part of the print by adding exposure. Dodging lightens part of the print by subtracting print exposure. Clear?

The longer you burn an area in, the darker it gets; the longer you dodge an area, the lighter it gets. Accurate tone control by careful timing is vital to successful dodging and burning.

WHY DODGE AND BURN?

Sometimes these techniques help make a picture visible. Sometimes they make the picture stronger as a visual message or more beautiful as an esthetic object.

Using a burning-in card. You see the picture on the card, so it's easy to put the hole exactly where you want to darken part of the picture. The light that goes through the hole adds exposure to that area of the print.

Not all negatives print well "straight." With some, the highlights of an otherwise good print "white out," and can't be seen clearly unless burned in. Some others print well except for dark areas that lose vital tone and detail because they "black out" unless dodged.

Some negatives need both dodging and burning. Their middle grays print well, but both ends of the scale are lost in blank white and opaque black. A less contrasty paper doesn't always solve the problem. A soft paper that fits such a negative technically may still be inappropriate to the picture: it may look too flat and gray. Then it makes sense to print on a contrastier paper, dodge to open up the shadows and burn to build up the highlight tones.

Some negatives fit the paper well enough to print with a full range of beautiful tones, but still gain strength and clarity from burning and dodging. We often photograph things that include optical illusions, areas of visual confusion ("camouflage") and points of misplaced emphasis. Then the printing problems are really shooting problems that either were seen too late, or couldn't be avoided when the pictures were taken. Dodging and burning can often repair the damage.

Sometimes large flat areas of tone, dull when left alone, become lively when modulation is introduced by burning or dodging. The photographer who is sensitive to the problems of putting three-dimensional visions onto flat rectangles, and who is alive to tone, can often work inconspicuous miracles that make weak pictures strong.

HOW TO DODGE PRINTS

If possible, use a small enough enlarging

f-stop to give yourself enough working time. It's much easier and far more accurate to dodge for six seconds of a 20-second print exposure than to try to dodge for six tenths of a second during a two-second exposure.

Different picture problems call for different dodging techniques. They all take practice. Some of them are: dodging small areas inside the picture; dodging small areas at edges or corners; dodging to lighten dark edges; and dodging to lighten broad areas that take in a whole side of the picture.

Dodging times are best determined by test strips, using the dodging technique you will use for the print. For a main exposure of 30 seconds, for instance, it would make sense to try strips dodged for 5, 10 and 15 seconds. Develop the strips together, and you will quickly learn how much dodging time to give.

Dodging Areas Inside the Picture. To lighten a spot without changing the tones around it, use a wire-handled dodger—usually a small disk of cardboard or folded-over black tape. Some photographers use a blob of modeling clay on the end of the wire so they can change its size and shape freely.

My usual dodger is about half an inch across. Raised toward the enlarging lens, it casts a large shadow on the printing paper; lowered, it casts a small shadow. A dodger of one size will handle print areas of widely varying sizes.

Avoid printing the wire's shadow as a line by keeping the wire moving in an arc around the dodger, which stays constantly in the picture area you want to lighten. If you want to dodge a long, narrow shape, tilt the dodger in the light so it casts as fat or thin an oval shadow as you need; or make a new dodger of the appropriate size and shape.

Don't overdodge, or you will get weird "glow-in-the-dark" or "radioactive" patches that are out of key with the rest of the picture. (This seems to happen more often than too little dodging, which leaves the spot too dark.)

Don't dodge too big an area, or the spot you want to lighten will be surrounded by a light halo. Dodging too small a spot won't

Dodging tool and dodged spot. The tool was laid on photographic paper, which was then exposed to light. The white spot was dodged out with a similar tool during the exposure. (In normal printing, you seldom change black all the way to white.)

lighten the whole area you want to lighten, but will leave a dark edge around a lightened center. If you raise and lower the dodger too much, you may produce an unwanted black edge with a dramatic white ring around it.

Dodging Small Areas at Edges and Corners. This is easy. Just stick a fist or a fingertip in at the right place and for the right length of time during the print exposure. Keep the size, shape and time accurate. If the area you must dodge has an un-handlike shape, cut a piece of cardboard to fit. Hold a card at a convenient height above the easel, project the picture onto it and trace the shape of the dodging area. Cut it out and dodge with it.

Dodging to Lighten Edges. Some lenses vignette, leaving dark edges all around the picture; and sometimes focal-plane shutters balk, leaving one dark edge. (Then it's time to see your repairman.) Such pictures can often be evened out by dodging that edge with a card. During the exposure, move the edge of the dodging card, held parallel to the picture edge, in past the edge for the right distance and length of time. For even lightening from the edge inward, move the card steadily in and out of the picture area, from just outside to the farthest-in-point that needs dodging. For smoothness, move the card slowly and steadily, not in rapid jerks. You have plenty of time: once in and once out will do the job.

If two sides that meet at a corner must both be dodged, you can hold two cards together to form an "L" and dodge them simultaneously. You can also dodge each side separately; then remember that each corner where two dodged edges meet will be dodged twice, so it will be too pale unless you burn it

back in for a "one-dodge" length of time. This is easy, but you have to remember to do it.

Dodging to Lighten a Whole Side of the Picture. Just shade that side of the print with a card or with your hand; either can often be bent to make the shadow fit the shape that needs dodging. If the card or hand won't fit, trace the projected image on cardboard and cut a dodging card that does fit. While dodging, move the card slightly so the dodged area will have a soft edge in the print. If your aim and timing are accurate, you should have no difficulty.

HOW TO BURN-IN

Unlike dodging, burning-in is done before or after, but never during, the main print exposure. It seems to make no difference in the print whether the burn comes before the main exposure or follows it; but burning-in first has one psychological pitfall. If the burn is an elaborate operation, you may get the feeling that you're finished exposing the print when all you've done is the burn. Prints developed after a complete pattern of burning-in, but with no main exposure, look pretty strange.

The basic burning-in tool is a (roughly) print-sized piece of cardboard with a small hole in the middle. The card keeps light off the print where you don't want it, while the hole is moved to direct the light where you do want it. It's the complementary opposite of the dodging tool. A half-inch hole is usually big enough. A second card with its hole near one edge is useful: a burn can "leak" past the edge of a card onto the edge of the

print unnoticed while you concentrate on the hole. Larger holes can help you burn in large areas.

For edge burns, hold a card without a hole over the print to shade all but the edge you're burning. Two or three such cards can be held together to form any desired "L," "V" or three-sided shape. If you run out of hands, hold them together with masking tape.

If the negative has "blocked" highlights (a sign of overdevelopment), or if you're printing on very contrasty paper, it sometimes helps to open up the enlarging lens by one or two f-stops when burning-in. This permits shortened burning-in times. When you open the lens for a burn, don't forget to stop it down again before you expose the next print.

With practice, you can use your hands as an infinitely variable burning-in tool; but it's hard to repeat a hand-formed burn accurately.

A foot switch to turn the enlarger on and off lets you start the burn with both hands already in place.

Burning-in to Darken a Spot. Sometimes a small area of a print can be burned-in successfully just by holding the card below the enlarging lens with the hole in the right place, moving it slightly to avoid printing a hard-edged image of the hole.

As you hold the card below the lens, look down at it and you'll see the picture clearly projected on it. This makes it easy to place the hole accurately. The hole moves with the card, of course, while the image stays still: don't try to move the projected picture by moving the card.

If you burn-in too large an area (card too close to the lens), your print will have a dark halo around the burned-in area. If you burn-

in too small a spot (card too far from the lens), the spot on the print will have a darkened center, but its edges will stay too light. Moving the card too far up and down while burning gives a combination of both problems: the spot has a dark center, pale edges and a dark ring around the edges.

Burning-in too long produces dark, dirty tones, out of key with the picture. Burning-in too little leaves the tones too light.

A problem of interpretation arises here. Beginning photographers often feel an obligation to render every surface in the picture with full texture and detail. In doing so, they often kill the sense of light. While we seldom want an absolutely blank white area that represents a surface in the picture, we often want a sense of brilliant light. The most practical decision is often to make a compromise, printing it darker than pure paper white, but lighter than a full rendition of tone and texture. Then the message is "bright surface," not "dull surface" or "white gap in the picture."

Burning-in to Darken a Large Area. Sometimes a large too-light area allows a broad, simple burn with a large hole in a card or with your hands. This is done just the way a large area is dodged, except that light is added instead of being subtracted.

Not all pictures allow this: the burn may become so obvious that it competes with the photograph. Then it's better to work the tedious way, building up the burn gradually by moving a smaller hole in a "search pattern" that covers the whole area evenly. Don't move the hole only in one direction, or your burn is likely to become uneven. Move it in a "cross-hatch" pattern. First cover the whole area of the burn with horizontal movement

of the hole, then with vertical movement, then diagonal, then the opposite diagonal and so on, and you will cancel out most of the irregularities in your movement patterns.

This kind of burn typically takes a long time. The paper may stay under the enlarger for half an hour or longer, so be sure your safelight is really safe. Such burns are most easily timed in multiples of the main print exposure (I think of them as "clockfuls"). The procedure, if you use a timer with your enlarger's light switch, is simply to poke the button on the clock (or step on the foot switch) the right number of times, and burn for all of each clockful, moving the hole in one direction for each. I count clockfuls on my fingers (folding one for each), which takes me up to 10x—enough for all but the most stubborn burns.

Is this print necessary? If more than a 10x burn is needed, ask yourself if you really want the picture that much. If you do, go ahead: if not, why not drop it and print a more cooperative negative?

Burning-in to Darken Edges. Light edges sometimes result from uneven subject tones, from light bouncing around in the camera or from too much agitation in film development. Burning-in such edges is just like dodging out dark ones, except that here the card is held over the paper and its edge is moved past the edge of the print, in and out, to let in light that darkens the edge of the print instead of blocking light out to make it lighter.

When you burn-in three or four edges of a print, remember that the corners will be burned twice wherever two edge burns overlap. Such corners must first be dodged during the main exposure to compensate. The dodg-

ing time should be equal to one burning-in time: it takes care and thought, but it's easy.

WHEN SHOULD YOU DODGE? WHEN SHOULD YOU BURN-IN?

Any print that needs local exposure manipulation can be dodged, burned-in, or both, to get approximately the same results.

The Alternatives. The print can be exposed so as to render the darkest tones well, and the highlights then burned-in. It can be exposed for the highlights, and the shadow areas dodged. Or it can be given an intermediate exposure, with dodging to bring out shadow values and burning-in for richer highlights. The choice is usually made by deciding which approach is simplest to use with the picture that is being printed.

Start by making a straight print, with no manipulation. Give it the best overall exposure indicated by your test strips. This print will either show you that burning-in and dodging are not needed, or it will give you some indication which one is needed in what areas. This suggestion is prompted by old and new experience.

I used to look at the negative, decide what manipulation to give it and start right in with a manipulated first print. Typically, it would take 5 to 10 prints that failed before I'd get the burning and dodging right, and two or three more tries to make another print as good as the first successful one—a lot of work and paper per picture.

Recently I reprinted some of these old negatives for exhibition and found that most of them printed perfectly well straight. It was so easy, and I had turned it into such a struggle

before. So try a straight print first, in case you are as naïve as I was.

Rehearse with Dry Runs. When the picture turns out to need manipulation, try the obvious choice—dodge or burn—if there is one, with a dry run: no "live" paper under the enlarger. Then do dry runs of the other approaches, and you'll learn which is easier and quicker.

Then make your manipulated print. As you do this for a few printing sessions, you'll get the feel of it, and the dry runs will have served their purpose. Then you'll need them only when in doubt.

Manipulation Maps. Complicated dodging and burning patterns can get so elaborate that you can't remember all the things you've decided to do. It is also hard to remember, during the process, what you've done and what still remains to be done. Rehearsals help, and a chart that shows how much exposure each area needs will refresh your memory as you go.

Put a sheet of non-photographic paper in the easel, turn the white light off and the enlarger on, and draw your map on the paper by tracing the projected image with a felt-tipped marker. Write on this map the exposure times needed for each of its sections. Write big, so you can read it easily by safelight. With this map beside your easel, it's simpler to organize all your procedures and forget none of them.

The dodge-and-burn map shown here simply gives the number of seconds of exposure needed for each area. With negatives that need much longer burning-in times, it's sensible to replace the larger numbers of seconds with the number of clockfuls of burn that each area needs ("2x" or "7x," for example —whatever multiple applies).

ABOUT THE SAMPLE PRINTS

I made several straight prints, each exposed to render one or more areas of the picture well. This is not a usual procedure: it was done here to clarify its point. But such prints would be a good way to get relative-exposure information when working on difficult prints.

All the sample prints are on No. 3 paper: the tones looked muddy on No. 2, possibly because of flare from the bright sky. All prints were made with the enlarging lens at f/11.

They gave me the following optimum-exposure information:

Darkest grass: 20 seconds at f/11. (Everything else was too light.)
Lighter grass: 25 seconds. (Top of sign too light, dark grass now too dark, sky blank.)
Sign: 30 seconds. (Grass all too dark, sky still blank.)
Sky: 60 seconds at f/11. (Everything else much too dark. The sky might have looked better with still more than 60 seconds' exposure, but it would then be badly out of key with the rest of the picture. Sixty seconds is the compromise that shows the clouds, though not richly, but remains related in tone to everything else. I wanted a one-piece picture that wouldn't look too tortured.)

Procedures. I decided on a main exposure of 30 seconds, since the bottom of this picture is easy to dodge, and since one clockful

Straight (undodged, unburned) test print, exposed for the dark grass: No. 3 paper, 20" at f/11.

Straight test print, exposed for the light grass: 25" at f/11.

of burn on the sky would then be just right.

Dodging. The whole bottom of the picture, up into the bottom third of the striped sign, was dodged for five seconds with a plain card (no hole). It was moved gently up and down so there would be no conspicuous edge.

The darkest area of grass was dodged for an additional five seconds with a hand stuck in from the lower right corner. No wire-handled dodger was needed this time.

Burning-in. The two signs and the bit of hilltop above the striped sign at the left are so nearly geometrical that no bent card or

hand could match their shape. I had the choice of doing a "search-pattern" burn through a hole in a card, or doing a simple burn past the edge of a shape-fitted cardboard mask. The shaped burn would be simpler and quicker, so I used it.

A small file card was held so it stuck out past the edge of a straight-edged card to match the shape of the small sign sticking up from the larger one; and a bit of hand wandered up to mask off the hilltop above the sign at the left so it wouldn't turn black and look out of place in the picture.

Straight test print, exposed for signs: 30" at f/11.　　Straight test print, exposed for sky: 60" at f/11.

After the main exposure, with its attendant dodging, a one-clock (30-second) burn was given to the whole sky area, the rest of the print being masked off.

Results. In the first try, I didn't hold the small card accurately enough, so the burn leaked into the top of the small sign. I noticed, too, that the striped sign was pale at the left edge of the picture, and estimated that a 10-second burn would help. I added this to the map and tried it on the second print, which worked better.

This picture could not be printed acceptably without manipulation. The way its tones were distributed dictated the choice of manipulation—an intermediate amount of main exposure, modified by dodging to lighten dark tones and burning-in to darken light tones.

A successful print was brought in fairly easily with four simple steps of manipulation —two of dodging, during the main exposure, and two of burning-in afterward. Few negatives need more fuss than that to print well.

Composite of cut-out sections from straight prints exposed at 20, 25, 30, and 60 seconds at f/11 (normally, this is a purely mental process. You use your mind, not paper).

A dodge-and-burn map, showing the total exposure for each area in seconds at f/11. Only bold lines are legible by safelight.

My first try at a manipulated print of this picture. The top of the sign is too dark (inaccurate burning-in), and the left end of the sign is too light (an oversight).

My second manipulated print, exposed according to the map, while remembering what went wrong before. This time every area is clear and looks "natural" (you see the picture, not the work that went into printing it).

13

Fine Controls

WHAT FINE CONTROLS CAN DO FOR YOUR PICTURES

So far, we've dealt with coarse controls. When your film exposure and development are accurate (and when your errors fall where you have leeway), straightforward processing will consistently give you negatives that print well "straight." The negative adapts the contrast of the subject to the tone range of the paper.

But we are not always that accurate. Typically, we make a quota of peculiar negatives that can be printed well only by bending our technique. That's where fine controls come in.

When a moving or changing subject will be gone before you can read your meter, it's no mistake to shoot first and worry about exposure later. Guess, shoot and hope. With luck or exposure sense, your negatives will print well easily. With less luck, you can often save the pictures by using fine controls in printing.

Not every inaccuracy is the photographer's fault. Occasionally the film, the paper or the equipment we use will change in behavior and surprise us.

These changes come seldom, compared to our mistakes, and many of them open up good new possibilities. In general, new films, papers and photo equipment seem to get better and better, though some of the best products are always being discontinued. Never mind. It makes more sense to adapt than to mourn.

When the Equipment Changes. Obviously, a sick shutter or an out-of-line enlarger needs repair or replacement. But a new camera lens that produces higher image contrast is altogether an improvement, if you remember to develop your film a little less in future (a contrastier lens renders subtle changes in tone more distinctly).

Meanwhile, fine controls in printing can bring in excellent prints from negatives that are slightly contrasty, soft, dense or thin for the paper.

When the Film Changes. The long-term answer is to adapt by modifying exposure, development or both, as the film's new behavior dictates. Experiment: see what happens when you increase and decrease expo-

sure and when you increase and decrease film development. Print your test films, examine the prints, then standardize on the revised exposure/development combination that delivers the most printable negatives.

Meanwhile, the odd negatives that told you something was wrong can be adapted to your paper by fine-control printing.

When the Paper Changes. There are two main long-term solutions. You can either revise your film exposure and development to fit the paper's new behavior, or find a substitute paper that works well with your present negatives.

Meanwhile, your old negatives can usually be printed well on the changed paper by using fine controls in printing.

STRENGTHENING MEDICINE FOR HEALTHY PHOTOGRAPHS

From the way this chapter begins, you might get the idea that fine controls are mostly useful to patch up mistakes.

They have a more important role. They can and do give added strength, depth and beauty to photographs that are already excellent. If you work intelligently, you'll use fine controls more to intensify your strong pictures than to prop up your weak ones.

CHEMICAL CONTROLS YOU CAN BUY

Under this heading, I list only a few products—the ones I know. For most of the purposes mentioned, other products are also available. Some of them are undoubtedly good, so don't assume that the ones I list are the only ones.

Special-purpose Film Developers. If you know your film is overexposed, it makes sense to develop it slightly less than the recommended time in Kodak HC-110, diluted 1-to-31 ("dilution B"); besides being a good general-purpose developer, HC-110 is unusually forgiving toward overexposed negatives.

If your film is one to two stops underexposed (one half to one quarter of the minimum normal exposure), try Diafine, a high-energy two-bath developer made by Acufine, Inc. When you use Diafine, time and temperature are not critical. You get only one degree of development. In a two-bath developer, the film soaks up developing agent in bath A; in bath B, an accelerating agent puts it to work. Development stops when the developing agent in the film is used up, so you can't overdevelop in Diafine if you follow the instructions. Nevertheless, it delivers higher effective film speed than normal developers.

With Diafine, Tri-X (vintage 1973) delivers an honest EI 800 (slightly dense) and a printable EI 1600. The EI 2400 claimed on the Diafine label has never worked out for me. I'm too fond of shadow detail and shadow contrast.

Both developers have been around for years, and they seem likely to endure. If they vanish, others will probably replace them.

Farmer's Reducer. Watch out for word traps in photography. Among photographic chemists, for instance, "reduction" is a technical term for development—building up the image. Among photographers, it more often means bleaching the image to a lower density. When someone says "reduce the image," it's a good idea to ask which kind of reduction he means.

Farmer's reducer is not a developer, and not a weight-loss product for rural markets. It is a bleach, consisting of potassium ferri-

Normally exposed, normally developed negative, shown for comparison.

Print from normal negative (print exposure, 11″ at f/16 on Kodak Polycontrast Rapid RC, no filter).

This negative was given only 1/2 the normal exposure, then developed normally. It is slightly too thin for easy printing.

This negative was also given 1/2 the normal exposure and was developed normally, but it has been brought back toward normal density by treating it with chromium intensifier.

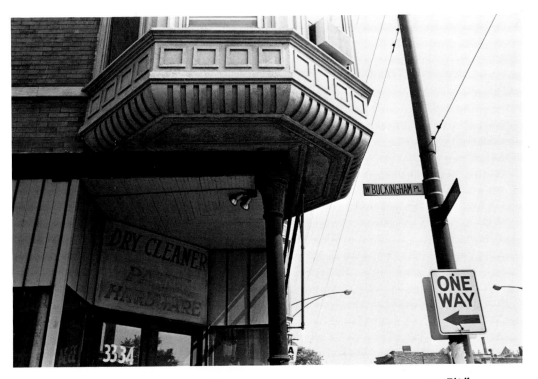

Print from the chromium-intensified negative on opposite page (print exposure, 7½″ at f/16, Polycontrast Rapid RC, no filter).

cyanide (poisonous) and hypo, dissolved in water. It is used to bleach the silver images on negatives and prints to lower densities.

You can mix your own Farmer's reducer from ferricyanide, hypo and water, but for plain bleaching it's more convenient to buy it in pre-mixed form. Dissolve it just before using: once dissolved, it doesn't last long.

How to use Farmer's reducer. To reduce a negative or a print that has been dried, first soak it in water for a few minutes. Meanwhile, mix your Farmer's reducer, following the instructions on the package, and pour it into a tray. Use a white tray for negatives so you can see the densities well. Use plenty of white light.

Bleaching. To start the bleach, put the negative or the print into the tray of reducer and agitate gently and constantly. Watch it carefully. The reducer seems to work imperceptibly, but you will suddenly notice that the image is considerably lighter. Remove it from the bleach when ready and rinse for five minutes in running water. Treat it in your regular hypo-clearing agent or washing aid, then wash and dry normally.

Don't wait too long. It's vital to take the negative or the print out of the Farmer's reducer shortly *before* it comes down to the density or lightness you want. The image goes on bleaching in the rinse until most of the reducer is removed from the emulsion—and once part of the image is dissolved away, nothing can put it back.

Kodak Chromium Intensifier. The package warns us that this is poisonous stuff, so don't get any of it "in eyes, on skin, on clothing, or on combustible materials."

This is the intensifier that interests me most, because the degree of intensification is said to be so variable that it can be used as a

reducer, too. You bleach the image out, then redevelop it: how much you redevelop determines the final density and contrast of the negative. (Kodak no longer mentions this possibility in their literature.) The whole process can be carried out in normal room light: avoid bright sunlight.

It's cheap: a small package (50 cents in 1973) is enough for 400 square inches of film. (A 36-exposure roll of 35mm film has an area of 80 square inches.)

Procedures for chromium intensification: In separate containers, dissolve "part A," the bleach, in 16 fluid ounces (½ liter) of water, and dissolve "part B," the clearing bath, in 16 ounces of water. Put each in a clean white tray for use.

Meanwhile, soak the negatives you want to intensify in clean water for 10 minutes (they must be fully fixed: if in doubt, refix and rewash).

Bleach the film in the "A" bath, with constant agitation, until the image is bleached from black or gray to yellow. Handle it with tongs—don't touch this solution. The bleaching process normally takes three to five minutes at 68° F.

After bleaching, rinse the film well in running water.

Clear the film in the "B" bath, with constant agitation, until the yellow stain disappears, leaving the image almost white. This normally takes about two minutes at 68° F.

After clearing, rinse the film well in running water.

Redevelop in a quick-acting, non-staining developer, such as Dektol or D-72, diluted 1:3 (one part stock developer to three parts water). Kodak suggests redeveloping for 10 minutes in 1:3 Dektol: that should be plenty. Do *not* use film developers that contain large

This 4× overexposed but normally developed negative has normal contrast but is very dense.

Normally exposed but given twice the normal development, this negative is both dense and contrasty.

This negative was overexposed 4× and overdeveloped 2×, so it was still denser and more contrasty than the preceding negatives; but it was brought back almost to normal by reduction with ferricyanide (Farmer's reducer).

Print from normally exposed but overdeveloped negative (not reduced). The grain is much coarser than in a normally developed negative (print exposure, 18" at f/11, Polycontrast Rapid RC, no filter).

Print from overexposed, overdeveloped negative after treatment with Farmer's reducer. The grain has become fine again (print exposure, 11½" at f/22, Polycontrast Rapid RC, no filter).

amounts of sodium sulfite, such as D-76 and Microdol-X: they tend to dissolve the bleached image before it can develop.

After development, just wash the film for 30 minutes at 68° F. and dry it normally. No fixing is needed.

This gives you a standard degree of intensification. To intensify further, rebleach, reclear and re-redevelop, and the final density and contrast will be still higher.

To intensify less—producing a softer, thinner negative than the original, if you want to—calls for further experiments using more dilute developer for redevelopment. I have not tried this out, so I cannot promise that it

will work well with today's films; but a pioneering study by Dr. Paul E. Boucher, first published in 1935, showed controllable results with redevelopment in D-72 diluted 1:8 (D-72 at 1:2 worked too quickly to allow control).

So it seems logical to try out Dektol (son of D-72) diluted 1:8, with test redevelopments of 2, 3, 4, 6 and 10 minutes at 68° F., for identically exposed and developed negatives.

Leave one negative from this series unintensified, or you won't know what, if anything, has been changed in the others.

Print the redeveloped negatives and the

untreated control negative and see what happened.

ABOUT REDUCTION, INTENSIFICATION, AND ALTERNATIVES TO THEM

There are too many methods to list: you'll find them in the technical books if you search.

As I've said, for me, torturing negatives and prints is a last resort, like taking to the lifeboats. There is always a loss of quality and a risk of total loss.

I'd rather—if the picture matters enough —make a new negative by copying the original one photographically. This leaves your original negative intact: if you fail, you can try again.

How to Make an Enlarged Negative.

Step one: the interpositive. First make a somewhat dense, low-contrast positive transparency by enlarging on a print-sized sheet of film instead of on paper. The brightest highlights in the resulting transparency should be definitely gray (to get them off the "toe" of the film and preserve highlight contrast), and you should be able to see easily through its densest shadows.

Step two: making the enlarged negative. Contact-print this "interpositive" onto another sheet of film to make the new negative, which you will contact-print onto paper for your final prints.

Quality control. The contrast and density of both the interpositive and the new negative are controllable by exposure and development, so you can easily gain or lose contrast and density in any desired relationship. You can also incorporate burning-in and dodging in both stages.

This was Edward Weston's way of making 8 × 10 prints from his small hand-camera negatives. He hated to enlarge from small negatives, so he made enlarged negatives of excellent quality and printed them by contact.

Film for interpositives and enlarged negatives. An excellent film for this is Kodak Commercial film (that's its name), a fine-grain "color-blind" sheet film that can be used under printing safelights such as the Kodak OC or the DuPont S-55X. It is slow enough to permit controlled enlarging exposures, and has fine-enough grain and high-enough resolution so it can be developed in paper developers with no visible loss of quality.

A Simpler Alternative: Let the technically weak picture go and take other pictures instead. Few pictures are worth that much labor. When they deserve the work, of course, go to it. But otherwise, why not go on and take stronger photographs instead of slaving to prop up weak ones?

Soft-working Print Developer. For negatives that fall between the grades or the v/c filters, Kodak's Selectol-Soft (not to be confused with plain Selectol) is available in camera stores. If they don't have it, they can order some for you.

As its name says, Selectol-Soft is a low-contrast print developer, the only one I know that you can buy pre-mixed.

Not all papers respond to it equally, but with most modern enlarging papers it gives you prints that are softer by half a grade or more than prints of the same negatives on the same papers developed normally in Dektol. The label says it is for warm-tone papers, but it works equally well with most neutral and cold-tone papers, so do not be alarmed.

Processing is entirely normal. The recom-

Enlarged interpositive from normally exposed but over-developed negative (see page 233, bottom, and 234, bottom). This transparency was printed on 8 × 10-inch Kodak Commercial film, just as you would enlarge on paper. It was deliberately made gray (by giving it plenty of exposure) and soft (by short development).

Enlarged negative, contact-printed from the interpositive onto another sheet of Kodak Commercial film. This negative was developed longer than the interpositive to get somewhat higher contrast.

This contact print from the enlarged negative has lower contrast than you could get on normal-contrast paper by printing directly from the overdeveloped original negative; but the coarse grain from that overdevelopment is still here. Contrast could be increased by developing the enlarged negative longer or decreased by developing it less.

mended dilution is 1:1. Tray life and bottle life are shorter than those of Dektol or D-72, so mix Selectol-Soft when you need it.

Print-developer Additives. You can increase the contrast of prints by adding extra restrainer—benzotriazole or potassium bromide —to the paper developer. This slows down the development of light print tones more than it slows the development of dark tones, producing prints of higher contrast. Make new test strips when you add restrainer: you will usually need more print exposure.

Potassium Bromide. The rough-and-ready method is to add a pinch of bromide crystals to your tray of developer. More repeatable results can be obtained by adding measured amounts of a 10-percent bromide solution. Start with 5cc of bromide solution per liter or quart of working developer.

To make a 10-percent solution, dissolve 10 grams of potassium bromide in 80cc of water, then add water to bring the volume to 100cc. (For our purposes, cc—cubic centimeters—and ml—milliliters—are the same.)

In avoirdupois, dissolve 1 ounce of bromide in 8 fluid ounces of water, then add water to make 10 ounces. For larger amounts, multiply. The same principle applies to mixing all dry-to-wet percentage solutions.

If a pinch or a 5cc-per-liter dose is not enough according to your test strips, add another pinch or another measured dose and repeat until you get the result you want. Once you know how much you need for a given effect, you'll be able to go straight to it instead of creeping up to it.

Bromide not only increases contrast, but gives the print tones a greenish tinge.

Benzotriazole (Kodak sells it as Anti-Fog No. 1). Stronger stuff, but it's easy to handle in a 2-percent solution (2 grams dissolved in 80cc of water, water added to make 100cc, or—roughly—30 grains dissolved in a quart of water). Kodak suggests adding two ounces of 2-percent solution to each quart of working developer. 60cc per liter would come close.

Benzotriazole works in the same way as bromide to increase print contrast, but it turns the prints a cold blue-black instead of green-black.

Other products that either use Benzotriazole or approximate its behavior are Edwal Liquid Orthazite and DuPont B-B Developer Additive. With either, follow the directions on the package.

Selenium Toner for Prints. Kodak Rapid Selenium toner, diluted 1:3 and used according to the instructions on the bottle, changes neutral-toned black-and-white prints to rich brown ones. Since I'm not interested in turning my black-and-white pictures into color prints, I do not use it that way.

Instead, I dilute it much more. In dilutions weaker than about 1:9, the toner no longer changes print color much, but it deepens the dark tones and slightly increases contrast in those tones. The print takes on new depth and life.

There is still a slight color change, which varies with toning time and from one kind of paper to another. Slight toning produces cold, rich blacks; further toning produces eggplant-like purple-blacks and reddish blacks, depending on paper and on treatment time. Since light-and-dark values interest me more than print color, I usually accept whatever color comes with the tonal quality I want.

There's a fringe benefit. Selenium toning protects the silver that forms the picture, making it less vulnerable than an untoned print to fading caused by sulfur compounds in the air.

Procedure for dilute selenium toning. Toning comes right after the second hypo, so get your toning bath ready *before* you put your prints in the second fixer.

After they have all gone through the first fixer, mix your toning bath and place its tray near the second hypo—but not so near that hypo or toner can splash into each other.

My toning bath consists of four fluid ounces of Kodak Rapid Selenium Toner added to a working Perma Wash bath (three ounces of Perma Wash concentrate in one gallon of water). I use it at about 68° F. Kodak Hypo Clearing Agent and other washing aids work well, too. Second fixing, toning and all that follows are done in plenty of white light.

Fix the prints in the second hypo for four minutes with constant agitation by rotation (bottom print to top of pile, then next, next, etc.).

After fixing, drain but *do not rinse* the

prints, then treat them in the toner with constant agitation. (The reason you don't rinse the prints is that small amounts of hypo in them will lead to permanent ugly yellow stains; but a massive amount of hypo—as in an unrinsed print fresh from the fixer—produces no stain in the toning bath.)

Tone the prints until they look right to you. My toning times vary unpredictably from about one minute to about 10. It's done purely by eye judgment, so you need good light.

(I use a black hard-rubber tray for toning: it gives me a black to compare to the blacks in the prints. They start out lighter than the bottom of the tray and end up as dark as the tray or darker.)

After toning, rinse the prints for five minutes in running water, with constant agitation.

Next, treat them for the normal time in a second washing-aid bath, this time without any toner. I use freshly mixed Perma Wash for five minutes with constant agitation. Why repeat the washing-aid treatment? Because the first one is not fully effective, for two

This negative is slightly too contrasty for normal printing on No. 2 paper. In this print, when the highlights show detail, the shadows become dark and hard to see—good in some pictures, but not in this one. Print on Agfa-Gevaert Portriga-Rapid 111, No. 2: 22½" at f/8, developed in Ilford Bromophen at its normal 1:3 dilution (quality similar to that produced by 1:2 Dektol or D-72).

reasons: there's no pre-rinse after the fixer before toning; and the toner itself (according to a chemist at Kodak) contains hypo. You use a second washing-aid treatment to get a better wash.

Finally, wash and dry the prints normally. That's all there is to it. The toner and the washing aids are cheap: it's good practice to use fresh solutions each time you print.

MIXING YOUR OWN CHEMICALS

Some of the most useful photo chemicals cannot be bought, but it's easy to weigh out the ingredients and mix them yourself. If you have been mixing packaged developers, you already have the necessary mixing pail, graduates, thermometer, stirring rod and funnel.

All you need to add is a small scale, a set of metric or avoirdupois weights, a supply of the chemicals called for by the formulas, and some bottles.

The scale need not be elaborate. I use a small one made by Pelouze, with metric weights from 2 to 50 grams (g.) and avoirdupois weights from 50 grains (gr.) to 2 ounces. (The metric system is simpler to use, and is rapidly replacing avoirdupois.)

Same negative, same paper: but a soft-working print developer opens up the shadows and makes them visible without losing the highlight detail. Selectol-Soft would have done it, but for this print I used home-mixed GAF 120, diluted 1:2. Portriga-Rapid No. 2, 30″ at f/8.

I suggest glass bottles—gallon ones for fixer, quart or pint ones for developers (small bottles keep unused developer fresh longer—you use up a bottle at a time and leave the rest unopened).

How to mix a formula. Bring the water to the right temperature and measure the required amount into your mixing pail.

Weigh out and dissolve each ingredient in turn, adding it to the water slowly while stirring constantly. Dissolve each ingredient completely before you add the next one.

Always mix chemicals in the order given in the formula. If you change the mixing sequence, you usually ruin the developer or fixer.

When all ingredients are completely dissolved, add cold water to bring the volume up to the required total.

Funnel the mixed solution into clean bottles, filtering if necessary. Label and date each bottle as you do this.

Wash and put away your mixing utensils. Make sure your chemical bottles are tightly closed, and put them away for the next time.

PRINT DEVELOPERS

The typical paper developer consists of several standard ingredients:

Solvent: water

Developing agents: metol or Phenidone for low contrast, hydroquinone for higher contrast

Preservative: sodium sulfite

Accelerator: sodium carbonate

Restrainer: potassium bromide.

The developing agents combine with exposed silver halides in the emulsion and convert them to silver.

My scale. This print was developed in D-72 and fixed in Kodak F-6, both weighed out on this scale.

The preservative counteracts the tendency of the developing agents to oxidize rapidly and lose their effectiveness: the sulfite combines with the oxygen first, before it can affect the metol and hydroquinone much.

The accelerator gives a much-needed boost to the activity of the developing agents. Accelerators are typically alkaline—weak alkalis in film developers, stronger ones in paper developers.

The restrainer holds back the less-exposed areas in the emulsion from developing as rapidly as the much-exposed parts, and prevents fog from veiling the white tones in prints.

Combined in different proportions, these standard ingredients produce a variety of developers with different behavior.

In the following formulas, sulfite means sodium sulfite (desiccated); carbonate means sodium carbonate (monohydrated); and bromide means potassium bromide. Elon is Kodak's trade name for metol; its other aliases include Pictol, Photol, Rhodol and several more. It's easier to ask for Elon or metol than for monomethyl para-aminophenol sulfate or $(CH_3NHC_6H_4OH)_2H_2SO_4$.

Kodak D-72. The classical formula for a normal print developer. Dektol is a modified form of it, with similar performance. I like D-72 slightly better—it seems to stay fresh longer in the bottle and in the tray. It costs a little less than Dektol, and takes a little longer to mix.

My version, given here, is closer to the original D-72 formula than to the one Kodak publishes now, but the differences are slight.

D-72	metric	avoirdupois
Water (125° F., 50° C.)	3 liters	3 quarts
Metol (Elon)	12 grams	175 grains
Sulfite	180 grams	6 ounces
Hydroquinone	50 grams	1½ ounces, 50 grains
Carbonate	270 grams	9 ounces
Bromide	7½ grams	¼ ounce
Water to make	4 liters	1 gallon

Normal dilution for use, one part stock D-72, two parts water; normal development times for prints, two to five minutes.

Developer ingredients: from left to right, they are in the order of mixing (Elon—otherwise known as metol—goes first because it dissolves extremely slowly if the sulfite precedes it). The developer used for the print came out of these bottles.

GAF 120, Formerly Ansco 120. An extremely useful low-contrast print developer. A look at the formula will show you that it is a conventional print developer except that it contains no hydroquinone.

I prefer it to Selectol-Soft, partly because it stays fresh longer, and partly because it permits shorter print exposures than Selectol-Soft (both developers sacrifice some paper speed as compared to Dektol and D-72). Depending on the paper, contrast is lowered by about half a grade to a full grade.

GAF 120	metric	avoirdupois
Water (125° F., 50° C.)	3 liters	3 quarts
Metol	50 grams	1½ ounces, 50 grains
Sulfite	150 grams	4¾ ounces
Carbonate	150 grams	4¾ ounces
Bromide	7½ grams	¼ ounce
Water to make	4 liters	1 gallon

Normal dilution, one part stock GAF 120, two parts water; normal development times for prints, two to five minutes.

Dr. Pratt's Variable-contrast Print Developer. Charles Pratt gave me this two-solution developer based on Dr. Beer's well-known formulas. It's much more concentrated stuff than the original Dr. Beer's, so I call it Dr. Pratt's.

Of the two solutions, part A works soft and part B works contrasty. To get different degrees of contrast with a given paper, you

mix and dilute A and B in varying proportions.

The contrast range for a responsive paper should approximate a one-grade difference from the softest print to the hardest.

Part A (soft)	metric	avoirdupois
Water		
(125° F., 50° C.)	3 liters	3 quarts
Metol	50 grams	1½ ounces, 50 grains
Sulfite	180 grams	6 ounces
Carbonate	120 grams	4 ounces
Bromide	7½ grams	¼ ounce
Water to make	4 liters	1 gallon

Part B (contrasty)	metric	avoirdupois
Water		
(125° F., 50° C.)	3 liters	3 quarts
Hydroquinone	60 grams	2 ounces
Sulfite	180 grams	6 ounces
Carbonate	330 grams	11 ounces
Bromide	30 grams	1 ounce
Water to make	4 liters	1 gallon

For different degrees of contrast, mix working developer as follows: (#1 is "soft," #4 is "normal" and #7 is "hard.")

#1: 1 part A, 1 part water.
#2: 7 parts A, 1 part B, 8 parts water.
#3: 3 parts A, 1 part B, 4 parts water.
#4: 5 parts A, 3 parts B, 8 parts water.
#5: 1 part A, 1 part B, 2 parts water.
#6: 3 parts A, 5 parts B, 8 parts water.
#7: 1 part A, 7 parts B, no water.

Why is there no maximum-contrast #8 (1 part B, 1 part water, no A)? Because hydroquinone works feebly without metol. Somehow, metol is not only a developing agent, but a catalyst that activates hydroquinone.

"*Canned Beer's.*" If you'd like to try out a variable-contrast print developer, but don't want to weigh out chemicals, you can make "canned Beer's" by mixing Dektol and Selectol-Soft. The contrast range is shorter than that of Dr. Pratt's—Dektol is a normal-contrast developer, not a high-contrast one.

Split D-76 Film Developer. The formula for regular Kodak D-76 is available, but you can buy it premixed, so there's no need to mix it.

Split D-76, however, is something else. It is not on any market, so if you want to use it, you must mix your own. It does not appear in the Kodak formula books. Photographers, not lab men, took this formula apart to make a two-solution developer. You use it the same way as Diafine, but with normally exposed film. Solution A contains the developing agents (metol and hydroquinone) and Solution B contains the accelerator (borax) that puts them to work. (Don't get any "B" into your bottle of "A.")

The special virtue of this developer is that you can use it without a clock or a thermometer, and yet consistently get beautiful negatives with fine grain, a long scale of tones, and no loss of film speed. There is no way to overdevelop using split D-76—at least, no easy way.

The formula that follows is one that I once improvised, when I couldn't find a magazine with Paul Farber's published split D-76 formula (which uses twice as much sulfite in Solution A, and none in Solution B. I didn't know where the sulfite should go, so I just put half in each. This worked so well I saw no

need to change it. The sulfite does two things: it helps preserve the developer, and it acts as a silver solvent, which helps to keep the grain fine).

SPLIT D-76	metric	avoirdupois
Solution A		
Water	3 liters	3 quarts
Metol	8 grams	116 grains
Sulfite	200 grams	6½ ounces, 30 grains
Hydroquinone	20 grams	½ ounce, 70 grains
Water to make	4 liters	1 gallon
Solution B		
Water	3 liters	3 quarts
Sulfite	200 grams	6½ ounces, 30 grains
Borax	8 grams	116 grains
Water to make	4 liters	1 gallon

To use split D-76, fill one film tank with Solution A and a second tank with Solution B, both at room temperature (time and temperature are not critical with this developer.)

In total darkness, place the film on its reels in Solution A, close the tank, turn on the light, and agitate normally (10 seconds once each minute) for about 3 minutes. The film soaks up developer during this time, but little development takes place.

After the 3 minutes, again in total darkness, open the "A" tank, lift the film out and let it drain for a few seconds, but *do not rinse it.* Put the film into Solution B, close the tank, and turn on the light again.

Develop the film for about 10 minutes in Solution B. The borax now goes to work and activates the metol and the hydroquinone that

have soaked into the film. When that is used up, development ends.

After 10 minutes with normal agitation in Solution B, turn off the lights again, put the film through the stop bath, then fix, use hypo neutralizer and wash as usual.

Let me repeat: do not get *any* of Solution B into Solution A.

Split D-76 can also be used with just one film tank, pouring the solutions in and out, with no bad effects. I don't know how many rolls a gallon each of Split D-76A and B are good for, nor do I have any idea how to replenish these solutions. Therefore I suggest using this developer as a two-part "one-shot" developer, and discarding all used solutions. (Storage in small bottles therefore makes sense.)

PRINT FIXERS

Plain hypo has no hardening action, and its print capacity is very limited. Don't use it for more than 30 8 × 10 prints per gallon.

Unhardened prints are vulnerable to damage, wet and dry, but they tone and bleach readily and they make spotting easy. Plain hypo is sometimes used as a third bath after two hardening fixing baths because it diminishes excessive hardening.

The simplest of all fixers is mixed without a scale. You measure the hypo crystals by volume, in a graduate.

Plain hypo	metric	avoirdupois
Water (125° F., 50° C.)	3 liters	3 quarts
Sodium thiosulfate (hypo)	1 liter	1 quart
Water to make	4 liters	1 gallon

Kodak F-6 Fixer. It seems inefficient to over-harden prints, then soften them again, when you can use F-6 directly and get prints that are hardened enough to protect them, but not so much that they are difficult to tone and to spot. F-6's moderate hardening seems just right to me.

F-6 has another advantage over every other hardening fixer I know: it is almost odorless. A freshly mixed tray of F-6 does not strangle the photographer.

There's more. F-6 washes out of prints more readily than any other hardening fixer I know of. For all these reasons, it is my regular print fixer.

This formula is for 8 liters or 2 gallons—enough for convenient two-bath fixing using 11 × 14-size trays.

Kodak Fixing Bath F-6	metric	avoirdupois
Water (125° F., 50° C.)	6 liters	6 quarts
Sodium thiosulfate (hypo)	2 liters volume	2 quarts volume
Sulfite	120 grams	4 ounces
Acetic acid 28%	384cc	12 fluid ounces
Kodalk Balanced Alkali (sodium metaborate)	120 grams	4 ounces
Potassium alum	120 grams	4 ounces
Water to make	8 liters	2 gallons

Mix the liquid acetic acid in as carefully and thoroughly as the dry chemicals before you add the Kodalk. F-6 is less acid than most fixers, so use fresh stop bath after the developer.

Capacity: one-bath fixing: 30 8 × 10

prints (or the same total area in other print sizes) per gallon. Two-bath fixing capacity is 100 8 × 10 prints per gallon (after fixing 100 prints, throw out the first bath and replace it with the second, which becomes the first hypo for the next 100 8 × 10s or equivalent. Use a fresh second hypo. After 200 8 × 10s, start over with two freshly mixed fixing baths. The idea is to throw the hypo away while it's still fresh, so it won't ruin your prints later.)

CHEMICALS FOR PRINT PERMANENCE

Fresh fixer and a good wash are the first essentials. If you follow them with the test and two treatments given here, you'll be doing almost all you can to make your prints clean and chemically stable.

The hypo test tells when your prints are well washed; the hypo eliminator gets them cleaner than the wash can; and the gold protective solution both armor-plates the silver image with gold and makes the pale tones of a good print look livelier and more luminous.

Kodak Hypo Test Solution HT-2. You test an unexposed but fixed and washed sheet of photographic paper that is processed together with your prints.

After the wash has reached the point where you think it may be done (40 minutes at 80° F. or 27° C.), take out the test sheet, blot off the surface water and put one drop of HT-2 on the paper's emulsion side. Time it with a clock or watch. Exactly two minutes after the drop touches the paper, wipe it off and compare the stain it leaves with the sample patches on the Kodak Hypo Estimator (available at photo stores). An "archivally" pale stain, according to the estimator, or no

visible stain indicates an archival wash—that is, the print is good for 50 years or longer if stored and handled well.

If the stain is darker than the lightest stain on the estimator, continue the wash until you get a pale test. Put the test sheet back into the wash for this, and try again after 15 or 20 minutes' more washing.

Kodak HT-2	metric	avoirdupois
Water	375cc	12 fluid ounces
Acetic acid 28%	62.5cc	2 fluid ounces
Silver nitrate	3.25 grams	58 grains
Water to make	500cc (½ liter)	16 fluid ounces (1 pint)

The quantity may seem small, but it's enough for thousands of tests. Date the solution and discard it after one year, no matter how much is left over. Keep HT-2 in a brown bottle, away from strong light (ordinary room light is OK when you are using it, but store it in the dark). Don't get it on your hands, clothes or prints unless you like black stains.

You don't have to mix your own HT-2. A similar silver-nitrate test solution is sold by Heico, Inc., the makers of Perma Wash. It's called PW Residual Hypo Indicator, and comes in a two-ounce bottle—enough for many, many tests. (For information and price, write to Heico, Inc., Delaware Water Gap, Pennsylvania 18327.)

Heico's procedures differ slightly from Kodak's, so follow Heico instructions when using PW indicator.

The Kodak Hypo Estimator. (Others are printed on paper, both by Kodak and by Heico; but that paper may not match the printing paper, which makes judgment more difficult than it is when you look through this transparent indicator.)

HT-2 hypo-test patches on printing paper taken from the wash at different stages. The dark patch shows hypo-saturated paper, washed only a minute or two; the next shows a half-washed condition; and the third (very faint here, but visible by color in the original patch) shows a commercially adequate wash—enough for temporary-use prints. The last—no stain at all—is the one to wait for with each wash if you want your prints to last.

Kodak Hypo Eliminator HE-1. Having washed your prints well enough to pass the HT-2 test, you can let it go at that: those prints are good for a long life. But if you want them to last as long as possible, HE-1 will remove the traces of hypo that remain. The formula is cheap and the process is simple.

Kodak Hypo Eliminator HE-1	metric	avoirdupois
Water	500cc	1 pint
Hydrogen peroxide (3% solution)	125cc	4 fluid ounces
*Ammonia solution	100cc	3¼ fluid ounces
Water to make	1 liter	1 quart

* To make the ammonia solution, add 1 part 28-percent ammonia to 9 parts water. Peroxide and ammonia are drugstore items.

Mix your HE-1 immediately before you use it. Don't put it in a closed bottle: it's unstable, and gives off oxygen. The pressure can build up enough to break a bottle. You may as well breathe deeply while using HE-1.

Procedures: After a good wash, treat the prints in HE-1 for 6 minutes with constant agitation, at 68° F.

Then wash them for 30 minutes at 65°– 70° F. and dry normally. (Kodak recommends a 10-minute wash, but peroxide can be fatal to prints, so a longer wash seems sensible.)

Capacity: 50 8 × 10s per gallon.

Kodak Gold Protective Solution GP-1. I think of this formula as a toner, although Kodak hates to say "toner" unless there is a massive change in print color.

Kodak's purpose in devising GP-1 was to provide chemical protection for silver images on film and paper. Gold coats each silver particle and does in fact give high stability.

For me, that stability is a fringe benefit. I'm more interested in what GP-1 does to the tones of the print. The effect shows most in highlight areas, which somehow—I can't analyze why—take on new luminosity after GP-1 treatment. Possibly it's the addition of subliminal color contrast in these tones.

Selenium toner intensifies the dark tones and GP-1 intensifies the pale ones. The print gains strength and subtlety from both.

The dark tones change, too. They take on a blue overtone (the print dries much bluer than it looks while wet, so it's vital not to overdo GP-1 toning). Ansel Adams points out that GP-1 blue can "cool" prints that have gone too purple from excessive selenium toning.

GP-1 is my main reason for using HE-1, which should precede GP-1 toning. The cost per print is moderate, probably less than the cost of the photographic paper. Gold chloride is expensive, but a little goes a long way.

Kodak GP-1	metric	avoirdupois
Water	750cc	24 fluid ounces
*Gold chloride (1% solution)	10cc	2½ drams
Sodium thiocyanate	10 grams	145 grains
Water to make	1 liter	1 quart

* To make a 1-percent solution, dissolve 1 gram of gold chloride in 100cc of water.

Mix GP-1 immediately before you use it. Add the 1-percent gold-chloride solution to the 750cc or 24 ounces of water.

Dissolve the sodium thiocyanate separately in

The hypo estimator in use. Its palest patch represents a minimum wash for "archival" prints—roughly .005 milligrams of hypo per square inch; .002 or less is better. Here the second-darkest spot looks like the No. 4 patch on the estimator—about .1 milligram per square inch (50 times as much residual hypo as a print can stand). Moral: keep on washing.

PHOTO CHEMISTRY BOOK LIST

Obviously, much more information and many more formulas than I have given are available. Here are a few good sources.

Ansel Adams, Basic Photo Series:
The Negative (Book I);
The Print (Book II). Morgan & Morgan, Dobbs Ferry, N.Y. Practical, comprehensive, consistently accurate information.

George T. Eaton: *Photographic Chemistry in Black-and-White and Color Photography.* Morgan & Morgan. A clear book written for laymen by a leading Kodak research chemist. Technical enough, but not too technical to understand.

Arnold Gassan: *Handbook for Contemporary Photography.* Handbook Publishing, Athens, Ohio. A textbook for university students of photography as art. Somewhat disorganized, but contains valuable information on silver and non-silver photo processes.

Hollis N. Todd and Richard D. Zakia: *101 Experiments in Photography.* Morgan & Morgan. A provocative, stimulating book of things to try out—many of them simple. An inexpensive paperback.

125cc or 4 ounces of water, then add it to the gold-chloride solution, while stirring rapidly.

Tone by immersing the HE-1-treated prints in a tray of GP-1 for about 10 minutes at 68° F., or until you can just begin to see the tones changing toward blue-black. Agitate constantly during toning. Wash the prints for 30 minutes and dry them normally. A gallon of GP-1 will tone about 30 8 × 10 prints.

(*Note:* I'm told—in 1974—that gold chloride is now unavailable, due to the increased price of gold. Don't worry about it too much: GP-1 is a luxury, not a necessity.)

Photographic Sensitometry: The Study of Tone Reproduction. Morgan & Morgan. A lucid, interesting textbook on the science of sensitometry. About half of it is over my head.

Caring for Photographs, with sections by Dr. Walter Clark and Eugene Ostroff. Life Library of Photography; Time-Life, New York, N.Y. The first half of the book is sound, with useful information about restoring old photographs and caring for new ones; includes some processing formulas and instructions I have not seen elsewhere.

Kodak Darkroom Dataguide. Eastman Kodak Co., Rochester, N.Y. Few formulas, but much information. The time-temperature calculator slide rule for film development is worth the price of the book.

Leica Manual, 15th edition. Morgan & Morgan. Specialized chapters by many authors —Ansel Adams and Bill Pierce among them—include much useful technical information. Also contains pictures and historical material.

Photo-Lab Index, edited by Ernest M. Pittaro. Morgan & Morgan. The broadest technical source book I know. A vast store of information (largely gleaned from manufacturers' literature, so subject to verification by test); and a comprehensive collection of formulas from many sources.

Processing Chemicals and Formulas for Black-and-White Photography: Data Book J-1, Eastman Kodak Co. Clear and concise. It's what a formula book should be, except that (naturally) it's limited to Kodak information. Inexpensive and indispensable.

FINE-TUNING PRINT CONTRAST

Emulsion color and paper surface texture affect the expression of the print, of course. A warm-toned paper will sometimes save tones that die on a neutral-colored paper. This varies capriciously: I'll just say here that print color is a matter of taste. Use what works best for you, whatever your friends may think.

When a picture is predominantly pale, a dull-surfaced print often looks better than an equally well-made glossy one. With few dark tones to suffer from the dull surface, little or no harm is done. As a surface—forgetting photographic tone for the moment—a plain matte finish is less obtrusive than a shiny one. Where the picture permits, you can take advantage of this. Such a print will look different from your glossy prints. Why not? It will be a different picture.

Prolonged print development, in some geographical locations, lowers overall contrast on most modern enlarging papers without sacrificing much of the local contrast. In the lightest tones, the contrast seems to increase while the print as a whole gets softer.

As far as I know, this technique is not mentioned in the technical literature of photography. I learned about it by trial and error in the early 1960s in New York City, where I used it with consistent success for the next 10 years to tune the paper to fit the negative precisely. It works well there (and Henry Wilhelm of the East Street Gallery tells me it works the same way in his darkroom in Grinnell, Iowa).

On moving to Chicago, I was astonished to find that prints given longer developments became contrastier, not softer. (I had begun to think that prolonged print development for softness was an eternal verity or universal truth. It's easy to make unwarranted assumptions!)

This made me think, so I experimented further. The difference between New York and Chicago, where printing is concerned, is almost certainly in the chemical content of the local tap water. Judging from film-development results, Chicago water is more alkaline—or less acid—than New York water. The difference in printing might lie there.

So I mixed some developer in distilled water and diluted it with distilled water to cancel out the tap-water effect. The contrast still increased with prolonged development.

That's as far as I've got at the time of writing.

In areas where the long-development-for-softer-prints technique works—and you can easily test this for yourself—the technique is utterly simple. You just give your prints a little less exposure (as determined by long-developed test strips), and develop the prints for 5, 10 or 15 minutes instead of the conventional 2 minutes, according to the degree of contrast you want.

What you need. To use this control, you need enlarging paper with a low fog level (the fresher, the better), immaculately clean trays, fresh developer and a really safe safelight. Heat and humidity in the darkroom make the paper fog sooner than when it is dry and cool.

What happens. In places, such as New York City, where long development lowers print contrast, it seems to work like this: As you develop the prints longer than is usually considered normal, the development of the dark tones slows down more than the development of the light tones, so the contrast decreases. The longer you develop, up to the

point where chemical fog appears, the lower the overall contrast of the print will be. This works equally well with normal-contrast developers like D-72 and Dektol and with low-contrast ones like GAF 120.

Exposure compensation. All tones go on getting darker throughout the long development, so you must expose a long-development print less than a short-development print to get the same dark tones. A rule-of-thumb starting point for this correction is, give 20 percent (1/5) less exposure for a 5-minute-development print than for a 2-minute one; and 20 percent less exposure for a 10-minute-development print than for a 5-minute one.

Papers. Cold-toned and neutral papers can usually take longer developments than warm-toned papers before becoming stained or fogged chemically. Test your favorite papers for their long-development behavior, and you will extend your ability to make consistently good straight prints from negatives of varying quality. This is true whether long development decreases or increases print contrast where you do your printing: either way, it is a useful measure of control.

Contrast range. In New York, I was able to get about a one-grade variation in print contrast by changing development time with most of the papers I use. If you add to this the control offered by different print developers, paper grades and variable-contrast filters with v/c papers, you can see that contrast choices are wide open. For example, I learned that if I wanted a cold-toned "No. 2" print on DuPont's Velour Black, I could easily get one by using Velour Black No. 3, with its colder color, and stretching the print-development time to bring the contrast down (No. 2 Velour Black is a warm-toned paper, though you

would not guess this from reading DuPont's description of it).

Test strips for long print developments. In softening the prints by long development, you determine both the exposure and the print development by making test strips. If your first strips show that the print will be slightly contrastier than you want with 2 minutes' development, you expose a new set of test strips and develop them 5 minutes. If they are still too contrasty at 5 minutes, try strips at 10 minutes' development. That may prove too soft: if so, try a first print with 7½ minutes' development. Zero in from there.

It saves time. Your local tap water permitting, it's a simple and practical approach. The extra time spent with tests and over the developer tray tends to be canceled out by the simple, quick exposures under the enlarger, and by the ease with which you can safely process up to half a dozen prints together with consistently good results—once the development time is five minutes or longer. This saves fixing time, too, since they go through the first fixer together.

If anything, my print production went up when I started to develop my prints longer.

New tonal qualities. There's more. Whether it has lost or gained contrast, a long-developed print takes on subtle new tone qualities which I can't describe—it's as if you were looking *into* the print, rather than at its surface. The tones take on transparency and depth, even when the print is not dark.

This way of printing on conventional papers produces much the same tonal qualities as platinum printing, with far less labor and expense. So now I normally develop prints for five minutes. The tones sing more because of it.

Contrast Control by Developer Dilution. I

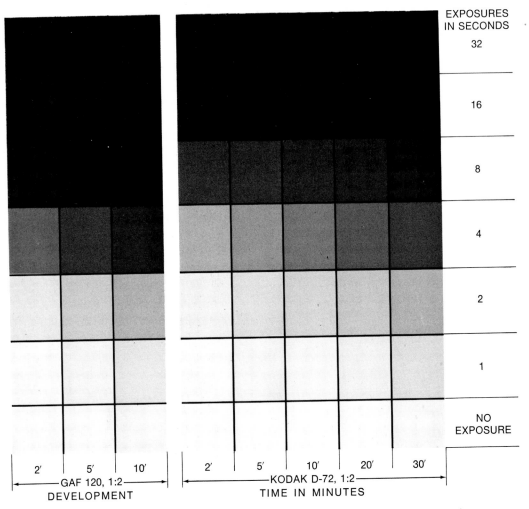

EXPOSURES
IN SECONDS

32

16

8

4

2

1

NO
EXPOSURE

2' 5' 10'

GAF 120, 1:2
DEVELOPMENT

2' 5' 10' 20' 30'

KODAK D-72, 1:2
TIME IN MINUTES

How prolonged print development affects contrast and tone rendition (in New York and some other places, but not in Chicago or New Mexico, to judge from my experience). This test was done in New York City in 1969, using Spiratone GL2 paper, GAF 120 soft-working paper developer, and Kodak D-72 normal-contrast paper developer. Different exposures were crossed by different developments.

All test exposures were made simultaneously on the same sheet of paper, which was then cut into strips and developed in two batches (GAF 120 and D-72). Development of each batch was simultaneous: all strips were put into the developer together, and they were taken out separately after different development times. Agitation was continuous throughout.

(Kodak, DuPont and Agfa-Gevaert papers, among others, all showed similar behavior.)

don't use this any more because I get more control by varying print development time. Still, it's worth knowing that the more concentrated the developer is, the higher the print contrast will be; the more dilute, the lower the contrast. Judging from my experience, the effect is not great: it's hard to tell the difference between a print from 1:2 developer and one from 1:3. I suggest using greater differences than that.

Undiluted "straight" developer will add a trace of contrast, and a 1:4 dilution will subtract a trace as compared with a normal 1:2 development.

Highly diluted, weak developers soon become exhausted, so change to fresh developer every five or six prints if you want consistent quality.

Developer Additives. I've mentioned the contrast increase you get by adding potassium bromide or benzotriazole to the print developer.

Hydroquinone. You can also get slightly more contrast by adding hydroquinone (easiest to control in the form of a 10-percent solution). Trial and error will tell you how much to use for a given effect.

Sodium thiocyanate. Warm-toned papers can be made to give neutral black print tones by adding a pinch of sodium thiocyanate to the tray of developer. This also increases the contrast markedly. Too little thiocyanate has no visible effect, but too much will stain the white tones in your print egg-yolk yellow, so go easy.

Contrast Control by Split Development. You use a tray of normal developer (Dektol, for instance, or D-72) and a tray of soft developer (Selectol-Soft or GAF 120), but you do not mix them. The print spends some time in each. This is an unwieldy technique, but it can produce both weird and beautiful prints.

How it works. The first developer dominates the print, and the second one modifies it. If you put the print in the normal developer first, it tends to be relatively contrasty; with soft developer first, if both developers have equal time, the contrast drops.

Caution. Prints can safely go from the soft developer to the harder one without a rinse; but a print that has been in the normal developer needs a good rinse in plain water before being put in the soft developer, or the hydroquinone that is carried over will soon "unsoften" the low-contrast developer.

Therefore you need three trays before your stop bath: soft developer, water and normal-contrast developer.

Balancing contrast. For contrast that is more or less balanced between the two developers, put the print in the first developer only for 30 to 40 seconds; then remove it, rinse if necessary and develop three to five minutes in the other developer. It can go into either developer first; while the effect will be "in-between" in both cases, the prints are usually conspicuously different from each other. You'll probably get some strange tonal effects. If you like them, work further with this technique.

Mixing "Hard" and "Soft" Print Developers. See p. 240 for the formulas and table of mixtures for "Dr. Pratt's v/c developer," a variation on the classic Dr. Beer's formulas; or you can use a mixture of normal-contrast and soft developer, such as Dektol plus Selectol-Soft, to get prints of intermediate contrast.

Split-filter printing on variable-contrast pa-

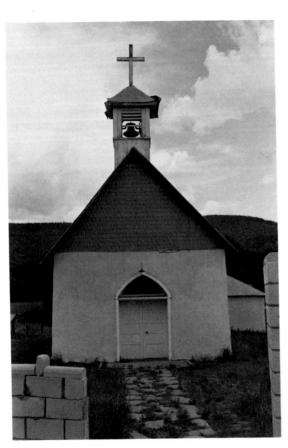

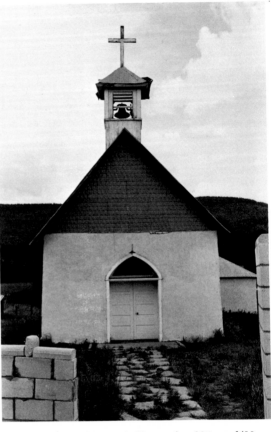

Split-filter printing: test print using No. 1 filter only on Polycontrast Rapid RC: 8¾" at f/11. All tones clear, but contrast is too low.

Test print with No. 4 filter only: 20" at f/11. Contrast looks good, but sky at top left is missing: to expose enough for it, at this contrast, would make everything else too dark.

pers can help you make good, normal-looking straight prints—with no burning-in and no dodging—from negatives that have important tones at both the light and the dark extremes. You use only two filters—the softest one and the most contrasty one (the PC-1, for example, and the PC-4, if you're using Kodak filters).

What the filters do. The whole picture is printed through each filter; but the soft filter's main purpose is to bring in enough highlight tone without overexposing the dark tones, and the hard filter's function is to deepen and enliven the dark tones without much affecting the light ones. Since the whole picture is printed through both filters,

Photographic Control

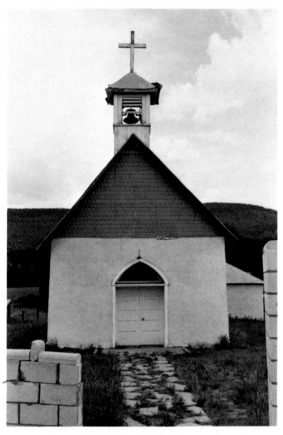

First try with both filters: 8¾" at f/16 with PC 1, and 20" at f/16 with PC4. Contrast OK, but the top-left sky is still too pale. Decision, give more No. 1 filter time, less No. 4 time, to darken sky without making everything else too dark.

Second two-filter print: 13½" at f/16 with PC 1; 15" at f/16 with PC 4. Result, a straight print with its density and contrast turned to the density range of the negative.

there is no forced separation between light and dark tones. The transitions feel and look "natural."

The principle. With this technique, you work from both ends of the tonal scale toward the middle tones, which take care of themselves. (In conventional printing, you work from the middle of the tonal scale and

hope the ends will come in all right.)

Procedure: Make separate sets of test strips with the soft filter and with the hard filter. You are working to find the minimum soft-filter exposure that will give good detail in the whites, and the maximum hard-filter exposure that will give good detail in the blacks. Make these test-strip exposures with

your enlarging lens at least one stop more open than its smallest aperture.

Let's say that you get your best soft-filter strip with an exposure of 11 seconds at f/16, and that your best hard-filter test strip was exposed 24 seconds at f/16.

To make your first test print, stop the enlarging lens down to f/22, then expose for 11 seconds through the PC-1 filter, and for 24 seconds through the PC-4 filter. The contrast of this print should be "in the middle," and it should be neither light nor dark. (The reason for stopping down is that you want 50 percent—not 100 percent—of your total exposure to come through each of the two filters. 50 percent of the "soft" normal exposure plus 50 percent of the "hard" normal exposure add up to normal exposure, split equally between the two filters.)

If the contrast is right but the print is too dark, subtract the same percentage from the exposure through each filter. If too light, add the same percentage. (11 seconds plus 10 percent = 12.1 seconds; 24 seconds plus 10 percent = 26.4 seconds. Round this off to 12 seconds of PC-1 exposure and 26½ seconds of PC-4 exposure and you'll be close enough.)

If the exposure is right but the contrast is too high to suit you, try subtracting 25 percent from the PC-4 exposure time and adding 25 percent to the PC-1 exposure time (24 seconds minus 25 percent = 18 seconds: 11 seconds plus 25 percent = 13.75 seconds. Call it 18 and 13½).

If the contrast is too low, of course, you add to the hard-filter exposure and subtract the same percentage from the soft-filter exposure.

By playing the percentages, you can con-trol print contrast precisely using the "straight" split-filter technique.

Split-filter bad medicine (I mention this only because someone is sure to try to sell it to you as a magic cure-all). A much-used trick which I do not recommend is to expose the whole print through a contrasty filter, then burn-in the highlights with a low-contrast filter. This can work well in the hands of a virtuoso printer, but, judging from too many prints I have seen, it is beyond most photographers.

These miserable prints shift abruptly from contrasty dark and middle tones to muddy light tones. They are off-key and out of joint. It takes great skill to print well this way, which "straight" split-filter printing does not.

Further, it encourages the photographer to keep on underexposing and overdeveloping his negatives (that's the only kind of negative that could need this treatment) while he feels complacent about what a clever, complicated printer he is.

But the most vital key to good printing is to make good negatives and print them simply.

Flashing the print means giving it a quota of non-picture exposure as well as the exposure through the negative. Flashing always lowers the contrast, and typically lowers it most in the highlight areas of the print, so it's a good way to bring over-bright "hot spots" under control.

Test your paper, at the enlarger height you're using for the print, to find the maximum exposure that falls just short of printing as a pale gray tone—the greatest amount of light that will *not* print visibly by itself.

Added to a normal print exposure, that small amount of light will raise even the

slightest amount of exposure in the print's highlights "over the threshold" so they will become visible in the print.

Not quite enough highlight exposure plus not quite enough flash exposure to register alone add up to enough total exposure to make visible, though low-contrast, highlights. The flashing hardly affects the darker tones.

You expose the paper twice, once through the negative, and once without it.

Let's say the print exposure is 22 seconds at f/11, and the flash exposure is one second at f/22. You expose the print normally. Then, leaving the paper in the easel, you remove the negative from the enlarger, stop the lens down to f/22 and give the print a one-second "plain light" exposure. Then develop the print.

If you need a richer gray, try twice the flash exposure, then zero in according to your results.

Flashing in the Developer. Flashing can be done during the print development. If this goes too far, you may get the partial reversal called the Sabattier effect or pseudo-solarization; but used with restraint, it can give the prints a beautiful smooth softness.

Use a very weak light bulb far above the tray, or use a flashlight with several layers of tissue paper over it to cut down the light.

Results vary both with the brightness and duration of the flash exposure and with the timing: it makes a difference how much development has taken place before the flashing begins.

This technique allows a wide range of results, from "normal" to very freaky.

Local bleaching with ferricyanide and hypo can change a picture remarkably, "spotlighting" highlight areas so they stand out bril-

liantly against a generally soft, dark print. One master of this mode is W. Eugene Smith, who edits content as well as appearance in his work by subduing some areas and emphasizing others through bleaching.

Your print should be wet and propped up on a smooth surface in good light so you can work on it easily. Before you touch it with ferricyanide, wipe all water drops off the area you want to bleach.

Mix a weak (light yellow) solution of potassium ferricyanide in water. Apply it to the parts of the print you want to bleach with a cotton wad or a brush.

When the print has begun to pick up some yellow stain from the ferricyanide, dunk it in a tray of cold running water to remove any ferricyanide that hasn't soaked into the emulsion.

After the rinse, put the print in a tray of plain, non-hardening hypo. This will bleach and "clear" the ferricyanided areas so they are slightly lighter and no longer yellow. Then rinse the print well again.

To bleach again and carry the process further, put the rinsed print back on your working surface and wipe off the water drops. Then work over the area to be bleached again with the ferricyanide. When the paper picks up a yellow tinge, re-rinse and clear in hypo again.

Rinse again and repeat as often as necessary, until the print is the way you want it.

Warning: It permits astonishing effects, but this technique automatically overfixes prints so they cannot be washed well enough to last for very long periods. If maximum permanence is important to you, make a good copy negative of the ferricyanided print. Then you can make new prints that

include all the tone changes achieved by bleaching, and you can process them archivally.

All-over Bleaching. For this, ferricyanide and plain hypo are mixed together to make Farmer's reducer. You dunk the print in a tray of reducer and bleach it all at once.

The purpose and the effect of printing dark, then bleaching the whole print back to normal, are utterly different from those of the local-bleaching approach.

The one thing you gain—and it can be a great gain—is livelier contrast in the highlights of the print.

The main reason for this has little to do with bleaching. It's simply that when you expose the print enough to bring the highlight exposure up off the low-contrast "toe" of the paper's characteristic curve, this produces much more contrasty highlight tones. The trouble is, the print then looks too dark. Bleaching it back until the highlights are brilliant is the answer.

If you use a fairly strong (deep yellow) Farmer's reducer and work with speed, accuracy and luck, you can bleach the print just enough without overfixing it. This skill takes practice, but it's well worth learning.

All-over print reduction is especially useful in copy photography, where obnoxiously flat, gray highlights are hard to avoid.

MORE ABOUT COPY PHOTOGRAPHY

Selenium toner, used very dilute as a gentle print intensifier, has been covered already. But together with overall bleaching in Farmer's reducer, it's the other half of post-printing contrast-enhancement in copy photography.

Shadows in copy photos are also characteristically flat. Plentiful exposure of the copy negative helps greatly, but a selenium-toner boost in the dark areas plus the highlight boost gained from bleaching can make the difference between a copy print that looks as good as the original print—or better—and one that looks "blah."

Use a Gray Scale. When you copy, be sure your lighting is glare-free and absolutely even, and copy a photographic gray scale that includes tones from white to black next to the picture.

A convenient ten-step gray scale is available in an inexpensive packet called "Kodak Color Separation Guides." It comes in a 7-inch length and a 14-inch length. I use the 7-inch one, which is coded as Kodak Publication No. Q-13, series VI.

Print the gray scale along with the picture. When the gray scale in your bleached and selenium-toned (but still untrimmed) copy print matches the original gray scale tone for tone, well, so does every tone in the picture match its original.

(For more about copying, if you're interested, see Kodak's excellent data book No. M-1, *Copying.*)

TURNING CONVENTIONAL PAPER INTO PRINTING-OUT PAPER (OR HOW TO MAKE ULTRA-SOFT PRINTS ON NO. 6 PAPER)

As far as I know, the late Lloyd Varden invented this technique. He told me about it and I tried it.

The printing-out paper ("P.O.P.") used by early photographers grew dark by the direct

A Kodak Gray Scale.

action of light. It needed no development. As a result, it could easily produce normal-contrast prints from almost incredibly contrasty negatives, which were considered "normal" in the 1860–1880 period.

How? Well, as the light darkened the surface of the emulsion, it no longer let much light through to the emulsion behind it. So the dark tones soon stopped darkening at a normal rate. They slowed down or stopped completely. But the light tones, not being masked off by a dark surface layer, stayed fully sensitive, so their exposure marched on at its usual brisk pace.

You just kept your printing frame turned toward the sun until inspection showed that enough tone had appeared in the highlights.

(Printing frames have that hinged back just to make this inspection possible without taking the paper out of the frame.)

This slow-in-the-shadows but fast-in-the-highlights behavior is called a "self-masking" effect, for obvious reasons. We can envy the P.O.P. photographers for the ease with which they could print contrasty negatives.

But Lloyd Varden had a free-wheeling, original mind. He said to himself, "But if the print is soaked with developer before exposure, it will darken as the exposure takes place: do-it-yourself P.O.P." He was right.

The process is much like normal printing, but you don't use an enlarging easel. A piece of glass takes its place. You focus on a piece of photo paper on top of the glass, which lies

directly on the enlarger baseboard. Remove the glass and mark the location of the projected picture on the baseboard so you'll be able to place your printing paper accurately.

By safelight, soak a sheet of unexposed enlarging paper in normal print developer such as Dektol or D-72, for about two minutes.

Drain it briefly, then lay it emulsion-side-up on the sheet of glass. Wipe off all surface liquid. Some like to squeegee it, some wipe it, and Varden liked to blot it. Whatever works for you is it. I'm a paper-towel man, myself. It takes great care: uneven wiping will leave streaks and even paper-towel surface texture on the print.

Place the glass on the baseboard of the enlarger with the paper up, placed accurately over your location marks.

Now expose. This is weird. As you expose, the image projected on the paper presently "fades" and disappears (because the areas the light strikes gradually darken in proportion).

To see how the print is coming along, just turn off the enlarger light and look at the print by safelight. When the highlights are dark enough, the print is exposed enough.

In my first experiments, the developer contained in the paper was not sufficient to develop the dark tones fully; about 30 seconds in the developer tray, after the exposure, finished the job. A later print, reproduced here, was made with the same No. 6 paper, using D-72 diluted 1:1. It didn't need any added development after the exposure. Further experiments with more concentrated developers might be a good idea.

Contrast control is a matter of timing the exposure in relation to the speed of the development. The quicker the exposure (the brighter the light and the larger the f-stop), the less self-masking will take place, so the print will be correspondingly contrastier. The slower the exposure (the dimmer the light, the smaller the f-stop), the more the print will develop and mask itself during the exposure, and the lower its contrast will be.

One negative I printed this way was used earlier as an example of high contrast due to the combination of a contrasty subject with overdevelopment of the film.

I printed it first on Dektol-soaked No. 6 paper with the lens stopped all the way down; it yielded a strange, but good-looking, print that looks about three grades softer than a No. 1 paper print of the same negative.

Why did I choose No. 6 paper? I figured that it would give me the maximum range of contrast possibilities.

I don't have enough experience with this odd technique to know much about its limitations and possibilities. The situation is wide open. If you get to work on it, you'll probably get it under control before I do.

Note: I've just given you most of the personal bag of tricks I've picked up in 25 years of photography.

If you think I use all of them constantly, you're wrong. I now make almost all my prints in the easiest, most straightforward possible way. These trimmings are mostly for emergencies or for sport—photographic parachutes.

Overdeveloped, high-contrast negative; conventional low-contrast printing, shown here for comparison, brings it down to "normal." Agfa-Gevaert Brovira 111, No. 1 paper: 60" at f/8; print developed in GAF 120, diluted 1:2, for 2 minutes.

Same negative printed ultra-soft on "high-contrast" No. 6 Brovira, using the POP principle. Paper was presoaked for 2 minutes in D-72 diluted 1:1, then exposed/developed under the enlarger for 4 minutes at f/8.

PART FOUR

MOUNTING, FRAMING, EXHIBITING, AND PUBLISHING

14

How to Mount Your Prints

WHY MOUNT PHOTOGRAPHS?

We mount prints for two purposes: to present them well, and to protect them when they are shown and handled.

Objectively, the mount holds the print flat so it is easy to light well. Dry-mounting tissue also protects the print against chemical contamination from behind, and the "mat"— the wide margin all around the print— absorbs fingerprints and knocks that would otherwise deface the picture itself. Damaged and dirty mats, unlike prints, are easily renewed.

Subjectively, the mount gives the print a "finish" that often makes it look much better, and surrounds it with a friendly neutral area of mat that separates the picture from distracting surroundings.

There are many ways to mount photographs. We will concentrate on three ways to dry-mount prints: with a margin of mount board around the print; with an "overmat"— a window mat hinged over the print and its mount; and "bled"—without any margins.

The Plain Mat. Here the print is fastened to the middle of a mount, leaving a wide margin all around it.

The overmat is a piece of mat board with a print-size window cut in it, hinged in place over a print mounted on a plain mat. It keeps the print from touching glass when framed, protects the edges of the picture from damage and provides a clean margin that can easily be renewed if it gets dirty or damaged.

The bled mount, where the edges of the picture area are the physical edges of the mount, is mainly a presentation device, since it leaves the edges and corners of the print extremely vulnerable to damage and contamination. A mounted bled print is even easier to ruin than an unmounted one, since it tends to break instead of bending. That's too bad: many pictures look better when bled than when matted.

WHICH PRINTS DO YOU WANT TO MOUNT?

I suggest that you mount only a chosen few, and only when the need arises. I've learned the hard way that the only prints I want to mount are the ones that are to be exhibited or sold right now.

If your prints are stored safely, mounts are useless except when the pictures are on display.

By leaving all prints unmounted until their day in public is at hand, I save much storage space, as well as time, money and energy I'd rather spend on taking pictures and enjoying life than on dead storage.

MOUNT BOARDS

Not many of the boards now sold for mounting prints are really good for the purpose. Many are chemically harmful, and many soon fall apart. If your prints are worth exhibiting, they deserve mount board that will neither destroy them chemically nor crumble under them.

As of 1974 when this is written, the paper industry is aware of photographic mounting problems, and is working to solve them; yet I know of no board now available that satisfies everyone's requirements for permanent display and storage of prints. Therefore I'll concentrate here on reasonable compromises.

Acid-free Paper Mount Board. The Hollinger Corporation, 3810 South Four Mile Run Drive, Arlington, Virginia 22206, provides an acid-free "Permalife" mount board in smooth white and in cream color. It is chemically preferable to most "all-rag" boards, and costs a little less. It is easy to cut and handle. Hollinger sells by mail order: a catalog is available.

All-rag Mount Board. "All-rag" now means less than it used to, since modern rags often contain unknown drip-dry chemical additives that may or may not be harmless to photographs. Nevertheless, such high-quality all-

rag boards as Bainbridge Museum Mounting Board and Strathmore Drawing Board have a life-expectancy of many years, and are among the best mount boards you can buy. Art dealers can order these for you from Charles T. Bainbridge's Sons, 20 Cumberland Street, Brooklyn, New York 11205, and from the Strathmore Paper Company, West Springfield, Massachusetts 01089.

Synthetic (non-paper) Mount Board. Sonic Equipment, P.O. Box 341, South Orange, New Jersey 07079, has introduced a white cellulose-fiber mount board of somewhat blotter-like texture. It is said to be acid-free and chemically stable, yellowing only very slightly as it ages (most papers do). This board may or may not be for you; but the approach is intelligent and the product seems worth investigating.

Countermounting on Photographic Printing Paper. This is a recent trend. If you mount your prints back-to-back on the same kind of paper they are printed on, you know that the "board" should last as long as the prints. Photographic paper is more stable chemically than most mount boards, so it makes sense to use it for mounting as well as for printing.

It's work: you must fix, wash and dry the paper you mount on as carefully as you fix, wash and dry your prints.

It's best to use the same paper for both the print and the mount—the same brand, thickness and surface texture, and preferably the same emulsion batch—and to match the direction of the paper grain in both sheets when you mount. Otherwise the two emulsions will pull unevenly against each other, and the print will warp after mounting.

Countermounted prints on glossy paper

cannot be dry-mounted afterward onto regular mount-board mats. The glossy back surface of the mount will not adhere to dry-mounting tissue.

To mat such prints, I suggest you use "corners" made of acid-free paper to hold them on a mount behind an overmat. (See page 276 for more about mounting with corners.)

DRY-MOUNTING

The one mounting method I can recommend for general use is dry-mounting with a dry-mounting press. This is the easiest, cleanest, safest method I know.

It is possible to dry-mount by hand using a laundry iron, but I do not recommend it. The labor is hard and tedious and the results are uncertain. I estimate that the press costs less than the prints you ruin in the first year of hand mounting.

A giant press is not necessary unless you must mount giant prints. I have a small press with an 11½ × 15-inch platen, so it will mount prints up to 11 × 14 inches in one bite. By taking them in sections, it can handle larger prints up to 23 inches wide by any length at all. This press cost me no more than a medium-priced lens would, and has saved me endless labor. For me, it's worth its price.

Dry-mounting tissue is thin paper impregnated with a synthetic adhesive that doesn't get sticky until it's heated. The tissue is placed between the back of the print and the mount.

Dry-mounting works on the same principle as the grilled-cheese sandwich. The firm, even pressure of the press squeezes print, tissue and mount accurately flat while its controlled heat binds the whole sandwich strongly together.

I use Kodak dry-mounting tissue, which comes interleaved with pink waxed paper. Throw the pink sheets away. Don't use them to separate prints: that wax is soft and may come off.

What You Need for Dry-mounting and Matting

Prints worth mounting.

Mount board.

Dry-mounting tissue.

Dry-mounting press.

Tacking iron (small iron used to attach tissue to print).

An accurate ruler (for measuring).

L-shaped carpenter's square (used to square

A mat knife. I prefer solid ones like this to thin-handled ones, which are not as easy to use.

right angles and as a cutting guide for the mat knife. A T-square or triangle for squaring and a heavy steel straightedge for cutting will serve the same purposes).

Sharp lead pencil.

Art-gum eraser or kneaded eraser.

Sharp mat knife and extra blades.

Thick cardboard (to protect your tabletop from the mat knife).

Timer or clock with second hand (or you can count seconds).

Hard, smooth rod (for "boning" print and mount edges).

A roll of 1-inch white linen bookbinder's tape—"Holland tape" (for hinging over-mats). Gummed linen tape (Holland tape) is available from Gane Brothers and Lane, Inc., 1335 West Lake Street, Chicago, Ill. 60607 (and other sources in other cities).

A damp sponge (to wet linen tape).

Scissors.

Paper towels or clean rags.

Clean, solid, spacious table.

Low humidity.

Assemble all the above before you dry-mount. Make sure the table and all equipment are clean.

Before You Dry-mount

Decide on a format. For years, I used to print every picture in a different size and often a different shape, so each print was a new game when it had to be mounted.

Now I've simplified life by making most of my prints in a standard format (arrived at by chance. Preparing a book dummy, I tried a size that would fit on a 10 × 10-inch page—just over 5 × 8 inches—and found that it worked well with my pictures). I print these 5 × 8s on 7 × 10-inch paper, cut either from 8 × 10 or 11 × 14. The leftovers become test strips.

This small print size lets me mount the pictures on mount boards which I pre-cut to 11 × 14 inches, a standard size that simplifies storage, shipment and handling.

I pre-cut my mount board so it will be ready whenever I want it. In recent years, I've used mostly the white two-ply form of Bainbridge Museum Mounting Board, which is thick enough for small prints. To hold prints larger than 8 × 10 inches flat, the stiffer four-ply board is better.

How to cut mount board. Don't use a paper-trimmer for mount board. Small cutters made for thin paper leave ragged, chewed-up, un-straight edges when used to cut anything thicker—and cardboard quickly ruins such trimmers. Use a sharp mat knife and a steel straightedge to guide it when you cut mount board.

Pad your table with thick, cheap cardboard: the gray kind called "chipboard" is good. This keeps your table from getting chopped up, and saves your prints from having chips of wood or plastic mounted under them or embedded in their faces. Renew the chipboard often.

Make sure your mount corners and print corners are accurately square by using a T-square, a triangle or a carpenter's square. I use the carpenter's square both to square corners and to guide my mat knife.

Measure your mount board to the size you want. If it has nicked or dirty edges, those are the ones to cut off. Mark the board

lightly with a sharp pencil so you'll know where to cut. A small mark for each end of the cut is enough.

To cut, first lay your steel straightedge or carpenter's square across the board, lined up accurately on the marks for your first cut.

Hold the straightedge down firmly (with your left hand, if you're right-handed, or vice versa) and use your other hand to make the cut, drawing the knife smoothly toward you along the steel edge.

Don't press the knife hard against the straightedge, and don't let it wander away from the edge, or you will cut subtle and expensive curves. Just cut accurately *along* the edge. Keep all fingers out of the knife's path. Don't press down too hard on the knife: press harder on the straightedge.

Unless your board is thin and soft, you will usually need two or more knife strokes to cut clear through it. Thick, hard board may take ten or twelve strokes: let it. You will soon develop a sense of how hard to press on the knife to cut most cleanly and easily.

Mat-knife blades do not stay sharp long. Ten or twenty cuts may finish one, so replace the blades often. They are cheaper than board and prints.

Pick your prints. The last vital step before dry-mounting is to choose the prints you really want to mount and eliminate all others. With some doubtful pictures, you just can't tell if they are good or not until you've given them every chance. Mount these to find out. With experience, you'll catch most of them earlier.

Dry-mounting Without Overmats

Clean your tabletop. Mine is white For-mica, and gets sponged with soapy water, rinsed and wiped dry.

Bring out the prints you want to mount, your dry-mounting tissue (I prefer Kodak's) and one sheet of pre-cut mount board for each print.

Plug in and turn on your dry-mounting press and tacking iron so they'll be hot when you need them. Keep the press closed while you heat it (and when it is not in use).

Temperatures. For conventional prints, I set my press thermostat at 225° F. and my tacking iron at "med." To mount RC (resin-coated) papers, which melt messily if the press is too hot, I set the press between 180° F. and 225° F., and the tacking iron between "low" and "med."

Pad the press. Make sure you have an extra sheet of board in the press while it heats: it pads the press during mounting so your prints never touch metal. If this pad, the prints and the mounts are dust-free, you'll get a clean, smooth mounting job.

Picture identification. While the press heats, I copy my negative and print numbers from the back of each print onto the back of its mount (the backs of the prints will soon be unreadable). From here on, it's vital to keep each print together with its mount.

Dry out the prints and mounts if the weather is damp. Dry each print and each mount separately by closing the hot press over it for one timed minute. Then bring it out, lay it on the table and dry the next print or mount. If the prints and mounts are not equally dry when bonded together by the press, they will warp later. (I avoid this tedious drying process whenever I can by mounting on days of low humidity.)

Inspect, clean and tack. Now examine both sides of each print and of its mount, and remove all dust before you tack a sheet of tissue to the back of each print.

Dust between the print and the mount causes lumps on the mounted print: handling soon wears the emulsion off the bumps and ruins the print. Dust on the face of the print is pressed down into its surface during mounting, leaving conspicuous holes and pits.

Tacking methods. Lay the print face-down on the table, lay a sheet of dry-mounting tissue on it (discard the waxed interleaving paper) and tack the tissue to the print by pressing lightly on it with the hot tacking iron. Hold the tissue in place with your other hand. When tacking, keep the iron moving so it won't emboss its shape clearly in your print.

Turn the print over, once the tissue is firmly stuck to it, and trim off any tissue that sticks out past its edges.

Center-first tacking. A conventional approach is to tack the tissue only to the center of the back of the print: the loose corners are used later to tack the print-and-tissue sandwich in place on the mount board before the whole thing goes into the press.

Corner-first tacking. I prefer to tack the tissue to each of the print's four corners, pulling the iron outward with each stroke—away from the middle of the print.

I tack one corner first, then the opposite corner, then the other two. The outward pull while tacking each corner makes the tissue lie flat against the print. Tacking all corners helps keep dust out, and prevents the tissue from flapping and folding together under the print to ruin the mounting job.

A corner-tacked print is later tacked in place on the mount by putting a clean sheet of paper over it, then tacking right through the paper and the face of the print. This tacking is done in the middle of the picture. Again, the iron must be kept moving: the paper keeps it from touching the print and leaving marks. It takes a few seconds to tack through a print: the heat must penetrate the cover paper, the print, the tissue and the surface of the mount before the tissue will hold the print in place. But first, before it is tacked to the mount, the print must be placed accurately on the mount.

About Margins. In Europe and America, it's customary to leave a wider margin below the picture than above it. In Asia, they leave the larger space at the top. I prefer to center my prints: this looks just as good to me, and it's simpler. But use whatever format you like best.

A jig for centering prints. If you use a standard mount size for most prints, it's convenient to center them with a simple jig that you can make.

Take a thin, stiff board exactly the size of your mounts. Measure two inches inward from each edge, and draw the smaller inside rectangle that results.

Cut this inner rectangle out with a mat knife, and you'll have a two-inch-wide frame of the same outside size as your mounts. (For 11 × 14-inch mounts, the center opening will be 7 × 10 inches.)

Mark the exact center of each side, drawing the marks clear across the two-inch width of each side.

Now measure one-inch divisions along the inner edges of the frame, from the center outward. Mark them accurately with one-

Drawing of my homemade jig for centering 7 × 10-inch or smaller prints on 11 × 14-inch mounts. Make your own jigs any size you want.

inch-long marks leading from the inner edges.

Number these one-inch marks from the center outward, starting with "0"—zero—at the middle of each side. Thus the ten-inch side of a 7 × 10 opening will read: "5–4–3–2–1–0–1–2–3–4–5, and the short side will read "3–2–1–0–1–2–3," with half an inch left over at each end.

Repeat with half-inch measurements and marks, which don't need numbering. Make these marks half an inch long.

Repeat again with quarter-inch measurements and marks. If you're a fanatic, you can go on to eighths and sixteenths: the quarter-inch calibration is fine enough for me.

To center the print on the mount, place the jig on the mount board with all edges lined up. Put the print in the opening in the middle and center it according to the calibrations.

To check print placement precisely, lay a ruler across the jig, first at one side of the print, then at the opposite side. Line up the ruler exactly on the closest calibrations outside the picture area. When the spaces are equal between both sides of the print and a ruler laid across calibrations with the same number value—say the "3" mark on each side, plus ⅛ inch—the print is centered in that direction. Of course, it must be centered in both directions—along and across—and the sides must parallel the jig.

When the print is centered, it can be tacked directly to its mount: there's no need to mark the mount at all.

Mounting with the press. Give each centered-and-tacked print-and-mount sandwich a final dust inspection as you go.

Open the press, hold up the mount-board pad and slide the print and mount under it. Center the mount in the press.

Close the press on the print and leave it closed for one timed minute. (Shorter press times are often recommended, but they do not always produce a lasting bond.)

At the end of the minute, open the press, take out the mounted print, lay it on the table and close the press. Put a weight on the print to hold it flat while it cools. The next print can be put on top of the first one, and so on. When you're through, all your prints are neatly stacked, and they are all flat.

Timing. It's convenient to use the minute when one print is "cooking" in the press to center and tack the next one on its mount

Centering a marginless print on a plain mat (no overmat) with jig and straightedge. Also in sight: carpenter's square, mat knife, dry-mounting tissue, interval timer and dry-mounting press.

and get it ready for the press. Once you have the rhythm, you can mount many prints quickly.

I'm lazy, so I use an interval timer, set for one minute, to keep track of my press time. That way I don't have to watch time while centering-and-tacking while mounting, which could get confusing. If I'm not through tacking a print when press time ends for the one before it, I just take the first print out of the press and go back to centering or tacking the next one—there's no hurry.

About trimming. For a simple mat—a marginless print centered on a mount board —be sure you tack the tissue to the print inside the picture area at each corner. (If you tack only on the margin, the tissue will fall off the print when you trim off the margins.)

After tacking, turn the print face-up and trim off all margins with a mat knife and straightedge. This trims both the print and the dry-mounting tissue to size.

Center the print on the mount, tack it to the mount and mount it in the press.

But if you are going to put an overmat on the mount, with a cut-out window for the picture, it is better to mount the print without trimming off its margins. The reason is simple.

Dry-mounting press, jaws open (keep the press closed when it is not being used).

Even when a print has been dry-mounted, the edges of the photographic paper are still its most vulnerable part. A print with unseen margins that are covered by an overmat is well protected against edge damage and contamination.

Dry-mounting with an Overmat

If you know from the start that you want to overmat a print, do *not* begin by mounting the print in the middle of a board and then try later to cut an overmat and fit it onto both the picture and the mount. That's possible, but it's the hard way.

The easy way: Cut the mat before you mount the print. First measure your print and cut the window in your overmat to fit it; then hinge the overmat onto the still-printless mount board.

Now you're ready to fold the mat onto the mount and place the tissue-tacked print between them. Adjust the print so it fits exactly where you want it in its mat window, and hold it in place.

Tack the print to the mount board. Then,

with the mat open—unfolded—put the print-and-mount part into the press and mount it in the normal way. Don't put the overmat in the press. Let it hang outside the press while you mount the print.

After mounting, fold the mat into place on the print, then place your mounted, matted print flat on the table under weight to cool.

Overmatting Procedures

Measure the height and width of your print precisely—not the margins, just the picture area that you want to show.

Write the measurements down: my note about the print in the illustrations says "5 5/16″ × 8 1/32″ Ø." (The Ø means the picture is vertical: Ө means horizontal.)

Bring out a mat board and a mount board for the print (I use the same kind of board for both). Decide which board will be the overmat, and which side will be its face (the better-looking side, if any).

By measurement, find the exact center of the mat board (or that point on which you want to center the picture). Make this mea-

surement on the *inside* of the mat, not its face: mark the spot with a cross (+).

Measure the width and height of the picture, center them on the + mark in the middle of the mat, and mark them inside the mat.

Using your T-square or carpenter's square, mark each corner of the picture area with a + inside the mat. (Here you have a choice: You can make the opening in the mat smaller than the print, to crop off unwanted edges; or you can make it fit the picture area exactly—my usual choice; or you can make an opening that is larger all around than the picture, leaving a margin inside the mat window. This last is called a "floating mat.")

From the inside—that is, from back to front—cut out the mat window, using either a mat knife or a mat-cutting tool such as the Dexter mat-cutter and a straightedge. Be sure you don't cut past your corner marks.

Erase all pencil marks from the inside of the mat.

Lay the mat, face-down, next to the mount board, which should be face-up. Place them together so their long sides meet and match. It's conventional to place the mat to the left of a vertical mount, or above a horizontal mount.

Cut a length of bookbinder's tape that is about ¼ inch shorter than the long side of the mount and the mat.

Measuring a print for overmatting.

Mounting, Framing, Exhibiting, and Publishing

Mark a cross (+) in the center of the back side (inside) of the mat board.

Measure and mark the height and width of the print on the back of the mat (half of each on either side of the center mark).

With a square or T-square, mark each corner of the mat window with a cross.

Cut the mat window out with a mat-knife and straightedge, working from the back side of the mat. Don't cut past the centers of the corner + marks.

Erase all pencil marks from the back of the cut-out mat. (No marks at all are made on the face of the mat.)

How to cut the window in an overmat.

Wet the tape, fairly quickly, by pulling it smoothly across the sponge in one continuous motion.

Immediately place the tape along the joint between mat and mount, with half its width on each side of the join. (First place the top, keeping the tape pulled straight so it doesn't droop. Then place the other end and put it down on the boards.) As soon as the tape is in place, press it down by moving your fingertip along it from top to bottom. This will make it stick firmly.

With a clean, dry rag or a wad of paper towel, rub lightly back and forth along the tape. As the gum on the tape dries, this movement will become light and free. When the friction decreases, the tape is becoming dry enough to fold without pulling it off the boards.

Lift the edge of the mat slightly so the tape begins to fold. Crease the fold of the tape with a fingernail, up and down the length of the join, before you fold the mat further.

Fold the mat closed over the mount. Place the print—with tissue pre-tacked onto its back side—on the mount before the fold closes completely.

Press down on the hinged edge of the closed mat in several places, to make the hinge lie flat.

Cutting tape to hinge the overmat to the mount.

Wiping the tape dry while pressing it down.

Creasing the tape.

Trimming off excess tissue, using mat knife and carpenter's square. Don't forget to put thick, disposable cardboard under whatever you are cutting.

Tacking dry-mounting tissue to the back of the print. Pressing lightly, pull the hot tacking iron toward each corner of the print in turn, stroking away from the center.

Centering the print in the mat window.

Holding the print down (next, open the mat while holding the print in place on the mount. It must stay exactly where it is).

Tacking the print to the mount.

The print is now tacked in place (next, put it in the hot press and mount it—leaving the window mat unfolded and outside while you close the press over the print and the mount).

Pressing the hinge flat.

Hold the mat slightly open, adjust the print to the exact position where you want it, and check by closing the mat on it and inspecting all edges as well as looking at the picture as a whole. Readjust as needed until the print is just where you want it.

Hold the print down firmly while you reopen the mat. If you find you're running out of hands to do things with, a small, heavy paperweight will hold the print in place. Put a small, clean sheet of paper between your hand or paperweight and the face of the print.

Use your tacking iron to tack the print to the mount board; keep the sheet of paper between the print and the tacking iron.

When the print is securely tacked in place, put the mount board with the print on it into

the hot dry-mounting press. Leave the opened-out mat outside the press.

Mount the print by closing the press on it for one timed minute.

Remove the mounted print from the press, fold the mat over it, and put the newly matted and mounted print flat on the table, under weight, until it cools.

The whole process is easy. It takes little more work to do it than to read about it, and the actions are simpler than the words. The results are beautiful.

How to Overmat Countermounted Prints

Countermounted prints are dry-mounted on fixed and washed photo paper just the way you would dry-mount them on a conventional mount board, except that the paper you mount on is the same size as the paper of the print, including its margins, which should be at least one inch wide: the wider, the better, up to about three inches.

Once countermounted, these prints cannot be dry-mounted on a mount board for overmatting: dry-mounting tissue does not stick to the emulsion side of photo paper.

"Photo corners." You must therefore hold them in place on the mount board with "photo corners" made of acid-free paper, such as Strathmore parchment (text weight) or Hollinger's Permalife Bond.

To make these corners, cut pieces of paper about 2½×1¼ inches, one for each corner of the print.

Fold both ends of each piece to form a right-angle corner (see drawing).

Measure your print, then cut a mat and hinge it to a mount board, just as in normal overmatting.

How to make and use "photo corners."

How to fold paper corners.

Placing paper corners on the print.

If the corners stick into the picture, cut them down.

How to tape a paper corner to the mount board.

Place the print exactly where you want it on the mount by lining it up with the closed overmat. Hold the print in place while you reopen the mat.

Hold the print in position while you place a corner, seamless-side-up, over each of its corners.

Check to be sure the paper corners do not stick out into the picture area or the area not covered by the mat. If any corners do extend too far, cut corners into those corners so they will not be seen past the closed mat (see drawing).

Fit the paper corners tightly onto the print corners so they will hold the print firmly in place.

Fasten each paper corner down to the mount board (with the print still being held in position), using a piece of linen tape cut long enough to stick out past the corner at both ends.

Close the mat, recheck the print position (if it's wrong, correct it at once before things dry) and place the closed mat and mount flat, under weight, until the corner tapes are completely dry.

A print mounted with corners can be removed from its mat-and-mount unit, and replaced in it, at any time.

Unmounted prints, as well as counter-mounted ones, can be matted for temporary exhibition by using corners. I do not recommend corners for permanent matting of un-mounted prints, however, because such prints lack the reinforced flatness and the chemical protection provided by dry-mounting.

Bleed-mounting Prints

If you want a bled mount, in which the mount ends where the picture ends, with no margins at all, cut your mount board for each print half an inch or so larger than the print in both directions.

Tack tissue to the untrimmed print, then trim the print and the tissue down to fit within the board; but don't remove all the margin from any side.

Tack the print to the mount board and mount it normally in the press.

Then trim the print and its mount down exactly to the edges of the picture, using a mat knife and a straightedge.

There's one further operation: "boning." A mat knife compresses the paper as it cuts, leaving the print with turned-up edges that are extremely vulnerable. For safety and neatness, run your boning tool lightly along each edge of the print to press it down.

Don't press hard, or you'll get a wavy, ragged edge. Use a firm but gentle stroke. Start each stroke near one corner and move the tool past the other corner of that edge—two strokes to each edge, in opposite directions.

Warning: If you want to blacken the cut edge of the mounted print to make it less conspicuous, do *not* use a felt-tipped marker. Such markers are chemically "poisonous" to photographs, and their color seeps into the picture area in time. Use India ink or Chinese ink, applied with the side of a watercolor brush or with an inked cloth or paper towel. Immediately clean off any ink that gets on the face of the print, using a damp towel.

As soon as your prints have been bleed-mounted, put each one into a clean storage envelope of its own. It needs all the protection it can get.

Dry-mount Trouble-shooting

Gummy-looking hard deposits on the

prints. Never let more than ⅛ inch of dry-mounting tissue stick out from under any print you mount in your press. It will gum up the press or your press pad, and that, in turn, will deposit hot, sticky goo, which hardens as it cools, on your prints. I habitually trim off *all* protruding tissue.

Remedy: With luck, a solvent may remove the goo (see the paragraphs on unmounting prints, on the next page).

Prevention: Obvious.

Scorched prints. Press, tacking iron or hand iron too hot.

Remedy: Reprint.

Prevention: Use a dry-mounting press, not a hand iron, and set it not hotter than 225° F. for conventional prints or about 200° F. for resin-coated prints.

Creased prints. Poorly heat-dried prints sometimes take on compound curvature so they cannot be pressed flat. Prints to which the tissue has been misapplied, either in tacking it to the print or in tacking the print to the mount, may also come out of the press creased. And, of course, prints that have been creased before or during mounting stay creased afterward.

Remedy: Reprint.

Prevention: Don't dry prints at too hot a temperature; don't tack them unevenly; and don't crease them any other way, either.

Pitted prints. If your mounted print has little holes pressed into its surface, the usual cause is that foreign objects such as dust specks or bread crumbs were trapped between the press platen or pad and the face of your print.

Remedy: Reprint.

Prevention: Mount clean prints in a clean press.

Small bumps on prints. These are caused by crumbs or dust trapped between the print and the mount—either between the mount and the tissue, or the tissue and the print, or both.

Remedy: With extreme luck, you might be able to unmount the print and remount it without lumps. No guarantee.

Prevention: Mount clean prints with clean tissue on clean mounts in a clean press.

Bubbles or shallow domes of print that stick up off the mount result from poor adhesion due to uneven, too cool, too hot or too quick mounting—usually by hand with a laundry iron.

Remedy: Remount for one minute in a press at the right temperature (works in most cases, though not always).

Prevention: Set your press temperature correctly, time your mounting; or stop using a hand iron and buy or borrow a dry-mounting press (many camera clubs and schools have presses).

Warped prints. Most prints warp a little after mounting. If the warp is extreme, it could be from using low-quality mounting board; from failing to dry both print and mount when mounting under humid conditions; or from storage that distorts the prints.

Remedy: If poor board or humidity has caused the trouble, unmount and remount correctly. If poor storage, lay the print flat under weight until it becomes flat. Store prints flat whenever possible.

Prevention: Obvious.

How to Unmount Dry-mounted Prints

There are two methods: one difficult and risky, the other easy, and safe for the print.

The hard way. Put the print in a hot dry-mounting press, or heat it with an iron, until

the adhesive in the tissue softens and melts. While it's hot, gently peel back the print from the mount and from the tissue, a small area at a time, until it cools and hardens. Reheat and repeat as often as needed until the job is done. It's hard, but possible.

The easy way. Cut off the edges of the mount, down to the print margins, or close around a marginless print.

Put the print—mount and all—into a tray filled with enough solvent (acetone or toluene will work) to cover it.

Be patient. Leave it in the tray long enough so both the print and the mount board will be soaked through. Then the solvent will soften and dissolve the adhesive in the tissue so you can pull the print off the mount easily and safely. It may take half an hour or more. If the print doesn't pull off easily, leave it in the solvent longer.

Acetone (lacquer thinner) and toluene are volatile; they evaporate out of the print completely, so they are chemically safe for photographs.

Caution: Treat these solvents with care and respect: they are not that safe for people.

Treat them like gasoline—no smoking and no open flame anywhere near.

Treat them like carbon tetrachloride—use them only in well-ventilated places, and don't breathe the fumes.

IDENTIFICATION AND INFORMATION.

When your prints are spotted, mounted and matted, they are ready to show, in all direct essentials, but they are not yet completely finished.

It is useful to mark the back of the mount with the information you can provide: your name, the time and place the picture was taken, names of people, and negative and print numbers.

As an editor and writer, I have done enough searching through old pictures to be grateful when the photographers of the past have provided information along with their pictures, though they could not know that anyone would need it. (There's no way to know whether your prints will be reference sources later.) Therefore I put essential information on my prints.

My name, the words "all rights reserved" —I never give away my right to use my own work—and spaces for negative and print numbers are put on the back of the print or mount with a rubber stamp:

**david vestal
all rights reserved**

**negative no.
print no.**

The negative number tells me where to find the negative; the print number leads me to my printing notes, to make reprinting easy.

Below the stamp, in lead pencil, I note the pertinent information. It's generally just a place name and a date: "Why, Arizona, 1966," or "Woodman, Wisconsin, June, 1973." When there's more to say, I try to keep it short: "Indubrasil cow, Mundo Novo, Sertão da Bahia, Brazil, 1961," or "Sr. Ferreira, Xique-Xique, Bahia, Brazil, 1961."

Caution: dangerous markers: Never use a rubber stamp with a maximum load of sticky ink: it often comes off on the face of the next print, from which it cannot be removed. I never touch a print or a mount with a freshly inked stamp. First I stamp once or twice on scrap paper to get rid of all excess ink. The print gets a light, clear, quick-drying deposit of ink.

Never mark prints or mounts with ball-point pens, nylon-tipped markers, felt-tipped markers or grease pencils. The ink or grease tends to come off onto other prints or bleed through the marked print, or both. A ball-point pen, pressed hard, will engrave its message right through the print, destroying it.

Never use pressure-sensitive tapes, labels or other "self-sticking" adhesives on photographs, even if they are sold as photo-mounting products. Chemical contaminants in many such materials will stain a photograph dramatically, right through the paper, in a few years.

How to Mark Prints. The only relatively safe markings I know of for photographs are lightly inked rubber stamps and lightly used lead pencil.

The information on the back of a counter-mounted print might best be printed photographically on the paper used as the mount, which will not accept pencil marks or rubber-stamp ink (paradox: rubber-stamp ink will easily ruin the face of a print, but it won't mark clearly on the emulsion side of a photo-paper mount—the ink smears).

Signing Prints. This is a private matter. Ansel Adams feels that the photographer who doesn't sign his exhibition prints is failing to accept responsibility for his work.

I do not sign my prints, however, because my handwriting does not go well with my photographs. For me, the fact that I exhibit a picture is my declaration of full responsibility for it. If the print itself is not personal, no written signature can confer personality on it: the print *is* the signature as far as I'm concerned.

Once in a while, someone buys a print from me and wants it signed. Then I sign on the back or under the overmat so the signature will be there but won't interfere with seeing the picture.

In any case, my rubber stamp doesn't appear on the back of any picture unless I'm willing to admit that it's mine.

(Stieglitz had a grander sort of cop-out: he asked, "Does God sign the sky?")

FRAMING PHOTOGRAPHS

For convincing showmanship as well as for protection, it's good to frame photographs when you exhibit them. A good print somehow looks better when cleanly framed and well lighted.

Usable cheap frames and excellent high-priced ones are available from many sources —five-and-dime stores, bookstores, art-supply stores and, of course, frame shops.

You can put either glass or plastic over the face of your prints. Glass is cheaper and chemically safer than plastic, but it's heavy and fragile.

A good plastic for temporary framing is Plexiglas (Rohm & Haas Chemicals, Washington Square, Philadelphia, Pennsylvania 19106). Plexiglas is lighter, more transparent and less breakable than glass. Disadvantages are its higher price, a tendency to build up a

charge of static electricity that attracts dust, and the ease with which Plexiglas can be scratched.

There may also be a chemical problem. In the East Street Gallery's generally excellent handbook, *Procedures for Processing and Storing Black and White Photographs for Maximum Possible Permanence*, we are told that acrylic plastics such as Plexiglas may, in time, give off compounds harmful to prints. Because of this doubt, I can recommend Plexiglas only for temporary use, and prefer glass for permanent framing.

(The East Street Gallery is at P.O. Box 68, Grinnell, Iowa 50112; the handbook is $1.00 per copy.)

Some cheap frames are very attractive: wood moldings covered with thin sheet aluminum. The raw wood on the inside of the frame is chemically not good for photographs, so these frames are for short-term use—say, a year or less—unless the wood is coated with a layer of epoxy paint or varnish (never put a print in a freshly painted or varnished frame: allow at least a month for the coating to dry completely). In 1973, I found beautiful ready-made frames of this type in art-supply stores at less than $5.00 for the 11 × 14-inch size.

If ordered direct from the manufacturer, they should cost still less. One such manufacturer is the Ladon Company, Inc., 825 South Wabash Avenue, Chicago, Illinois 60605. With these frames, you furnish your own glass.

Dime-store frames in plastic and in dark and bleached wood are priced below $3.00 for 11 × 14, including the glass. These frames are not elegant, but they are simple and inoffensive. Avoid the bleached wood frames: apparently all bleached wood is very bad for prints chemically. I wouldn't trust the dime store's choice of plastics, either. That leaves the dark wood frames, which should also be coated with epoxy for any long-term use.

An eye-opening catalog of all sorts of fascinating products is issued by S. & W. Framing Supplies, Inc., 1845 Highland Avenue, New Hyde Park, New York 11040. It can give you ideas you'd never think of without it.

One very simple frame is just a sheet of Plexiglas bent over on two sides to form picture-holding grooves. You just slide the picture in. The ones I have seen accept only unmounted or thin-mounted prints. The 1973 price for a 12 × 16-inch frame was $7.50.

A clear plastic box, just big enough to hold the mount and about an inch deep, makes an exceptionally neat frame. The "bottom" of the box is the face of the frame. "See-Thru" and "Dax" plastic-box frames back up the picture with a cardboard-box filler of dubious quality, but these frames are inexpensive— about $7.00 for 11 × 14. I'd suggest either building a new filler-box using acid-free board, or covering the original box with aluminum foil to protect the print against whatever chemical evils lurk in the cardboard.

A superb, expensive plastic-box frame is made by Kulicke Frames, Inc., 43 East 10th Street, New York, N.Y. 10003. The last Kulicke frame of this type that I saw had an internal wood frame or "rabbet" that would also need the epoxy treatment to be safe for long-term use.

Kulicke also makes beautiful thin-edged metal frames, widely used by museums and

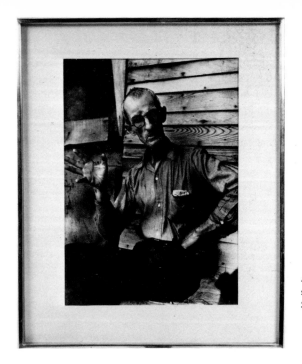

An aristocratic frame, if it's clean and simple, can still go well with a gutty picture. Photograph by Sid Grossman, c. 1940; frame by Kulicke.

A clean, classical photograph deserves an equally clean frame. Photograph by Gertrude Käsebier, c. 1898; frame by Neil Weston.

A good book-and-art-store frame—molded plastic and snap-in glass—the Danalco Framatic is neat and inexpensive, but takes unmounted prints only. (Danalco, P.O. Box 1084, Glendale, California 91209). Photograph by Alfred Stieglitz, 1910.

A neat, cheap minimal frame, the Danalco Framount consists of a backboard, a sheet of glass, and four retaining clips. It accepts mounts up to about 1/8 inch thick. This print is unmounted and borderless: the textured plastic of the backboard serves as the mat.

galleries, and a large variety of other designs. Their workmanship is typically excellent. If you can afford them, Kulicke frames are to be recommended.

Who is better qualified to design frames for photographs than a photographer? Neil Weston invented a high-quality light-weight steel frame that is well engineered and beautifully clean and simple. The Weston Frame is available from the Magnaframe Company, 5770 Hecker Pass Road, Gilroy, California 95020. Prices are reasonable—higher than Woolworth's, lower than Kulicke's. You provide your own glass.

Various "metal section frames" of clean design are sold in kit form at art-supply stores and large bookstores. Being all-aluminum, they are chemically desirable. You assemble strips, sold by length in pairs, to make your frames. The result is strong and handsome. The 11-inch and 14-inch kits that go together to make an 11 × 14-inch frame add up to a total of about $9.00 for anodized black or "gold" aluminum; plain brushed aluminum costs a little less. You have to supply the glass.

An important advantage of metal section frames is that, when not in use, they can be

taken apart and stored very compactly. Chemically and mechanically, these seem to be among the best frames available for photographs.

Odd frames: Some especially elegant black and white plastic frames are sold in bookstores, gift shops and art-supply stores; but these tend to accept only thin, unmounted prints. Even double-weight photo paper is too thick for some of them. They are still worth looking at in case you can find some that will take the thickness of a mat and a mount. These beautiful but often impractical frames tend to come and go on the market fairly rapidly.

Framing Technique

There are some basic principles to follow, though different frames require different methods for inserting the picture and holding it in place.

Let the picture "breathe." Never seal it into the frame so tightly that air and moisture can't pass in and out, or condensation in the frame may ruin the print or the mount.

Keep it accessible. Put the print in so it can be removed without major surgery. Don't tape the frame closed in back unless you use paper tape or another porous tape that will let air and moisture through and that will not remain gooey forever.

Keep it chemically pure. Keep all low-quality cardboard, composition board, paper, tape and what-have-you entirely out of the frame if you can. If they form a necessary part of the frame and must be there, use epoxy paint or varnish or aluminum foil to seal them away from the print and the mount.

Don't let glass or plastic touch the face of the print. Use an overmat to gain separation.

Otherwise, you may suffer from "local ferrotyping," especially if the humidity is high. Spots where the glass presses harder than elsewhere take on a high gloss that looks like a wet spot when seen through the glass. This can sometimes be cured by touching that spot on the print with a clean, damp sponge or cloth, but it's better to avoid the trouble in the first place.

Some cheap frames lack adequate arrangements for hanging the picture. It's often a good idea to fasten a length of picture wire to a heavy backboard behind the print. Fasten the wire well above the center and make it tight enough so it doesn't stick up past the top of the frame once the picture is hanging on it.

Make a loop in each end of your wire and staple it to the backboard. Don't let the staples touch the mount board: a layer or two of foil should provide a chemical barrier against rust.

With wood frames, it's easy to fasten the backboard in place with a few wire brads, driven in far enough to be firm, but not so far that they don't hold the board in place. They don't go into the backboard itself, just into the wood of the frame behind it.

Metal section frames are designed with a groove deep enough to hold a mounted and matted print together with a substantial backboard, and no further fastening is needed. You assemble the frame around the picture and its various layers of board.

Before your print is finally closed away in the frame, remember to copy all your picture information from the back of the mount onto a label on the back of the frame or the backboard, so you and others can read it without unframing the picture.

PRINT STORAGE

Prints keep best at relative humidities below 50 percent (different authorities recommend different humidities), at temperatures below 65° F. and in filtered air. Most of us can't fill all these requirements, but do your best. Keep your prints and negatives out of damp basements and hot attics. Humidity is worse for photographs than dry heat, if you must choose between evils.

Store mounted and unmounted prints horizontally in boxes, and stand framed prints up on shelves, like books.

How you organize your prints is a personal matter. I arrange mine loosely by categories, as described on page 148. Where the categories overlap or otherwise break down, I go by feel and put the prints where they most seem to belong.

For other photographers, it might make more sense to arrange their prints in strict chronological order or straight alphabetical order, or in any other way that fills their needs.

The New York Public Library picture collection, with an astronomical number of pictures from thousands of sources and showing all imaginable subjects, successfully keeps them in order by filing them under the headings that people most often ask for. (Pictures of births and deaths are in folders marked "Arrivals and Departures.")

There are many ways to organize collections of pictures.

Print Containers. For information on chemically safe envelopes and boxes for prints, see page 149.

Shelves. Metal shelves are now considered better than wooden ones for long-term print storage; but I've built so many wooden ones that I'll go on using them.

Storing Framed Prints. Keep them upright on shelves, like books, but with a polyethylene bag over each frame to keep dust out, and with rigid dividers between the frames to keep them from scratching each other. The dividers can be corrugated cardboard or what-have-you.

This way the prints and their frames stay clean, and the weight of the frames does not accumulate and crack the glass, as it may when frames are stacked on top of each other in a horizontal position.

Besides, it's easier to pull the one print you want off the shelf if it isn't buried under twenty others that weigh three or four pounds each.

An identifying label that you can read without pulling the frame from the shelf is a convenience. It doesn't have to be fastened to the frame: just put it in the bag.

PACKING AND MAILING PRINTS

A Popular Myth. People who mail many photographs sometimes come to believe that the post office has specialists who look for that lying message

PHOTOGRAPHS
DO NOT BEND

and put all packages marked with it through the heavy-duty crusher.

It isn't true. Still, there is a real need to pack defensively. Put no trust in labels.

What Can Go Wrong? Almost Everything. To pack intelligently, consider what evils befall photographs: they get folded and occa-

sionally punctured; more often, edges and corners are bent or torn. Your packing job must keep the prints flat and protect their edges and corners.

Unmounted prints can be mailed in envelopes with fair safety if they are centered between two oversize sheets of stiff corrugated cardboard, preferably with the corrugations running at right angles to each other for maximum stiffness.

Prevent print drift. Don't leave the print loose so it can drift within this package, or it will wander to the edge or corner that gets run over by a truck. Fasten the print (or prints) in place.

How to hold prints down. I do this by putting the prints in a print-sized, defanged envelope, which I then tape onto the middle of one cardboard so it can't drift edgeward. The other cardboard is put on top, and the corrugated sandwich is fitted into a larger envelope, on which the addresses are written. It is the outer package.

Defanged? What do I mean, a "defanged" envelope? I mean one from which all hard and sharp metal fittings—clasps, grommets and whatnot—have been cut away, leaving nothing behind that can gnaw on the prints.

This small package anchored in the center of a larger one is the safest simple package that I know of for unmounted prints.

Mounted prints should be packed as snugly as possible in envelopes within rigid boxes. Photo-paper boxes are not strong enough for safe shipment: if you use them, reinforce them on all sides with heavy corrugated cardboard.

Fiber Cases. It's probably best, if you are shipping prints that are to be returned to you, to use heavy fiber print-shipping cases, like those in which movie film is shipped, but rectangular instead of square.

Photo dealers can order these cases for you in several sizes and depths—from small to large and from thin boxes to deep ones. The cases have strong webbing straps with buckles that hold them reliably closed, yet allow them to be opened without an axe, a blowtorch, or a Phillips-head screwdriver.

Pack Snugly. Don't let the prints rattle around in the box. If you put all the prints into a large sheet or bag of plastic, you can pad the edge space in the box around them by stuffing it with foam rubber, sheets of plastic bubble-pack material, or clean, wadded-up paper towels. Don't use newspapers: that's looking for chemical trouble.

If your case is packed gently enough not to hurt the prints, but firmly enough so nothing moves when the case is thrown violently across the room, your pictures should arrive intact.

15

What to Do with Your Pictures

PRESENTING YOUR WORK

Private Showings. If you photograph for yourself and your friends, there's no problem. Just show them the new pictures as you go. Edward Weston used to put his new work on the wall at once. There was much coming and going at his house, and his friends watched the wall to see what Edward was up to. This satisfied their curiosity and gave him constant feedback, with its pleasures and drawbacks. (If you don't know what you want, other people's conflicting reactions can confuse you. Weston knew what he wanted.)

Reaching the Public. To reach strangers, you must work harder. You can publish, if any publisher wants your pictures, or you can exhibit.

Publication takes many forms, from magazines, newspapers and books to posters, calendars and postcards. They share one disadvantage: in general, halftone reproductions don't look as good as well-made photographic prints, though there have been exceptions.

Photo Annuals. One of the easiest ways to get some of your pictures published is to submit a selection of your strongest work to one or another of the photo annuals.

Rejections. Most pictures sent in are rejected instantly because they are simply not worth publishing. Among the rest, some good and many poor ones are rejected later for other reasons (lack of space is a compelling one), and some good and some poor ones are published. Token payment is typically made for pictures that are used, and a few hundred thousand copies of the annual that contains them are soon available at newsstands and bookstores around the country. A few copies go abroad as well.

Having a picture published in an annual is no world-shaking event, but it holds some satisfaction. The picture is launched. It isn't idle. If it is going to accomplish anything, the process has been started. If not, it will soon be forgotten: you can easily survive the publication of one of your mistakes.

Magazines and Books. It's harder to get pictures into other magazines and books. When you see that a certain magazine or book publisher keeps printing pictures that you like, that publisher is a logical one to get in touch with. He shares some of your tastes.

Do not send pictures to editors uninvited, or you may never see your prints again. Ask first. An answer that says the publisher is honored and pleased that you asked, but that

does not directly ask you to send work, means "no." If the answer means "yes," you will know it.

What to send. Remembering my editing days, I suggest that you send only excellent, well-spotted prints in good condition. Moderate-sized prints, roughly in the 8 × 10-to-11 × 14-inch range, are easiest to store, ship and reproduce; and unmounted prints are easier to handle and safer than mounted ones. It's good to leave a margin around the picture to save its edges.

Identify every picture. Mark the back of each print clearly with your name and with any information needed in order to understand the picture. Make sure the editor knows where to reach you.

Publishers are human, too. Publishers are eager to get pictures they can use, but they cannot use everything they like. If you send them what they need, they will grab it gratefully: if you don't, they won't. Not many cases are that clear-cut, however. Many promising "almosts" never pan out, to everyone's regret. If you work with publishers, don't be too expectant: it's too frustrating, not only for you, but also for the publisher. Publishers do not conspire against photographers: they have other things to do.

Payment, if any, is normally small and slow. Not all publishers pay. Before you send work, find out about payment terms and rates.

Sometimes it is well worthwhile to send pictures out for unpaid publication. Those few small publishers who work with the greatest love and care typically have nothing else to offer; but a well-published picture can live for a long time.

EXHIBITING

Showing prints directly is less ambitious and easier than publication. You don't need tons of costly paper and ink and the skills of highly paid printers before people can see your pictures, because you're not trying to reach out that far when you exhibit.

Instead of sending out thousands of reproductions of each picture, you are putting one original print each of a careful selection on a wall and waiting for people to come and see them.

Print quality is vital. The shortcomings of halftone engravings provide no excuses when people look at your original prints. Any blame for poor printing will be placed where it belongs—on you.

Where Can You Show? Galleries that show photographs are as old as photography, but there are more of them now, in the United States and Canada, than ever before. The rest of the world seems less interested, though we sometimes hear of photographic shows in England, France, Germany, Italy, Japan and elsewhere, in locations that range from department stores to the Louvre.

Photographic galleries. New York City has several active photo galleries, each with its list of pre-scheduled exhibitions stretching a year or more into the future. It is not easy to get your work shown in such galleries, or in the art museums that show photographs.

Other places to show. Libraries, schools, bookshops, coffee houses, camera clubs and many other casual galleries may show more photographs to more people than the full-time photography-as-art galleries, which tend to attract a limited audience. I've seen excellent photo shows in banks, school hallways,

Once you have pictures and a space where they can be seen, you still have to make the pictures and the space work together, whether it's in a publication or a show. Photographers Ann Treer and Charles Pratt are shown sizing up the walls of New York's Image Gallery back in 1959: the first step in hanging a joint show.

office-building lobbies, and in the lofts and apartments of photographers.

If you want to exhibit in any kind of museum or gallery, find out who is in charge and ask about the chances. If your work is convincing, and if you stay with it, an eventual show should result. (Don't hold your breath while waiting for it.)

It's an Odd Experience. Whether your show is held in a museum, a photo gallery, a coffee house or any other space, you will probably then experience a strange mixture of pride, pleasure and bitter disappointment.

You'll be pleased because you made it and your work is there for everyone to see.

You'll be disappointed because the show is not installed as well as you'd like; because

people either don't come or don't pay attention to your work; and because you now begin to see weaknesses in your work that you didn't suspect before.

What Can You Expect? Your first one-man show is a concentrated lesson. No show anywhere is ever perfectly selected and hung in ideal surroundings and visited by a constant stream of intelligently appreciative viewers; but we always seem to start out expecting all these miracles to converge on us automatically. Of course, it doesn't happen.

What does happen, normally, is that those failings of your show or mine for which we are not to blame usually meet our own failings halfway. We get about what we earn: it is very seldom instant fame and fortune.

A later stage in hanging the 1959 Pratt-Treer show. Laurence Siegel, who ran the gallery on a frayed shoestring, stands by. Image suffered from a spectacular lack of expense money, but had better lighting than most museums, simply because the problems were considered before the secondhand fixtures were installed. By no great coincidence, Image—now long gone—was in the block where Mathew Brady had died broke. In its time, Image was one of three or four places in the United States where you could consistently see photographs that were made and shown with care and perception. Now there are more.

What's the Use? Perhaps half the good a photographer gets from a show is in the gratification of being a temporary center of attention and the pleasure of putting the pictures to work. The other half, which probably matters more, is in what the show teaches you about your work and yourself.

What Can You Learn? With luck, you can learn to work for the best compromises you can arrange, and to have few illusions, but much pleasure in accomplishment. If you can lose your more grandiose ambitions, you will be well rid of them: they bring more pain than pleasure.

How Often Should You Show? The painter Hans Hofmann used to tell his students to exhibit wherever and whenever they could. I think that's overdoing it—like talking incessantly. I'd say, exhibit when you have something new that you want to show, and when it's not more trouble than it's worth.

The escape clause. When you can't spare the time, labor and thought that are needed to do a good show, save yourself the aggravation of doing a mediocre one, and rejoice in your escape.

Critics. If obtuse, malicious or perceptive critics threaten to spoil your sleep, don't let them. They have to say what they think, not what you think. Agreement is not the object.

If your work is honest and well realized, you have no cause to worry about people

Mounting, Framing, Exhibiting, and Publishing

who can't see it. When you find out that some of your work is empty or weak, don't worry when critics praise it.

What Matters. The work, you see, is what matters; and it is yours, not theirs. The critical response is the critic's problem, not yours.

EXHIBITION PROBLEMS

Time. In arranging a show of your photographs, first work out when it is to open. Give yourself twice as long as you estimate it should take to prepare the show, and start getting your prints ready at once. It usually takes longer than you think: a show is a lot of work. If you are ready ahead of time, you can feel smug.

Space. Look the exhibition space over with an analytical eye. Note the places where pictures can be seen best, and also the places where they can't be seen well. Figure out how many prints can be hung in the good spots: that's the size of your show. Select pictures with the space in mind. Most people show too many.

Light. If the light in the gallery is fairly even, bright but not too bright, and produces no glare problems, you are very lucky, and the only sane attitude is gratitude. But don't expect this. Gallery lighting is normally poor —dim, uneven or angled so it produces more glare than clarity. If that is the situation and if there's no way to change it, you will have to try to hang the pictures to give them the best possible chance of being seen well in spite of the lighting.

Practical Lighting for Galleries. If you are starting a gallery, you can easily light it well from the beginning. There are four main considerations:

Brightness (a matter of wattage, money and heat, as well as light);

Color of light;

Light distribution (controlled or even); and

Angle of illumination.

They must all be coordinated.

Brightness. Photographs need light that is bright enough so you can see clearly into the dark tones of the prints, but not so bright that it makes those dark tones look weak or washed-out, or makes the whites painfully bright.

An objective starting point. In most galleries, photographs seem to look best when the room light is bright enough so a meter reading on a white wall at print height equals a middle-gray reading outdoors on a light overcast day (on my old Weston meter, about 13 c/ft². Few galleries provide more than half this much light, according to many meter readings I have made).

A subjective goal. But gallery lighting is largely a subjective matter. In some rooms and with some photographs, this bright-gray-day amount of light may be too bright or too dim to show the prints well. Use prints on the wall to find out, and adjust the brightness until they look their best.

Color of light: incandescent. Most prints in black-and-white and color tend to look good in the warm yellow-white light of incandescent bulbs: but enough incandescent light for the pictures may overheat the room and bake the viewers as well as bringing in a very high electric bill. Unless you have heavy wiring, air-conditioning and plenty of money, incandescent light is probably not the ideal answer for you.

Fluorescent tubes produce far more light

per watt, and far less heat. The conventional "daylight" fluorescent tube casts a cold blue-white light that has clinical overtones and is not friendly to most photographs, though, so it is also not the answer.

Mixed light from one "warm-white" and one "cool-white" fluorescent tube per fixture looks beautiful with most black-and-white prints, and provides much light at fairly low and inexpensive wattage, so this combination is probably a good starting point for experiment. The warm-cool balance can be adjusted by swapping "warm" tubes for "cool" ones or vice versa until you get the color of light that pleases you most when you look at the prints.

Light distribution. "Spotty" light—gloom relieved by patches of intense glare—tires the eyes and makes everything hard to see. It is fairly common in museums and galleries.

If all prints had the same tones, absolutely even light might be ideal—or it might be dull. As things are, I think it's generally preferable to light about half the wall space evenly at normal brightness, and put slightly brighter light on about a quarter of the wall space and slightly dimmer light on the remaining quarter, to establish areas that work in favor of pictures that need more or less light than most. Then you hang the pictures or adjust the lights accordingly.

A few small floodlights that can be moved to light any part of the wall are helpful, but if the light is generally adequate, you don't really need them.

Angle of illumination. This may be the least understood aspect of gallery lighting. When the light crosses the room at a shallow, nearly horizontal angle, it bounces off the glass and the surface of the print into our

How not to exhibit photographs, I: (galloping showmanship takes over at the pictures' expense).

eyes, so we see glare instead of seeing the picture. For some unknown reason, this flat-angle, maximum-glare lighting is often used in museums and galleries.

"Non-glare" glass. "Non-glare" glass is very expensive and seldom helps. This dull-surfaced glass doesn't really eliminate glare, but diffuses it, spreading it evenly across the whole area of the glass and degrading the tones of the picture. In my opinion, it is really *all-glare* glass.

The optimum angle. The light that shows pictures up to the best advantage comes from

How not to exhibit photographs, II: (unless you provide stepladders for viewers).

How not to exhibit photographs, III: (glaring spots of intense light compete successfully against the pictures. Replacing the narrow-beam spotlights with broad-beam floodlights would have helped).

A clean, well-lighted show (Bill Brandt's photographs at the
Museum of Modern Art, New York, 1969).

At a public library: poor but not offensive lighting, and
cleanly hung photographs—a fair compromise. Pictures in
the shade suffer, but there is no sense of cruelty toward
them: the show still looks good.

Mounting, Framing, Exhibiting, and Publishing

A houseboat gallery, the Floating Foundation of Photography, New York. The good lighting—baffled fluorescent tubes augmented by skylights—is directly descended from the lighting at Image in the late 1950s.

an angle that is more nearly parallel to the picture surface than at right angles to it. The ideal place for gallery lights seems to be as high as possible, and quite near the wall the lights illuminate.

How high-angle lighting works. The high placement minimizes the fall-off of the light as it gets farther from its source, and the close-to-the-wall position prevents glare on pictures seen near eye level.

Where to start. To establish the lighting for a new gallery, first find the best angle and placement for your lights. To do this, put prints on the wall and look at them in light that comes from different angles and distances.

Then, when the angle is established, make your experiments with different types of lights, keeping heat, color and the electric bill in mind, as well as the capacity of your wir-

ing. Base all these tests on the chosen angle of lighting.

SELECTING AND HANGING YOUR SHOW

What to Show? Choose your strongest pictures—not necessarily the nicest-looking ones, but the ones that you feel really connect—and eliminate your failures and your "almost good" pictures.

Find a Sequence. Work to arrange the survivors in a visual order in which each picture reinforces the ones next to it and is strengthened by them. This is an elusive thing. The many theories about how to do it contradict each other, and, in any case, they do not help. Therefore, don't try to work out your picture groupings or sequences by any cut-and-dried method, but by trial and error.

Don't Start by Putting Prints on the Wall. Lay out the prints on clean paper on the floor, just below the wall you're going to hang them on, and play with different juxtapositions until all the pictures get along well with each other. If there is some pace and change as you go from one end of a wall to another, so much the better. Call it phrasing. But the main essential is to have each picture look as good as it can among the rest.

Make the Lighting Work for You. Keep in mind the bright and dark patches caused by uneven lighting, and exploit them. Put prints that need strong light in the bright spots, and prints that need weak light in the dim areas. This could be a good starting point around which to build the order in which you finally hang the pictures.

Sequence vs. Lighting. If you have a definite preconceived sequence, your biggest problem is to fit it into the situation so the sequence and the room with its lighting work together instead of defeating each other. You may end up with a new and better sequence.

Stay Flexible. Every exhibition is unpredictable. Things that you'd never expect happen, some terrible, some good. Stay flexible. Bring a few more pictures than the walls will hold, because you are likely to have to replace some that you can't fit in for one unforeseen reason or another.

When You're Stuck. You will probably get into at least one impasse—a spot where you just don't know what to do. Take a break, relax and try again. It's often useful to put all the pictures out of sight, then look through them and start from the beginning again. Try a new starting point. You learn from the pictures as you go if you let them teach you.

A Show Has Its Own Existence. The pictures are the building blocks from which you construct another piece of work—your show. If you do it well, the show will be more than the sum of its parts—not just a set of pictures, but expressive in itself.

Editing: Shows Are Like Books. Incidentally, the same basic choice-and-compromise process that goes into making a show is involved in publishing, where it is called editing. If you can do a good show, there's a fair chance that you can do a good picture book, too. It's a question of facing and solving a different but equivalent set of problems within a different but equivalent set of limitations.

The Heart of the Matter. As in photographing and printing, it is mostly a matter of seeing receptively and accurately, and following your feelings faithfully.

YOU DON'T HAVE TO SHOW OR PUBLISH

I suppose we all share the urge to show our pictures to others, but this urge is not an obligation.

You don't have to show, publish or justify your pictures. It may be better to take them, put the prints in boxes and show them to no one. In some ways, this is a most rewarding way to work. It simplifies independence and integrity.

The Lowdown: Fame Is Fickle. Half of art history is a many-sided and totally convincing lesson in the perennial futility and worthlessness of established taste and informed opinion, and in the enduring value of that persistence that makes artists keep on whether anyone else likes what they do or

not. Artists can be as wrong as connoisseurs, and vice versa. *There is really no one to trust but yourself.*

Ability Is Worth More Than Talent. Today's universally admired masters are often yesterday's incompetent misfits. Take painting. Cézanne and Van Gogh both conspicuously lacked talent—the knack for doing things well easily—when they began, and both were bitterly attacked by critics who saw their later work before they died. Now anyone can see the strength and radiance of their paintings—largely, I think, because we have grown up with them. When they were new, these pictures were generally considered monstrous.

Luckily for Us All, Talent Can Be Outgrown. Rembrandt's story is different. His talent was recognized early, and he was fashionable and successful while young. Soon afterward he outgrew certain values people liked in his early work—slickness and a tendency toward flattery—and promptly became a failure. His later paintings, the ones his former patrons most detested, were his favorites. Today we agree with him: we like his later paintings so much that utterly preposterous amounts of money are paid for them.

The Best Work Is Not Always Noticed at the Time. The admirable Eugène Atget lived and died in poverty and obscurity. It was the price he paid for earning his living by taking pictures he believed in. His work came to wide public attention only in the 1960s, some 40 years after his death. Thirty years ago, a few people liked it. Now many do.

The Very Latest Old-time Photographers. Each year we discover more "new" good photographers from the past: people whose work we are only now learning to see.

How to Be Right (happiness not guaranteed). These painters and photographers worked on stubbornly against all good advice and authoritative opinion, and they were right. It was right for them because they did not waste their lives, but accomplished much of what they set out to do, and enjoyed the process. (They suffered, too, but that is the price artists choose to pay for their privileges.) It was right for us, too, because we can now enjoy much fine and strong work that nobody liked when it was new.

The Survival Factor. Their work survives in spite of ignorance, obscurity, publicity, good taste—you name it: in spite of everything but the strength within it.

Illegitimati non carborundum. Therefore, if you keep liking what you do, but everyone else is sure you're wrong, just keep on working quietly. If nobody wants to see your work now, why show it to them?

You can never know if people are right when they love or hate your pictures; but if you are sure you like your work, you are right enough. Trust yourself, and you can work on and on, with or without recognition. Obscurity saves us from conflict and needless compromise.

I believe strongly in making the best pictures you can, even if nobody likes them, and putting them carefully in boxes. So many of the best pictures have come to us this way.

PART FIVE

NOW IT'S UP TO YOU

16

What to Photograph?
How to Photograph It?

WHO DECIDES?

If you take pictures for money, most clients tell you what to photograph and how they want it to look, while leaving the skill to you.

Other People's Problems. Some professionals earn their large incomes, and my astonished respect, by photographing most superbly when the jobs seem most hopeless. Hard-working and gifted problem-solvers, some of them are actually grateful for "impossible" assignments that bring out the best in them. These are rare people. I am not one of them, and I don't suppose you are likely to be one.

Camera Clubs and Contests. Camera clubs sometimes provide amateurs with a client-substitute, in the form of cliques and competitions that ordain who shall photograph what, and in what established manner. The results are judged by success in conforming to decree. Club leaders and contest winners are typically better at pleasing others than at finding their own approaches and pleasing themselves. They might do better to earn money with their talents. The losers are also losers.

The best I can say for camera clubs is that they provide their members with limited stimulation and technical help, usually leavened with confusion. The best clubs really help, but they are rare. Most clubs seem photographically deadening, though they may be socially enjoyable. They tend to standardize and depersonalize photography. An individualist in a club may have enjoyable battles, but he is not likely to win anyone else over to his viewpoint.

The survival of the unfittest. Professionals and camera-club kings compete for money, medals and status, more than they work to express anything they see and feel. They convert ugly ducklings into cardboard swans on demand, by sheer resourcefulness and hard work.

Prospecting for Ideas. Camera magazines and books that tell you how to photograph generally contain both useful and useless ideas. There is good ore in most of them, but you have to do your own smelting.

"Authorities" are often just people who think that they know. Indeed, some do know what they're saying; but you can learn which

are which only by trying out the things they advise. Find out for yourself. *You can't count on others to think or see for you.*

George Won't Do It. Who Will? With no clubs, clients or authorities to tell us what to do, we independent amateurs and artists must decide for ourselves. From start to finish, it's entirely up to us.

Who decides? In my work, I decide. In your work, you decide.

This freedom is a privilege and a problem. If we don't solve the problem, the pictures and the privilege are no good, and photography becomes an expensive bore.

PROBLEM: FIND YOUR TERRITORY

Horrible Cliché. People sometimes say, "I don't know anything about art, but I know what I like." They are usually wrong on both counts. They know too much that isn't so about art; and they don't know what they like, but only what they think they ought to like.

The Truth Behind the Cliché. If you know accurately what you really like, you hold the key to using photography or any other medium of expression well. Technical information and acquired skill aside, that's all you need to know about art—a word that no one can define anyway.

Pay Attention to Yourself. Start noticing how you feel about the things you see, and you will soon know what to photograph and how to show it in your pictures.

The problem is to recognize your own photographic territory, which might be anything and anywhere. It can be a rational aim or an irrational urge. One is as good as another.

A Rational Purpose. Lewis W. Hine, who made many moving photographs, started as a sociologist and teacher with a rational aim: "There were two things I wanted to do. I wanted to show the things that had to be corrected. I wanted to show the things that had to be appreciated." Often they came to-

For me, a professional product shot, like this one I did for a magazine article, is just a nature picture in which I'm stuck with an impersonal purpose and can't choose my subject—the most difficult, least interesting sort of photography. (Incidentally, these products all work.)

Photograph by Lewis W. Hine, 1907.

gether in the same package. Hine had the luck to know his territory from the start—the problem of social injustice, seen through seeing people. He had a message he was burning to deliver, and he chose photography for his tool.

A lot of us are not that lucky. We buy a camera because it's a fascinating machine, then look for something to do with it. All dressed up and no place to go.

You Don't Need a Program. Compared to Hine, most photographers, including me, have no such clear purpose; but you don't need a definable mission. I can't tell you what your motivation for photographing is or should be: that's strictly up to you.

For example, I can tell you something about my own approach—the only one I know much about.

I am self-indulgent. When I photograph, I'm scratching the same itch that makes people gossip or tell jokes; only this gossip is visual, not verbal. There is nothing exalted about it, and it does not transcend any reality whatever. It tries to pass an experience on as nearly intact as possible.

What happens, and (maybe) why. The process is that something comes in my eye and stimulates me to shoot because I'm bursting to let it out again—preferably to inflict it on an audience. If the audience likes it too, so much the better; but my photography is selfish, not altruistic. I do it for me.

It's like conversation. Watch people talk-

I had no purpose in photographing the church and the sky at Cleveland (New Mexico). I enjoyed seeing it and felt like passing it on—more for my pleasure than for yours.

ing. Notice how we wait with poorly hidden impatience for the other fellow to stop talking so we can start. Apparently it is more blessed to send than to receive. A photographer carries on a one-sided conversation through vision, with enormous satisfaction. ("Look what I saw!")

If you're not tempted, you don't have to resist. Knowing my own selfishness, I am not tempted to try to please or impress people by doing anything that doesn't suit me. This kind of selfishness is an artist's attitude. When I was a professional photographer, it made me a poor one: I couldn't work up enough interest in the client's needs. But selfishness helps me to be a good artist with my camera. I'm all right when I can call my own shots. Maybe you work in the same way. Why not? It harms no one, and it's enjoyable.

The manufacture of well-made photographs is not the aim: we already have a surplus. Expression is the point.

The Expression Equation. There's this to say about expression: We are all alike, so we can understand each other; and we are all different, so we have things to tell each other. The sameness makes communication possible, and the difference makes it worthwhile.

Selves Are Dull Compared to Everything Else. Self-expression doesn't interest me. The rest of the universe is so much bigger, more

varied and more interesting than any self, and, in any case, the self is never left out. It includes itself automatically in everything we do, so no effort toward self-expression seems necessary. Keeping the self-expression down to an appropriate proportion in pictures helps them stay interesting, so I'd rather subdue it than expand it.

Unexalted. Call it art or call it photography, the attitude that leads to strong pictures is seldom "above" things. It's *with* them. With what you see and feel, not with what you think someone else wants. You have no way of knowing what others want.

For Whom? Gertrude Stein said that she worked for herself and strangers. She was right. It's a mistake to try to photograph to please your friends. You don't know them as well as you know yourself. They don't know you as well as you know yourself. Work with what you have.

You Don't Have to Please People. Photography is not a popularity contest. Your best pictures confirm and clarify your own experience—directly or indirectly, facts or dreams. Whether other people like them at first sight is secondary. Real pictures eventually find an appreciative audience. Pictures calculated to please soon lose their audiences.

How Much Is Enough? You can, like Lewis Hine, photograph what you love and hate in full consciousness. But your feeling does not have to be a raging passion to lead to strong photographs. It can be quiet; it can be outside the range of words. Many people photograph because pictures can show things that words can't say. Loud or silent, explainable or not, clear feeling in any strength can be enough. If it comes through in the picture, it is definitely enough.

Limitations. The still camera in black-and-white photography is not wired for sound, smell, touch or even color, to name only a few of its limitations. But what it shows, it can show either weakly or with incredible clarity, force and conviction. To get strong pictures, you must generally work within the limitations of the medium. To push them—often a good idea—you must first be acquainted with them, or you will usually fail.

A Twist of Mind. I have a private, rationalized way to pick my shots. In looking around at the world, when I see something that "wants to be photographed," I take the picture if I can. It's a matter of recognition, a "yes" signal. The method is intuitive. The want, of course, is my own.

What Should You Shoot? What Should Be Expressed? The subject and the feeling can be anything. The only restrictions are the technical limitations of photography. When you're up against them, try anyway, on a calculated-risk basis, instead of telling yourself you can't do it. Our idea of the limits is sometimes too conservative, and film is cheap. Good photographers cheerfully, carefully, selectively, push their technical luck.

Your own territory in photography—what you shoot and how you handle it—is the visual side of anything you care about. It's whatever you see most sensitively through the camera.

SHOOTING PROBLEM: SEEING WHAT'S IN FRONT OF YOU

The Camera and the Eye See Differently. The eye normally sees selectively. It picks out whatever interests you most and ignores everything else. But the camera is utterly indiscriminate and incapable of being interested.

Learn to See Indiscriminately. To use the camera perceptively enough to get more good surprises than bad ones in your pictures, you must learn to see indiscriminately, too.

We need selectivity in most photographs, but first we need to see all that will appear in them.

Seeing Too Selectively. The telephone pole that grows out of your mother's head in a snapshot results from seeing too selectively for photography. You're interested in her, not the pole, so you concentrate on her and don't notice the pole. But the camera records it all faithfully, including the pole.

Look at All of It. When you look through the viewfinder of your camera, look at everything there, interesting or not, or it will betray you.

Seeing What's There. The first problem in shooting is to see what's in front of you. This is easy: just pay attention to every part of the picture. You will often forget to, at first, but your mistakes will remind you if you look at the pictures as attentively as you need to look at the subject. Indiscriminate seeing is a discipline that needs practice.

Organizing the Picture. In the viewfinder, fill your picture area with clear shapes, tones and textures of things you care about, in relationships to each other that feel right to you, and leave everything else out, and you'll have, at least, a well-organized photograph. There's a good chance that it will also carry feeling, which has an astonishing way of leaking in; and feeling is what photography is about. (There is no way to force feeling into pictures.)

Learning to Look. You usually can't consciously take each detail of a picture into account—little that's worth photographing is that simple. But a strong conscious effort at the start soon pays off by letting you work intuitively, without effort, and still get good results.

There's a Method to It. If you struggle with any difficult matter long and hard enough to get frustrated about it, it usually works its way deeply enough into your mind to simmer on its own. You can then "sleep on it," and presently you will find yourself doing what's necessary without conscious effort. This is a generally effective learning technique that you can use in any field, not just photography.

PRINTING PROBLEM: SEEING WHAT'S ON THE PAPER

In printing, as in shooting, the thing that seems hardest to learn is to see what is actually in front of you instead of what you wish were there.

Where Printing Problems Come From. Most of our difficult printing problems are really shooting problems: two matching tones have been placed together so you can't tell one vital area of the print from another. This often happens when we mistake color contrast for light-and-dark contrast. A careful look at the print will show this if you failed to see it when shooting.

The remedy is obvious: Next time, watch the tones when you shoot, and don't let the colors fool you.

Mistakes Are Easier to Avoid Than to Repair. Few pictures that are weakened by tonal confusion are worth the struggle of printing with enough manipulation to "fake in" clarity. The ones that you do print will remind you to shoot more observantly. The ridiculous amount of labor needed to repair harm that a two-inch camera movement

could have prevented is a strong lesson.

After a few such prints you will *know* that black-and-white film can't tell one color from another. Then you'll see light-and-dark as well as color when you shoot, and your camera will give you fewer printing problems.

Psychological Hitch. But first you must see the trouble when it appears in the prints. This is often difficult at first, because we confuse wishes with facts. But wishes don't reflect or absorb light, so no one else can "see" them in your prints. When you see what's there instead of what you want to see, the problem vanishes.

An Unscrupulous Trick. In a sneaky, underhanded way, I have been able to teach students to shoot observantly. I tell them to shoot a picture with a confusing background. No one can do it. As soon as they pay full attention to what they see in the viewfinder, as they must when looking for a confused background, their sense of order takes over, and the pictures become crystal-clear.

A basic principle is involved here: *The key to clear shooting is to see accurately in the viewfinder; the key to clear printing is to see what's on the paper with the same accuracy.*

These self-evident, simple things are easy to do after the first time, but they are not always easy to arrive at in the first place. Many people find it hard to let go of wishful seeing.

Seeing Print Tones:

The inspection light. A good print-inspection light in the darkroom is a great help, though you can print well without one. If the light is too bright, you'll print too dark: if it's too dim, you'll print too light. Look at the prints when they're dry and adjust your inspection light until the problem disappears.

Know your papers. Different photographic papers darken in different ways when they dry, and each picture takes that darkening differently. If your negatives are good, the mechanics of printing are simple, but accurate tonal judgment is not always simple. When your inspection light is right and your eye is well tuned to the pictures and the paper, there's usually no problem: a look at the wet print on the inspection board will tell you if it's too light or dark, too soft or contrasty, or "just right," and you know what to do next.

Don't expect miracles. If you're like me, your eye is not always well tuned. My printing judgment fluctuates. Sometimes I'll print several negatives before I find out that the prints I have been making are disappointing, though I liked them while making them.

Follow through. Then there is one thing to do: Learn the lesson. Identify the trouble and print again to eliminate it. If I've printed in muddily soft tones, as I sometimes do, the failures tell me to use more contrast next time. Have the patience to follow through, and the prints will reward you.

PROBLEM: WHAT ARE PHOTOGRAPHIC SUBJECTS?

Visually Speaking, Life Is a Mess. The reality we live in does not spring from cosmic file cabinets, ready-sorted into categories; but conventional ideas of what to photograph seem to.

Foolish Questions and the Answer. People keep asking, "What do you photograph? Portraits? Landscapes?" and so on. The only answer I can give is, "Anything."

What Most Photographers Shoot. Looking at their pictures, we find that people tend to photograph only a few of the things they see,

Is this picture original? I neither know nor care.
Category: spontaneous photograph of a posed
portrait.

ignoring all the rest. They shoot landscapes, portraits, cats, dogs and birds, children dressed up or at play, "street pictures," "abstractions," nudes, still lifes and whatever else is in fashion at the time—road pictures shot from the car, say, or "poverty" and "pollution."

This approach simplifies picture filing and tends to make photography dull. If you shoot only what you already know from pictures, and make only the pictures you know from other photographers' work, you are missing most of the best possibilities.

Clichés. The word "photogenic" generally means "well established as a cliché." But a cliché is just a good idea that is usually misused. If you really cope with them, cliché subjects are as good as any others. Here are some cliché ideas about photography.

"*Originality*" is a much overrated concept. A truly original picture can fail as resoundingly as an imitative one; and either can succeed equally well. Good photography does tend to be original, but seldom because the photographer is trying for originality. It doesn't work that way. Originality is a by-product of doing whatever you want to do as well as you can. Even a recognized cliché can become original all over again.

"*Spontaneity*" is another sacred cow. Spontaneous pictures and deliberate ones can be equally strong or weak. Some people are better at spontaneous photography, and some do better by patient planning and earnest contriving.

("*Contrived*," then, is a scare word. A well-contrived picture can be as good as a well-discovered one.)

What's Worth Photographing? Almost everything you see that interests you is good photographic material if you use it. As the speed of film increases, the possibilities open up.

For a long time, emulsions were too slow to permit sharp photographs of things that moved. Now we know that we can "freeze" movement by short exposures or show it as a flow pattern by long ones, and that either is truthful.

For a long time, emulsions were too slow to use except in daylight. Now we can easily shoot by moonlight or starlight or night street-lighting. (Most photographers still seem to overlook the night.)

Photographic subjects are anything you like, from things so familiar that everyone ignores them to utterly unfamiliar things that the eye cannot see directly.

Approaches

The "decisive moment," made famous by Henri Cartier-Bresson, has many possibilities. It's that moment when things come together, changing in front of the camera and briefly forming a complex expressive whole. (But sometimes I think it's really that moment when the things in front of the camera look most like a nineteenth-century battle painting. Many of the "decisive moments" in photography are just that.)

Photographs can be jokes, insults, caresses, factual records, anything you want. They do not have to show landmarks, moments of crisis, "points of interest," spectacular events.

Photographs can start from ideas; but a visual expression of the idea must be found or made, or nothing happens. Most ideas are word stuff, not picture stuff. I seldom have or use ideas for pictures, but sometimes ideas

Decisive moment, I: that of a photographer's odd action (why is he in such a hurry?).

Poaching in McLuhan country: the picture is the caption.

Decisive moment, II: complex interaction or "cho-
reography" (Olinda, Pernambuco, Brazil, 1961).

Now It's Up to You

More mixed categories: "decisive moment,"
"light" "street shot," "shadows and reflections"
—and others.

sneak in. At highway construction sites in Missouri, I saw signs that cracked me up: "END OF IMPROVEMENT, THANK YOU FOR YOUR PATIENCE." So I shot the signs as I drove past. A fairly complex idea—the words, their absurdity, and their rich load of social implications—had sneaked in through direct seeing, not at all through thinking. It's a literary picture and depends heavily on the words you read in it, a thing that many people consider sinful. I used to, but when I asked myself why, I couldn't find an answer. I changed my mind, so I can now enjoy literary photographs without a qualm.

My Own Approach. Mostly I work with no plans or ideas. I just wear a little camera so I can conveniently let the good things I see into it—whatever their nature. When I see something I love or hate the look of, I tend to pause long enough to shoot it.

Categories have nothing to do with this approach, which depends on pure luck. I have to be lucky enough to see some of the fascinating stuff around me, which is roughly comparable to the luck needed to find air to breathe. It's free and it's there. All you do is use it.

SAMPLE STARTING POINTS

If the beginning of this chapter is too vague for you, and you want more specific suggestions, here are a few.

1. *Photograph light and shade.* It's fascinating in itself.

2. Most people don't look much at *reflections and shadows* (a kind of light-and-shade game itself—but so is all photography) because they "don't really exist." They aren't "things." But visually a shadow of a rock is

as real as the rock. Watch shadows and reflections, and you'll find they can be fascinating.

3. *The human face* has special emotional power for humans. We are born with a powerful response to it that is active as soon as we can see—before anything can be learned about it. Fill up pictures with faces and some of them are almost sure to be strong.

4. *Places have personalities, too.* If you have a feeling about a place, try a few pictures. They do not have to contain people to work: sometimes the absence of people adds power.

5. *Conditions.* Weather, for one, is loaded with rich and strong photographic possibilities. Wetness, dryness, roughness, smoothness, softness and hardness, all such qualities can lend meaning—which means feeling as much as it means information—to your pictures,

6. *Relationships.* If a heavy object is poised above a light, fragile one, you get one feeling. Reverse the order, and the feeling is different. But don't get too literal-minded about it. The feeling may be different from anything you'd expect. Instead of trying to pre-calculate the effects of relationships, try them out and let them work on you. Observe your feelings, but not too expectantly, or the effort of searching will drown out the feeling and you won't find anything at all.

7. *The feelings that things evoke* are a natural starting point. I mean hot, cold, loose or tight, and things on that sensory level as much as I mean anger, love, hate and the rest of the "name" emotions. When you get a strong feeling, shoot before you analyze. But after you shoot, consider. What did you feel? What did the feeling come from?

Face power: W. Eugene Smith on his own street—Sixth Avenue, New York City, 1965. (Tri-X at EI 1600—Diafine.)

8. *Accidental pictures.* If you're absolutely stymied and can only find pictures that bore you to tears, an accident or two may help. The problem is conditioning: Dr. Pavlov rings a bell and you see only clichés that make you groan. Bypass the conditioning by shooting without selection or control.

One method is to *shoot without looking.* Load your camera, set it for ten feet and the exposure the day calls for, then go into a crowded public place and shoot back over your shoulder without looking. (You may get some good pictures of people looking puzzled.)

The clock routine. Another approach, slightly less cockeyed, is to carry an alarm clock or watch set for half an hour from now. *Whenever it rings, look around and take the most interesting picture you can find from where you are.* If you do this all day for a couple of days, you should find yourself photographing unexpected subjects in unexpected ways.

Cash in on chance. Both approaches give you the benefit of the law of averages, since good accidents will happen sooner or later if you let them. (Many photographers defeat the law of averages and manage to go

Places have personalities—like this gently eerie park in Kalamazoo.

through years of constant work without a single lucky accident. Poor them.)

9. *Shooting in the street.* Photographers suffer from stage fright as badly as actors do. But there is rich and good hunting in the streets once you get started. Summon up your nerve, pre-set focus and exposure, and watch through the viewfinder. When it looks good, press the button. Hint: Don't keep walking. Stand still when you find a good place. Don't try to be inconspicuous—you ARE conspicuous when you use a camera, and furtiveness makes it worse. Stand your ground and blaze away.

Why not ask? If you're very nervous, you can soothe yourself and others by asking for permission to take their picture. If they don't want you to, don't. There are plenty more.

If you fear violence, take along a large, tough-looking friend.

10. *Record a fact.* If they're tearing down the old city hall to put up a new plastic one, you might suddenly find that you like the old monstrosity and want a souvenir. Look it over carefully, pick the best viewpoint and time of day (a synomym for "quality of the light") and work to make the clearest picture you can. If you're not careful, you may make a picture that's more than just a souvenir. It may turn into a work of art.

11. *What can you do with a mountain?* (It's strange how small they look in most photographs.)

12. *What can you do with a leaf or a pebble?* (It's strange how "nothing" they look in most photographs.)

(Clue to 11 and 12: they are the same problem. Don't try to make a mountain or a leaf into anything. Let them be what they are.)

PROBLEM: WHAT DO YOUR PICTURES MEAN TO YOU?

How Can You Tell What You're Feeling? This is another easy hard one. You can't always pin it down, even when you know it's there. You feel, but what?

One reason for the difficulty is that there just aren't any words at all for many of the things pictures make us feel. Accept that; it's a fact.

How Do You Know if the Picture Works? The best I can do for you here is to say that the picture can either be about its apparent subject or not, and that this does not matter. If it moves you when you look at it, it's working. If it doesn't move you, it isn't working.

The "move" does not have to be transcontinental: a small, quiet, definite feeling, whether there are words for it or not, is enough "move" for me.

Explanations Explained. You do not have to explain your pictures. In fact, that is generally a poor idea. If the picture works, explanation is unnecessary. If it doesn't, no amount of explaining will save it. Most explanations explain nothing.

"What," more than "Why." Hint: You can never really get at *why* you like or dislike a picture; but often you can see immediately *what* you like or dislike in it. Concentrate on identifying *what*, then, and let *why* go.

If you can neither say why nor what, but the feeling persists, trust it. In other words, trust yourself.

Tangible is not the same as logical. The reason we can't always put down our response to a photograph in words is not that the photograph is intangible. It *is* tangible, or there would be no feeling. It's merely unwordable. Pictures are a more direct kind of language than words, and they show different things than words say.

Pictures complement words. That's one reason words and pictures work so well together when they're combined intelligently. Each fills the gaps that the other leaves.

A tactful cop-out. When people insist that you explain a picture that's perfectly clear to you, say what has been credited to both Count Basie and Louis Armstrong when asked what rhythm was: "If you have to ask, you'll never know." (Maybe they both said it.)

PROBLEM: SCALE, OR THE SIZE OF THINGS

This is simple. *Get close enough to fill up the picture with things that count*, and leave out everything that doesn't count. *Get far enough away to include in the picture everything that it needs.*

If in doubt, move forward or backward until the doubt is replaced by recognition that now it's right. If that doesn't happen, take a different picture instead, because this one isn't going to work. If in superdoubt, push the button before you quit, on the

Conditions, I: sometimes all you can see is weather.

Conditions, II: gloomy afternoon in the canyon.

Relationships: can he get those big trees into that little camera? (Why not? This shot was made with a smaller one.)

Street shot: Christmas cheer in Chicago. It's amazing how often people ignore photographers.

WHAT TO PHOTOGRAPH? HOW TO PHOTOGRAPH IT? 317

The scale problem: shot from too far away.

chance that you are really decisive and clear and just don't know about it.

WHAT NOW?

Too many photographers are finished by the time they achieve finish.

Things Are Not What They Seem—or Are They? The Zen people say that a novice sees mountains as mountains and water as water; later he sees that mountains are not mountains and water isn't water; and finally (if and when enlightenment turns up) he once again sees mountains as mountains and water as water. This time he knows the score.

Photographers go through the same process.

The Simple-minded Start. We start out ignorant, but with a long-accumulated shopping list of pictures we want to take. Knowing nothing about how, we go straight at them and shoot, crudely but directly. The pictures tend to be awkward but true to our feeling. Mountains are mountains, even if they're out of focus.

About the time we exhaust these pictures that we've been waiting to take, we have begun to learn photographic skills.

Full of Sound and Fury, Signifying Nothing. At this point, photography looms larger for us than the things we photograph and the pictures that result. We are in a how-to-do-it period and see everything in technical terms, not in terms of what things are and what

The scale problem: shot from too close: a blown-up, oversimplified
fragment. (German photographers who write books keep saying "Less
is more." Actually, enough is enough, and less is less. Tunnel vision
and croposis solve few problems.)

Scale: no problem. Close enough and far enough.

they mean to us. We talk about lenses a lot. Mountains are no longer mountains, but have shrunk down to being raw material or subject matter—something to manipulate.

What to Do? What to Do? By the time we have learned technique but forgotten what it's good for, there are two sensible ways to go.

Maybe Quit. One is to *stop photographing*, as many people do at this stage. (Others, less sensible, just go on repeating the mechanical motions over and over, for years, and wonder why they aren't happy about their pictures.)

Maybe Start Fresh. The second sensible course, and the one I recommend, is to *start all over again*, this time using your acquired

skill to show the nature of the things you photograph and how you feel about them, in the strongest and most personal way. All resources are used to strengthen expression.

The Simple-minded Arrival. Then mountains are again mountains; and in the pictures, they look and feel as big as they are.

Technique is a means, not a goal.

This is the beginning, not the end.

HOW DO YOU FIND PICTURES?

Photographs with vitality are not made by cleverness. They come from sensitive seeing and an appropriate technical follow-through.

You don't find them by hunting for "good

pictures" or "photogenic subjects." These are formulas for repeating the good pictures of the past in watered-down form. All you get is *Son of Decisive Moment* or *Photo-Secession Meets Frankenstein and Wolf Man.*

Forget about pictures and look around you. Photograph whatever interests you most. The pictures that need to be taken will come to you if you let them. Searching for them tends to drive them away. (This is what Picasso was talking about when he said, "I do not seek, I find.")

Photography is still new. It started in the 1820s and '30s. In its present form, with the capacity to record life in passing, it's no older than the 1880s. Much has been accomplished, but we are still only beginning to understand our medium and what we can do with it.

Vital new pictures that will seem necessary and self-evident as soon as they are made, but which nobody can now predict, are waiting in the wings. They are waiting for you as much as for anyone.

The following portfolio by various photographers is to show you that anything goes if the picture works. There is no one right way to photograph.

Henry Modjilin: photograph by Sid Grossman, Oklahoma or Arkansas, about 1940. A complex mixture of "straight" documentary photography (fact recorded in detail) and conscious artistry (changes made to clarify and dramatize the picture: for instance, the contrasting tones introduced artificially beside the head and around the gesturing hand and arm).

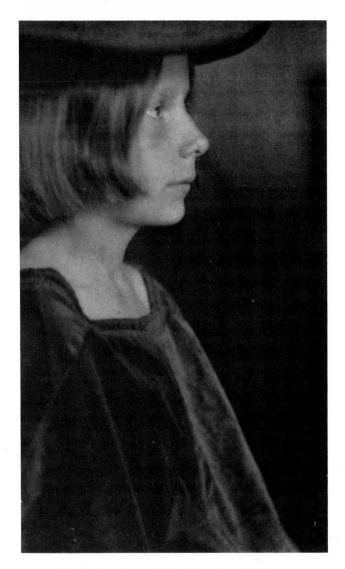

"Study," by Gertrude Käsebier, about 1898 (copy from a platinum print). Her obsession with renaissance painting turns out not to be so bad for her photography. This picture is physically about 75 years old, conceptually about 400 years old, and still beautiful.

Portrait of André Kertész, Brooklyn, 1969. A spontaneous pose: Kertész saw the wall and the light and made spooky hands so I could take this picture. Later he said I should have cropped it. I don't agree: I shot it that way, too, but liked this version.

Now It's Up to You

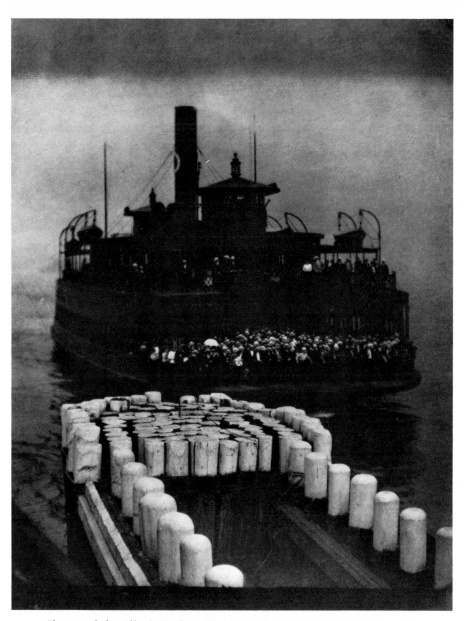

Photograph by Alfred Stieglitz, 1910 (copy from a photogravure in *Camera Work*). Another case of altered realism—halfway between Käsebier's costume fantasy and Grossman's amplified record of fact. Stieglitz has simplified tones and textures greatly here, for maximum mood. He wasn't much concerned with information in this picture.

Portrait of a saguaro, Tucson, 1966.

Now It's Up to You

Portrait of Sid Grossman, 1949.

Photograph by Maggie Sherwood.

Now It's Up to You

Photograph by Helen Buttfield.

Photograph by Helen Buttfield.

330 *Now It's Up to You*

Photograph by Shalmon Bernstein.

332 *Now It's Up to You*

Photographs by Charles Pratt.

WHAT TO PHOTOGRAPH? HOW TO PHOTOGRAPH IT? 333

334 *Now It's Up to You*

Photographs by Lilo Raymond. (Lilo accidentally put a roll of exposed film through the laundry: special effects thanks to New Blue Cheer detergent in the wash cycle.)

Glossary

absorption Blotters absorb water, dark surfaces absorb light, good photographers get absorbed in what they see and do.

accelerator The ingredient in a developer that speeds up development. Usually sodium carbonate in print developers, and milder alkalines in film developers.

acetic acid The acid used in stop baths and acid fixers. A 28 percent solution is called for in most formulas.

acid fixer A fixing bath containing acetic acid.

acid hardening fixer A fixing bath containing a hardening ingredient, usually alum, to toughen film or paper emulsions.

actinic light Any kind of light that affects photosensitive materials such as film or printing paper.

acutance In sensitometry, a measurement related to sharpness, especially in films: to oversimplify, the abruptness of white-to-black tonal change in an emulsion exposed to light past an opaque "knife-edge," then developed and measured. Acutance is not the same as sharpness, which is an unmeasurable sense of clarity.

adapter Any device that adapts one piece of machinery, lens element, or what have you to another which it wouldn't otherwise fit.

additive color Color theory according to which light of three primary colors combines to form white light; and any other color can be obtained by mixing two or three of the primaries in varying proportions.

aerial perspective The way "thick air"—fog or haze—makes objects look fainter in tone, lower in contrast, and less distinct in outline as they are farther away.

agglomeration The clumping together of the silver grains of an emulsion so as to form visible "grain."

agitation Systematic movements of processing solutions and/or the photo material being processed so that fresh solution is regularly distributed over the whole surface of the image for even, consistent development, fixing, washing, etc. As vital in fixing and washing as in development, an almost universally overlooked fact.

air bells Technical jargon for bubbles, which can cause trouble in processing by preventing developer, etc., from reaching the emulsion. Unwanted round spots in the picture are the result.

alkali The converse of an acid. Most developers are mildly alkaline, most fixers slightly acid.

alum Short for potassium aluminum sulfate, the hardening ingredient in most fixers.

amateur A photographer who works because he likes to, not because he must. Most of photography's highest and lowest achievements are attained by amateurs.

ambrotype An early photo process in which the silver of a glass "negative" is seen as "light tones" against black velvet or lacquer. The ambrotype was cheaper than the daguerreotype, and quickly replaced it in the 1850s. The same principle produced the still cheaper tintype.

amidol A powerful developing agent.

ammonia In its liquid form, an ingredient in hypo-eliminator formulas. In dilute solution, a good glass cleaner, but not for lenses.

ammonium thiosulfate The active ingredient in rapid fixers. See Hypo.

anastigmat Technical term for the highly corrected lenses used for most photography today.

anhydrous Chemical term meaning without water: desiccated.

ANSI American National Standards Institute, formerly USASI, formerly ASA.

Anti-Fog No. 1 Eastman Kodak trade name for the chemical restrainer, benzotriazole, which see.

anti-halation backing A light-absorbent coating behind film emulsion to prevent light from being reflected back into the emulsion from behind.

aperture (1) The opening, usually variable in size, through which light enters a lens. It controls the amount of light that passes in a given time and changes its focal behavior. Things "go out of focus" more gradually at small apertures than at larger ones. The calibrations of the aperture are in terms of f-stops and f-numbers, which see, which relate the diameter of the opening to the focal length of the lens. (2) The name of a photographic art magazine.

art Undefinable word implying, among other things, "more than just skill," and "high-intensity communication." Is photography art? Yes and no: if you take care of the photography, art takes care of itself.

art photography Photography with delusions of grandeur: seldom coincides with art.

ASA ratings Film speed, when measured by the methods of the United States of America Standards Institute, is described by ASA ratings, which relate arithmetically to each other. An ASA 400 film is twice as fast as ASA 200, or 10 times as fast as ASA 40.

astigmatism An optical aberration; vertical and horizontal lines at the same distance are not rendered with equal clarity. One or the other looks sharper at any given focus.

automatic diaphragm Most modern lenses for single-lens reflex cameras "stop down" automatically to a pre-selected aperture when the button is pushed to take the picture, and reopen as soon as the shutter is closed. Viewing and focusing are done with the lens "wide open."

automatic-exposure camera In common usage, a camera that sets its own exposure mechanically according to a built-in light meter.

auxiliary lenses Optical elements that, when added to a basic lens, change its effective focal length and angle of view.

available light In popular usage, dim light.

In fact, any light available, natural or artificial.

avoirdupois The system of weights and measure generally used in the U.S. Avoirdupois weights include the grain (gr.), 1/7000 of a pound; the dram, 1/16 of an ounce; the ounce, 1/16 of a pound; the pound; and the short ton, 2,000 pounds. Replaced over most of the world by the more convenient metric system.

Azo A contact-printing paper made for many years by Kodak, and still in production. It is a slow chloride paper, about 1/100 the speed of most enlarging papers.

B "Bulb," a shutter setting; the shutter when set at B opens when the button is pushed and closes when it is let go.

back focus A confusing term that has nothing to do with focus. It stands for the distance from the back surface of the lens to the film when the lens is focused at infinity.

background A painter's concept in photography; the area around a more or less central subject.

backlight When the light comes toward the camera from behind whatever is being photographed.

balance The many meanings include controlled ratios in lighting and in color filtration; scales for weighing chemicals; and a visual factor in picture design; the proportional distribution of emphasis.

barrel distortion An optical effect; the sides of a "barrel-distorted" rectangle appear to bulge outward.

baryta The barium sulfate coating that supports photographic paper emulsions. Baryta is the "white" of the paper.

base The paper or plastic or glass on which the emulsion is coated. Also the flat "foot" on which an enlarger stands.

bath Any chemical solution used in photo processing.

Bayard, Hippolyte One of the several people who invented photography in the 1830s.

beam-splitter A semi-reflecting, semi-transmitting surface that divides a beam of light into two identical half-strength beams. Used in rangefinders, viewing systems in cameras, etc.

behind-the-lens shutter Usually a leaf-type shutter placed behind the lens instead of between its elements to make lens-changing possible.

bellows The accordion-folded leather or plastic bag between the lens and the camera back in view cameras, etc. Also an accessory for 35mm and other small cameras to extend the focusing range of the lenses.

bellows-extension correction The term, whether a bellows is used or not, for the exposure increase required when lenses are focused closer than about 8× their focal length, in effect making the aperture smaller in relation to its distance from the film and so changing the effective aperture.

benzotriazole A powerful restrainer used in some developers instead of the less active potassium bromide. Benzotriazole is also used as a developer additive for brighter whites in prints. A side effect: benzotriazole tends to give prints blue-black dark tones where bromide produces greenish blacks. One trade name for benzotriazole is Kodak Anti-Fog No. 1.

between-lens shutter A shutter located between the front and back element of a lens.

black An imaginary dark tone that theoretically absorbs all the light that strikes it, reflecting back none of it. In photographic paper, the darkest obtainable gray.

Blancquart-Evrard The grandfather of photographic printing. He invented albumen paper about 1850.

blocked-up Describes overexposed and/or overdeveloped "highlights" in negatives, too dense for easy or very good printing.

blotters, photographic Hypo-free blotters made for photography.

blur A vague word that stands for several kinds of photographic rendition, such as out-of-focus areas of several distinct sorts, and the photography of paths of motion during extended exposure times.

borax A mild accelerator used in some film developers.

boric acid An ingredient in some fixers.

box camera A simple camera that allows few technical mistakes.

breadth A positive quality in pictures and seeing which is best defined by what it is not: fussiness or overemphasis on the parts of a picture at the expense of the whole is the opposite of breadth.

brightness range From how bright to how dark the things being photographed are. Extreme brightness ranges demand accurate exposure and development, or printing will be difficult.

brilliant The word a literate photographer uses instead of "snappy." Agreeably contrasty.

bromide paper Fast, cold-toned photographic paper made with silver bromide as the working part of its emulsion.

BSI ratings Arithmetical film-speed ratings established by the British Standards Institute: at the time of publication, BSI ratings are identical to ASA ratings. (There are also BSI logarithmic ratings, used more in the lab than for picture-taking.)

BTL meter A "behind-the-lens" light meter, typically built into a reflex or rangefinder hand camera. The BTL meter measures light that has passed through the picture-taking lens. Synonym: TTL (through-the-lens) meter.

buffered A solution containing ingredients that stabilize its alkaline-acid balance is said to be buffered.

bulb See B.

bulk film 35mm film sold in long rolls instead of individual cartridges. The photographer loads his own cartridges. The cost is a fraction of what factory-loaded film costs.

burning-in In printing, the addition of exposure to part, but not all, of the picture. The burned-in area gets darker. The opposite of dodging.

cable release A long-range button. Minimizes vibration when tripping the shutter.

calotype An early paper-negative process, invented by William Henry Fox Talbot in the 1830s. Also called Talbotype.

camera obscura Italian for a dark room. A viewing device that cast an optical image from a lens onto a groundglass screen. Used by painters in the Renaissance and later, it stimulated the invention of photography. The problem was to keep the image.

cartridge A light-tight container for a spool of 35mm film. The cartridge is loaded into the camera, and the film pulled out of it for exposure, and wound back into it when the roll is finished.

cassette A high-priced cartridge.

Celsius The metric temperature scale (also called Centigrade), named for a Swedish astronomer, Anders Celsius, who described it in 1742. 100°C = the boiling point of water at sea level and 0°C = its freezing point. Before the metric system began to invade the U.S.A. in nonscientific use, Centigrade was the usual term. Now Celsius is becoming the preferred term.

characteristic curve A graphic expression of how exposure and development measurably affect density and contrast in negatives and prints. Also called H & D curve, for Hurter and Driffield, the scientists who devised it, and D log E curve. Useful for manufacturers, less so for photographers.

chiaroscura Italian for light and shadow.

chloride papers Slow contact-printing papers made with silver chloride. Azo is one.

chlorobromide papers Photo paper made with both silver chloride and silver bromide; sometimes used to mean warm-toned papers, but most modern papers are chlorobromides, whether warm or cold in tone.

cinch marks Abrasion on film from winding it too tightly.

circle of confusion An unintentionally poetic phrase for the rendition of an out-of-focus point as a circle in a photograph.

cliché Any exhausted idea, visual or verbal. Most clichés begin as excellent ideas, but their sense is usually forgotten by those who parrot their forms. Any cliché can be used freshly, but it seldom happens.

clip A clothespin or other device for hanging up film, etc.

clumping See Agglomeration.

collage Combining different objects or parts of pictures to make a new picture.

collimation What a condensing lens does to light, making it radiate in approximately parallel rays. This increases image-contrast in condenser enlargers over that of diffusion enlargers.

color The ways different wavelengths of light look to us are called colors. No one knows how anyone else sees colors, but we do know that both taste and color vision differ from person to person. Color can be measured objectively in several ways, a facility more useful to engineers than to photographers.

color-blind film A conventional term for a black-and-white film sensitive only to blue light. Most early photographs were made with color-blind emulsions.

color filters Colored glass or gelatin that screens out some of some colors of light so they do not reach the film. Different filters subtract different colors, so the photographer can use them to lighten or darken things in the picture selectively. A deep red filter, for instance, blocks almost all blue light, so it will render a bright blue sky as nearly black. The blue light doesn't reach the film, so that area is underexposed.

compensating developer A semi-mythical kind of film developer that develops less-exposed parts of negatives more vigorously than much-exposed parts, thus controlling

contrast. Some developers do compensate slightly in this way, but not to the extent that photographers hope for. Accurate exposure and development is more useful.

complementary colors In conventional color theory, an infinite variety of sets of three primary colors is supposed. Any one primary color is considered complementary to a mixture of the other two that encompasses all the colors which it does not. Theoretically, primary colors can be mixed to obtain any hue. When all three—any color and its complementary color—are mixed in terms of colored light, this is called additive color. In equal proportions, mixed light of all three primary colors adds up to white light. When mixed equally in terms of light-absorbing pigments, a color and its complementary "two-other-primaries" color theoretically mix to form a black pigment. This is called subtractive color. Actual dyes and pigments approach, but do not attain, these theoretical results.

composition A weary word for the ways things work together within the area of a picture. Almost meaningless from much misuse.

condenser A lens that collects rays of light and bends them so they form a beam of light. Used in enlargers and viewing systems.

contact print A print made with the negative pressed against the printing paper instead of by projecting the image onto the paper from a distance.

contrast A key word in photography which has confusingly different important meanings. *Over-all contrast* in negatives refers to the total scale of densities they include, and also to how that scale relates to the brightness-range of the subject. In prints, contrast refers to how abruptly the tones change and modulate between black and white. A *contrasty* negative normally requires a "soft" or low-contrast paper for "normal" or median-contrast printing, which renders all the tones of the subject clearly so they fit the tonal range of the paper from black to white. A "soft" negative requires a "hard" paper for a similarly normal print; a "normal" negative is one that prints "normally" on "normal" paper, with no need for manipulation. *Local contrast* refers to the liveliness of change within similar tones—dark ones, light ones, middle-gray ones. Excessive *over-all contrast* in a negative gives high *local contrast* in one part of the print's tone range—say, the middle range—but it gives very low local contrast in the other parts of the range—in this case, the "whites" and the "blacks," which run together to become featureless dark areas and blank white ones. The great problem of photography is to keep high local contrast while limiting over-all contrast.

contrast index A form of contrast-description devised by Kodak to relate negative contrast more directly to the negative's printing characteristics than the older concept called *gamma* does. Contrast index is based entirely on the gradient between two given densities as they appear on a film's characteristic curve, so a CI number is less informative than a *gamma* number, which is based on a larger series of densities. See *gamma*.

contrasty High in contrast, with relatively abrupt and extreme tone and density changes.

coupled rangefinder A distance-measuring device connected to a camera's lens mount so that when the "range" is "found," the object used as a target is in focus. You focus until a double image of the target object merges or coincides to become a single image.

credit line The photographer's name printed with the picture.

critical focus Accurate focus, as distinguished from nearly accurate.

crop To change the shape and/or area of a photograph by removing part of it. Cropping is not good or bad in itself, but often it is a tacit admission that the photographer was not paying attention when he took the picture. However, many photographers take strong photographs and weaken them by insensitive cropping. In that case the inattention is at the other end of the process. Occasionally a picture is strengthened by cropping.

curl What overhardened negatives and single-weight prints relentlessly do. A nuisance.

cut film Obsolete for sheet film.

cutting reducer See Subtractive reducer.

Daguerre Louis Jacques Mandé Daguerre (1789–1851), the most successful of photography's first inventors.

daguerreotype Daguerre's process; a whitish deposit on a silvered plate represents the light tones while dark reflections on the silver serve as dark tones. Daguerreotypes look like little mirrors with pictures on them, and have the most delicately rendered tones of any photographic medium.

darkroom The dark room where photographs are processed.

daylight loader A device for loading bulk film into cartridges in subdued light.

decoration A trivial but positive quality in pictures.

definition An indefinable word covering various technical and pictorial qualities of pictures. What they have in common is that they all refer to one form or another of clarity.

dense In negatives, approaching opacity. In prints, dark.

densitometer A device for measuring density in negatives and prints.

density Relative opacity and transparency in negatives and slides; relative lightness and darkness in prints.

depth of field From how near to how far in front of the camera things will apparently be in focus. Small lens apertures give greater depth of field, while large ones decrease it.

depth of focus How far in front of the plane of focus in the camera and how far behind it the film can be and still receive an acceptably sharp-looking image. Sometimes mistakenly used to mean depth of field.

developer A chemical solution that "brings out" the latent image on exposed film or paper, making it visible and usable.

developing tank A container that holds the film in the developer so it can be developed evenly. Reels, "aprons," or other kinds of holders or hangers are used together with the tank.

development The process of converting invisible or unusable latent photographic images into visible or usable form, typically by chemical means. Physical development also exists.

development by inspection The difficult art of judging a nearly invisible image in the poorest possible light. Most development-by-inspection is overdevelopment, but a few gifted people can actually do it well. They describe it as an intuitive process. For the less gifted, time-and-temperature development is easier and more controllable.

diaphragm See Iris diaphragm.

diffused light "Non-directional" or "all-directional" light, like that of a cloudy or foggy day, as distinguished from directional light from "small" sources such as the sun.

diffusion When an optical image is diffused it becomes lower in contrast and less sharp in delineation than an undiffused image. Used in portraiture for tactful fantasy. A diffusion enlarger gives prints of lower contrast than a condenser enlarger.

DIN ratings Deutsche Industrie Normal logarithmic film-speed ratings, the German national standard; equivalent to ASA speeds except that DIN ratings represent doubled film speed by adding 3 to the DIN number instead of by doubling it (27 DIN is twice as fast as 24 DIN). To translate DIN numbers to ASA numbers or vice-versa, see the table on p. 54.

distortion All photographs look different in many ways from the "natural appearance" of the things photographed, some ways being more obvious than others. In general the word distortion refers to *unconventional* differences between the picture and the reality, so its meaning changes from year to year along with the conventions. Distortion is neither a sin nor a sign of genius; it is just always with us.

D log E curve Preferred laboratory usage for characteristic curve, which see.

dodging The local withholding of exposure from part of the print by making a shadow on the paper for part of the print exposure. The dodged area becomes lighter. The opposite of burning-in.

double-weight paper Photographic paper on heavy stock. Single-weight paper is thinner, cheaper, and curls more.

dry-mounting Probably the most practical way to mount prints: A thin dry-mount tissue (impregnated with shellac or a heat-sensitive plastic adhesive) is placed between print and mount, and is bonded to them by heat and pressure in a dry-mounting press.

easel The device that holds the paper flat and establishes the print's margins in enlarging. A stand on which pictures can be placed for viewing.

effective aperture The lens opening, not always the same as the marked f-stop, by which exposure time is determined. In extreme close-up photography, the lens moves so far forward from the film that more exposure time must be given; when something is photographed "same size," for instance, the lens is at twice the normal distance from the film, and four times the exposure time must be given. (A lens of 1-inch diameter and 8-inch focal length, normally an f/8 lens, is now 16 inches from the film, so its effective aperture is now f/16.)

EI Prefix for exposure index film-speed ratings. See exposure index.

Elon Kodak's name for the developing agent, metol.

emulsion The light-sensitive coating on photographic paper and film.

enlarging Making prints that are larger than the negative, by projection.

exposure (1) The act of exposing. (2) The amount of image-forming light that is allowed to fall on the film or paper by correlating aperture and exposure time with the amount of light available.

exposure index Standard usage for arithmetical film-speed ratings established by observa-

tion, trial-and-error experiment or other non-standard or non-scientific methods. In all but the test methods used, EI numbers are the same as ASA numbers, and the two are interchangeable in picture-taking practice. ASA 400 = EI 400: the same light-meter readings dictate the same exposures for both. The disadvantage of EI ratings is that they do not necessarily fit industry standards, so when you use them, you are on your own. Their advantage is that they can include your personal variables which the industry cannot take into account.

exposure meter A light-measuring instrument with a slide rule for finding time-and-aperture combinations for accurate exposure of film of known speed. Reflected-light meters, including spot meters, measure the light from the surface of the subject. Incident-light meters measure the light itself without regard to the subject's reflectivity. Each type has its advantages and uses. The light-sensitive material used also differs. Selenium-cell meters are self-powered and highly reliable; cadmium-sulfide meters are far more sensitive, but more complex and subject to more technical troubles.

extension tubes Tubes that are used to place a lens farther forward than its normal mounting permits, allowing closer focusing.

f-number Describes the diameter of the aperture in relation to focal length. Thus f/2 stands for an aperture equal to ½ the focal length (fast), and f/64 stands for one that is only 1/64 the size of the focal length (very slow). Each f-number represents an opening that admits twice as much light in a given time as the next smaller one. The usual f-numbers on modern cameras, from largest and fastest to smallest and slowest, range from f/1.4 to f/32, in this order: f/1.4, f/2, f/2.8, f/4, f/5.6, f/8, f/11, f/16, f/22, and f/32. Occasionally larger stops (f/0.95) and smaller ones (f/64) are found.

f-stop The setting an f-number marks.

fading Chemical changes in poorly fixed and/or poorly washed black-and-white photographs in which the image becomes pale and may disappear. Color photographs also fade, but in their case careful processing cannot prevent it.

Fahrenheit Temperature scale still used in the U.S.A. but becoming obsolescent as the metric system replaces our old systems of measurement (Celsius or Centigrade is becoming the new temperature standard). Water at sea level boils at 212° Fahrenheit and freezes at 32°F.

Farmer's reducer The chemical combination of potassium ferricyanide and hypo used as a controllable bleach for reducing the density of negatives or prints. Highly poisonous.

fast film Highly light-sensitive film requiring relatively little exposure.

fast lens A lens of large aperture that admits much light quickly.

fast paper Highly light-sensitive paper requiring relatively little exposure.

ferrotyping Technique of pressing prints on glossy paper against a polished surface to dry, giving them a high gloss.

field of a lens A wide-angle lens has a wide field; the pictures it makes show a wide slice of the world on a small area of film. A telephoto shows a narrow slice of world comparatively big on the film. "Normal" lenses are in between.

film base The plastic on which film emulsion is coated.

film speed The relative sensitivity of a film to light. A prominent method to determine film speed is the ASA test procedure from which most manufacturers derive their exposure recommendations. See ASA ratings.

fixer Processing solution used after the development of negatives and prints to remove the unused "non-image silver" from the emulsion to render it insensitive to light and "fix" the image. The fixer must be thoroughly removed from the negative or print by washing, or it will destroy the image chemically in time. See Hypo.

flare Bright spots or areas in a photograph that were not part of the intended picture, caused by stray light striking the lens and being transmitted or reflected onto the film.

flat Informal way to say low in contrast: more emphatic than "soft."

fluid ounce A measure of volume, not weight, in the avoirdupois system. 1/32 of a quart, 29.57 cubic centimeters (cc.) in the metric system.

focal length The distance from the optical center of a lens to the film when the lens is focused at infinity.

focal plane The plane of the film, on which the image is focused.

focal-plane shutter A camera shutter—two curtains with a slit between them—that travels across the picture area just in front of the film, near the focal plane but not on it.

focusing mount A lens mount that can move the lens forward and back for focusing.

fog The tonal veil on a negative or print caused by stray non-image light striking the emulsion, or by misbehaving chemicals, or both. Also see Flare.

footcandle A unit of measurement for the brightness of light.

foot switch An electric switch worked by a pedal, leaving the hands free; a convenience in the darkroom.

forced development Development of a film carried further than is normal. Often, though not always, a mistake.

formalin A chemical used to harden emulsions after processing.

frame One negative in a roll; the picture area; the act of arranging the picture in its format while shooting; and a picture frame, are among the many meanings.

frame counter A dial on a camera telling how many frames have been exposed, or else how many are left.

frilling When the emulsion starts to come off the film or the paper.

front element In a lens, the piece of glass nearest to the subject and farthest from the film.

gamma A technical measurement of image contrast in relation to subject brightness-range, as applied to negatives. Derived from the gradient of the "straight-line portion" of the film's characteristic curve. In theory a *gamma* of 1.0 is a one-to-one correspondence. Printable negatives are mostly developed to a *gamma* between .5 and .8. See Contrast index.

gamma infinity Film development prolonged to maximum possible development is called, for some reason, *gamma*-infinity development.

gelatin The substance that fastens the emulsion to the base.

glacial acetic acid A 99 percent concen-

trated solution of acetic acid. Stinks powerfully and can cause bad burns, so treat with respect. See Acetic acid.

glycin A slow-working developing agent.

gradation The range of tones in a photograph, and how they relate to each other.

graded paper Photographic paper that comes in different contrast grades. From softest to hardest, the standard grade numbers are 0, 1, 2 ("normal"), 3, 4, 5, and 6 (ultra-contrasty). Other papers either come in only one grade or are variable-contrast papers.

graduate A measuring container for liquids.

grain (1) The visible texture of the developed emulsion of a negative; not the silver particles themselves, but clumps of them. See Agglomeration. (2) An avoirdupois unit of weight. (438 grains = 1 ounce. Abbreviation, gr.)

gram A metric unit of weight. Since 1 gram is equal to 15 grains, it is important to know which unit of measurement you are using. The abbreviation for gram is g.

gray card An 18 percent reflectance gray card is a standard "middle gray" used for measuring light with reflected-light meters. An accurate gray-card meter reading will match an accurate incident-light reading in the same light.

halation "Haloes" in the image caused by strong light spreading in the emulsion during exposure of the negative. It destroys both tone and sharpness, and is usually considered a fault, but halation can be used expressively.

halides The salts of fluorine, chlorine, bromine, and iodine. The light-sensitive halides usually used in photography are silver bromide, silver chloride, and silver iodide.

hand camera A camera that is normally held in the hands when used, unlike a stand camera, which is normally used on a tripod or other support.

H and D curve See Characteristic curve; see Hurter and Driffield.

hardener The toughening ingredient in a fixer, or sometimes used separately, to keep the emulsion from damage due to physical softness. Formalin, alum, and chrome alum are hardeners.

hard Informal way to say contrasty.

Herschel, Sir John The English scientist who helped smooth the way for photography in 1819 by discovering the image-fixing properties of hypo. In the 1830s, he was still another of the several people who invented photography independently.

high key A dilettante's word for pale pictures. Low key means dark in the same jargon.

highlights Technical language for any much-exposed part of a negative or bright part of a subject, and its rendition in the print.

Hill, David Octavius A Scottish painter who with the help of Robert Adamson became an early great photographer in the 1840s. His best known pictures are powerful portraits.

Hurter and Driffield Pioneers in sensitometry, the science of measuring photographic sensitivity and the behavior of photographic materials.

hydrogen peroxide A bleach, which is also, with ammonia, an ingredient in Kodak's HE-1 formula for eliminating hypo completely from negatives and prints.

hydroquinone A contrasty-working developing agent. See Metol.

hypo Sodium or ammonium thiosulfate, the active ingredient in fixer that dissolves the unused silver salts out of the developed negative or print, making it permanent—but only if the hypo is thoroughly washed out of the photograph. If left in it, hypo will chemically destroy the image in time.

Hypo Clearing Agent Originally a Kodak product to aid in washing hypo out of photographs. Now used by at least one other manufacturer as well.

hypo eliminator A formula for the chemical removal of all hypo from photographs.

illuminance Technical term for the measurable intensity of incident light (the light that falls on a photographic subject, not the light it gives off).

incident light Light that is on its way to a photographic subject, but has not quite reached it. To measure incident light, you place an incident-light meter between the subject and the light source: near the subject, but aimed toward the light source.

incident-light meter An exposure meter used by turning it toward the light source, since it measures the light itself without reference to the subject being photographed.

infinity On a focusing scale, the setting for any great distance—say from 50 or 100 feet and farther. The symbol for infinity is ∞.

intensification A chemical treatment to increase the density and/or contrast of a negative or print.

interval timer A short-term alarm clock for photographers, used to time development, etc. Most interval timers can be set for any length of time from ¼ minute to 2 hours or more.

inverse square law The brightness with which a surface is lighted varies inversely with the square of the distance from the light source. (A light that is twice as far away illuminates the surface only to ¼ the brightness, etc.)

iris diaphragm In eyes and in lenses, the device that makes the opening through which the light comes larger or smaller, to control the amount of light and to alter the focal behavior of the lens. (A small aperture offers greater depth of field than a larger one.)

kilogram In the metric system, a weight of 1,000 grams; equal to 2.205 pounds avoirdupois.

Kodak Trade name coined by George Eastman, reminiscent of the sound of a camera shutter.

Kodalk Trade name of Kodak Balanced Alkali, a mild alkali used in many Kodak formulas. Essentially sodium metaborate.

latent image The photographic image after exposure but before it is developed and made visible.

latitude The margins for plus and minus variation or error, typically in exposure and in development, within which photographic quality remains "good." An elastic term.

lens speed The ability of a lens to transmit more image-forming light or less in a given time. The main factor is the size of the aperture relative to its focal length. See f-number.

lens stop See f-number.

light trap A black "maze" through which air, but not light, can pass. On a small scale, light traps are used in film cassettes; on a larger scale, as darkroom entrances, etc.

liter A metric measurement of liquid, the

volume of 1 kilogram of water. 1 liter = 1.057 quarts avoirdupois.

long scale In a subject, a great range of brightness, from very dark to very light. In a negative, a great range of densities, from thinnest to densest—typically to render all the tones of a long-scale (contrasty) subject. In a print, clear, detailed rendition of most or all tones in a long-scale subject and/or a long-scale (contrasty) negative. In printing paper, a soft or low-contrast paper, which registers a longer scale of negative densities than more contrasty papers can.

low key See High key.

luminance Technical word for the "measurable brightness" of a subject or part of a subject—the intensity of the light it reflects or emits (as distinguished from "illuminance" or incident light. "Reflected-light meters" are more strictly called luminance meters). Technically, "brightness" is an impression—subjective and not measurable.

matte A dull, low-luster surface in printing paper. Works well with pale prints, but usually not with dark ones.

meter (1) Any measuring instrument. (2) A metric unit of measurement: 1,000 millimeters, or 100 centimenters, or 39.37 inches.

Metol A soft-working developing agent used, either by itself in developer formulas, or for more contrasty results, together with hydroquinone. The same as Kodak's Elon.

metric system A rational, decimal system of weights and measures, the international standard for scientific use. Its basic units for length, volume, and weight are the meter, the liter, and the gram, respectively. It has replaced the avoirdupois and other systems in most countries.

millimeter In the metric system, 1/1,000 of a meter, about 1/25 of an inch. Abbreviation, mm.

monohydrated Containing one water molecule per molecule of the chemical substance it describes. Some photo chemicals are normally used in monohydrated form, others in desiccated or even dodecahydrated form; the formulas specify which.

montage The combination of two or more images or parts of them to form a new image. The combination can be in terms of time or of space or both. Similar to collage, but not always the same. Collage is the simpler concept.

multiple image Any picture made up of more than two exposures.

Nadar Pseudonym of Felix Tournachon, a great 19th-century French photographer, sportsman, and balloonist. He made wonderful portraits, lived a lively life, and gave to his friends, the French impressionist painters, their first major chance to exhibit, in his studio. At the time they were considered to be incompetent sensationalists, but Nadar know the real thing when he saw it, and supported it.

neutral density filter A "gray" filter that cuts down the amount of light that enters a lens without changing its color. Allows the use of large apertures and/or slow shutter speeds in bright light without overexposing.

Newton's rings Little amoeba-shaped "rainbows" that appear when two specular surfaces touch—such as the base-side of a negative and glass negative carrier. A strong argument for the glassless negative carrier for enlarging.

Niépce, Joseph Nicéphore One of photography's earliest inventors. A Niépce photo-

graph made in 1826 exists today. Later he became Daguerre's partner, but died before the invention of the daguerreotype itself. It has been popular to think of Daguerre as a thief who legally "stole" Niépce's invention, but that view is not supported by the facts.

non-actinic light Light that does not affect photosensitive materials. Darkroom safelights need to be non-actinic, at least in relation to the materials they are used with.

normal Catch-all word for what we find most usable: everyone has a different idea of what it means. For example, my idea of a normal negative is one I can print well "straight" on No. 2 paper using my enlarger. Some 35mm photographers consider 50mm the normal focal length for a lens, while others normally use longer or shorter lenses. Among all the contradictory definitions, it probably makes sense to pick the ones you like best as applied to your own work.

objective In German, an *Objectiv* is a lens. A factual, not an emotional, relation to reality. Most human and photographic attitudes are an indefinable blend of the objective with its emotional counterpart, the subjective.

opaque No light can pass through an opaque object. Density is sometimes thought of as relative opacity, a contradiction in terms, but a useful one.

orthochromatic Film that is not color blind in that it is sensitive to green and yellow light as well as blue; but "ortho" film is not sensitive to red, unlike panchromatic film.

ounce An avoirdupois unit of weight; 1/16 of a pound or 437.5 grains. One ounce equals 28.35 grams. (There are also Troy ounces and apothecaries ounces, which happen to be the same as each other, but different from the avoirdupois ounce at 31.103 grams. A good argument for the metric system.) Also see Fluid ounce.

overdevelopment (1) More development than usual. (2) Too much development, so that quality suffers. In both senses, the converse of underdevelopment.

overexposure (1) More exposure than usual. (2) Too much exposure, so that quality suffers. In both senses, the converse of underexposure.

pan (1) The technique of swinging the camera from side to side or up and down during the exposure, as in following action. (2) A short form of panchromatic.

panchromatic Film sensitive to all visible colors of light. Most modern films are "pan films."

parallax The discrepancy between what is seen from two different viewpoints, no matter how close together, as between a viewfinder and a lens. Single-lens reflex cameras and view cameras use the same lens for "taking" and viewing, thus avoiding parallax problems.

perspective All the ways there are to perceive differences in distance. In the 15th century Leonardo da Vinci listed over 30 kinds of perspective, but did not exhaust the subject.

pH A symbol for the degree of acidity or alkalinity of a substance. Neutral ones such as pure water have a pH of 7.0. Acids have lower pH and alkaline substances have higher pH.

Phenidone Ilford trade name for the developing agent 1-phenyl-3-pyrazolidone, which behaves like metol but is more powerful (it can be substituted for metol in many formulas by using 1/10 as much Phenidone).

photogram A negativeless, cameraless photo-

graph made with light and shadow directly on photographic paper.

photogrammetry The use of aerial photography for mapping and measuring terrain.

pincushion distortion The converse of barrel distortion. A rectangle photographed with pincushion distortion will have concave sides in the picture.

P.O.P. See Printing-out paper.

potassium bromide In developers, the "restrainer" that prevents less-exposed parts of the image from darkening unduly. Thus in printing bromide keeps the highlights bright; without it they would tend to become dull and gray. See Farmer's reducer.

potassium ferricyanide Together with hypo, ferricyanide acts as a bleach, used to reduce the density of photo images, either all over or locally lightening selected parts of the picture. It is a useful but tricky and difficult printing control method.

prefocus It can be useful to focus the camera before you start shooting. When photographing on a busy street, it's convenient to focus at 10 or 15 feet and shoot when the people you're photographing arrive at that distance. If you are shooting from an airplane, you prefocus at infinity.

preservative The ingredient in a developer (or other photo solution) that saves the rest of it from oxidation. Usually sodium sulfite.

preset lens An ancestor of the modern lens with the automatic diaphragm. A preset lens allows you to focus your single-lens reflex wide open, and "spin" the diaphragm by turning a ring to stop down quickly to the chosen aperture.

pressure plate In cameras, the springloaded plate that holds the film in the focal plane for exposure.

printing-out paper Photographic paper that darkens upon exposure to light, and does not need to be developed. The print must then be fixed, toned, and washed. Very few printing-out papers are made any more. Most modern photo papers require development.

proportional reducer Reduces density in the negative in proportion to the amount of silver in the different tones of the image, so lowered contrast results.

rangefinder An optical device to measure distance; used as a focusing aid. In a coupled rangefinder, linked to the lens mount in a camera, two images typically "coincide" (merge together) when the object seen in the rangefinder is in focus for the camera. A rangefinder or RF camera typically has a built-in rangefinder of this kind. (A "split-image rangefinder" spot is sometimes found on the groundglass of a reflex camera, but this does not reclassify the reflex as a rangefinder camera.)

rapid fixer A fixer made with ammonium thiosulfate instead of sodium thiosulfate; it acts much more quickly than conventional hypo.

RC paper Resin-coated printing paper, which does not absorb water and processing chemicals. This permits short fixing and washing times (Kodak Polycontrast Rapid RC fixes in 2 minutes and washes completely in 4 minutes). RC paper can just be hung up to dry, and dries rapidly.

reciprocity (1) The reciprocity law: other things being equal, a given increase in the

light admitted through the lens (as by opening the diaphragm) is canceled out exactly by decreasing the exposure time in the same proportion (or vice versa). The total exposure is unchanged. (2) In popular misuse, "reciprocity" stands for its converse, reciprocity-law failure.

reciprocity-law failure The breakdown of the reciprocity law, typically with prolonged exposures. In effect, the film speed "slows down" as longer exposures are required by dim light. The same principle applies to photographic papers, which start slowing down when the exposures are longer than twenty or thirty seconds. Approximate exposure compensations for average black-and-white films follow:

indicated exposure	increase exposure by	
1 second	½ stop	(1½×)
5 seconds	1 stop	(2×)
15 seconds	1½ stops	(3×)
30 seconds	2 stops	(4×)
60 seconds	2½ stops	(6×)
90 seconds	3 stops	(8×)

(Not all films behave alike: this table is a starting point for testing, not a final authority.)

reduction Chemically, the process of development is the reduction of silver salts to metallic silver. Reduction also refers to the chemical process of lowering the density of a photographic image.

reflex camera A camera with viewing and focusing via one or more mirrors and/or prisms which direct the image from the lens into the viewfinder. Single-lens reflexes (SLRs) use the same lens both for viewing and for picture taking. Twin-lens reflexes (TLRs) use one lens for each purpose: a viewing-and-focusing lens is mounted above the "taking" lens.

refraction When light passes from one transparent medium to another—from air to glass and vice versa—its angle is changed by the surfaces through which it passes. A lens produces its images by refraction.

replenisher A chemical solution that restores a depleted processing solution to its normal working strength. The replenisher for a developer contains a higher proportion of the ingredients that are rapidly used up than of those that are more stable, so it can replace the exhausted ingredients approximately in proportion to their use.

resolution Along with acutance, another measurable aspect of sharpness. Resolution is measured by the number of lines per millimeter that can be seen distinctly in the image of a resolution target—sets of black bars separated by white spaces of equal thickness. The usual resolution targets have several sets of bars of different sizes (see p. 55). Contrast is an integral part of resolution, together with the number of lines rendered per mm. Both lenses and emulsions are tested for resolution.

resolving power The capacity of a lens or an emulsion to record minute image detail.

restrainer The ingredient in a developer that slows the development of the image's least-exposed areas, maintaining clear, bright highlights in prints, etc. Potassium bromide is the most widely used restrainer. Another is benzotriazole.

reticulation A texture, sometimes mistaken for grain, caused by the physical break-up of

the gelatin that supports the emulsion. Typically caused by drastic temperature changes during film processing.

RF See rangefinder.

safelight A darkroom light of a color that will not affect the photographic emulsions with which it has been designed to be used. It enables you to see what you are doing without fogging your paper.

safety film Film on slow-burning cellulose acetate base instead of explosive cellulose nitrate.

scale (1) The range of tones in a print, of densities in a negative or transparency, and of luminances in a subject—in each case, from darkest to lightest. (2) The relative sizes of pictures and things in pictures, and the implications of such proportions. (3) Instrument for weighing chemicals.

semi-matte paper Dull-surfaced but smooth paper, not very well adapted for printing pictures that need richly printed detail in the dark grays and blacks. See Matte.

sensitivity Physically and chemically, the degree to which an emulsion is affected by light. Perceptually, the degree to which a photographer is affected by what he sees.

sensitometry The craft of measuring emulsion sensitivity and its contrast and density behavior. Pioneered by Hurter and Driffield in England in the late nineteenth century.

short scale In a subject, a limited range of brightness, the lightest not much lighter than the darkest. In a negative, a limited range of densities—typically representing a short-scale or low-contrast subject. In printing paper, a high-contrast or "hard" paper, which registers only a short scale of negative densities, expanding them from "gray-on-gray" in the negative toward print tones that more nearly approach "black-against-white."

shoulder On the characteristic curve of an emulsion, that region where so much of the silver has been exposed and developed that the contrast drops (because there cannot be a drastic difference in density between, say, 95 percent of the available silver and all of it).

silver bromide One of the light-sensitive silver halides used in photographic film and paper.

silver chloride Another silver halide used in photo emulsions.

silver halides See Halides.

single-lens reflex A reflex camera with one lens, used both for viewing and focusing and for taking the picture.

single-weight An inexpensive, thin, relatively "curly" thickness of printing paper.

SLR A single-lens reflex.

snappy Contrasty

sodium carbonate An energetic accelerator used in print developers.

sodium sulfite The usual preservative in developers. See Preservative.

sodium thiosulfate See Hypo.

soft Informal way to say low in contrast.

soft-focus A slightly unsharp, diffused manner in photography, a form of photographic romanticism.

soft-working developer A developer that produces images of lower than normal con-

trast. Typically made with Metol, but no hydroquinone.

spot meter A "narrow beam" reflected-light meter that reads only within an angle of acceptance of approximately 1° to 5°, enabling the user to make accurate readings of small areas of subjects, or of far-distant subjects. The spot meter is to the conventional reflected-light meter as the telescope is to the unaided eye.

spotting Retouching out unwanted spots on prints. The spots are mostly light (from dust, scratches, etc. on negatives) and dark dye is usually applied with a fine-pointed brush to make them match the surrounding tones and so disappear.

stand camera A camera normally used on a tripod or other support, as distinguished from a hand camera.

stock solution A concentrated form of a developer or other processing chemical, which is normally diluted with water for use.

stop See Aperture and f-number.

stop bath Typically a weak acid bath used to stop development abruptly and to de-alkalize the film or printing paper to avoid stains and to preserve the fixer, prolonging its usefulness. A typical stop bath is made by adding 48cc of 28 percent acetic acid to each liter of water (1½ oz. 28 percent acetic per quart).

straight photography Photography in which the picture made by the camera is accepted as it is, without significant changes. Does not exclude the use of filters, added lighting, etc.

straight printing Photographic printing without dodging, burning-in or any retouching except spotting. Requires negatives that fit the printing paper well: contrary to common belief, such negatives are usually easy to make.

subtractive color Color theory according to which pigments of three primary colors combine to form black. See Additive color.

subtractive reduction Process of reducing the density of a negative or print chemically so that the same amount of density is removed from the shadows as from the highlights.

superproportional reduction Process by which a greater proportion of the tone in dense areas is removed than from thinner areas. As a result, contrast is reduced as well as density.

swing back A view camera's back characteristically can be pivoted and tilted to change linear perspective and to focus on oblique planes as well as those at right angles to the direction the lens is pointed.

T Setting on shutters for "time exposure."

test strip Trial and error systematically applied to learning what exposure to give a print, and what paper to use.

time-and-temperature development The easy way to develop film accurately; anyone can read a thermometer and a clock, though very few can judge development by looking hastily at partly processed film in nearly total darkness, the procedure used in development by inspection.

TLR A twin-lens reflex camera.

toe On the characteristic curve of a photographic emulsion, that region where so little silver has been exposed and developed that the contrast drops (because there can be little difference in density between, say, 5 percent of a film's silver and none of it).

Modern films often have ASA ratings which place important dark areas in pictures far down on the toe, so the dark tones of the prints are disproportionately flat. This can usually be remedied simply by giving the film 2 to 4 times the recommended exposure, thus placing the dark tones "above the toe" in an area of healthier contrast. The improvement in quality more than offsets any disapproval from the photo industry, which seems to regard the practice as heresy.

tonality The interrelationships of the tones in a photograph; tonality is as much in how a picture feels as in how it looks.

tone range The range of tones in a print; or the range possible in a print, from paper white to saturated black. (Tests show that the ratio of reflectance attainable with a good glossy enlarging paper is about 50 to 1; the white is 50 times as bright as the deepest black of the paper.)

TTL meter Through-the-lens meter. See BTL meter.

twin-lens reflex See reflex camera.

underdevelopment (1) Less development than usual. (2) Too little development, so that quality suffers. The converse of overdevelopment.

underexposure (1) Less exposure than usual. (2) Too little exposure, so that quality suffers. The converse of overexposure.

USASI The United States of America Standards Institute, formerly the American Standards Association; their film speed ratings are still called ASA exposure indexes.

values Tones, in the sense of lightness and darkness, without regard to color or other qualities.

variable-contrast paper Printing paper that yields prints of different contrast when exposed through different printing filters.

vignetting Tonal "fall-off" at the corners of negatives and prints, where the circular image projected by the lens has not covered the whole picture area evenly. Vignetting by a camera lens produces dark corners in the pictures: vignetting by an enlarging lens produces pale corners. In commercial and portrait photography, especially in the 19th century, it has been common to vignette deliberately by shooting through a hole in a black, white or gray board in front of the lens, as a way of getting around "the background problem."

viscose sponge A cellulose sponge used to wipe excess water from negatives and prints before drying.

water to make Cryptic last line in many formulas. "Water to make . . . 1 gallon" means, add water until you have 1 gallon of the solution you are mixing.

Weston, Edward A conspicuously great photographer who worked in California from the 1920s through the 1940s. He had his faults but they do not impair his value.

wide-angle lens A lens that takes in a very wide field and shows it very small in the picture; the converse of a telephoto lens.

working solution In photographic chemistry, a processing solution at its working strength, having been diluted from the stock solution. Print developers, for instance, are usually diluted 1 to 2; one part stock developer to two parts water.

Z Stands for *Zeit*—time—in German. Shutter setting for time exposures.

zoetrope A phenakistoscope.

Index

Page numbers in **boldface** refer to illustrations

reduction (*cont'd*)
 Farmer's reducer, use of, 224-228, **230-31**, 256
 local, of prints, 255-56
resolution, 55-56
rewinding, 35mm, 25
roll-film cameras
 films, black and white, 58
 SLRs, 19-20
 TLRs, 19-20
 viewing and focusing, 19-20

safelights, 65, 67
 testing, 139-40
scale, "correctness" of, 315, **318-19, 320**
selenium cells, light-meter, 26-27
selenium toner for prints, 235-37
 copy photography, 256
selling to publications, 287-88
sharpness, 54-55
Sherwood, Maggie, **328**
showings, private, 287
 see also Exhibiting prints
shutters, 14
 focal-plane, 14
 leaf, 14
 speeds, 14
 motion and moving object, sharpness of, 14-16
 2x factor, 14
 35mm SLRs, 18-19
Siegel, Laurence, **290**
Smith, W. Eugene, 136
Stein, Gertrude, 305
Stieglitz, Alfred, **325**
still cameras
 pinhole, 21-23
 press, hand-held, 20
 roll-film, 19-20
 35mm
 RF (rangefinder), 19
 SLR, 17-19
 view camera, 20
 see also Camera(s); *specific subjects*
studio photography
 light balance, 32
 subject contrast, 44
subject contrast, 43-44
 development and, 47-49

subjects and techniques, **322-35**
 camera clubs, and contests, role of, 301
 magazines and books as authorities on, 301-2
 meanings and feelings, personalness of, 315
 organizing the picture, 306
 printing
 judgment, developing, 306-7
 problems: seeing what's on the paper, 306-7
 scale, "correctness" of, 315, **318-19, 320**
 "seeing" as a learned skill, 305-6
 selection of subjects, 307-12, 320-21
 starting points suggested for, 312-14
 self-determination of, 302-5
 technique as means not goal, 318-20

techniques
 history of development of, ix-xix
 subjects and, learning to handle, 301-21
 see also specific subjects
terms, photographic, 336-54
35mm cameras
 films, black and white, 58
 loading, 23, **24**
 rangefinder (RF), 19
 rewinding after shooting, 25
 setting and shooting for box-camera approach, 23
 SLR, 17-19
 eyepiece, prescription lens for, 19
 lenses, 18-19
 shutters, 18
 viewscreen, 19
 viewing and choosing, 23-24
tonal quality
 development and, 40-42
 Polaroid prints, 60
tones, gray scale of, 256, **257**
toning
 copy photography, 256
 GP-1 Gold Protective Solution, 245
 selenium, 235-37

Varden, Lloyd, 256, 257
view camera, 20
viewing
 filter, 56

75 76 77 78 79 80 10 9 8 7 6 5 4 3 2